D1349915

TREASURES OF THE ROYAL COURTS

TUDORS, STUARTS &
THE RUSSIAN TSARS

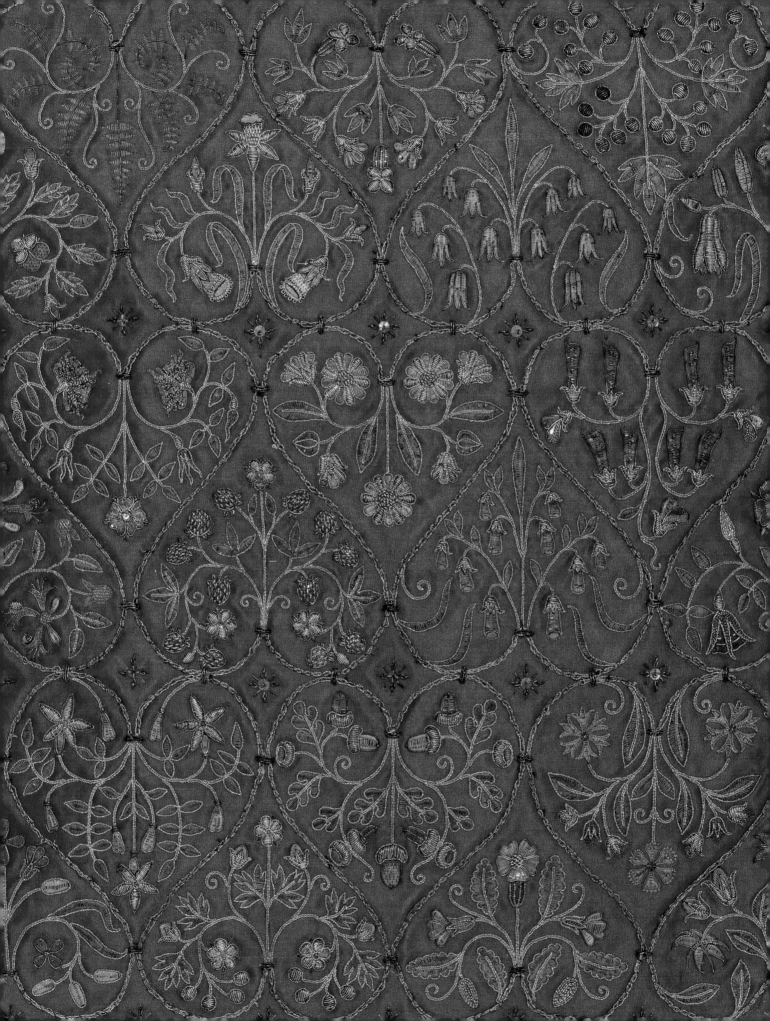

TREASURES OF THE ROYAL COURTS

TUDORS, STUARTS &
THE RUSSIAN TSARS

EDITED BY OLGA DMITRIEVA AND TESSA MURDOCH

V&A PUBLISHING

EXHIBITION SUPPORTERS

This exhibition is supported by the Friends of the V&A

On behalf of all 32,000 V&A Members, the trustees of the Friends of the V&A are delighted to support *Treasures of the Royal Courts: Tudors, Stuarts and the Russian Tsars*, a scholarly and exciting exhibition that sheds light on a fascinating aspect of the historical connections between Britain and Russia, and underlines the international role of our Museum. We wish the exhibition, and the V&A, every success.

Lady Vaizey of Greenwich CBE, Chairman of the Friends of the V&A, 2007–2013
John Everett, Chairman of the Friends of the V&A, 2013–

With further support from Summa Group

Summa Group is honoured to support *Treasures of the Royal Courts: Tudors, Stuarts and the Russian Tsars*. As patrons of Russian art and culture, we hope that the long-standing historic bonds between Russia and the United Kingdom will be strengthened by this unique exhibition.

Additional thanks to Vnesheconombank

VNESHECONOMBANK
STATE CORPORATION
‹BANK FOR DEVELOPMENT AND FOREIGN
ECONOMIC AFFAIRS (VNESHECONOMBANK)›

First published by V&A Publishing, 2013
Victoria and Albert Museum
South Kensington
London SW7 2RL
www.vandabooks.com

Distributed in North America by
Harry N. Abrams Inc., New York

© The Board of Trustees of the
Victoria and Albert Museum, 2013

The moral right of the authors
has been asserted.

ISBN 978 1 85177 731 0

Library of Congress Control Number
2012948900

10 9 8 7 6 5 4 3 2 1
2017 2016 2015 2014 2013

A catalogue record for this book is available from the British Library.

Printed in Hong Kong

Every effort has been made to seek permission to reproduce those images whose copyright does not reside with the V&A, and we are grateful to the individuals and institutions who have assisted in this task. Any omissions are entirely unintentional, and the details should be addressed to V&A Publishing.

Front jacket illustration: *Elizabeth I (The Hampden Portrait)* (detail), see pl.17
Back jacket/cover illustration:
Page 2: Cushion cover with floral design (detail), see pl.160
Page 6: Field armour of Sir Henry Lee (detail), see pl.139

Designer: Maggi Smith

New photography by Richard Davis, V&A Photographic Studio

V&A Publishing

Supporting the world's leading museum of art and design, the Victoria and Albert Museum, London

CONTENTS

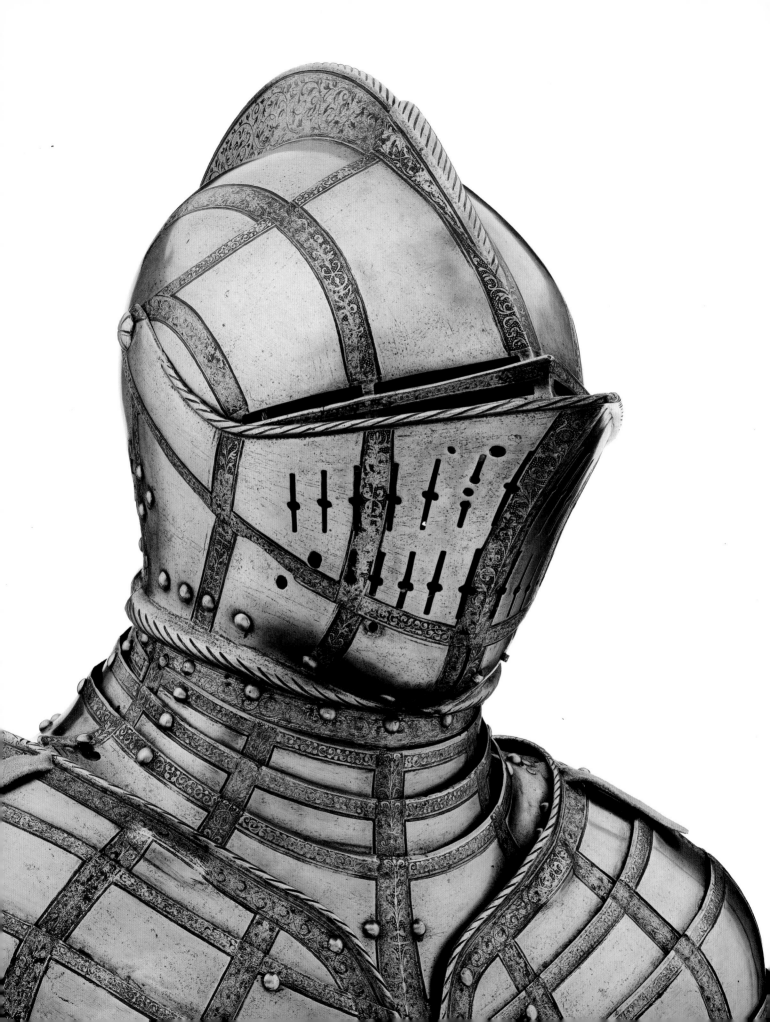

DIRECTORS' FOREWORD

Treasures of the Royal Courts: Tudors, Stuarts and the Russian Tsars illustrates the most colourful period of English history. It celebrates the patronage of successive British monarchs and their leading courtiers from the accession of the young King Henry VIII in 1509 to the death of the mature King Charles II in 1685. Henry VIII encouraged the best artists and craftsmen from overseas to settle in England; Charles I was the greatest royal collector in English history. With the Restoration of the monarchy in 1660 the full panoply of royal majesty and protocol was restored.

We are delighted that the joint programme between our two institutions, Moscow Kremlin Museums and London's Victoria and Albert Museum, provides this opportunity to share the best examples from London's national collections of arms and armour, jewellery, portraits and portrait miniatures, silver, and textiles. We are particularly thrilled that Her Majesty the Queen has graciously agreed to lend Henry VIII's 1539 Greenwich armour from the Royal Collections. Henry's presence will thus preside at the entrance to both the Moscow and London exhibitions.

We thank our colleagues at the British Library, the College of Arms, the Museum of London, the Natural History Museum, the National Portrait Gallery, the National Maritime Museum, the Royal Armouries and the National Museum for Science and Industry for their generous participation and also extend our thanks to several private institutions and lenders.

The London exhibition features spectacular English silver from the Kremlin Armoury Museum. Marking 400 years since the founding of the Romanov dynasty in 1613, an international audience will have a fresh opportunity to review cultural, diplomatic and trading relations between Russia and England – a relationship that began over 50 years before the Romanov dynasty. We welcome this exciting celebration, and look forward to future opportunities to develop this important cultural friendship. We thank our colleagues in both institutions for such a fruitful collaboration.

Martin Roth
Director, Victoria and Albert Museum, London

Elena Gagarina
General Director, Moscow Kremlin Museums

INTRODUCTION

Tudor and early Stuart England enjoyed a long spell of internal peace after the civil wars of the fifteenth century. But the coming of the Reformation, and the uncertainty of national religious identity that followed the severed ties between England and the Church of Rome, brought huge disruption and social upheaval. Monarchs were acutely conscious of their vulnerability and often sought, through diplomacy, trade and royal marriage alliances with great overseas countries, to bolster their power. They made overtures to old and new enemies, France and Spain, and to potential allies like Sweden, the newly independent Netherlands, and Russia. Works of art were part of a luxury trade in expensive and rare objects that demonstrated access to precious materials and the skills of the best craftsmen to transmit messages about the country's wealth and resources.

The Reformation led to a reframing of the meanings and purposes of imagery. Under Henry VIII some 800 monasteries were dissolved by Acts of Parliament in 1536 and 1539: buildings were stripped of their valuables, everything from movable contents, such as plate and vestments, to the lead of their roofs; historic collections of manuscripts were dispersed or burned; their lands were sold on the open market. The attack on religious images was especially vehement during the reign of Edward VI (1547–53). Yet not all was lost. About half of the former monasteries were converted into houses or public buildings, offering new challenges of architectural ingenuity that altered the direction of English architecture. Roman Catholic images may have been defaced or destroyed, but the later sixteenth century used imagery from the Bible for the new purpose of telling moral stories via tapestry, plasterwork ceilings and fireplace overmantels, and embroidery. After the Reformation, painters – some settled in England after leaving Germany or the Netherlands – turned their attention to portraiture, creating images of sovereigns, political and military figures, and merchants, that begged to be admired and celebrated with a devotion different from that of an act of religious worship: portraits commanded respect for wealth, power or physical beauty in face, hands and costume.

The principal engines of energy in the visual arts were the Court, with its sovereign and royal household, and the City of London, with its wealthy merchant classes and foreign bankers and agents. They met at the interface of the urban celebration of the sovereign, in triumphal entries into the City that were comparable with those taking place all over Continental Europe, and which started at the various gates that interrupted the London wall. The relationship between Crown and City was always tense and controlled – so that sovereigns conventionally used the river Thames, outside the City, to move themselves and the Court from Westminster to the Tower and the royal palace of Greenwich in one direction, and westwards to Hampton Court, in the other. Henry VIII was a great builder of royal palaces, in many cases of brick, all over the south-east of England. Here were housed new luxury items of tapestry, plate and furnishings which, along with the royal jewels and personal effects, were inventoried to the grand total of more than 17,000 items at the King's death in 1547. Elizabeth I built very little, but many great courtiers constructed lavish houses to entertain her on her progresses around England. Elizabeth was meticulous about her personal appearance at Court occasions, especially when ambassadors were present, and something of the range and lavishness of her dress is captured in a succession of portraits of her, controlled by royal edict to

preserve the image she wished to portray. Artists played a crucial role in the making of royal imagery. Hans Holbein, from 1536, helped Henry VIII form the powerful sense of presence he conveys in his later portraits. The later images of Elizabeth show her as the Virgin Queen, 'married' to her country, ageless and unchanging, despite the war with Spain and the poor economic conditions at home that beset her later years. The other face of portraiture, miniatures, were made as gifts and tokens of affection in the private world of the more intimate rooms of the royal palaces or courtiers' homes.

Continental sources of design, through prints and imported goods, influenced the style of the Renaissance, the revival of classical antiquity, which originated in Italy and was transmitted to England both through direct contact and through the intermediaries of France and the Netherlands. Some historians have seen the full impact of Renaissance style as only imperfectly achieved in Tudor and early Stuart England, but it might also be seen as a matter of choice, of adopting new ideas where relevant and appropriate. Foreign styles of ornament were especially prevalent in small, luxury goods rather than in great buildings or large portraits: the border of a magnificent tapestry, the frontispiece of a book, the chased surround of a dish in gold and silver may show the latest incarnations of naked cherubs, acanthus leaves, candelabra and suchlike, taken from prints of Italian ornament, sometimes mixed with the Gothic, or the late English medieval, style. The expensive material of an object, or its replication in paint, plaster or paper, said more about the owner's pretension to status and high fashion than the style in which it was made.

In 1603, James VI of Scotland became James I of England, uniting the Crowns of the two principal parts of Great Britain. The imagery of monarchy changed to a more imperial message. The early Stuart monarchs made their peace with Catholic Europe by ending the war with Spain and via the marriage of Charles I to Henrietta Maria, the sister of the French king. During the early seventeenth century the Crown and leading courtiers certainly became more aware of the practice of collecting works of art for their own sake and as a reflection of the patron's learning and good taste. Whole collections were exchanged between those knowledgeable about sculpture from ancient times, Renaissance paintings and prints, and the art of modern Italy. Flemish artists, notably Daniel Mytens and Anthony van Dyck, moved the forms of royal and aristocratic culture towards less formal modes through a broader, looser style in the handling of paint. Rather than merely incorporating small symbols of classical culture into costumes, sitters – kings, courtiers, poets – now appeared actually clothed in the guise of figures from classical literature.

After the Restoration of the monarchy in 1660 the British Crown found itself increasingly bound by constraints on its authority, but in portraiture it retained the trappings of power, similar to those of the absolutist monarch Louis XIV of France. It was an age when ambassadors were resident in foreign cities for longer periods so that diplomatic gifts became ever grander and more expensive, such as the great sets of silver of the late seventeenth century and huge sets of porcelain in the century after. This was a different world of international exchange, but perhaps something was lost of the exuberance, experiment and richness of many of the works that feature prominently in the early stages of the present exhibition and the image they presented of England at courts and in great cities all over Europe, from Lisbon to Moscow.

Maurice Howard
President of the Society of Antiquaries of London
Professor of the History of Art, University of Sussex, Brighton
University of Sussex Exchange Fellow, Victoria and Albert Museum, London

ACKNOWLEDGEMENTS

The exhibition *Treasures of the Royal Courts: Tudors, Stuarts and the Russian Tsars* is the result of international collaboration between the Moscow Kremlin Museums and the Victoria and Albert Museum, London. In Moscow we are extremely grateful to all those who have made this exhibition and publication possible: Elena Gagarina, General Director of the Moscow Kremlin Museums, Zelfira Tregulova, Deputy Director for Exhibitions, and Katherine Karavaeva who has guided the plans at every turn. Natalia Abramova and Elena Yablonskaya have generously shared their expertise. Working with Olga Dmitrieva, Deputy Director, has been an inspiration. We are particularly grateful to the former Director of the Victoria and Albert Museum, Sir Mark Jones, for his vision of greater cooperation between our two institutions, made possible by the energetic commitment of the Exhibition Department led by Linda Lloyd Jones. This is the fourth exhibition in a programme of exchange, and we would like to thank Rebecca Wallace, Senior Assistant Registrar, for her careful attention to detail and David Packer, Registrar, for his advice. In Moscow we would also like to thank Dr Alexey Levykin, Director, The State Historical Museum and Alexander Sotin, Curator, The Old English Court Museum.

At the V&A we are particularly grateful to Rebecca Wallace and Zoë Louizos for coordinating the loans from other British institutions and collections. These include, in London, loans from the following institutions: through Peter Barber, Map Librarian at the British Library; through Jack Lohman, former Director at the Museum of London, brilliantly supported by Hazel Forsyth, Senior Curator, and their Registrar, Nickos Gogolos. We would also like to thank colleagues at the National Maritime Museum, Kevin Fewster, Director, Margarette Lincoln, Christine Riding and Jane Fisher; at The National Museum of Science and Industry, Ian Blatchford, Director; and at the Natural History Museum, Paul G. Davis and Dr Joanne H. Cooper; the National Portrait Gallery loan was agreed by former Chief Curator Jacob Simon and his successor Tarnya Cooper, with Catharine MacLeod and Juliet Simpson.

We are most grateful to Her Majesty The Queen for the loan of the magnificent Greenwich armour made for King Henry VIII. We thank Jonathan Marsden, Director of the Royal Collections, and his colleagues Rufus Bird, Desmond Shawe-Taylor, Kathryn Jones, Caroline de Guihault and Simon Metcalf, Master Armourer, who have all assisted with advice. We are delighted that the Master and Wardens of the Worshipful Company of Armourers and Brasiers have agreed to the loan of Sir Henry Lee's Greenwich armour made possible by the Company Clerk, Commodore C.W. Waite RN. We are grateful to Patric Dickinson, Clarenceux King of Arms, The College of Arms, Sonia Solicari, Director, The Guildhall Art Gallery, London, Cathy Power and Laura Houliston at English Heritage, for their assistance. Thanks are also due to Dr Jonathon Riley, Director, and Victoria Adams, Thom Richardson, Katherine Richmond, Alison Watson, Lisa Gaunt and Ciara Gallagher at the Royal Armouries, Leeds.

Our European colleagues László Csorba, the Director General of the Hungarian National Museum, Budapest, and Gunta Garms and Christiane Lukatis at the Museumslandschaft Hessen Kassel, Germany, have agreed to facilitate important loans. Private European lenders include the Prince de Ligne, from the Château of Beloeil, Belgium.

The exhibition also benefits from additional loans from English private collections.

We are grateful to Lord Rothschild, and his Chief Curator Pippa Shirley, with Susan Absolon, Ruth Bubb and Naomi Hicks for the portrait lent from Waddesdon Manor, Buckinghamshire; The Hon. Simon Howard and Christopher Ridgway, Curator, for the loan of the portrait of Charles Howard, 1st Earl of Carlisle, from Castle Howard. Todd Longstaffe-Gowan has generously agreed to lend the recently rediscovered heraldic stone lions. Further loans from English private collections include, through the kind assistance of Dr Bendor Grosvenor of Philip Mould Ltd, the Hampden portrait of the young Queen Elizabeth I; through Robert Holden, the silver-mounted fire furniture; through the V&A and the National Maritime Museum, the lender of the Drake Star and Drake Jewel; through the Trustees of the Berkeley Will Trust, the spectacular Hunsdon Jewels; through S.J. Phillips, the Charles I memorial and Gresham grasshopper rings; and through Charles Cator of Christie's and his assistant Clemency Henty, the exquisite contemporary watercolour of Nonsuch Palace.

At the Victoria and Albert Museum we would particularly like to thank Beth McKillop, Deputy Director, Julius Bryant, Keeper of Word and Image, Paul Williamson, Keeper of Sculpture, Metalwork, Ceramics and Glass, Christopher Wilk, Keeper of Furniture, Textiles and Fashion, Liz Miller, Acting Head of Research, and Angela McShane (V&A/Royal College of Art) for their support and encouragement. The exchange of exhibitions has benefited from advice given by curators Clare Browne, Rachel Church, Katherine Coombs, Richard Edgcumbe, Mark Evans, Nicholas Humphrey, Kirstin Kennedy, Sarah Medlam, Angus Patterson, Matthew Storey and Rowan Watson, and conservators Albertina Cogram, Alan Derbyshire and Joanna Whalley. We would also like to thank the team of interns who have helped to muster the necessary information: Carolin Alff, Alisa Oleva, Claire-Emily Martin, Elouise Maxwell, Inès Pinot-Perigord de Villechenon, Jane Sconce, Amanda Seadler and Julia Webb. Other colleagues who have helped include Bryony Bartlett-Rawlings, Ruth Hibbard, Jonathan Hopson, Christopher Marsden, Abraham Thomas, Mor Thunder and Esme Whittaker. We would like to thank Davina Cheung, Clare Davis, Mark Eastment, Tom Windross and Kate Phillimore from V&A Publishing. Jemma Davey has provided administrative support throughout. Frances Parton has coordinated the curatorial contributions and made a huge contribution to delivering the V&A exhibition and publication.

We are grateful to Julian Munby for sharing his enthusiasm and research on the Kremlin coach, and for his work filming the coach, ably assisted by Peter Kelleher. Thanks are also due to Peter Barber, British Library, Ellenor Alcorn, Metropolitan Museum of Art, New York, Michèle Bimbenet-Privat, The Louvre, Paris, Tobias Capwell, The Wallace Collection, Philippa Glanville, David Mitchell, Barry Shifman, Virginia Museum of Fine Arts, Karen Hearn, former Curator at Tate Britain, and Alexander Sotin, Curator of the Old English Court Museum in Moscow, all of whom have provided valuable advice and ongoing support for this project.

Finally, we gratefully acknowledge the support of the Friends of the V&A, Summa Group and Vnesheconombank.

Tessa Murdoch
Acting Keeper, Department of Sculpture, Metalwork, Ceramics and Glass
Victoria and Albert Museum, London

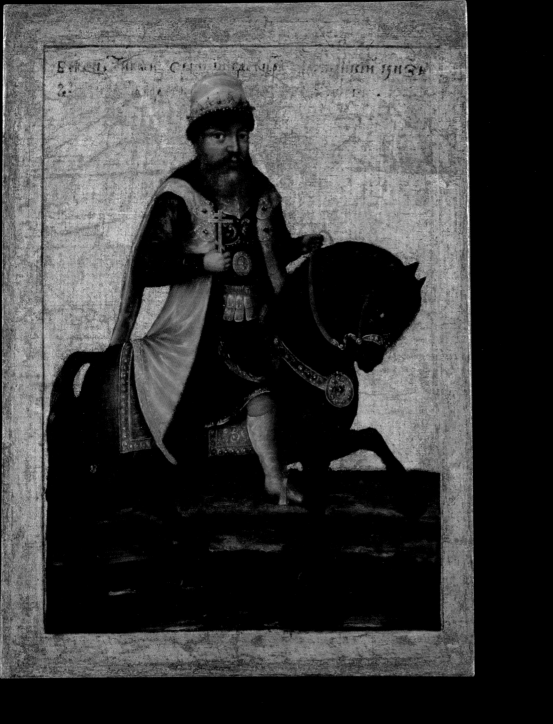

Olga Dmitrieva

FROM WHITEHALL TO THE KREMLIN: THE DIPLOMACY AND POLITICAL CULTURE OF THE ENGLISH AND RUSSIAN COURTS

This book explores English court life and the political culture of the Tudor and Stuart monarchies, within the framework of international relations. The political language and nature of early modern monarchy are wrapped up in its rituals of power, diplomatic protocol, and the use of artefacts as intermediaries in symbolic communication between rulers.

First encounters

The history of regular commercial and diplomatic contacts between England and Russia dates back to 1553, with the tragic odyssey of three English ships under the command of Sir Hugh Willoughby and Richard Chancellor. Sent by the Company of Merchant Adventurers to explore the North-East Passage to China and India via the Arctic Ocean, they passed Scandinavia, only to be scattered by a storm. Two ships were jammed in ice and their crews perished, while the sailors from the third, led by Chancellor, found themselves in the mouth of Northern Dvina River, where they were met by local fishermen and subsequently escorted to Moscow to the court of Ivan IV (r.1533–84, later known as 'The Terrible').[1]

At that time Muscovy had been gradually acquiring the status of a newly powerful centralized state, claiming to be a sole heir to the Byzantine Empire. After the Fall of Constantinople in 1453, Russia remained the largest Orthodox state, and the Grand Dukes of Muscovy adopted the title 'Tsar' (Caesar). Ivan IV was crowned Tsar of All the Russias in 1547. Before the arrival of the English merchants he had defeated the Tatars, annexing the lands of Kazan Khanate. Russia was emerging as a multi-ethnic state stretching across Europe and Asia (pl.12). Seeking recognition by the European nations of Muscovy's new status, Ivan received the Englishmen most kindly. Thus the foundations were laid for the stable relationship between two powers situated on the opposite extremes of Europe, two would-be empires that were to dominate world politics for centuries to come.

Politics of commerce

In 1555 the Muscovy Company was established in London under a charter signed by Queen Mary I (r.1553–8).[2] Many leading statesmen, noblemen and courtiers joined this venture, investing in trade with Russia. Tsar Ivan (who, from his political opponents, acquired the epithet 'the English Tsar') granted the Company extensive privileges and a monopoly on tax-free trade.[3] The merchants brought to Russia lead and copper, pewter, English cloth, silks, velvets and damasks for the Tsar's court and munitions for

1 (*opposite*)
UNKNOWN RUSSIAN ARTIST
Tsar Mikhail Romanov
Oil on canvas, c.1675–85
State Historical Museum, Moscow
GIM 32936/1-3459

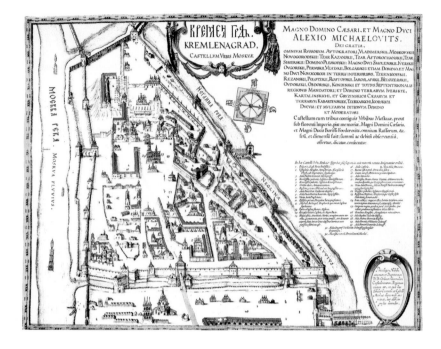

the army, while returning with hemp, tallow, cordage and furs. This was the beginning
of a special relationship, England becoming Russia's first privileged economic partner.[4]
English merchants were allowed to settle in the North of Russia, as well as in Moscow,
where their residence was located near to the Kremlin (pl.2). Owing to the persis-
tence of Anthony Jenkinson (see pl.12),[5] who had undertaken a voyage down the Volga
River to the Caspian Sea, in 1567 the Company was granted permission to trade in
Kazan and Astrakhan, and to move on further to Persia and China.[6] (It is likely that
a beautiful Renaissance font-shaped cup (pl.96), was one of Jenkinson's early gifts to
Tsar Ivan, pl.3.)

Commerce determined the character and content of the diplomatic interchange
between the two states during the reign of the Ryurikovichi (Rurik dynasty) and the
Tudors. Under Elizabeth I (r.1558–1603) the Muscovy Company enjoyed royal patronage
and acquired a unique place in diplomacy: merchants, who formulated the objectives of
the English policy in Russia, not only influenced the appointment of ambassadors, but
frequently acted in a dual role – both as agents of the Company and official envoys of
the Queen to Ivan IV and his successors.

While the English focused on profits and commercial opportunities, for the
Russians political issues came increasingly to the fore in the 1570s. Tsar Ivan's failures in his
wars over the Baltic states (1558–83) made England his sole political ally against Poland,
Lithuania and Sweden, and the potential source of military aid in terms of money, modern
ordnance and manpower.[7] He cherished the idea of signing a treaty of 'eternal friend-
ship' that encompassed military and even dynastic alliance. Having proposed marriage
to his 'beloved sister' Elizabeth, which she declined, Ivan carried on negotiations to find
an English bride of royal blood.[8] In fact, in 1569, both monarchs were quite close to
some kind of political alliance, and the Queen in a secret letter offered Ivan support and
refuge in England, if necessary,[9] but no formal bilateral treaty was signed.

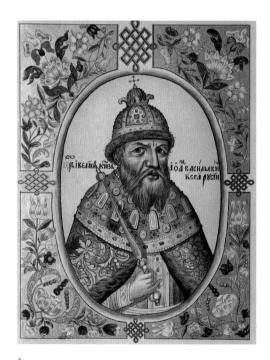

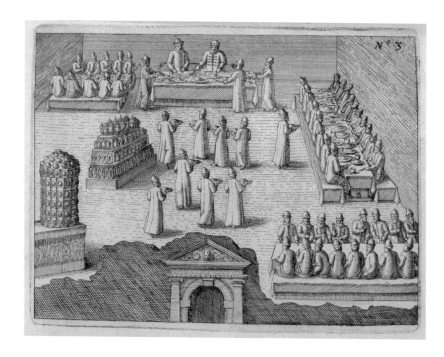

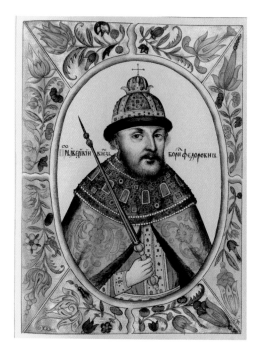

The Queen's apparent reluctance to become involved in the Baltic conflict led to disappointment and increasing hostility on the part of the Russian administration, which resulted in the annulment of the English monopoly on tax-free trade in Russia, and in 1571 the withdrawal of the Company's rights to travel to Persia.[10] In 1580–90 the Russian authorities were increasingly turning towards protectionism, having realized that the English monopoly was conflicting with the economic interests of the Russian state. From then on recovery of former privileges became the main objective of English diplomacy and the recurrent theme in Anglo-Russian negotiations. Deterioration of Anglo-Russian relations encouraged the Dutch, whose merchants appeared in the Russian North for the first time in 1577. Competition with the Dutch became a matter of concern for the Muscovy Company – and for the Queen and her Council – along with the fact that during Russia's next two reigns its interests in the international arena tended towards an alliance with the Catholic Habsburg Empire. During Tsar Fyodor's reign (1584–98) an anti-English mood dominated at the Moscow court. Even the accession to the Russian throne of Boris Godunov (r.1598–1605, pl.5), known to favour the English, did not help restore the Company's lost trade monopoly, although the tone of Anglo-Russian dialogue became more amicable. During this period the two powers were united by common anti-Polish interests and the search for an alliance with Denmark.[11] Similar political aims ensured unprecedented success of the ambassadorial missions of Gregory Mikulin to London (1600)[12] and of Sir Thomas Smith to Moscow (1604).[13]

Romanovs and Stuarts: a new beginning

After the death of Boris Godunov in 1605, Russia entered the Time of Troubles, which was marked by a serious internal political crisis, a Polish invasion, the taking of Moscow by Dmitri the Impostor in 1605–6 and intervention from Sweden, all of which threatened English economic interests.[14] At that moment, the governors of the Muscovy

Company – along with some military officers – masterminded the establishment of an English protectorate over the Russian North.[15] James I was offered the possibility of taking this territory under his rule, which was supposed to be 'the greatest and happiest ouverture that ever was made to any King of this realme, since Columbus offered King Henry VII the discovery of West Indies'.[16] But in 1613 the Polish invaders were successfully expelled from Moscow and young Mikhail Romanov was elected to the Russian throne (r.1613–45; pl.1).

James I was informed of the Romanov accession by the embassy of Alexei Zyuzin (1613–14), which aimed to bring the English into an anti-Swedish alliance, as well as to obtain financial support and munitions for the army.[17] He had a very welcome reception, owing to James's growing involvement in European political affairs, and his schemes for the northern anti-Habsburg and anti-Catholic league.[18]

The major role in Russo-Swedish peace negotiations of 1617 was played by John Merrick, agent of the Muscovy Company.[19] His efforts were rewarded bountifully, but even so the Company did not gain the former trade monopoly and privileges it was hoping for. Tsar Mikhail and King James almost achieved a major breakthrough in relations between the two states: in 1623 an agreement of 'eternal alliance' between Britain and Russia was drawn up and approved by the English side, but it was never signed by the two sovereigns.[20]

6

A Tsar receiving a delegation in the Reception Hall of the Palace of Facets at the Moscow Kremlin
Germany, early 17th century
Herzog August Bibliothek,
Wolfenbuttel, Germany

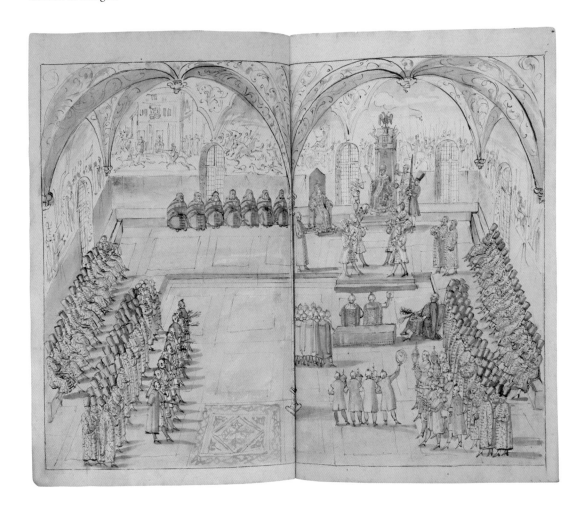

Russian court ceremony seen through English eyes

Richard Chancellor and his fellow explorers are the first Englishmen to have left a detailed description of Russia. Recent scholarship has tended to emphasize cultural and religious differences, obvious dissimilarities in the way English and Russian societies carried out their daily lives, and language barriers, which hampered the European travellers' understanding of some realities of local life. The English account demonstrates, however, that the languages of political culture, used at both courts for the purposes of representing the ruling monarchs, proved to be identical, and perfectly comprehensible to both sides. This was the rhetoric of solemn ritual and magnificent spectacle that, throughout Europe, constituted a universal language of power. Englishmen were undoubtedly impressed by the way such rituals were performed in Russia (pl.4). They appreciated the setting for their first ceremonial audience in the Kremlin, the majestic behaviour of the royal dignitaries and the rich attire of the courtiers, 'all apparelled in cloth of golde, downe to their ankles'. The climax of the ceremony was the Tsar's public appearance:

> Being conducted into the chamber of presence, our men beganne to wonder at the Maiestie of the Emperour: his seat was aloft, in a very royall throne, having on his head a Diademe, or Crowne of gold, apparelled with a robe all of Goldsmithes worke, and in his hande he helde a Scepter garnished, and beset with pretious stones: … there was a Maiestie in his countenance, proportionable with the excellencie of his estate … This so honourable an assemblie, so great a Maiestie of the Emperour, and … of the place, might very wel have amazed our men and have dasht them out of countenance.[21]

One of the key structural elements of the Russian court ritual was the ceremonial dinner (pl.6). Invited to dine in the Golden Chamber, the travellers found the food served to be extremely rich, the ritual most solemn. 'They find the Emperor sitting upon a high and stately seate, apparelled with a robe of silver, and with an other Diademe on his head.' Ivan changed his precious crowns three times during the course of this one day. In addition to the insignia, an important role was played by the precious tableware, which was set out in the room with the specific intention of amazing all those present. A long passage of Clement Adam's report was dedicated to the royal treasures displayed for general view:

> In the middes of the roome, stoode a mightie Cupboorde upon a square foote, whereuppon stoode also a rounde boorde, in manner of a Diamond, broade beneath, and towardes the toppe narrowe, and every steppe rose uppe more narrowe then another. Upon this Cupboorde was placed the Emperours plate, which was so much, that the very Cupboord it selfe was scant able to sustayne the weight of it: the better part of all the vessels, and goblets, was made of very fine golde: and amongst the rest, there were foure pots of very large bignesse, which did adorne the rest of the plate, in great measure: for they were so highe, that they thought them at least, five foote long [pl.7].

Over a hundred servants attending to the guests were dressed in rich attire, which they too changed three times during the feast. 'This is true,' continued the author, 'that all the furniture of dishes, and drinking vessels … for the use of a hundred guests, was all of pure gold, and the tables were so laden with vessels of gold, that there was no roome for some to stand upon them.'[22] Glittering of gold and twinkling of precious stones, opulence and exotic oriental luxury would later become a recurrent theme in English descriptions of the Russian court.

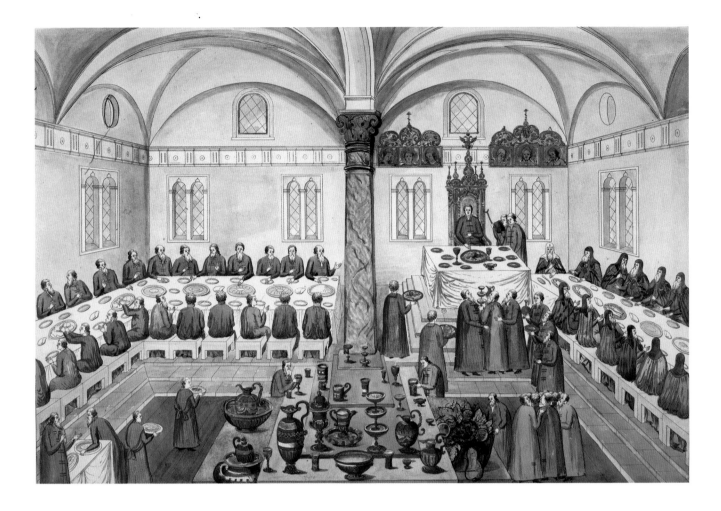

Diplomatic protocol

The structure of the diplomatic protocol in both countries reveals more similarity than divergence. Its main elements included the meeting of the ambassadors at the country's borders, their ceremonial entry to the capital, the official audience with the monarch, the presentation of gifts followed by the state banquet, negotiations, the last audience and the departure of the diplomatic envoys with farewell gifts from the host ruler.[23] In both countries the expenses of diplomats' stays were borne by the treasuries of the countries they visited, although in many cases victuals and accommodation for the Russian ambassadors in London were provided by the Muscovy Company.

In Moscow, the reception of foreign diplomats was arranged by the Ambassadorial Office, a special administrative body established in 1549. The progress of the ambassadorial procession heading to the Kremlin through the city, accompanied with drums and trumpets, lasted for hours. It was a brilliant political performance, staged carefully to impress both the foreign visitors and the Tsar's own subjects. Jerome Horsey, merchant and diplomat, has left his description of ambassador Jerome Bowes's entry to the Kremlin in 1583: 'the streets were filled with people, and a thousand gunners attired in yellow and blue Garments set in rankes by the Captaines on Horsebacke with bright Harquebuses in their hands from the Ambassadours doore to the Emperours palace'.[24]

7
Unknown Artist
A Tsar at a banquet in the Reception Hall of the Palace of Facets
Moscow, Russia, 1671–3
The Moscow Kremlin Museums

8
The Palace of Facets, 1916
Reproduced from S.P. Bartenev,
Moskovskii Kreml v starinu I teper
(vol.II, no.254) Moscow, Russia, 1916
The Moscow Kremlin Museums

9
JOHANN RUDOLPH STORN
*The Reception of the Austrian Mission
(the presentation of the gifts) in the
Chamber of Tsar Alexei Mikhailovich
in the Terem Palace of the Kremlin
on 24 April 1662.* Augustin von
Meyerberg, *Album, View, and
Everyday Life Pictures from Russia
of the 17th Century* (reprinted 1903)
The Moscow Kremlin Museums

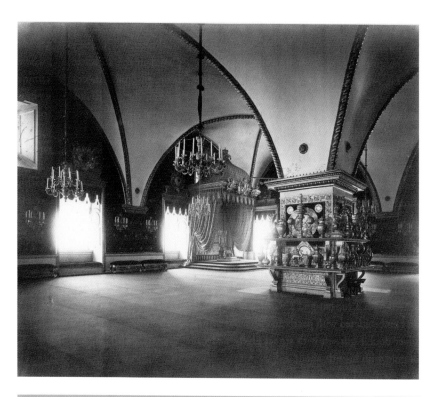

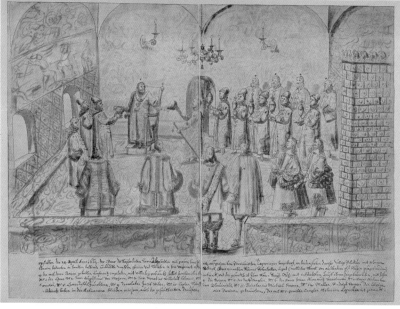

The procession marched slowly through the streets, the royal presents being carried, each of them separately, by members of the ambassadorial suite and Russian guards, to impress the onlookers.

Official audiences took place in either the palace's Golden or Faceted Chamber (pl.8), where diplomats were presented and handed their credentials to the Tsar, who sat enthroned and dressed in his state robes (see pls 3 and 5). During the course of

exchanging official speeches, the Tsar would enquire about the health of his royal counterpart and greet the ambassador. Then the formal ceremony of the presentation of the gifts took place. Beforehand they were displayed in the antechamber, where the high-ranking officials, noblemen, courtiers and foreign diplomats could examine and evaluate them (pl.9). Then the gifts were brought in, the officials of the ambassadorial office making a solemn announcement of every item presented for public appreciation.[25]

At dinner the Tsar sat alone; the English ambassadors and Russian diplomats involved in the negotiations were placed at a separate 'ambassadorial' table. The Tsar would propose toasts and raise a cup to the health of the English monarch and his family. As a sign of particular favour he might have sent food and drink from his table to the guests.

Traditionally, after the completion of their mission, ambassadors were rewarded by host rulers with personal farewell gifts, regarded as a gratuity and a signal of special favour. Tsar Mikhail Romanov gave the most expensive presents to John Merrick, who acted as an intermediary during the Russo-Swedish negotiations of 1617. He was presented with a fur hat and a Russian-style court dress of Persian silk lined with sables and embroidered with pearls and precious stones.[26] Merrick also mentioned a 'kovsh of silver double gilt sett with stones given me by the Emperor of Russia, also his picture of gold with his title about it'.[27]

10 (*below and opposite*)
The letter of credence for
Jerome Bowes from Elizabeth I
to Tsar Ivan IV, 5 June 1583
Russian State Archive of
Ancient Acts, fund.35. op.2, no.4

The Russian rulers' perception of themselves as omnipotent emperors, their expectation of divine right and the traditions of elaborate Byzantine political ritual, determined the atmosphere of the diplomatic reception at the Tsar's court. The Russians paid much attention to the codes of conduct of foreign diplomats and to their social status. Conflicts frequently occurred around the proper manner in which the Tsar should be treated. The Russians might be annoyed by diplomatic representatives of low status or the intrusion of the merchants into political affairs. Tsar Ivan's irritation with the personnel of the English diplomatic missions, as well as with their priorities, must have reached its climax when he wrote to Elizabeth:

> And wee had thought that you had been ruler over your lande and had sought honor to your self and profitt to your countrie, and therefore wee did pretend those weightie affaires betweene you and us; But now wee perceive that there be other men that doe rule, and not men but merchaunts the which seeke not the wealth and honour of our maiesties, but they seeke there owne profit of marchauntdize: and you flowe in your maydenlie estate like a maide.[28]

Affairs had been aggravated by the last two of Elizabeth's envoys to Ivan – Thomas Randolph (1568)[29] and Jerome Bowes (1583–4) – whose behaviour was found provocative and insulting by the Russian side (pls 10 and 22). Bowes had confronted the Tsar himself, and left his departure gifts – as well as Ivan's letter to Elizabeth – behind at the border.[30] Later the Queen had to apologize for the diplomat's escapade.[31]

Russian diplomats at the English court

Until 1603 there was no special body of officials in England who dealt with diplomatic protocol; the Lord Chamberlain and the staff of the royal household (gentlemen of the Privy Chamber and the Master of the Revels) were in charge of the reception and entertainment of foreign visitors. When Osip Nepeya – the first Russian ambassador dispatched to England by Ivan IV – arrived in London, in 1557, he was

> honourablie received at Totenham by the merchants of London, having trade in those countries, riding in velvet coats and chaines of gold ... The Lord Montacute with the Queens pensioners met him at Islington townes end: and at Smithfield barres the lord maior and aldermen in Scarlet received him, and conveyed him through the Citie ...[32]

Taking into account their commercial interests, it seemed natural that the Muscovy Company enthusiastically participated in the ceremony and carried the burden of the ambassador's expenditure. In Nepeya's case, the ambassadorial procession incorporated the officials of the household, representing the Crown, the City magistrates and the Muscovy Company merchants. The presence of the mayor and aldermen in their ceremonial dress revealed the willingness of the Corporation of the City to join the English and Russian monarchs in their political dialogue. This pattern for the procession was to be used later. In 1600, when the embassy of Gregory Mikulin (pl.11) arrived to inform Queen Elizabeth of the accession of Boris Godunov to the throne, the aldermen and the Muscovy Company merchants escorted the ambassador to the court gates, where he was committed into the hands of the household officials. But the merchants by no means withdrew: 'The Ambassador was very honourablie entertained, feasted and entreated by the Queen, and as kindly used and dyetted for eight monthes space, at the sole charges of the Company of the Moscovy merchants.'[33] The Company's engagement with diplomatic protocol was not entirely a matter of the merchants' own initiative. Their participation in ambassadorial receptions became institutionalized, partly due to the regular financial problems of the Crown. Elizabeth had been praised by her Parliaments for her parsimonious policy, 'the pompous embassies' being turned into decent ones, 'voide of excess and yet honorable and comely'.[34] In the late decades of her reign, however, the Queen increasingly tended to rely on the resources of her subjects and various corporations. The way Elizabeth made use of the Muscovy Company was part of her financial strategy, which was inherited later by her successors. Having paid the expenses of several ambassadorial missions to and from Russia between 1610 and 1623, the Company complained that the extraordinary charges were too burdensome for it to meet further financial demands from James I.[35]

In most cases the Russian ambassadors were satisfied with the reception they met in England, but they were extremely sensitive to questions of hierarchy: for instance, their precedence among other foreign diplomats, the places allocated to them during state banquets and public ceremonies, or the manner of formally referring to the Tsar. Perhaps the atmosphere of the Elizabethan court appeared too informal to them, and attempts to conduct negotiations in the private houses of statesmen[36] or during frivolous entertainments following receptions annoyed them (although it seems they never missed church services, Accession Day tilts, Saint George's Day celebrations, or royal hunts).[37]

There was much similarity between the court ceremonies of both countries. When Gregory Mikulin was entertained at Whitehall, many of the Queen's ceremonial

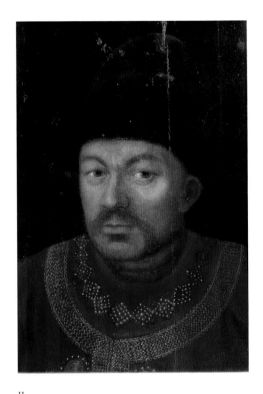

11
UNKNOWN ARTIST
Gregory Mikulin
Oil on panel, early 17th century
State Historical Museum, Moscow

gestures would have been familiar to him. She raised a cup to the health of the Tsar, his wife and children, announcing their full titles, and then sent a cup from her table to the ambassador. The Queen also presented him, via the carver, with a loaf of bread.[38] To impress the Russians, on this occasion seven huge chests filled with plate were fetched from the Tower of London to the Palace of Whitehall, and two Cupboards were installed – one with golden plate, the other with silver. Cupboards of estate were to become an indispensable part of the reception of Russian diplomats in London, and not only in the royal residences. In 1621, when ambassador Isaak Pogozhiy was to be entertained by the Lord Mayor of London, the Muscovy Company merchants asked the Privy Council to allow that 'on the company's security, a fitting proportion of the King's plate be delivered for his use'.[39]

However, divergence of the political cultures reveals itself in how the diplomats perceived the ruler, and the way they behaved in the presence of the monarch. One episode makes this dissimilarity apparent: when the feast was over, the Queen performed a ceremony of washing her hands (assisted by three noblemen who carried the ewer and the cover, and two gentlemen who held the towels), and then sent the ewer to Mikulin – which caused some confusion. The ambassador made a low bow but reverently rejected the honour, saying: 'Our Great Lord, the Great Tsar calls Elizabeth the Queen his beloved sister; and it does not befit me, his serf, to wash my hands in her presence.'[40] It is misleading to interpret the Russian ambassador's behaviour in terms of etiquette and conventions regulating courtiers' conduct at the table, for he obviously perceived the whole situation in a different dimension – as a ritual that reinforced vertical hierarchy and expressed the vast distance between the omnipotent semi-divine monarch and his (or her) reverent subjects. No wonder that Elizabeth appreciated the ambassador's precise behaviour in this case, and praised him for it. In 1613, Russians demonstrated similar reverence for the sacred persona of the British monarch, when the ambassador Zyuzin induced the Englishmen to stand up while drinking to the health of their own king,[41] and later when he dined with James I himself.[42]

Policy of intimacy

As a sign of particular favour, host rulers might receive ambassadors in the inner apartments of their palaces that were inaccessible to the general public. In such cases, proximity to the monarch and an atmosphere of intimacy emphasized a special relationship between the two countries. However, when Elizabeth invited Gregory Mikulin to the Privy Chamber and asked the ambassador to sit next to her, he felt slightly uncomfortable, and reverently pushed the chair further away to keep a seemly distance between himself and her sacred Majesty.[43]

It is well known that the first Stuarts didn't like ceremonies involving multitudes of people, and refrained from dining in public, even with foreign diplomats. Instead, James I continued the policy of privileged access to restricted areas when he invited Alexei Zyuzin to Somerset House to the court of his Queen, Anne of Denmark, to meet 'the sovereign … without superfluous people'.[44]

Russian diplomats also received special attention. Zyuzin was shown the Council Chamber in the Palace of Whitehall, and shown to the King's place.[45] In spite of Zyuzin's excuses he was compelled to sit in King James's chair after Lord Dorset said: 'There is a command in the name of our sovereign that he ordered you to sit on the royal place. And you should not disobey our sovereign, but do what pleases our sovereign.' After

that Lord Dorset 'taking Alexei by hand, sat him on the King's place. And the ambassadors sat at the end of the table where the King sits and the royal boyars, all the lords who were meeting them … and the great gentlemen stood of both sides of the table. And not one person sat down.'[46] Zyuzin and his fellows were at the same time flattered and embarrassed when during the course of an official audience they were ordered to put on their hats, the King and Prince Charles remaining bareheaded.[47]

James I dealt with the matters of diplomatic protocol with more precision than Elizabeth I and, apart from the unusual political gestures mentioned above, his ceremonial conduct as well as that of his entourage was impeccable in Russian eyes.

The diplomacy of giving gifts
The exchange of gifts played a key role in maintaining Anglo-Russian political dialogue. In relations between rulers and states during the Middle Ages and the Renaissance period it is a commonplace that gifts often smoothed the way to successful negotiations, serving as an effective means of securing peace, friendly attitudes and amicable policy.[48]

12
ABRAHAM ORTELIUS, after
ANTHONY JENKINSON
*Map of Russia, Muscovy and
the land of the Tatars*
Antwerp, Flanders, 1570
The British Library
(Royal MS 18.D.III, ff.123v–124)

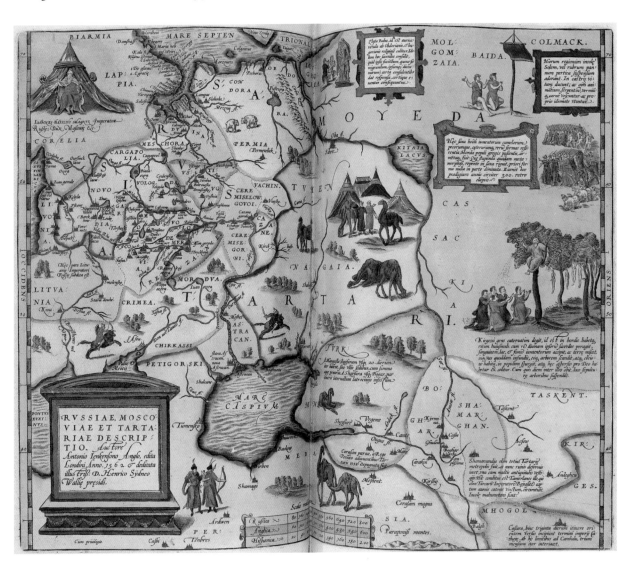

However, while sending formal presents on various occasions to European monarchs was a long-established medieval tradition and, as such, so trivial that the gifts are barely mentioned in the contemporary treatises on the art of diplomacy,[49] the rules of England's sixteenth-century diplomatic game with Russia were being formulated for the first time. The significance of the gift-giving in bilateral relations owed much to the Russians' sensitivity to the ritual, perceived by them within the framework of Byzantine diplomatic protocol, with its public ceremonies of presentation of gifts sent by foreign potentates. The impressive display of the Tsar's Cupboard, and the magnificence of receptions at his court, must have convinced the English that the most appropriate – and most welcome – gift for the Tsar would be elaborate silver produced by English artisans.

The pattern for the Anglo-Russian exchange of 'state' gifts was set by Ivan IV and Elizabeth I, whose personal control over the selection of diplomatic presents determined their highest artistic quality and value. The Queen's instructions to Thomas Randolph in 1568 revealed her personal engagement in the process, as well as her artistic and intellectual tastes: the envoy had to present Tsar Ivan with 'a notable great cup of silver, with verses graven in it, expressing the histories workmanly set out in the same'. The cup was to be praised for 'the newness of the device … it being the first that ever was made … of that manner'.[50]

Ambassadors travelling to Moscow were expected to bring, alongside the personal letters of Queen Elizabeth to 'her loving brother' Tsar,[51] fashionable silver plate as token of her respect. Among the royal presents there might have also been precious stones, gold coins, arms and weapons, wine, sugar, wild beasts and birds, clocks, musical instruments, pieces of furniture, silks and high-quality cloth. Over the course of the seventeenth century, more jewels and firearms appeared in the lists of diplomatic gifts. The Russians reciprocated mostly with furs – sables and black fox, highly valued at the English Court[52] – as well as with oriental textiles, Persian carpets, knives, horses and birds of prey, including hawks and falcons.

Some of the gifts employed in diplomatic exchanges reflected notable trends and tendencies in sixteenth- and seventeenth-century intellectual life: various curiosities, rare species of exotic birds and animals, as well as artworks created of so called 'naturalia' – corals, shells, 'unicorn' horns and walrus tusks. As presents for Tsar Ivan, Anthony Jenkinson brought from his journey to Bukhara a Tatar drum and a tail of a white Chinese cow, which were accepted favourably. On the other hand, in 1600, in response to a request from Elizabeth I's ambassador Sir Richard Lee, Boris Godunov gave him as a farewell present the Tsar's own mantle lined with what was thought to be the fur of a miraculous beast, 'Agnus Scythicus', or a 'vegetable lamb', which supposedly grew from the ground on stalks. Lee made every effort to conceal his treasure from the Queen, who would inspect the private presents received by her diplomats and take some of them for her own use. Later he bequeathed the famous mantle to the Bodleian Library as the fittest place for a 'jewell of so great work and aestimation'.[53]

Sir Jerome Horsey took to Tsar Fyodor gifts that embodied a century-long tradition of sending exotic beasts to join the monarch's menagerie: 'a goodly white Bull all spotted with natural black dapples, his gorge hanging downe to his knees, washed with sope and sleeked over, with a green velvet Collar studded, and a red Rose, made to kneele before the Emperor and Empresse … twelve goodly masty Doggs with Roses in Collars in like fashion led by twelve men, two faire Lions brought forth of their Cages drawne in Sleds, etc.'[54] This custom was not alien to the Russians either; in 1662, Prince

Prozorovsky's ambassadorial mission brought to King Charles II live ermines, camels, herons and pelicans – the very first ones to nest in St James's Park.[55]

The gift could convey important political messages. In 1604 James I sent Boris Godunov a huge carriage richly decorated with gilded relief carving that was full of political symbolism.[56] The decorative programme embodied the idea of Christians' triumph over Turks, and was consonant with the goals of the diplomatic mission of Sir Thomas Smith, who had arrived to discuss Anglo-Russian alliance against the Ottoman Empire.

The royal gifts for the Tsars were selected by the Lord Chamberlain, the Master of the Jewel House, and the Keeper of the Privy Purse. It is therefore possible that some of them might have originally been presented to the English monarch by courtiers during royal 'summer progresses' or as New Year gifts. In one instance we can be almost sure that this was the case. The so-called Warwick Cup (pl.111), delivered to Moscow in 1620 by John Merrick as a present from James I to Mikhail Romanov, had most likely been given to James I by Fulke Greville (1554–1628), a well-known poet, courtier and Chancellor of the Exchequer, on the occasion of the royal visit to Coventry and Warwick in 1617. The phenomenon of the redistribution of courtiers' presents by kings is well known. Evidence produced by the Kremlin Armory Museums suggests that, apart from their symbolic meaning as expressions of loyalty, subjects' gifts to English monarchs had a real economic significance for the Crown, allowing rulers to pay the expenses of their diplomatic missions abroad. From this viewpoint, Russia might be seen as a distant point in a circulating constellation of gifts given and received at the English court.

In other cases, however, costly diplomatic presents were specially commissioned from London silversmiths at the expense of the Muscovy Company.[57] Frequently, alongside the ambassadorial presents given on behalf of the ruler, the Company sent gifts in its own name. Sometimes officials of the Muscovy Company acted as the Tsar's agents, bringing at his request English silver plate and firearms to his treasury (pl.149).

The Tsars were not the only recipients of English silver plate; their councillors also received gifts. Boris Godunov – who as Tsar Fyodor's brother-in-law was a member of the royal family before becoming a Tsar himself – was presented by Jerome Horsey with many rich gifts and spent 'a whole day in viewing' them, 'he and the Emperesse his Sister liking all, admiring nothing more then the Organs and Virginals; never having seene or heard the like before'.[58] At their departure, ambassadors rewarded their Russian gentlemen attendants (*pristavs*), who might also have received separate gifts from the agents of the Muscovy Company.[59] Thus English silver found its way into the private houses of Russian noblemen.

Russian diplomatic envoys to London were also bountifully rewarded by British monarchs for their service.[60] Although the standard value of plate chosen for such occasions was established by the ruler in whose name the gifts were given,[61] frequently it was the Muscovy Company that had to provide the silverware. In some cases members of the royal family might have given departure gifts in their own name.[62]

Historians have often studied gift-giving in the context of political and commercial links between the two countries, as a means of achieving their respective diplomatic objectives, and oiling the wheels of the administrative machine. But the phenomenon certainly had another dimension. Within the framework of political culture, it can be viewed as a specific means of representing the monarchs through the symbolic exchange of gifts. Impressive ceremonial vessels conveyed the idea of the magnificence of the English kings, the splendour of their court, the wealth of the country and London as

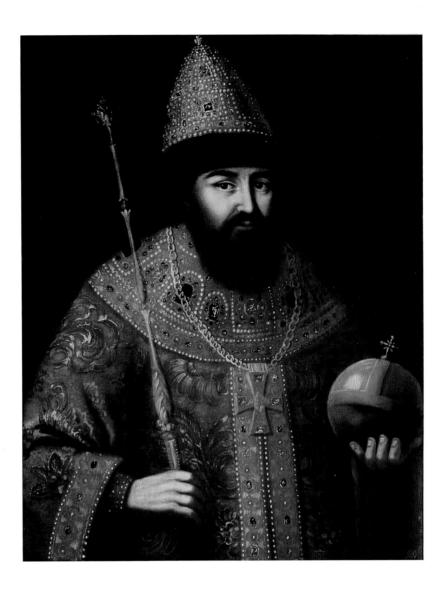

its commercial capital. The choice of expensive and fashionable silver plate of exquisite artistic quality was, of course, a sign of respect bestowed on Russian counterparts, but at the same time it reflected the high self-esteem of the givers. The English royal coat of arms, present on many of the items sent to Moscow, were the most visible and direct way of emblematically representing the ruling dynasties – the Tudors and Stuarts (Flask, pl.102; Warwick Cup, pl.111). Tudor roses and Stuart thistles were also frequent decorative motifs used for state gifts (Water pot, pl.105; Flask, pl.108; Flask, pl.115). The same tendency can be traced in the decoration of illuminated royal letters sent to the Tsars.

While, when leaving London, diplomatic gifts represented the status, might and generosity of the giver, having arrived in Moscow they subsequently came to represent the greatness of the recipient and to adorn his State Cupboard in the Kremlin. Probably, the most fascinating example of English silverware changing places, as well as being the object of representation, was the story of several outstanding masterpieces that had been registered in 1626 as part of Charles I's Great Cupboard of Estate, which went on sale

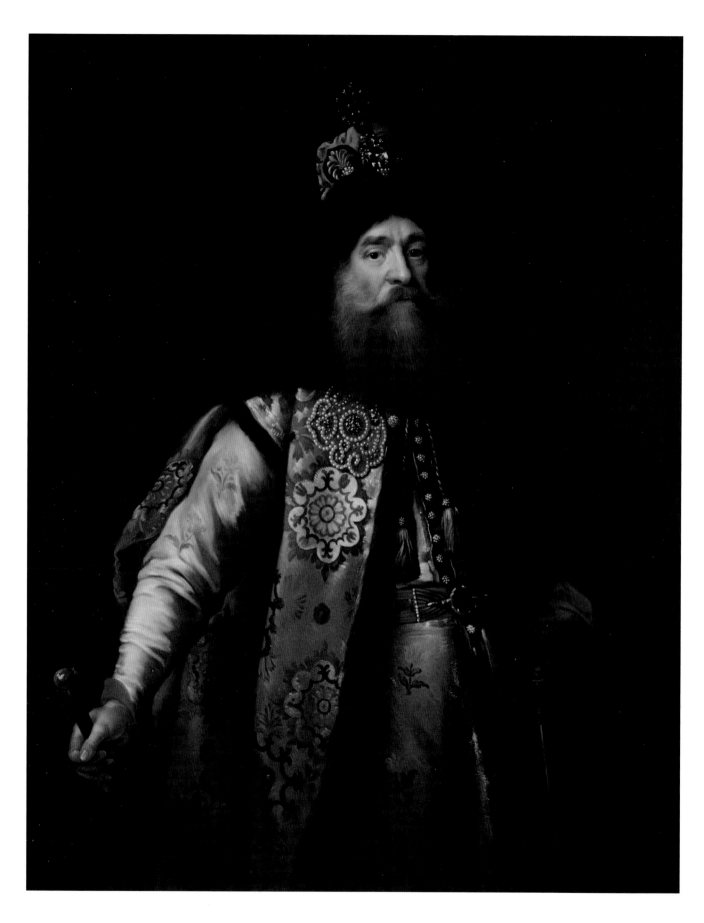

in 1629 due to the Crown's insolvency, and were purchased by the Muscovy Company and subsequently delivered by Fabian Smith to the treasury of Mikhail Romanov in 1629.[63] Among the pieces were a famous pair of leopard ewers (pl.104) and huge silver-gilt water pots (pls 105 and 113). This shift of silver plate from the royal buffet in the Palace of Whitehall to the Tsar's Cupboard in the Golden Chamber of the Kremlin bears witness to the fact that English silver was part of a universal political language of court culture shared by seventeenth-century Britain and Russia.

While Russia was successfully coping with the consequences of the Time of Troubles, England was entering its own dark period. The conflict that broke out in 1640 between Charles I and Parliament led to the Civil War. The Russian messenger Gerasim Dokhutorov, who had arrived in London in 1645[64] with the news of the accession to the throne of Alexei Mikhailovich (r.1645–76, pl.13), was not permitted to see the King, although he was accorded a marvellous reception in Parliament. The members of the Muscovy Company were more sympathetic towards the Parliamentarians than the Royalist cause, and this led to their fall from grace in Moscow; news of the execution of Charles I in 1649 was received with indignation in Russia. Tsar Alexei immediately published a decree banning the English from trading in the Muscovite state: 'the English have wrought a terrible deed, in killing their sovereign, King Carlus, to the death'.[65] Even though both sides – the Royalists grouped around Charles II and Oliver Cromwell's envoys – petitioned the Tsar to restore trading links, he never condescended to their appeals. After the death of Charles I the Parliamentarians melted down his silver plate, but the treasury of the Russian Tsars provided a safe home for the masterpieces of English silver and thus evidence for the past glory of the Early Stuart court were preserved.

Anglo-Russian dialogue resumed only after the Restoration, when in 1662 the embassy of Prince Prozorovsky arrived in London and was received with great solemnity.[66] The Russians promised Charles II trading privileges in exchange for a loan necessary for their war with Poland. It seems that the failure of these negotiations predetermined unsuccessful results of the return embassy of the Earl of Carlisle to Russia in 1664. Neither attempts by the English to restore their position on the Russian market during the reign of Tsar Fyodor Alexeyevich (1676–82), nor the mission of his ambassador Prince Potemkin (pl.14) to London (1681–2), enjoyed success.

Despite the growing divergence of British and Russian economic and political interests, the sixteenth and seventeenth centuries witnessed a dynamic interplay of both monarchies moving in the same direction: towards absolutist personal rule and the sacralization of power. The rulers of both countries demonstrated a growing awareness of the importance of image-making and ritualistic performance at court. Autocratic aspirations of the Stuarts led to the formalization of English diplomatic protocol. It seems that the English came to a better understanding of Russians' obsession with ceremony. If English courtiers were still slightly uncomfortable with Prince Potemkin 'knocking his forehead against the ground before the king', Charles II nevertheless met him enthroned 'in Majesty' as a true earthly God. According to the contemporary account he 'sat in great State, environed with the Nobility, as the Sun with stars: the Glory of his friends, the envy of his foes, and the wonder of the world'.[67] Just as the Russians would have thought fit for a king.

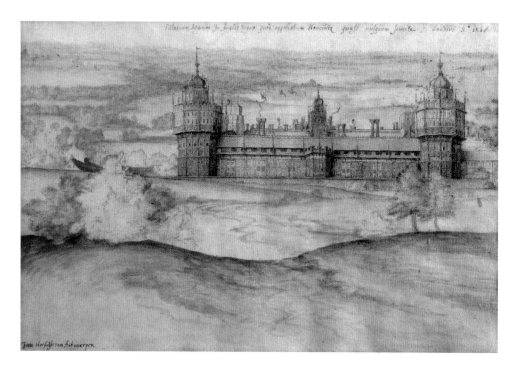

15
JORIS HOEFNAGEL
Nonsuch Palace from the South
Black chalk, pen and brown and
black ink, watercolour, heightened
with white and gold, on paper, 1568
Christie's, London

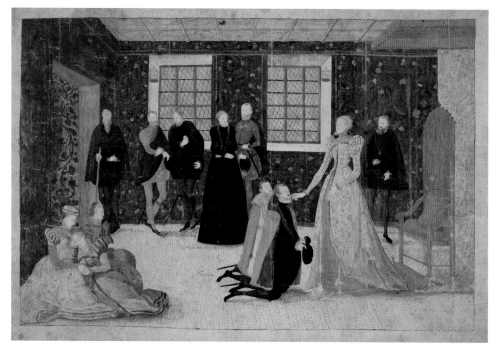

16
GERMAN SCHOOL
*Queen Elizabeth receiving the
Dutch ambassadors*
Gouache on paper, *c.*1585?
Staatliche Museen Kassel,
Graphische Sammlung
10430

17 (*opposite*)
Attributed to STEVEN VAN HERWIJK
or otherwise STEVEN VAN DER MEULEN
Elizabeth I (The Hampden Portrait)
Oil on canvas, *c.*1563
Private collection

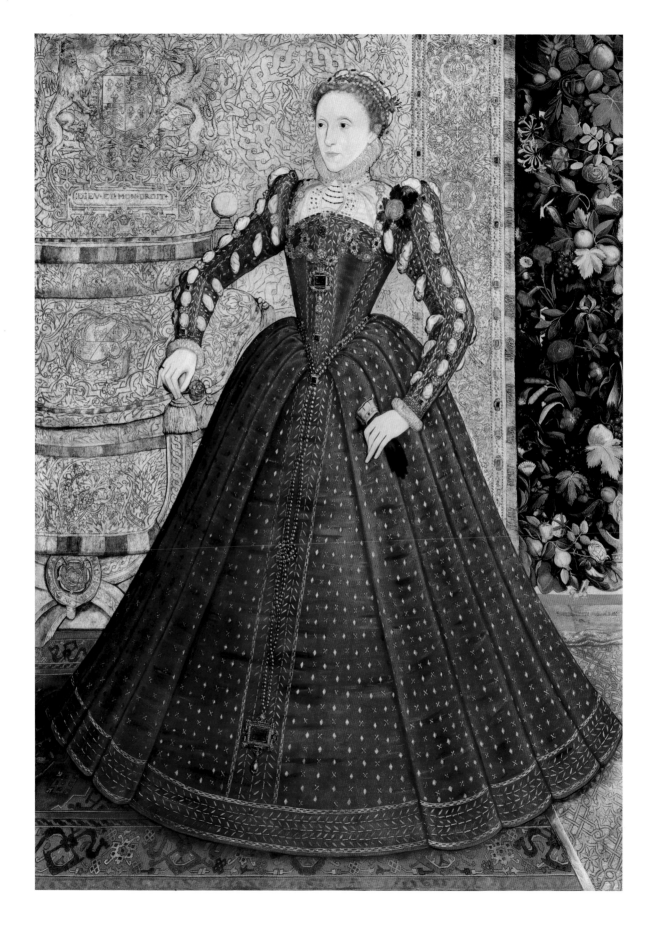

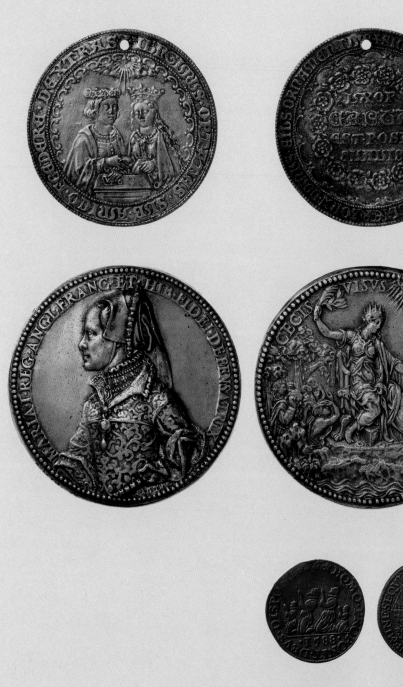

18
Medal commemorating the marriage
of Henry VII and Elizabeth of York
Prague, late 15th century
Museum of London
NN18449

19
Possibly by a Netherlandish
follower of JACOPO DA TREZZO
'State of England' medal
commemorating the marriage
of Mary Tudor and Philip II of Spain
Madrid, Spain or the Low Countries,
1555 or later
Museum of London
NN18452

20
Games counter depicting
the 'Defeat of the Armada'
Possibly Dordrecht, Netherlands, 1588
Museum of London
NN18457

21
NICHOLAS BRIOT
Coronation medal of Charles I
London, England, 1626
Museum of London
A7528

22
UNKNOWN ENGLISH ARTIST
Sir Jerome Bowes
Oil on canvas, *c.*1583
English Heritage, Suffolk Collection

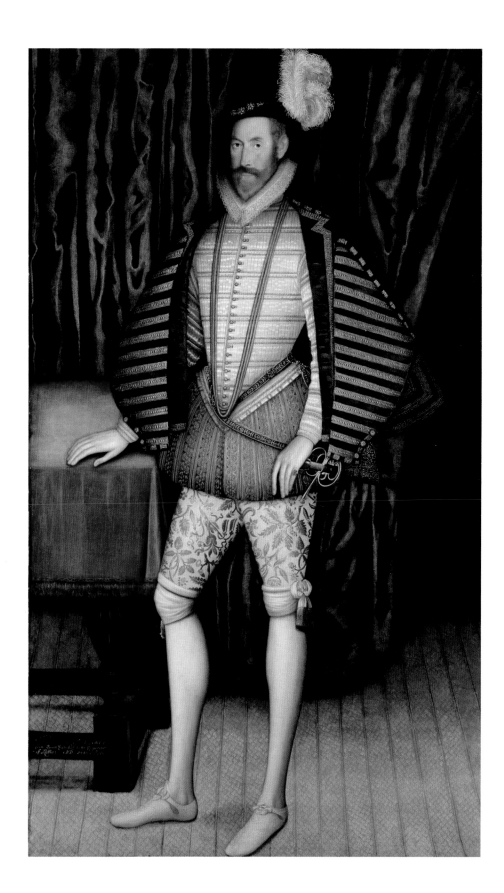

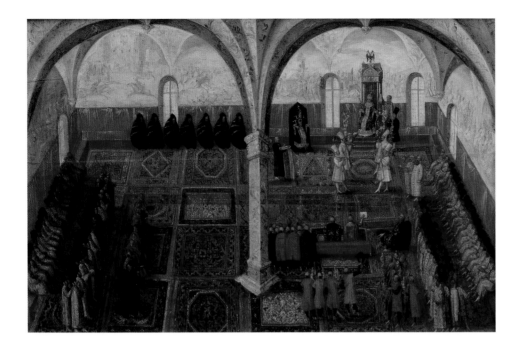

23 (*left*)
Attributed to Simon Boguszowick
A Tsar receiving a delegation in the Hall of the Palace of Facets
Oil and tempera on panel, 1630s
Hungarian National Museum, Budapest

24 (*below*)
Attributed to François du Chastel
Charles II receiving the Spanish Ambassador, the Prince de Ligne
Oil on canvas, *c.*1660
Prince de Ligne, Château de Beloeil, Belgium

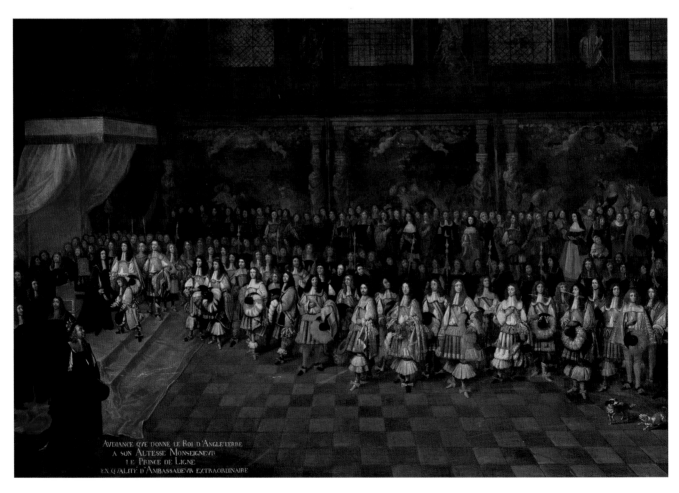

25
PFANDZELT LUCAS CONRAD
Tsar Alexei Mikhailovich
Oil on panel, 1766
The Moscow Kremlin Museums
ZH-2015/1-2

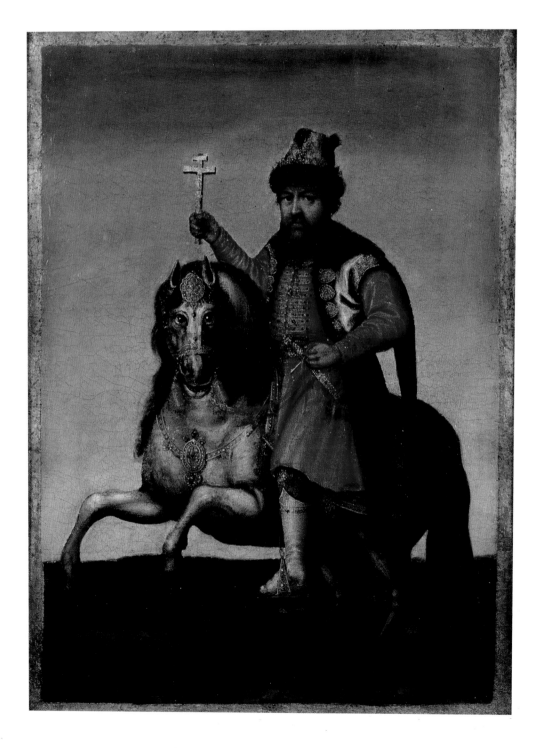

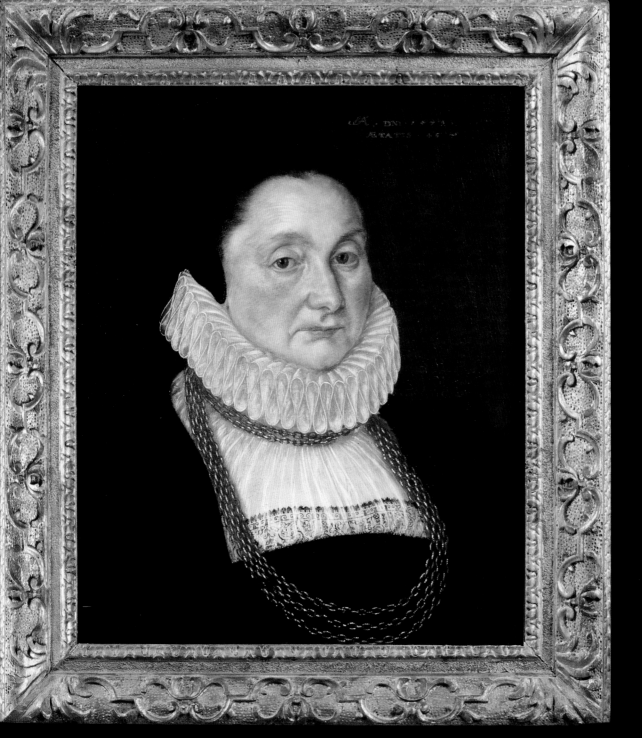

Karen Hearn

MERCHANT-CLASS PORTRAITURE IN TUDOR LONDON: 'CUSTOMER' SMITH'S COMMISSION, 1579/80

It was not uncommon in sixteenth-century Europe for merchants of wealth and status to wish to commission portraits of themselves, in order to mark and convey their success and achievements. Often such portraits were paired with matching images of their wives, the couple appropriately attired according to their rank and prosperity.[1] These portraits could also demonstrate the sitters' piety, perhaps through the inclusion of accessories such as devotional books, crucifixes, or skulls as reminders of mortality.[2]

Examples from Germany and the Netherlands abound. A leading exponent of the genre was the Utrecht-trained Antonis Mor (1516/21–c.1576) who from 1549 onwards worked for various Habsburg rulers across western Europe, but who also depicted merchant-class sitters. In September 1564, for instance, it was reported that he was in Antwerp, painting '*les marchantz*'.[3] Mor's compositions were to be adopted by numerous portrait painters in northern Europe, including Britain.

Like the merchants who were their clients, portrait painters, such as Mor, often travelled widely, from city to city, court to court, and country to country. Indeed, in both England and Scotland (two separate countries during the sixteenth century) the leading painters tended to be incomers and, from about 1500 until the 1690s, royal, aristocratic and merchant patrons who wanted high-quality and innovative portraits usually chose to sit for foreign-trained artists. This may have reflected dissatisfaction with British-born and British-trained painters, who may not have been considered sophisticated enough by the elite clients in England and Scotland.

Like the merchants, the artists might have had more than one reason for travelling.[4] They might have done so in search of economic success and advancement. Or, during a century of political and religious turmoil in Europe, they might primarily have been religious exiles, escaping to a society in which they could follow their beliefs.

In sixteenth-century England and Scotland, following the Reformation, the demand was mainly for portraits. Portraits served a number of practical purposes: they could mark a major life event for a sitter, they could convey likenesses in marriage negotiations, or, when displayed in his or her residence, they could demonstrate the sitter's or owner's political or familial affiliations.[5] Portraits appear also to have been acceptable in a Protestant culture that was anxious to observe the Second Commandment's ban on 'bowing down to graven images'.

Once Elizabeth I had ascended to the English throne, in 1558, the country was officially Protestant, and thus, to judge from the images that survive, portraiture became the definitive genre. Extant easel paintings from this period reflect this overwhelming

26 (*opposite*)
CORNELIS KETEL
Alice Smith, née Judde
Oil on panel, 1579
Private collection, UK

preference. After Catholic Habsburg rule was re-imposed in the Netherlands in 1567, Protestant England became a refuge for Netherlandish members of the Reformed religion, including artists.

As it was extremely rare for artists of this period to *sign* their works, it is now generally difficult to identify the painters of specific extant works. Occasionally it is possible to use the characteristics seen in a documented work as a means by which to identify the maker of another work that shows the same features. However, artists often ran substantial workshops, employing other competent practitioners to assist them, which makes definitive identification problematic.

Surprisingly little firm information about the principal artists active in sixteenth-century England has survived, although it is clear that many of them were migrants from northern Europe. Some of these settled in England permanently, gaining naturalization. Among them was 'Hans Eworth' (originally Jan Eeuwouts, from Antwerp, active *c*.1540–1573) who was first definitely recorded in London in 1549. Eworth was to become a leading court artist in England, and the principal painter to the Catholic Queen Mary I; later he also painted Elizabeth I.[6]

Other artists came to England for only a few years, and then returned to the Continent. Marcus Gheeraerts I was a leading member of the Protestant community in Bruges until the Duke of Alva's campaign forced him into exile in London, with his young son Marcus II, in 1567/8. The elder Gheeraerts became a member of the Dutch Reformed group there, before returning to the Netherlands in the late 1580s. However, his son (1561/2–1636), having been raised, and presumably trained, in London, subsequently made his entire career there, becoming the leading court painter to Elizabeth I and afterwards to James I's Queen, Anne of Denmark.[7]

One source of evidence for the lives and careers of some of these artists is Karel van Mander's *Het Schilderboek* (The book of painters), published in 1604.[8] Van Mander was a Dutch poet and writer, as well as a practising artist, and one of his more extensive biographies is that of his friend Cornelis Ketel (1548–1616).[9] Ketel worked in England between 1573 and 1581, where he portrayed 'great lords of the nobility, with wives and children' as well as, in 1578, Queen Elizabeth I herself (a portrait that is now thought to be lost).[10]

Born and trained in Gouda, Ketel had also received training in Delft, before working in France. Moving to London in 1573, Ketel initially lived in Southwark with the Netherlandish sculptor of funerary monuments William Cure (Willem Keur), a friend of his uncle. In 1574 he married a woman from Gouda and moved to Bishopsgate in the City of London, an area in which a number of his wealthy merchant patrons were based. Ketel also received commissions from the German merchants at the Steelyard, the Hanseatic trading base on the bank of the Thames, from which, 40 years earlier, many of Hans Holbein II's clients had come. In 1581, Ketel left England for Amsterdam, where he spent the rest of his life, dying there in 1616.[11]

A uniquely extensive and high-calibre set of head-and-shoulders portraits painted by Ketel in England has survived.[12] Inscribed with the date 1579, they now comprise eight head-and-shoulders portraits of children and one of their mother (pl.26) – just the type of commission that van Mander described. Further siblings may also originally have been depicted – as well as, presumably, the father of the family, Thomas Smith (1522–1591). Known as 'Customer' Smith, he was the collector of customs duties in the Port of London, and one of the wealthiest merchants and financiers of his day.[13]

27
Cornelis Ketel
Thomas Smith the Younger
Oil on panel, 1579
Private collection, UK

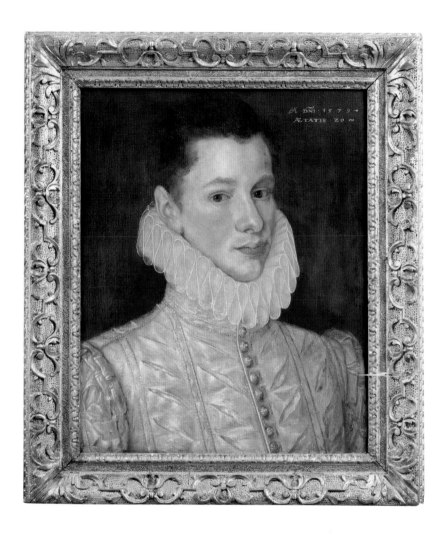

One of the young sons depicted in this group of eight portraits was Thomas (*c.*1558–1625, pl.27) who subsequently became a governor of the Muscovy Company. In 1604, having been knighted, he was to travel to Russia as special ambassador to the Tsar. We shall return to this portrait later.

In about 1554 the elder Thomas Smith had made an advantageous marriage to Alice, daughter of the powerful Sir Andrew Judde (*c.*1492–1558). Judde, who became Lord Mayor of London in 1550–1, was Master of the Skinners' Company six times, and a founder of the Muscovy Company. Smith was able to develop his contacts within Judde's overseas trading circle and, at Judde's death, Alice Smith inherited an extensive fortune and various properties.

The author of the *Oxford Dictionary of National Biography* entry on Judde considers that 'It is highly unlikely that he himself travelled to Muscovy and Guinea, as a later epitaph alleged (though he had an elephant's head displayed as a curiosity in his house), but he was certainly one of the richest and most prominent of overseas merchants in early Tudor London.'[14] Judde had many charitable interests, founding six almshouses and, in 1553, a free educational establishment, Tonbridge School. His grandson, Sir Thomas Smith, was later to be a benefactor of this school.

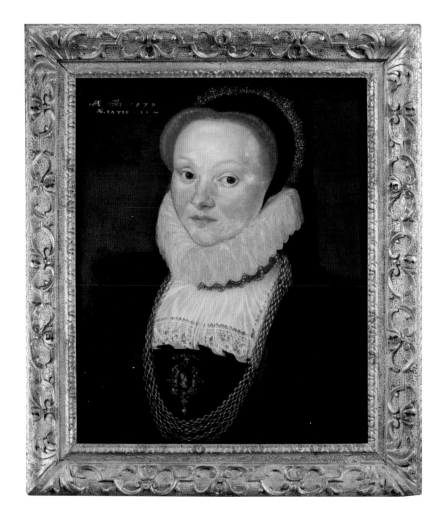

28
CORNELIS KETEL
Joan Fanshawe, née Smith
Oil on panel, 1579
Private collection, UK

Smith had close links with leading court figures, including William Cecil, 1st Lord Burghley, and Robert Dudley, 1st Earl of Leicester. He invested in industrial and overseas enterprises, and died a very wealthy man. His opulent Southwark-school funerary monument in St Mary's church, at Ashford in Kent, was apparently erected by his eldest son, John. The recumbent figures of the 'Customer' and his wife are accompanied by kneeling figures of their six sons and six daughters ranged along the external-facing long side of the tomb chest. One of these figures represents the younger Thomas.[15]

So, from Ketel, the Netherlandish painter, 'Customer' Smith evidently commissioned head-and-shoulders portraits of himself (now lost, and known only through later copies), his wife Alice Smith (pl.26), and their children, twelve of whom lived to adulthood, and most of whom were baptized at All Hallows church, Lombard Street. Portraits of their sons Thomas (born in 1558), Richard (baptized on 1 December 1563) and Robert (baptized 7 October 1567), and of their daughters Ursula (baptized 27 May 1555), Joan (baptized on 15 October 1560; pl.28) and Alice (baptized on 21 December 1564) have all come down in the collection of their descendants. Two further portraits from this group have also survived – that of the Smiths' eldest son John (baptized on 15 September 1557; now at the Yale Center for British Art, New Haven; pl.29) and of their daughter Mary (baptized 20 June 1554; now in a private collection, UK).

It is not currently known whether the remaining Smith children – Henry (born 1559/60 or 1562/3), Katherine (born 1561), Simon (born 1570) and Elizabeth (born 1572) – were also painted.

Each portrait is dated '1579' and gives the age of the sitter. Comparing the inscribed ages with the known dates of birth of the sitters suggests that the portraits were made towards the end of the Old Style 1579 (in other words, up to 24 March 1580).

The form of the inscriptions, each beginning 'Ao DNI' (for the 'Year of our Lord') contains an unusual and characteristically serpentine capital letter 'A'. This is seen on other paintings known to be by Ketel. In addition, the portraits exhibit Ketel's distinctive Flemish painting technique.[16]

Smith and Ketel were neighbours in the mercantile heart of the City of London, which may have influenced Smith in his choice of painter. His mansion extended from Gracechurch Street to Philpot Lane, while, as mentioned above, Ketel lived in nearby Bishopsgate. The two men may also have met in 1577, when Ketel carried out a significant commission for 19 portraits for the Cathay Company, depicting, among others, the explorer and trader Sir Martin Frobisher (Bodleian Library, Oxford) and the two Inuit who had accompanied Frobisher back from his expedition in search of a North-West Passage to China (these portraits are now lost).[17] Smith had various links with members of the Cathay Company.

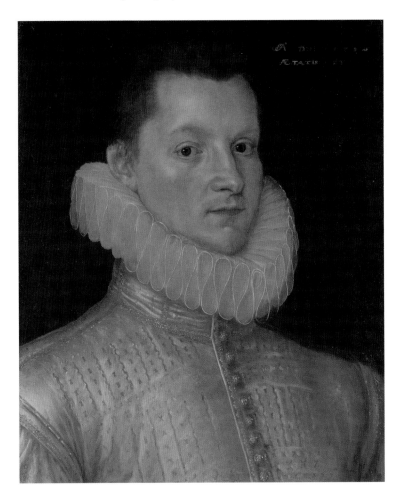

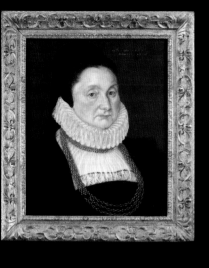
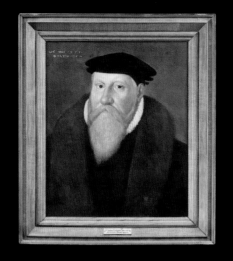
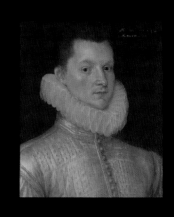
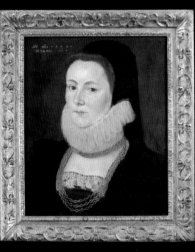
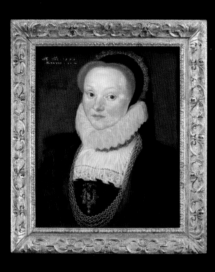
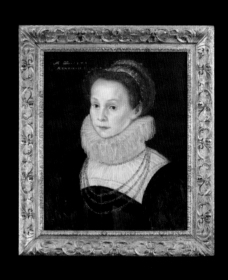
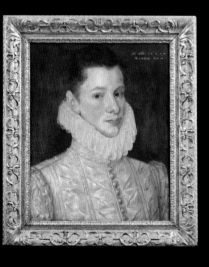
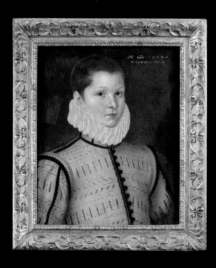
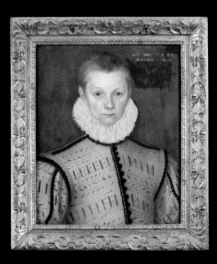

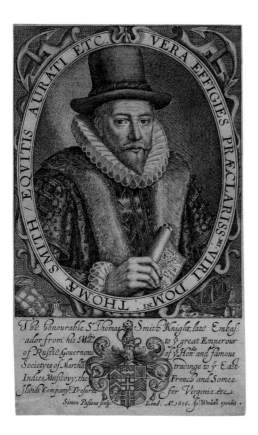

31
SIMON DE PASSE
Sir Thomas Smith, 1616
Engraving from John Woodall,
The Sirgion's Mate (London 1617)

30 (*opposite*)
Nine of the known portraits of the Smith
Family, including John Smith (see pl.29).
All by Cornelis Ketel on panel, except
Thomas 'Customer' Smith (top row,
middle), which is on canvas.

No other set comprising so many individual portraits of family members survives from this period in England, making this a very remarkable commission. It would have been a major statement on the part of 'Customer' Smith of pride in his family – in their number and their evident healthiness – and in the potential for advantageous marriages that they offered.

In terms of the present exhibition, the most interesting of the group is, of course, the image of the second surviving son, Thomas. He was to inherit considerable wealth from his father and invest heavily in overseas enterprises, succeeding his father as Customer in the Port of London, and becoming the first governor of the East India Company on 31 December 1600. For 20 years his house in Philpot Lane was the headquarters of the Company's activities.[18]

The younger Thomas also benefited from the accession of James VI of Scotland as James I of England in 1603, and was knighted the same year. In June 1604 James appointed him special ambassador to the Tsar, and he landed at Archangel on 22 July. Over the following winter Smith gained a grant of new privileges for the Muscovy Company, sailing for England on 28 May 1605.

He was also treasurer of the Virginia Company until 1619, and was greatly involved in Bermuda. According to his *Oxford Dictionary of National Biography* biographer, 'The crown relied heavily on Smith's talents: a grandiose London merchant-prince, he was the main link between government and merchants. For thirty years he was overseer of virtually all the trade that passed through the City of London.'[19] In 1625 Smith retired to his country house at Sutton-at-Hone, Kent, where he died on 4 September. In the local church his opulent monument is decorated with globes, sextants, compasses and ships in sail; the goods transported in them are represented by barrels and bales.

Ketel's head-and-shoulders image of a handsome, confident young man attired in a satin doublet offers an interesting contrast with the portrait print of the by-then elderly Sir Thomas made by Simon de Passe in London in 1616, which was included in John Woodall's publication *The Sirgion's Mate*, published in 1617 (pl.31). The print shows a prosperous, bearded figure in a tall hat and fur-collared gown, who grasps a partly rolled chart inscribed with the words 'RUSSIA' and 'Virgi[nia]'.[20] The caption incorporated in it identifies the sitter as: 'The honourable Sr Thomas Smith Knight, late Embas: / ador from his Ma.stie to ye great Emperour / of Russie, Gouernour of ye Honble: and famous / Societyes of Marchants trading to ye East- / Indies, Muscovy, the French and Somer / Islands [that is, Bermuda] Company; Tresurer for Virginia. Etc.'

The elder Smith's paternal pride, expressed in his ambitious portrait commission to Cornelis Ketel, was to be fully borne out in the career of his son Thomas, one of the early British ambassadors to Russia.

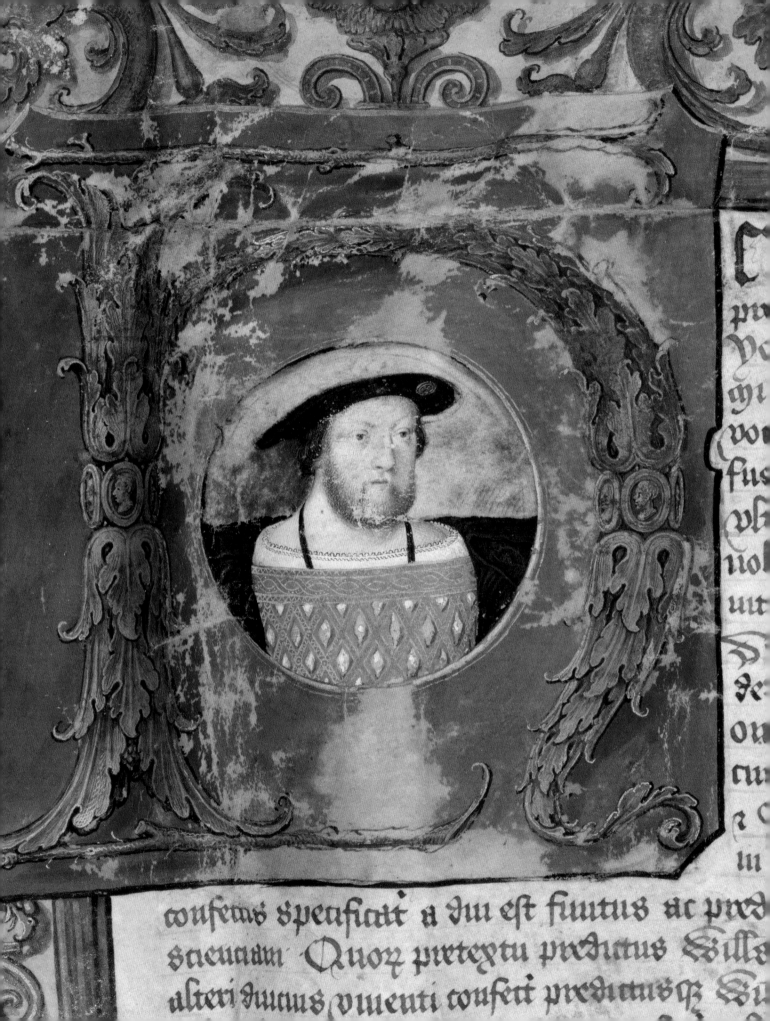

Katherine Coombs

ENGLISH LIMNING:
THE PORTRAIT MINIATURE IN
TUDOR AND EARLY STUART ENGLAND

In 1526 the secretary to the Venetian ambassador in England described a gift from the French king's sister to Henry VIII of two gold lockets, one containing a portrait of Francis I, the other two portraits of his young sons.[1] Francis's children were hostages of the Emperor Charles V and we can imagine the emotional impact on the English court of these novel little portraits, cradled gently in the hand and viewed closely.

Such tiny images would have been painted in watercolour on vellum (fine animal skin), which needed the protection of 'picture boxes' that were sometimes described as having 'cristall' covers, probably either slivers of rock crystal or thin glass.[2] The independent portrait miniature originated from the art of decorating handwritten religious books and important secular documents. In England both arts were called 'limning', deriving from the Latin *luminare*, to give light. But the Italian for this art was *miniare*, identical to the Latin *miniare*, to colour with red lead. In the seventeenth century the Italian noun *miniatura* – anglicized to 'miniature' – began to replace 'limning' and also came to mean something small, by association with the diminutive size of limnings and a mistaken link to words beginning with the Latin *min*, expressing smallness.

The great Elizabethan miniaturist Nicholas Hilliard wrote that limning was '… for the service of noble persons very meet, in small volumes, in private manner, for … portraits … of themselves [and] their peers'.[3] The portrait miniature was a notable Renaissance invention, expressive of humanist interest in individuality;[4] Hilliard claimed that the perfection of painting was 'to imitate the face of mankind'.[5]

In England the earliest known separate miniature is of Henry VIII (Fitzwilliam Museum, Cambridge), datable to between 1524 and 1526. A version of this portrait is also found on a letters patent dated 1524 (pl.32), though this was perhaps specially commissioned by the document's recipient at a later date.[6] Both are attributable to Lucas Horenbout – whom Vasari praised as an 'excellent' limner[7] – who is documented in Henry's employment by 1525. The two key artists in the development of the separate portrait miniature around the mid-1520s are Jean Clouet at the French court and Horenbout, both of whom were Flemish. But arguably it was the German Hans Holbein who first demonstrated the potential of this new art.

Holbein was employed by Henry VIII from about 1536 and his great work for the Crown was the monumental dynastic wall painting at Whitehall Palace, which included a full-length portrait of the King intended to 'abash and annihilate' all who looked on it.[8] Holbein apparently learned the techniques of limning from Horenbout, but notably worked from drawings rather than straight onto vellum, scaling up or

32 (*opposite*)
Attributed to LUCAS HORENBOUT
Letters patent of Henry VIII for Thomas Forster (detail), dated 1524, with a portrait of Henry VIII, *c.*1525–6
Watercolour on vellum
V&A: MSL.6–1999

down to paint large oils or small limnings, giving his miniatures a presence quite unlike Horenbout's delicate paintings.[9] Only about 14 miniatures are attributed to Holbein today,[10] including one of Anne of Cleves, Henry's fourth wife, painted at the court at Düren, Germany; Henry was famously disappointed by Anne's appearance when she arrived in England for their marriage.[11]

Catherine Parr, Henry's sixth and last wife, was notably fond of miniatures. After Henry's death in 1547 Thomas Seymour, Baron Seymour, courted the Queen, writing: 'I shall humbely desyer your highness to give me one of your small pictures, if ye have any left.' Seymour possibly shared her enthusiasm for these intimate likenesses as his miniature (pl.33) is one of two surviving examples.[12] The artist is unknown – Holbein died in 1543 and Horenbout in 1544 – but, significantly, Hilliard claimed that Henry 'had in wages for limning divers others'.[13] The future Elizabeth I, who lived briefly with Catherine Parr and Seymour after they married, also acquired an interest in miniatures. In 1564, Mary Queen of Scots' ambassador witnessed Elizabeth's subtle play on their potent personal and political possibilities. Diplomatic relations between the two young Queens were delicate, but the ambassador reported how by candlelight Elizabeth showed him a cabinet in her most private chamber, containing miniatures wrapped in paper, inscribed with the sitter's name: 'she took out [Mary's] picture and kissed it …'[14]

The few surviving English miniatures painted between Horenbout's death in 1544 and Hilliard's rise in the early 1570s are not all by one hand. But some have been attributed to Levina Teerlinc, such as the tiny limning of a lady who, with her expensive black dress and fur collar, is clearly of high rank (pl.34). Teerlinc was the daughter of the renowned Flemish limner Simon Bening (they are mentioned together by Vasari) but, although Henry VIII employed her in 1546 as 'paintrix', she was paid an annuity until her death in 1576 as a 'gentlewoman', and also described as 'sworne to the privye chamber to the Queen's Majesty'.[15] She clearly painted portraits, as in 1551 Elizabeth I wrote to her brother Edward VI that Teerlinc was 'to drawe out her picture' for the

King,[16] while Teerlinc's New Year gifts to Elizabeth are documented as limned portraits and court scenes.[17] It is possible therefore that the unknown woman shown in pl.34 was, like Teerlinc, one of the Queen's gentlewomen.

Miniature painting was never solely an English phenomenon, but this art has come particularly to epitomize the Elizabethan age, due to the English-born limner Nicholas Hilliard, whose miniatures so brilliantly evoke the court of the 'Virgin Queen'. Hilliard trained initially as a goldsmith, emerging as an accomplished miniaturist in the early 1570s, and probably first painted Elizabeth in around 1572. On becoming Queen in 1558 Elizabeth, as a young unmarried woman, had to cultivate the loyalty of her proud, powerful male courtiers by turning the disadvantage of her sex to her advantage. She encouraged an artificial and yet highly successful theatre of love, with its attendant flattery, flirtation and devotion, charging with emotion her knights' service to their Queen.[18] Clearly an intimate portrait miniature of her could play a potent role at such a court. More widely Elizabeth was also the focus of national sentiment as the Protestant head of the Church of England. The loyalty of her subjects was reinforced by her excommunication in 1570, the Pope effectively sanctioning her overthrow by a Catholic prince, which also encouraged a desire for portraits of the Queen.

Hilliard's earliest miniatures of Elizabeth were straightforward likenesses, some no doubt supporting her marriage negotiations with foreign courts. But by the early 1580s it was clear the Queen would sacrifice the chance of a child and heir rather than compromise her hold on the throne by marriage. Miniatures of the Queen increasingly fulfilled a domestic political role, the highlight of which was the victory over the Spanish Armada in 1588. Hilliard's miniature of Elizabeth with the attribute of the moon goddess Cynthia (Diana) – a crescent-shaped jewel in her hair – dates from about 1585–6 (pl.35). The symbolism of the Queen as 'Cynthia', 'the wide Ocean's Empresse', was personal to Sir Walter Raleigh,[19] but became more widely used, alluding to her status as Queen of a maritime nation. Another version is set in the Drake

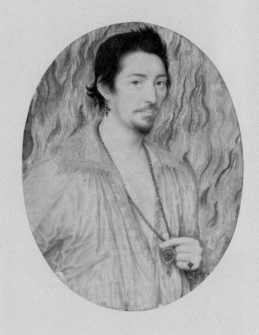

Jewel (see pl.185), an elaborate picture box worn prominently by Sir Francis Drake, turned towards his heart in a formal full-length oil (see pl.184). The gift of Elizabeth's image was increasingly understood as a mark of royal favour: Lord Zouche, on receiving her miniature wished he had 'a rich box to keep it in as I esteem the favour great'.[20] Elizabeth and her successor often gave miniatures unmounted – a miniature cost about £3, but James I, for example, ordered one with a jewelled setting costing £35 (Hilliard's annuity from James was only £40).[21]

Such mounted miniatures were often simply called 'jewels'; in Shakespeare's *Twelfth Night* (Act 3, Scene 4) Olivia says to her reluctant lover, 'Here wear this jewel … Refuse it not, it hath no tongue to vex you'.[22] Hilliard, as a trained goldsmith, developed exquisite new ways to paint jewels that complemented such jewelled settings but were, as he acknowledged, 'no part of limning'.[23] To create pearls Hilliard painted a blob of white crowned with a touch of silver, which was then burnished 'with a pretty little tooth … of a wild little beast' (today such silver has often oxidized to become black).[24] Transparent stones such as rubies were formed with a ground of burnished silver over which Hilliard used a heated needle to model the jewel with resin stained red. In a sonnet, Henry Constable praised Hilliard for giving 'to stones and pearls true dye [colour] and light'.[25]

Hilliard relied on his court reputation to attract patrons to his London workshop in Gutter Lane, noting that he was much 'spoken of'.[26] Nonetheless the court led the way, especially in the growing taste for symbolism. This was encouraged by the Queen's annual Accession Day ceremonial tilts (jousts), at which Elizabeth received the homage of her knights in the form of shields bearing their *imprese* – a combination of emblem and motto 'borne by noble … personages, to notify some particular conceit [notion] of their own'.[27] The most elaborate limnings relating to the tilts are full-length 'cabinet'

36 (*above left*)
Nicholas Hilliard
Unknown Youth. England, 1590–3
Watercolour on vellum stuck to a playing card with a six of hearts, 52 × 42 × 10 mm
V&A: P.3–1974

37 (*above right*)
Nicholas Hilliard
Unknown Man. England, c.1590–1600
Watercolour on vellum stuck to a playing card with one inverted heart, 60 × 50 mm
V&A: P.5–1917

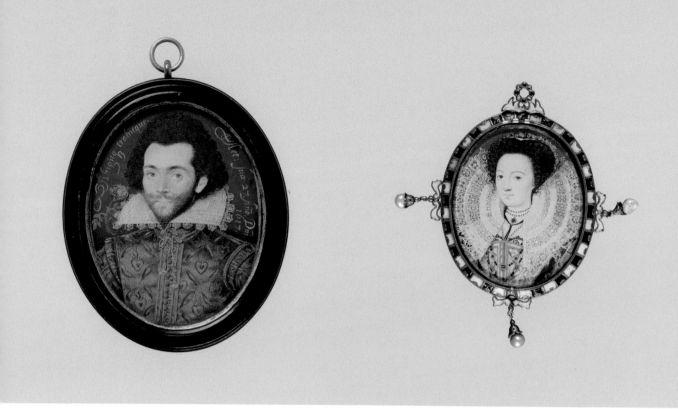

38 (*above left*)
Follower of NICHOLAS HILLIARD
Unknown Man formerly identified as
Sir Arnold Breams. England, 1617
Watercolour on vellum, 57 × 47 mm
V&A: Evans.2

39 (*above right*)
NICHOLAS HILLIARD
Unknown Lady. England, *c*.1590
Watercolour on vellum stuck to
plain card, 51 × 41 × 5 mm
V&A: P.8–1945

miniatures intended for display on walls. But complex symbolism and mottoes are found also in small oval miniatures, with sitters undoubtedly guiding Hilliard as to their wishes; William Camden advised that *imprese* should be 'neither too obscure nor too plain'.[28]

Set against black – probably symbolizing constancy – a young man plays the love-lorn suitor, his hand resting on his heart (pl.36). Framed in a modest ivory case with a fitted lid, this miniature could have been carried by his intended, hidden in a pouch tied to the waist. In contrast, the miniature of a man against a flame background (pl.37) is likely to have been set in a jewelled case, complementing the rich gold flames that shimmer when gently moved. The sitter's intimate state of dress, with what is probably a picture box turned to his heart, suggests that the flames symbolize passion; another miniature, now at Ham House, of a sitter similarly set against flames carries the motto 'Alget qui non ardet' (He becomes cold who does not burn).[29] The miniature of a man wearing a jacket adorned with flaming hearts (pl.38) carries a more enigmatic motto in curling gold calligraphy: 'Abigitq[ue] trahitque' (It both repels and draws), a conceit from Camden's *Remaines* (1605), comparing love to a rose (depicted on the left) whose bloom attracts and yet whose thorns repel.[30] Though typically Hilliardesque, this miniature is by a follower of his style, and bears out Hilliard's claim to have trained 'divers' to 'please the common sorte',[31] meaning simply those of good but not noble birth.

Intimate miniatures could kindle the flames of passion, but John Donne paid tribute to them also as keepers of memory, always kept close: 'Here take my Picture; though I bid farewell / Thine, in my heart, where my soul dwells, shall dwell. /[…] This shall say what I was' ('Elegie: His Picture').[32] Miniatures were above all likenesses of beloved faces. To modern eyes Elizabethan sitters can seem very formal in their stiff ruffs (pl.39), for which Hilliard used an especially thick white paint. But the focus

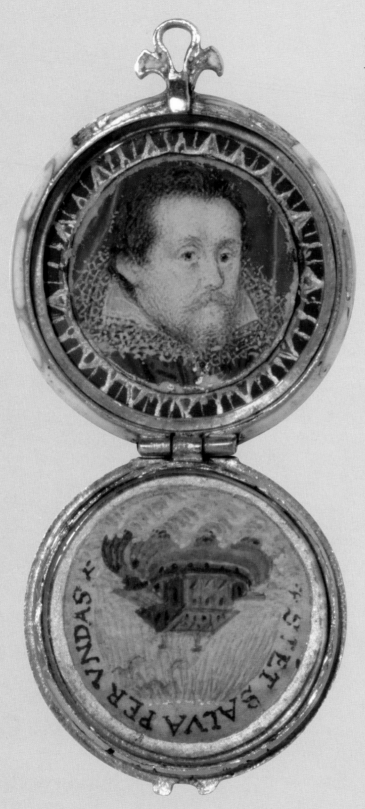

40
NICHOLAS HILLIARD
James I and the Ark
England, *c*.1610
Locket of enamelled gold, with
miniature on vellum stuck to card,
closed 30 × 19 × 5 mm,
open 42 × 19 × 5 mm
V&A: M.92–1975

of the miniature, especially small ovals, was the face – the sitter's characteristic looks captured *ad vivum* (from life). Hilliard was especially entranced by his countrywomen, calling them 'rare beauties',[33] and wrote evocatively of working quickly to catch 'those lovely graces, witty smilings … stolen glances, which suddenly like lightning pass'.[34] Hilliard understood that his miniatures would be 'viewed … in hand near unto the eye', and condemned 'hard shadows', which were only needed in 'great pictures' displayed high up and far off.[35]

Miniatures suited the romantic play and emotional intensity of the court, which centred on the Queen's favour. A possibly apocryphal report from 1602, the year before the Queen's death, tells how Elizabeth actually took from one of her ladies a locket containing a miniature of her young adviser, Robert Cecil, and attached it to her shoe. A subsequent elaborate play of compliment and counter-compliment ended with Elizabeth pinning Cecil's picture at her elbow, nearer her heart.[36] In 1596 the Queen had reached the astrologically significant 'Grand Climacteric' – the feared age of 63.[37] In the late 1590s the reality of her sunken cheeks and blackened teeth, feeding anxiety about her death and the succession, encouraged an emphasis instead on her iconic status as the powerful 'Virgin Queen'. At her first sitting Elizabeth had instructed Hilliard to paint her in the light of a 'goodly garden', avoiding unflattering shadowing.[38] In his last miniatures of the Queen, Hilliard reduced her image to a schematic likeness, rejuvenating her features and focusing on her ornate costume; Sir John Harrington told how Hilliard could delineate the Queen's face in four lines he knew it so well.[39] It became the fashion to wear her miniature, and foreign courts often asked to view miniatures of Elizabeth carried by English diplomats; Sir Henry Unton told how the French King kissed Unton's miniature of the Queen 'with passion and admiration'.[40]

The repetition and dissemination of royal portraits was even more marked with Elizabeth's successor, James I, who ascended the throne in 1603, establishing the Stuart dynasty in England. James was keen to broadcast images of the royal family – his Queen, Anne of Denmark, two male heirs and one marriageable daughter. But although Hilliard was the King's limner he had little direct access to the King, who notoriously disliked sitting for his portrait. To meet the demand for the many versions of James's portrait Hilliard undoubtedly had the assistance of former apprentices to produce miniatures such as the Ark Jewel (pl.40). This shows a standard likeness of James, enhanced by a setting harking back to symbolism current after the defeat of the Armada: the ark representing the monarch as head of the English Church, guiding it through troubled waters.[41]

It was Hilliard's 'well profiting scholar' Isaac Oliver who now came to the fore. He was appointed limner to the Queen, who unlike James I was genuinely interested in the visual arts. Oliver was a refugee of French Protestant parentage who came to London as a child. He learned limning from Hilliard (who was probably 15 to 20 years his senior), but – unlike Hilliard – was responsive to Continental influences and closely involved with London's immigrant artistic community. It is not known whether Oliver travelled abroad in his youth, but his early miniatures from the late 1580s, with their emphatic modelling and shadowing of the sitter's features, were influenced by the portrait engravings of Hendrik Goltzius. A moderated version of this style can be seen in a miniature from around 1610 (pl.41), with its sober but elegant naturalism. Oliver's documented visit to northern Italy in 1596 is evident in such sophisticated cabinet miniatures as *Unknown Lady* (pl.42), with its circular Renaissance *tondo* format, and also its subtle

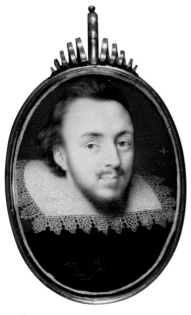

41
ISAAC OLIVER
Unknown Man. England, *c.*1610
Watercolour on vellum stuck to
a playing card, 43 × 35 × 4 mm
V&A: P.129–1910

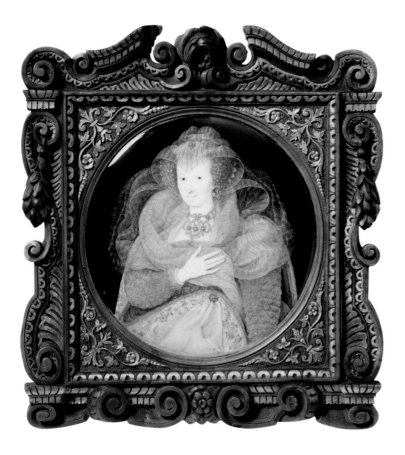

42
ISAAC OLIVER
Unknown Lady, formerly called
Frances Howard, Countess of Somerset
England, c.1596–1600
Watercolour on vellum, stuck to plain card,
214 × 200 × 30 mm including frame
V&A: P.12–1971

low-key colouring and sitter's pose, both features reminiscent of portraits by Leonardo da Vinci and his followers.[42]

The taste for small oval miniatures continued, encouraged especially by Queen Anne, who often wore a picture box (pl.43). But Oliver's portrait of an unknown lady prominently wearing masque costume (pl.44) illustrates the paradox of the oval miniature as both private and public. The court masques, a form of symbolic theatre in which Anne and her ladies often took part, celebrated the Stuart monarchy. This miniature therefore identifies the lady as one of the Queen's intimate circle, allowing the recipient – perhaps a husband – to use her private token to demonstrate public royal favour. James's daughter, Elizabeth of Bohemia, notably shared her parent's predilection for miniatures as personal tokens of favour after she and her husband were exiled from Bohemia in 1620. Oliver's son, Peter, produced a number of miniatures of the so-called 'Winter Queen' (pl.45) – tokens of private loyalty that also broadcast her political plight.

Isaac Oliver died in 1617 and Nicholas Hilliard in 1619, and in 1625 James I was succeeded by Charles I. The new King transformed the court artistically, creating a collection of art to rival the great European dynasties, and inviting Continental artists such as Anthony van Dyck to Britain. Van Dyck's full-length oil portraits defined Charles's Cavalier court, much as Hilliard's miniatures had defined Elizabeth's court, but the particular qualities of the miniature continued to move contemporaries. Sir Kenelm Digby famously said that 'cavaliers' preferred 'their mistresses picture in limning than in a large draught with oyle colours',[43] and Henry Peacham, who recommended limning to gentlemen readers in a series of publications from 1606, commented in *The Compleat*

43 (opposite, above left)
ISAAC OLIVER
Anne of Denmark
England, c.1612
Watercolour on vellum, 55 × 43 mm
V&A: FA.689

44 (opposite, above right)
ISAAC OLIVER
Unknown Woman in a Masque Costume
England, 1609
Watercolour on vellum stuck to plain card,
62 × 51 mm
V&A: P.3–1942

45 (opposite, below left)
PETER OLIVER
Elizabeth of Bohemia, daughter of James I
England, c.1623–6
Watercolour on vellum put down
on pasteboard, 56 × 41 × 7 mm
V&A: Dyce.88

46 (opposite, below right)
PETER OLIVER
Mrs Edward Norgate (born Lanier)
England, c.1616–17
Watercolour on vellum stuck put down
on pasteboard, 54 × 43 × 9 mm
V&A: P.71–1935

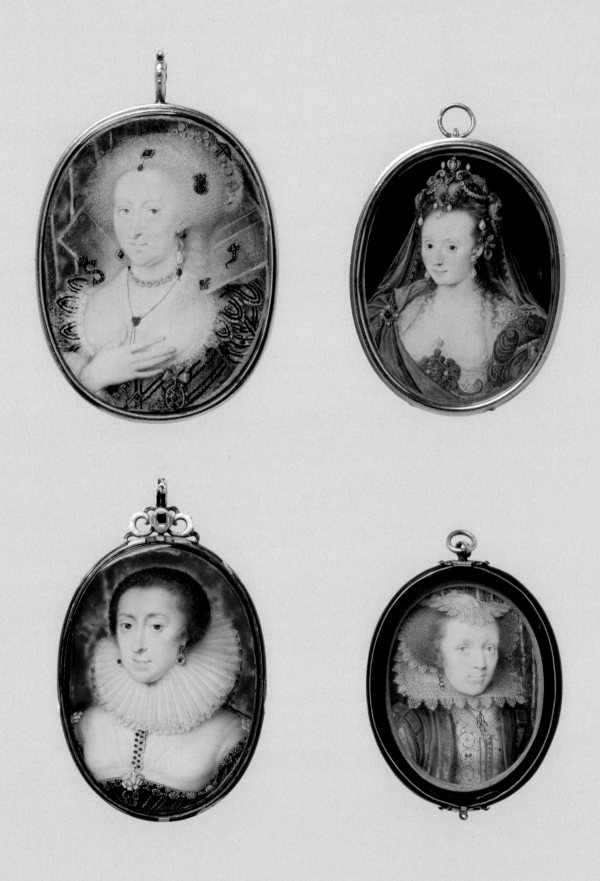

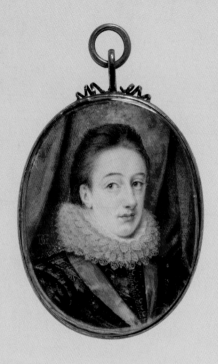

47
SIR BALTHASAR GERBIER
Charles I as the Prince of Wales
England, *c*.1616
Watercolour on vellum put down on a
leaf from a table book, 50 × 39 mm
V&A: P.47–1935

Gentleman, republished in 1635, that limning 'preserveth the memory of a dearest friend, or fairest mistress'.[44] Peter Oliver's miniature of Edward Norgate's wife (pl.46) carries a later moving inscription: 'she has not died but gone away. Most special ornament of modesty … and beauty. To the most sweet wife.'[45]

Both Peacham and Norgate point to an interest from the early seventeenth century in limning as a gentlemanly pastime. For example, in around 1616 Sir Balthasar Gerbier, later Charles I's ambassador in Brussels, notably attempted a miniature of Prince Charles (pl.47) – probably after an engraving – having recently arrived in England to join the Dutch ambassador's household. Hilliard wrote his treatise on limning in around 1600 at the invitation of a gentleman enthusiast, Richard Haydocke, and in around 1627 Norgate also wrote a treatise, *Miniatura, or the Art of Limning*; both were unpublished but circulated in manuscript form.[46] Norgate was a limner of important state letters for James I and Charles I, and was possibly responsible for some of the hundred or so decorated letters sent to the Russian court by English monarchs, from Elizabeth I to Charles II (pl.48), now in the Russian State Archives.[47]

Norgate's treatise, discussing limning both as a practitioner and a connoisseur, is characteristic of the new court culture. Charles had appointed a curator of the royal collection, Abraham van der Doort, who recorded over 80 miniatures in the Cabinet Room.[48] The King acquired dynastically significant portrait miniatures, and had possibly inherited examples from the Tudor collection. But he also appreciated the exquisite nature of limning and employed Peter Oliver, Norgate's 'cousinell',[49] to make copies in limning of his oil paintings. For Norgate the beauty of limning was the fineness of its materials and techniques; of all painting it was 'the most close, smooth and even'.[50] This speaks of a sensibility that appreciated the 'curious' (finely wrought) limnings by Oliver – perhaps more than the originals 'in a large draught with oyle colours' – and no doubt agreed with Hilliard's proud claim that limning was 'a thing apart … which excelleth all other painting whatsoever'.[51]

48 (*opposite*)
*Letter to the Russian Tsar Mikhail
Romanov from James I, with a
portrait of James I*, 20 May 1623
Watercolour on vellum
Russian State Archives of Ancient
Documents, Moscow
RGADA, fond.35, no.33

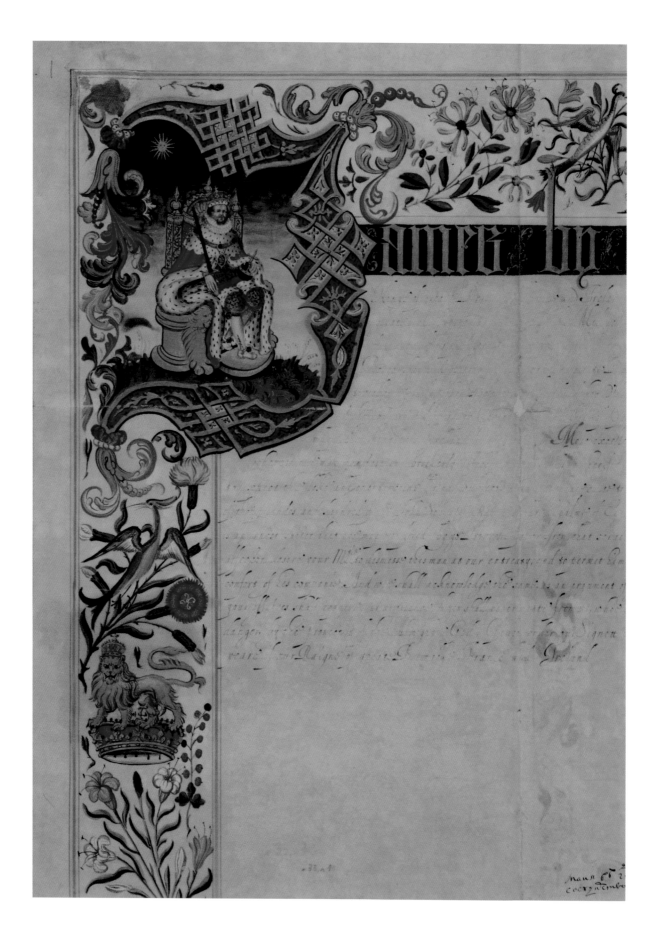

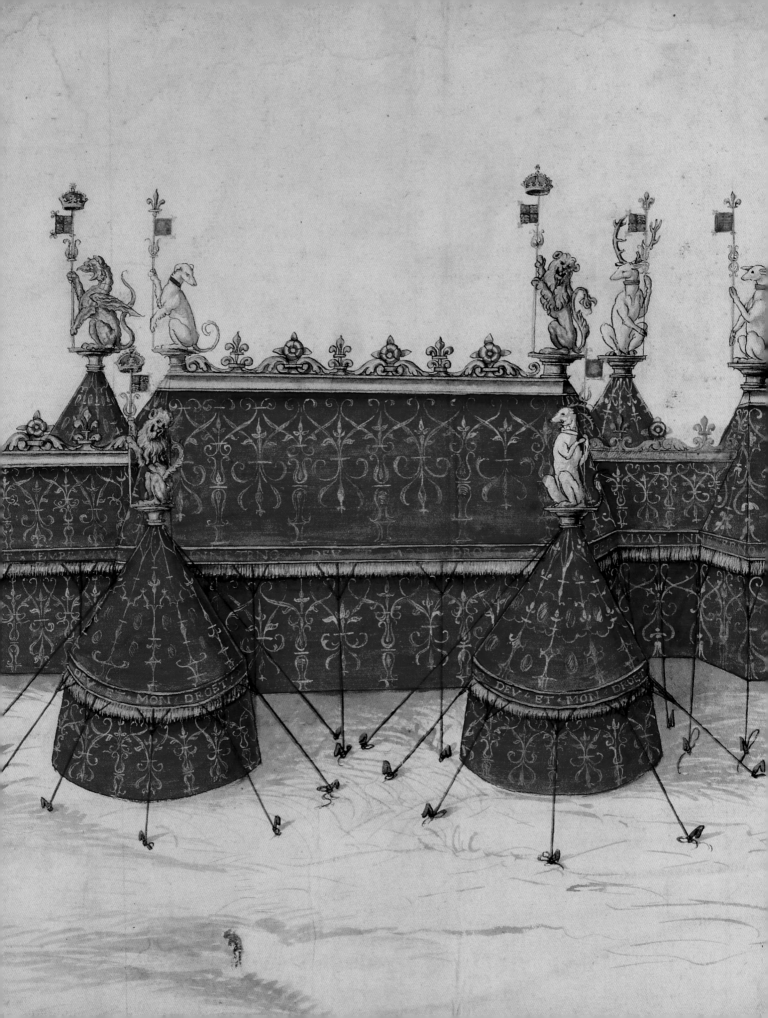

Maurice Howard and Tessa Murdoch

'ARMES AND BESTES':
TUDOR AND STUART HERALDRY

In sixteenth-century and seventeenth-century England the display of heraldry played an important role in allowing the viewer to identify the power of individuals and great families. Heraldry was found on great public buildings such as palaces, country houses, colleges and churches; on household objects of every kind of material; on objects used only on ceremonial occasions and therefore usually in very expensive materials; and on clothes and personal items that people carried with them every day. Heraldry was conveyed in two principal ways: through the coat of arms (sometimes called the 'shield') which signified family status and its links by marriage with other families; and the badge, a more personal sign associated with an individual and worn by his servants and on standards or flags in battle.[1] During the period the role of the heralds became professionalized: their responsibilities grew from medieval beginnings, when their chief duty was to organize and keep records of tournaments, into the specialist activity of resolving disputes about who was entitled to armorial bearings and how they should be drawn up. The display of heraldry became a matter of fierce pride among all the powerful groups of society. Heraldic signs worked by juxtaposing fully-saturated colours next to each other and creating patterns that could be recognized across a variety of objects.[2] Through the depiction of beasts as supporters to coats of arms, a world of imagined creatures came into being that has had an influence right up to modern times.[3]

As the Tudor dynasty became established, the decorative programme of the royal palaces at home, and royal pageantry abroad, changed. Under Henry VII the skyline of the Thames-side Richmond Palace was punctuated by a forest of pinnacles that supported royal heraldic beasts and banners.[4] Abroad, the young Henry VIII's energies

49 (*detail opposite*)
Design for a Royal pavilion,
early 16th century
British Library, London
Cotton MS August iii.F.18

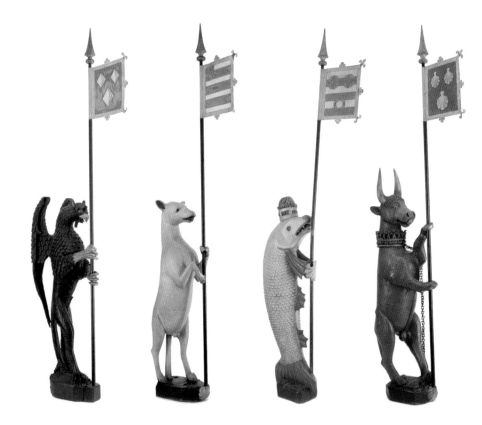

52
The Dacre Griffin
Cumbria, England, 1507–25,
banner added *c.*1844
V&A: W.7:1 to 4–2000

53
The Dacre Ram
Cumbria, England, 1507–25,
banner added *c.*1844
V&A: W.8:1 to 4–2000

54
The Dacre Dolphin
Cumbria, England, 1507–25,
banner added *c.*1844
V&A: W.9:1 to 5–2000

55
The Dacre Bull
Cumbria, England, 1507–25,
banner added *c.*1844
V&A: W.6:1 to 5–2000

50 (*opposite, top*)
Ceramic tile with the antelope
badge of Edward de Stafford
England, 1500–21
V&A: 1104–1892

51 (*opposite, below*)
Ceramic tile with the swan
badge of Edward de Stafford
England, 1500–21
V&A: 1098–1892

were focused on courtly pageantry. Tilts and tourneys reached their climax at the Field of Cloth of Gold in 1520, which was intended to dazzle Europe and to eclipse Henry's French rival Francis I. An early sixteenth-century design (pl.49) shows Henry VIII's pavilion decked in crimson and gold with tent poles set with 18 heraldic 'royal beasts'; four gold lions, three red dragons, six white greyhounds, two white harts and three white antelopes. This is almost certainly a record of the preparations for the temporary pavilion constructed for the meeting of the two monarchs. For this spectacular event Charles Brandon, Duke of Suffolk, was asked to send 'divers of the Kinges armes and bestes cast in moldes, which wold do great ease and furtherance to the Kynges busyness'.[5] The beasts, evidently cast in plaster or terracotta, and painted in the appropriate heraldic tinctures (colours), support banners charged with royal arms or badges. The tent is further decorated with fleurs-de-lis, Tudor roses and the royal motto 'DIEU ET MON DROIT'.

Noble courtiers attempted to emulate royal practice. In 1515 Edward Stafford, 3rd Duke of Buckingham (1478–1521), began to build a residence worthy of the monarch at Thornbury Castle, Gloucestershire, that was intended to rival a royal palace at Richmond. Buckingham's slight claim to the Crown as a descendant of Edward III made Henry VIII nervous, and contributed to Buckingham's execution in 1521. Floor tiles from Thornbury are decorated with heraldic badges: the swan is a royal badge (pl.51) but the chained antelope is personal to Buckingham (pl.50).

The Dacre Beasts – the black griffin, white ram, crowned white dolphin and red bull – were commissioned by Thomas, Lord Dacre (1467–1525), a formidable soldier who fought for Henry Tudor against Richard III at the Battle of Bosworth in 1485 and against the Scots at the Battle of Flodden in 1513. The red bull was the supporter of Lord Dacre's coat of arms and his family crest (pls 52–5). It thus served to identify

him in battle, underlined by his battle cry 'a red bull, a red bull, a Dacre, a Dacre'. The four beasts celebrate Dacre's dynastic alliances. The crowned dolphin supports the Greystoke coat of arms. In 1488 Lord Dacre eloped with Elizabeth de Greystoke (1471–1516), the heiress to the baronies of Greystoke and Fitzwilliam – and this union brought him Morpeth Castle and the manor of Henderskelfe, later rebuilt as Castle Howard (the seat of Charles II's ambassador to Muscovy, Charles Howard, 1st Earl of Carlisle). The black griffin represents the Dacres of Gilsland, Thomas Dacre's forebears. The barony of Gilsland was acquired through Ranulph de Dacre's marriage to Margaret De Multon almost two hundred years earlier in 1317. The white ram is the supporter of the De Multon coat of arms and serves as a rebus – the ram deriving from *mouton*, French for 'sheep'. The beasts serve therefore to demonstrate the longstanding ancestry of one of the most powerful families in the North of England. Dendrochronological analysis shows that the four beasts were carved from the single trunk of an oak tree felled in the early sixteenth century, and traces of original paint on the bull, the ram and the dolphin suggest that their redecoration after the fire at the family home, Naworth, Cumbria, in 1844, carefully supervised by the Victorian architect Anthony Salvin (1799–1881), was true to the original. It has been suggested that they were made for the funeral of Thomas, Lord Dacre, in 1525. They were later mounted on the gallery in the Great Hall at Naworth under a ceiling painted with portraits of the sovereigns of England up to Henry VI.[6] Another contemporary heraldic ceiling in the Great Parlour of the Bishop's Palace, Chichester, was painted by Lambert Barnard (1485–1567) for Bishop Robert Sherburn. There, the royal Tudor badge, the rose, is flanked by the initials 'H' and 'K' for Henry VIII and his first wife, Katherine of Aragon; the other groups illustrate the Bishop's devices, and those of local noble patrons, reflecting the Bishop's network of influential men with a presence at the royal court.[7]

By the mid-1520s, Henry VIII's attention turned to his royal buildings; he took on Hampton Court from Cardinal Wolsey and extended it with a great hall, state apartments and gardens.[8] He had the Privy Orchard adorned with royal beasts – including antelopes, dragons, lions, harts, greyhounds and hinds – carved in wood and painted in bright colours, highlighted with gilding, and then perched on posts painted in the Tudor livery colours of green and white. In the Privy Garden created in the mid-1530s, the King's beasts were joined with green and white railings to those representing the new Queen, Anne Boleyn. The adjacent Mount Garden provided a bird's-eye view of the extended palace and its grounds from a three-storey arbour with a leaden cupola surmounted by the King's beasts and a gilded crown. The approach to the arbour was lined with carved stone dragons, a greyhound, a luzern (a female lynx) and a griffin. Such a gaudy display of status and dynasty provided a spectacle from the palace windows throughout the seasons, even during the winter months.[9] Heraldic beasts also adorned the interiors of Henry's palaces: two stone leopards or lions (pl.56) are remarkable survivals, possibly connected to Henry VIII's palace at Dartford, Kent, where stone lions are recorded at the bottom of the main staircase. They were rediscovered in 1985 adorning the exterior of a local public house at Worcester Park, Surrey, and then taken to France to form a feature for a campsite at Saint-Geours-de-Maremne. They were subsequently identified and acquired by a leading garden historian who lent them for display at Hampton Court Palace from 2009. They are carved in Taynton stone, quarried near Burford, Oxfordshire.[10] They are the only original royal beasts known to survive from Henry VIII's royal palaces.

Pair of heraldic royal beasts,
possibly 'Leopards of England'
known as 'Kyng's Beestes'
England, *c.*1520–30
Todd Longstaffe-Gowan

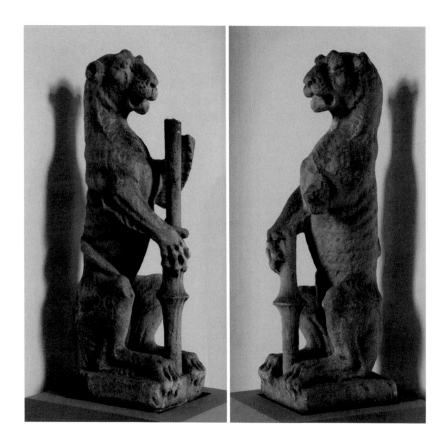

At Whitehall Palace, also taken by Henry VIII from Cardinal Wolsey, the Privy Garden or Great Garden to the west of the palace was again adorned with different heraldic animals perched on columns, carved in wood, with their horns gilded. This feature is glimpsed in the background of a group portrait of Henry VIII and his family, dating from *c.*1545.[11] Edward III's griffin, the Beaufort yale, the Richmond white greyhound and white hind, each carrying flags with the Queen's arms, are supported on marbled wooden columns linked by green and white fencing. (The yale is a dark mythical creature with a lion's tail, a boar-like snout, tushes and horns.) By the reign of Queen Elizabeth these animals bore flags bearing her arms, and under James I they are described as standing at the corners of several garden plots. By the late sixteenth century, garden ornament included representation of heraldic beasts in topiary, probably inspired by Italian practice. The presence of such heraldic companions continued to find favour as garden ornament. In Yorkshire in the 1630s, Sir Arthur Ingram commissioned heraldic stone beasts for the decoration of the parterres in his new gardens at Sheriff Hutton and Temple Newsam, near Leeds. Of the 20 heraldic beasts carved in stone by Thomas Ventris for Sheriff Hutton, three, including an imposing lion, still survive in situ.[12]

Royal beasts were also used for public commissions in a civic context. During James I's reign royal beasts commissioned for the drawbridge over the Medway at Rochester, Kent, included a lion, a unicorn, a buck, a greyhound, a bull, a boar, a dragon, a leopard, a talbot (a hunting dog) and a panther; they may have replaced Tudor beasts that included Jane Seymour's heraldic supporters the unicorn and panther, which would date them between her marriage (20 May 1536) and her death (14 October 1537).

Predictably, the horns of the bull and unicorn were vulnerable to damage from passing traffic, and there is evidence of regular repair of these features as well as wholesale replacement of entire beasts when necessary.[13]

On buildings commissioned by Henry VIII's courtiers and by leading merchants of the period, heraldry proclaimed a sense of ownership, with coats of arms often placed over the entrance gateway to a major house. Prominent figures might also acknowledge that all land and buildings were held under the sovereign. Thus at Hengrave Hall, Suffolk, in 1538 the merchant Sir Thomas Kytson commissioned a window over the entrance to the inner court of his great new house that showed his own personal arms on the moulded supports to the base of the window and the royal arms of King Henry VIII above, immediately under the window lights (pl.58).[14] This was especially significant because the window was ordered by special contract, and was the most expensive single item of work at the end of a 13-year campaign of building. A member of the London-based Company of Merchant Adventurers, Kytson served as Sheriff of London in 1533 and had substantial financial dealings with the Crown.

Equally, coats of arms could symbolize an endowment, so that over the gateway to both of her two foundations at the University of Cambridge, St John's College and Christ's College, the arms of Lady Margaret Beaufort, mother of King Henry VII (pl.57), recognize the money and support given by the foundress (pl.59). Visitors to the college thus proceed from the gateway, across the courtyard and into the great hall, where her portrait would be displayed, also showing her coat of arms. By repeating coats of arms on buildings and objects, ownership, power and prestige were reinforced and, in the case of these Cambridge colleges, were intended to encourage a continual sense of gratitude to their benefactress.

However, as the sixteenth and seventeenth centuries progressed, heraldry on the outsides of buildings became less fashionable or, if still used, tended to be contained by the architecture's classical orders. For a time in the late sixteenth century heraldry

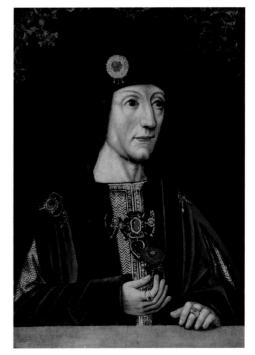

57
Unknown English Artist
Henry VII
Oil on panel, 16th century
V&A: 572–1882

58
Royal coat of arms, and those of
Sir Thomas Kytson, London merchant
Hengrave Hall, Suffolk, 1538

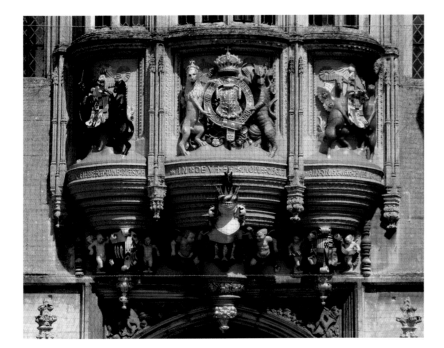

59
Coat of arms of Lady Margaret
Beaufort, mother of Henry VII
The Gate House, St John's College,
Cambridge, 1511–20

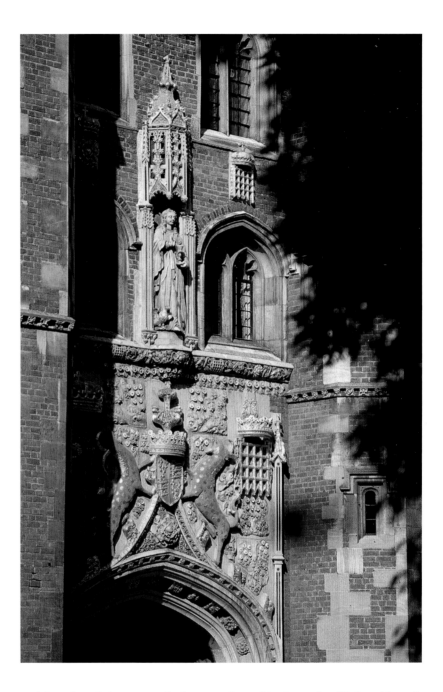

proliferated inside houses, on the fittings and movable objects that filled wealthy resi-
dences. Coats of arms were found on plaster ceilings, carved in stone or wood on the
overmantels of great fireplaces in the most important rooms, incorporated into the
stained glass of windows and worked into textiles. In a great tapestry made for Elizabeth I's
favourite, Robert Dudley, 1st Earl of Leicester, his coat of arms sit amid a wealth of
floral design demonstrating the best of contemporary tapestry manufacture.[15] On a
cushion cover made for the Sandys family in about 1560 (for one of their great houses,
The Vyne or Mottisfont, both in Hampshire) the family coat of arms at the centre are
quartered with those of that of Windsor, acknowledging a recent family alliance through

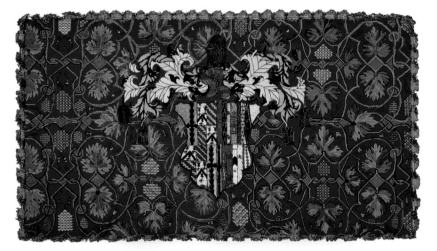

marriage (pl.60). The cushion cover does something more, however. The noble title held by the family was the Barony of The Vyne, named after their more historic seat, so vine leaves and bunches of grapes were worked into the design.[16] Heraldry often played on this kind of allusion, mixing both verbal and visual languages to amuse and provoke the observer. Heraldry was essentially a serious process, but it could also, in this way, allude to knowledge shared by the owner and viewer.

Wearing the royal badge or the royal initials on clothing was an essential part of the uniform of royal servants during the Tudor period. On some of Holbein's portraits of the men of Henry VIII's court they are wearing 'HR' for 'Henricus Rex' on their coat. Likewise, Cornelius Vandun, Elizabeth I's cook, wears the 'ER' for 'Elizabeth Regina' on his tomb in the church of St Margaret, Westminster (pl.62). In a famous miniature, the *Young Man among Roses* by Nicholas Hilliard, all those at the court of Elizabeth I who were privileged to view this essentially private object would have known that the colours green and white, so prominent in the piece, were worn by the close servants of the Tudor monarchs (pl.61). In a sense, therefore, this unknown young man is swearing his loyalty to the Queen – and there has thus been much speculation as to which of her favourite courtiers this image might represent.

In sixteenth-century and seventeenth-century England no single type of object became so covered with heraldic information as the great funeral monuments of the most powerful, especially if their rise to power had been relatively recent and their place in the great hierarchy not fully established. As this was immediately after the Reformation, the suppression of religious imagery left plenty of space for such display on monuments. The newly powerful called on remote connections with important figures from past and present, stressing family alliances and common posts held at the court.[17] Great heraldic displays were often accompanied by lengthy texts explaining the worldly success of the person interred. On the tomb of Sir Augustine Nicholls (1559– 1616) the place that formerly would have been held by saints in the pre-Reformation world were now taken by representations of the Virtues, underlining his good character and acting as supports to his coat of arms (pl.63). The closer to the altar a great tomb was placed, the more important the family, thereby communicating to the congrega-tion that the most powerful of the neighbourhood were constantly present (pl.64). While elaborately decorated tombs gave way to more simple, more overtly classical,

forms during the course of the seventeenth century, coats of arms were still present as hatchments – circular or lozenge-shaped boards – that were attached to the pillars of the church itself. The royal coat of arms also dominated these ecclesiastical spaces: after the Reformation it was written into law that the royal arms had to be present in every parish church, the sovereign now being the Supreme Governor of the Church of England. Sometimes the royal arms even supplanted the image of the crucified Christ over the rood screen between nave and chancel, a position towards which everyone participating in the service and facing east would automatically look.[18]

As well as carrying messages of power and influence within the kingdom, heraldry was viewed by foreign visitors to international occasions, such as the Field of Cloth of

62
Monument to Queen Elizabeth I's cook, Cornelius Vandun (died 1577) St Margaret's, Westminster, London

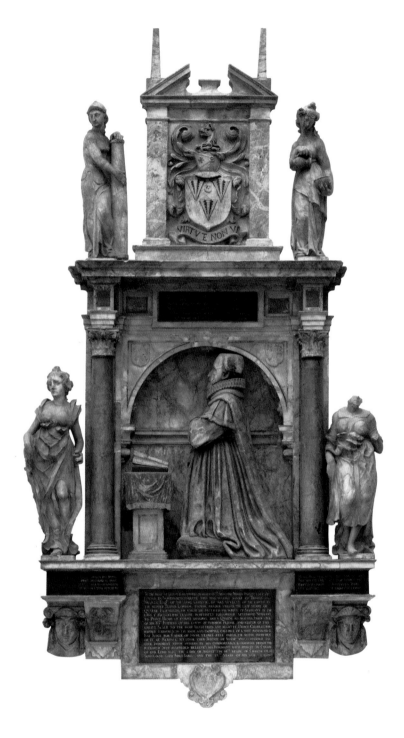

63
Attributed to NICHOLAS STONE
Monument to Sir Augustine Nicholls
England, early 17th century
V&A: A.9–1965

Gold, and to the royal court; they equally would also have understood its significance when applied to objects and buildings. Heraldic ornament thus became the appropriate language of status for the decoration of ambassadorial gifts (see 'From Whitehall to the Kremlin' in this volume). James I's ambassador to Tsar Boris Godunov, Thomas Smith, presented the remarkable coach (pl.220) that is still preserved in the Kremlin Armoury Museum.[19] On the back the Russian double-headed eagle is flanked by the English lion and unicorn, supporters of the royal coat of arms; each carries a shield adorned with the rose of England (the Lion) and the thistle of Scotland (the Unicorn), demonstrating

the newly united kingdoms of England and Scotland under the monarch James I, who was also James VI of Scotland. The Leopard ewers (pl.104) brought by the merchant Fabian Smith (pl.88) of the Muscovy Company to the treasury of Tsar Mikhail Romanov were made in London in 1600–1, possibly as a gift for Queen Elizabeth I. The pair probably formed part of the display of King Charles I's 'Great Guilt Cubberd of Estate' in 1626.[20] It is thought that their shields were originally decorated with royal badges or coats of arms, but they have been subsequently re-engraved with strapwork ornament. Their heads are removable to allow their bodies to be filled. The leopards are beautifully chased in imitation of fur. Applied cast ornament includes lions' heads from which pendant chains are suspended and linked with a finer chain descending from the leopards' heads.

In Tudor and Stuart courtly culture, coats of arms and heraldic beasts were an instantly recognizable indication of status and familial connexions. Heraldic badges were adapted as decorative ornament on buildings, chattels and dress. Such practice continues to the present day but was championed during the nineteenth-century revival of tournaments as evocations of the medieval past which owed much to the writings of Sir Walter Scott (1771–1832) and in particular his novel *Ivanhoe*, published in 1820. Its most famous manifestation was the Eglinton Tournament of 1839, where heraldry was emblazoned on every surface and fabric.[21] Heraldry was also influential in the world of book illustration, for historical re-creations and imagined creatures. After John Tenniel (1820–1914), illustrator of Lewis Carroll's *Alice's Adventures in Wonderland* (1865), had stayed at Naworth Castle, Cumbria, with the Howard descendants of Lord Dacre, the black Dacre Griffin became the inspiration for his imaginative rendering of Alice's beastly companion. Heraldry's inspiration endures – to this day.

64
Details from the tomb of John Sydenham (died 1626) in St Andrew's, Brympton d'Evercy, Somerset, showing the back panel of the canopy and the end of the chest

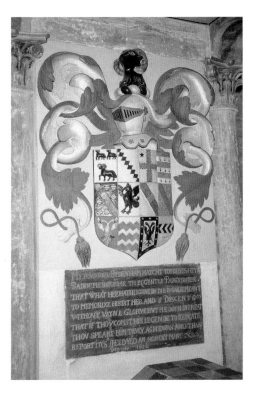

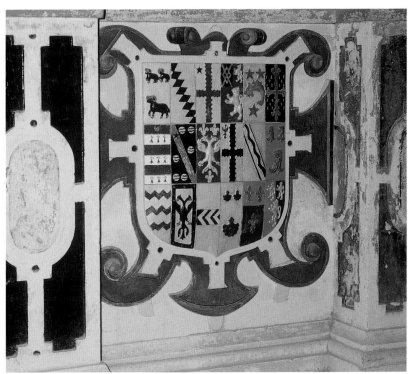

Natalia Abramova

SIXTEENTH-CENTURY AND SEVENTEENTH-CENTURY ENGLISH SILVER IN THE KREMLIN

The Kremlin Armoury Museum in Moscow is a unique collection of extraordinary riches. It holds the surviving treasures of the Tsars and Grand Princes, which were created by Russian craftsmen, as well as outstanding works of art from western Europe and the Orient. The latter were brought either as diplomatic gifts or purchased for the Tsar's treasury by specially appointed agents. During the course of the sixteenth century an ambassadorial ritual became firmly established in Russia, and was observed strictly by the Ambassadorial Office, which was founded specially for that purpose. The Office aimed to promote links with foreign states, as well as to organize Russian diplomats abroad. The ceremony of receiving a foreign ambassador, and accepting their gifts, was often held in the Palace of Facets – which acquired its name from the white faceted stone cladding of its exterior walls facing Cathedral Square, the main Kremlin square. The palace was commissioned by Tsar Ivan III (The Great), and built between 1487 and 1491 by the Swiss Italian architect Pietro Antonio Solari.

The Armoury contains pieces from the Tsars' treasury, and possesses the world's only collection of ambassadorial gifts from sixteenth- and seventeenth-century England, Holland, Sweden, Denmark, Poland and Austria. The Armoury Museum holds over 500 pieces of English silver, of which 115 were made between 1557 and 1663 (pl.66). The collection is one of the biggest and the most important of the period in the world.[1]

Surviving documents connected with the ambassadorial missions of Thomas Randolph (1568–9), Jerome Horsey (1586–7), Sir Richard Lee (1600–1), Sir Thomas Smith (1604–5) and Sir John Merrick (1614–17 and 1620–1) to the Tsars Ivan IV (The Terrible), Fyodor Ivanovich, Boris Godunov and Mikhail Romanov, as well as concerning the activities of the merchant agents Fabian Smith (known in Russia as Fabian Ulyanov) and Simon Digby between 1607 and 1636, testify to significant imports of silver pieces. Gifts and purchases entering the Kremlin were transferred to the Court of Exchequer, where they were carefully weighed and recorded in special inventories. On many objects were engraved Slavonic letters signifying their weight, and sometimes inscriptions indicating the source of the gift and the date of import were added (pl.67). Such careful documentation makes it possible to assess reliably the provenance of many objects, and identify a significant number of silver pieces from England in the Armoury.

One can identify existing objects with specific embassies only for the visit of 1604, when the coach given by James I to Tsar Boris Godunov arrived in Moscow. James I also sent a variety of silver vessels in 1615. Among them there were 11 cups, a basin and ewer, flasks, pairs of livery pots and a brazier-like deep pan with an openwork lid and

65 (*opposite*)
Water pot (detail showing embossed decoration), see pl.113

66
16th- and 17th-century English silver in the Kremlin Armoury Museum, Moscow

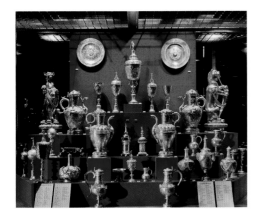

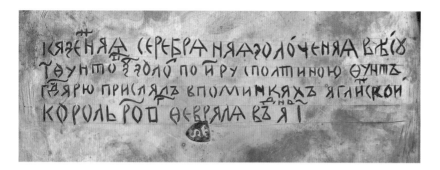

wooden handles. There was a 'chalcedony tub on a stand with a lid, the stand and lid silver gilt' as well as a 'gilded salt with lid' and candlesticks.[2]

In 1620 John Merrick delivered items from James I that were not entirely the standard English seventeenth-century royal gifts, since they included not only silver plate and textiles but also semi-precious stones (these were more characteristic of gifts made during the second half of the sixteenth century), as well as silver sculptures (which were more typically given by Continental countries). Nor was the order in which the silver was presented the usual one: cups (among which was pl.115) were not only presented first, but after a crystal salt, a jasper cup in a gold mount, and table sculptures of an ostrich, lion and unicorn.[3]

In 1636 diplomatic gifts were sent by Charles I via the agent Simon Digby. They included a pair of gourd cups, pairs of livery pots with flat-chased bodies showing 'people of the sea riding sea-fish and masks and shells' (pl.112), flasks 'chased in the manner of shells', single-branch candlesticks and a lavabo set decorated with 'beasts of the sea'.[4] In 1664 the embassy of Charles Howard, 1st Earl of Carlisle (pl.68), brought very significant commemorative pieces from Charles II: a gun that had belonged to Charles I (pl.69), and an ewer and basin that was part of the dowry of Charles II's mother, Henrietta Maria (pl.70). These were among more usual ambassadorial gifts, such as pairs of cups, livery pots, flagons and candlesticks.[5] Some newly fashioned pieces – six fruit dishes and one perfuming pot – were added.

English ambassadorial gifts were often chosen from the silver objects in the Royal Treasury (the Jewel House) and those gifts selected for presentation to the rulers of Muscovy naturally included the very best, and most novel, examples of work by English silversmiths (for example, pl.102). The royal instructions given to Thomas Randolph, an ambassador for Elizabeth I, show that he was to present to the Tsar, in the Queen's name, 'a rich standing cup of silver, containing in it a great number of pieces of plate artificially wrought', which was to be prized rather for the 'newness of the device than … its intrinsic value', and which was 'the first that was ever made in England'.[6]

This attitude explains the presence of so many unique pieces in the Armoury Museum, and gives us an outstanding opportunity to study the highlights of English Renaissance and Baroque silver.

The Renaissance period

English Renaissance silver, produced during the period 1520–1620, can be characterized by precise, logical and symmetrical construction of form, and a clear division between all the functional parts. Decoration is always subordinated to a physical structure.

69
After ANTHONY VAN DYCK
Charles I
Oil on canvas, *c.*1635–7
National Portrait Gallery, London
NPG 2137

70
After ANTHONY VAN DYCK
Henrietta Maria
Oil on canvas, *c.*1632–5
National Portrait Gallery, London
NPG 227

 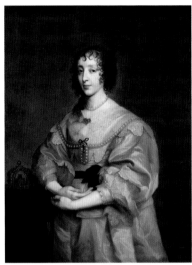

Composition and ornament are dominated by horizontal articulation of the form, and ornament is centred or arranged in bands. English Renaissance silversmiths favoured the font-shaped cup, ewer and basin sets, a variety of cups, large pillar-shaped salts, livery pots, candlesticks and flagons; all these forms are represented in the Armoury. Among the earliest, the font-shaped or flat cup of 1557–8 (pl.96) is of exceptional interest. Cups of this type, recalling the Italian *tazza* (or wine-bowl) but differing significantly in having a broad and massive stem, were widespread in England in the first half of the sixteenth century. The latest examples date from the 1570s. Traditionally, such vessels were found in local parish churches, where they were used as chalices, and there are still examples to be found today in churches in Kent, Oxfordshire and Leicestershire.[7] More luxurious versions appear in paintings (for example, *The Last Supper* by Frans Pourbus the Elder, Museum voor Schone Kunsten, Ghent), and during the second half of the sixteenth century it became fashionable to adorn such vessels with bust-length figures in antique armour and emblems in medallions at the centre of the inside of the bowl. The Armoury cup is one of the best surviving examples of the form. Seventeenth-century manuscript inventories, and the published inventory of the Armoury of 1884–93, describe the vessel as a '*razsolnik*'.[8] This Russian word, meaning sweetmeat, reflects the fact that in northern Europe the cup was used not for drinking, but for serving fruit and other dainties.

The cup is a striking example of how Renaissance style was applied to three-dimensional objects. Its compositional structure is clearly legible, thanks to the precise, carefully conceived separation of load-bearing and supported parts. The marked horizontal articulation differentiates it from the upward soaring, more monolithic, forms of Gothic plate, which clearly alternated horizontal and vertical elements in terms both of construction and decoration. Smooth or flower-patterned elongated *laminae*, or lobes, were possibly derived from ivory vessels. The unusual stocky form with its thick stem, the strapwork ornament and low-relief chasing of the tendrils are all evidence of English origin. For the wedding of Henry VIII and Jane Seymour, Hans Holbein the Younger produced designs for vessels showing antique profiles in medallions and arabesque ornament (pl.71) similar to the decoration on the Armoury cup.

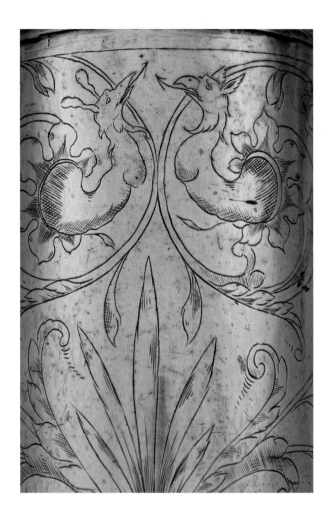

Silver vessels made during the second half of the sixteenth century were characterized by flatter treatment of ornamental motifs that cover the whole surface. Many pieces were engraved: a livery pot dating from 1594–5 is covered with elegantly engraved grotesque spiral tendrils, heads of fantastical beasts and birds, large palmettes, shells and rosettes (pl.72). The engraver Niçaise Roussel, who arrived in England from Flanders in 1563, developed this type of ornament from a complex combination of grotesques.[9] His compositions were widely known to English silversmiths, through the book of grotesques Roussel published in 1623, and reissued twice in the seventeenth century. The Armoury's nine livery pots include some extremely interesting pieces from the period 1585–1663. All of them are 'Hansekanne' (pots of the Hansa type), with the exception of the Baroque livery pots of 1663 (MZ-660; see pl.125). Hansekanne are cylindrical and elongated, unlike the conical tankards of the Elizabethan period, and they were generally used for beer and ale, although they might also be kept in churches. They were very popular in the Baltic region sea towns linked via the Hanseatic League – Riga, Lübeck, Rostock and Hamburg – where they were made until the mid-eighteenth century. The name 'Hansekanne' appeared in English documents of 1526, in the inventory of the royal Tudor plate compiled in 1574, and is repeated a dozen times in the list of objects in the royal treasury compiled in 1649.[10]

71 (*above left*)
HANS HOLBEIN
Design for a cup for Jane Seymour
London, England, 1536–7
Ashmolean Museum, Oxford

72 (*above right*)
Livery pot (detail), see pl.103

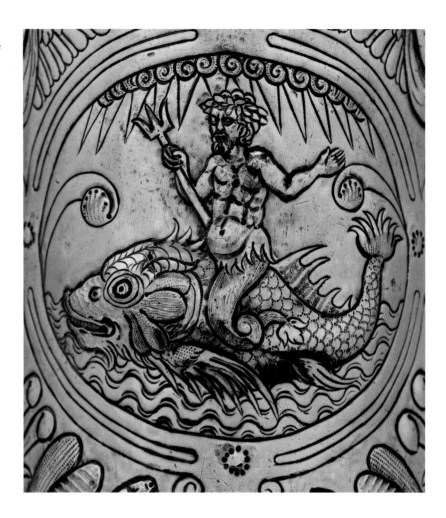

73
Livery pot (detail showing Neptune
on a sea monster), see pl.112

The livery pot of 1613–14 (pl.73) is a splendid example of early Stuart silver, chased with images of Neptune and tritons on dolphins, the heads of winged cupids beneath baldachins, winged sirens with fish tails, a coat of arms and shells. The combination of convex decorative elements (the shells and a row of large *ova* on the base) with flat strapwork and images in relief creates a play of light and shade that emphasizes the sculptural effect typical of late Renaissance silver.

The Armoury owns a very rich collection of English standing cups. Cups traditionally occupied an important place among ambassadorial gifts, and indeed usually featured at the head of the lists of gifts. Large gilded cups with covers, up to 90 cm high, were specially chosen or made as gifts. Ceremonial in purpose, they were not generally used, but placed on display buffets or stepped cupboards. More modest cups, 40–50 cm high, were the most common kind of English gift during the late sixteenth and early seventeenth century, and they headed the lists of New Year presents in surviving inventories of the royal plate of the later Tudors. They were also given by livery companies, colleges and societies. The Armoury's collection reflects their variety of form and decoration, allowing us to trace their evolution.

One more common type of cup has an ovoid bowl and a characteristic ornament of Tudor roses in strapwork, alongside hops, pears, daisies, pinks, lilies of the valley or

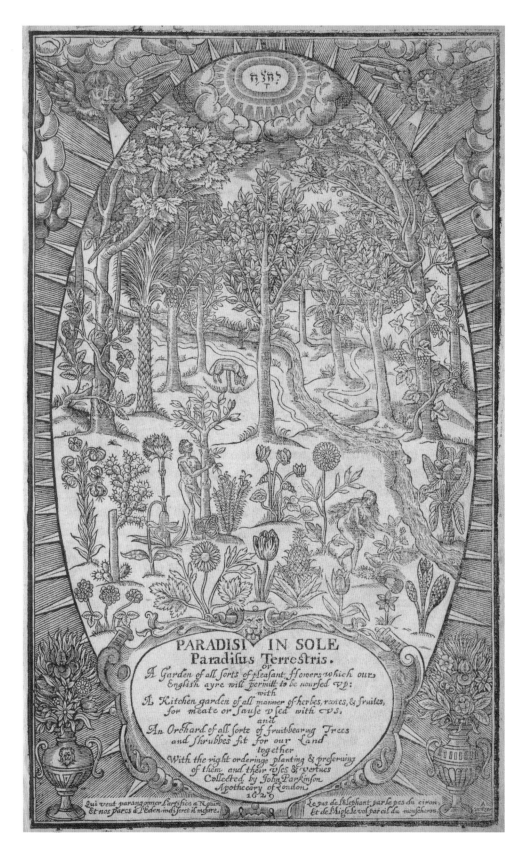

Title page of JOHN PARKINSON's
Paradisi in Sole Paradisus Terrestris,
engraved by Christopher Switzer,
London, England, 1629

harebells spread evenly across the whole surface. These ornamental motifs give English silver a very specific national flavour. Some idea of the favourite flowers of the time is indicated by *Paradisi in Sole Paradisus Terrestris*, a book by the apothecary and botanist John Parkinson (1567–1650), where a depiction of the earthly paradise on the title page is accompanied by the words 'A Garden of all sorts of pleasant flowers which our English ayre will permit to be nursed' (pl.74).

Marguerites, or daisies, were the personal emblem of Lady Margaret Beaufort (1443–1509), mother of the first Tudor monarch, Henry VII. These flowers were often combined with the emblem of the Tudor dynasty, a five-petalled dog rose known as the Tudor rose (pl.75).[11] The double Tudor rose represents the symbolic union of two emblems, the roses of Lancaster and York, and we know from the poetry of Edmund Spenser and Richard Barnfield – and the paintings of Nicholas Hilliard – that five-lobed dog roses were, in the minds of contemporaries, the flowers of Queen Elizabeth.[12]

In addition to floral decoration, ovoid cups might also be adorned with images of beasts – as we can see from two items in the Armoury. On one of these the execution and the treatment of the hunting subjects are markedly English. Unlike the idealized hunting scenes represented on German silver, English silver is dominated by realistic action and naturalistic depictions of animals. The decoration is animated, with unexpected naive details, such as the frog seated on a dragon (pl.76). The Armoury collection includes heraldic cups adorned with lions, unicorns and griffins. One is adorned with

a striding *opinicus*, a typical English heraldic symbol that depicted a composite beast, part-dragon, part-lion; it is surrounded by heavenly orange trees (pl.77).

The Armoury collection also has two cups whose thistle-shaped form was almost exclusively the product of English silversmiths – although the shape was also popular in Portugal (pl.78). This form, which first appeared in the late sixteenth century, was flatter than was to be seen later and, like the Italian *tazza*, used as a wine-bowl. There are eight known globular cups produced using the diamond faceting technique between 1604 and 1615.[13] The spread of diamond faceting (which imitates the faceting of precious stones) in European silverwork, notably among Dutch and Augsburg silversmiths, was linked to contemporary Venetian glass vessels, mimicking the *vetro de trina* pattern. On English vessels a link with Venetian glass was combined with the traditional heraldic depiction of the thistle (pl.79).[14]

A vessel with a tall baluster stem and loops on the foot made its appearance at the start of the seventeenth century. Two cups of this type in the Armoury, dating from 1605–6 and 1608–9, are the sole examples to survive with their steeple covers intact. Such cups were presented as gifts by livery companies, colleges and various societies as well as diplomatic gifts. Such cups and covers might be displayed on sideboards ranged along walls, or in the middle of tables, and a single cup was often passed around the table for all to drink from during the ceremonial election of a guild leader. Their special significance was emphasized by the shape of their steeple finials – symbols of the power of the Tudor and Stuart dynasties.

Pyramids, associated with majesty and strength, glorified the English ruling dynasty. Such forms occupied a special place in the visual repertoire of the sixteenth and seventeenth century. Small pyramids were frequently part of the decoration of structures used for both secular and religious purposes, adorning the facades of palaces and noble mansions, the interiors of Oxford and Cambridge colleges, church pulpits and tombs.[15] Throughout the seventeenth century, park landscapes developed under Dutch influence, and trees were trimmed into pyramid shapes. Silver pyramids were widespread throughout the last quarter of the sixteenth and first quarter of the seventeenth century, and feature on cups of all kinds, as well as on salts.[16] Three steeple-cups in the Armoury were presented to Tsar Alexei Mikhailovich soon after his coronation in 1645, by the Prior of the Monastery of the Nativity in Vladimir, by Prince Fyodor Ivanovich

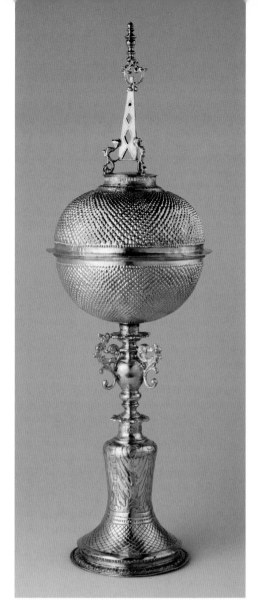

78
Thistle cup, monogrammed: AB (conjoined)
London, England, 1610–11
The Moscow Kremlin Museums MZ-638/1-2

79
Water pot (detail showing an engraved thistle), see pl.105

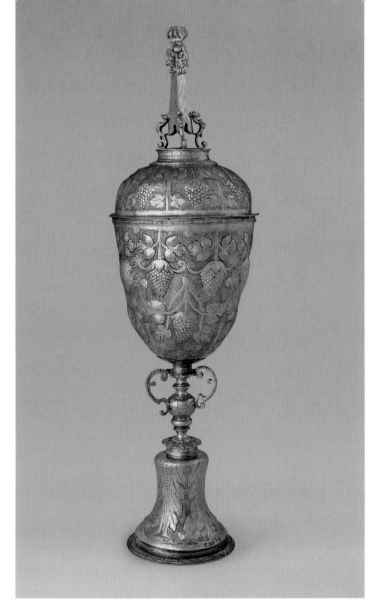

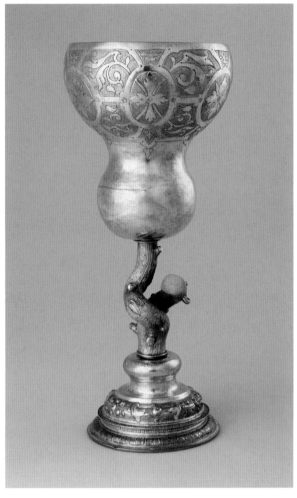

80 (*above left*)
Steeple cup, monogrammed: LB
London, England, 1605–6
The Moscow Kremlin Museums
MZ-629/1-2

81 (*above right*)
Gourd-shaped cup, monogrammed: K
London, England, 1589–90
The Moscow Kremlin Museums
MZ-636

Sheremetev and by Grigory Gavrilovich Pushkin (pl.80). English silversmiths borrowed decorative forms from their Continental counterparts, and yet sometimes interpreted them in a particularly English manner. The bell-shaped and grape cups directly repeat the shapes of German prototypes, but the gourd-shaped cups are clear examples of local masters applying a local, 'national' interpretation to a form introduced from elsewhere.[17] Hollowed gourds had been used as vessels for storing and transporting liquid since ancient times, certainly during the ancient Roman campaigns in Greece and then during the Crusades. Depictions of gourds of all kinds are found in the celebrated book of emblems by Geoffrey Whitney, published in London in 1586, and the natural form of the *Cucurbita lagenaria* (bottle gourd) was repeated by craftsmen when making silver plate. Prints by Albrecht Dürer (1471–1528), Hans Brosamer (1500–1554), Johann (Hans) Sibmacher (d.1611) and other German engravers also feature images of gourd cups.[18] Even though the form, as borrowed from the German masters, represents a specific type of gourd, there are clear differences between German and English work.

The stems of German gourd-shaped cups are usually shaped as a tree trunk, wound about with a vine or a silver spiral. Such tree-like stems are often accompanied by the figure of a woodcutter, or perhaps Adam and Eve.[19] English vessels usually have a stem

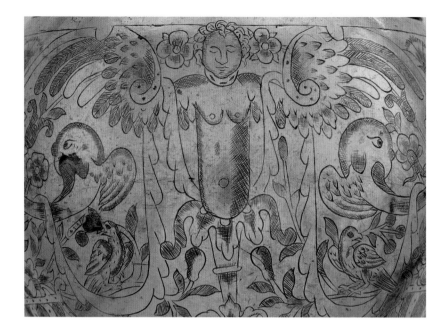

of much heavier proportions, a sturdy stump with shoots, lacking any figures. English
and German cups of similar form are produced with subtle variations, the elegance and
whimsy of the decoration of German cups contrasting with the expressive simplicity
of the English.

In the Armoury there are two different types of gourd cup, each having a distinct
decorative scheme. A standing cup of 1589–90 is decorated with typical English flat-
chased ornament of quatrefoils and multi-petalled rosettes in ovals and circles linked
by strapwork (pl.81). Another cup of similar form employs motifs characteristic of
Netherlandish ornament, the Sirens (pl.82) and tendrils ending in dolphins' heads of the
kind widespread in, for instance, the prints of Theodore de Bry (1528–1598) and Marcus
Gheeraerts the Elder (1530–1590).[20] Decorative vessels changed to reflect developing
tastes and fashions, but also depended on social habits and practice. New types of vessel
appeared during the English Renaissance, among them lavabo sets consisting of an ewer
and basin, richly ornamented and often chased. These contained scented rosewater for
washing hands between courses or after a meal. Without forks, eating food with fingers
required a new vessel to meet the sanitary and elegant habits of a new age. The basins
described in the royal inventory of 1574 are distinguished by a raised centre boss with
the owner's coat of arms in enamel and a decorative (chased or engraved) flat border.[21]

The most common type of ewer was oval in form, with an S-shaped handle and
a mask on the neck beneath the spout. Surviving Italian design drawings show ewers
that imitate classical examples such as the Armoury's ewer of 1652–3 (pl.83). Its bowl
is divided into two unequal parts by a horizontal band, and the decoration combines
Italian Renaissance ornamental motifs (acanthus leaves, shells and mascarons) with typi-
cally English elements (sea creatures in oval medallions). Characteristically, a paired ewer
and dish would have had similar ornament, their imagery usually linked to the sea.

Flagons – commonly called 'pilgrim bottles' as their shape derives from the flasks
carried by pilgrims on their way to the Holy Land – are another characteristic English
vessel that emerged during the Renaissance. Numerous prints, drawings and paintings

83
Ewer, monogrammed: WB
London, England, 1652–3
The Moscow Kremlin Museums
MZ-718

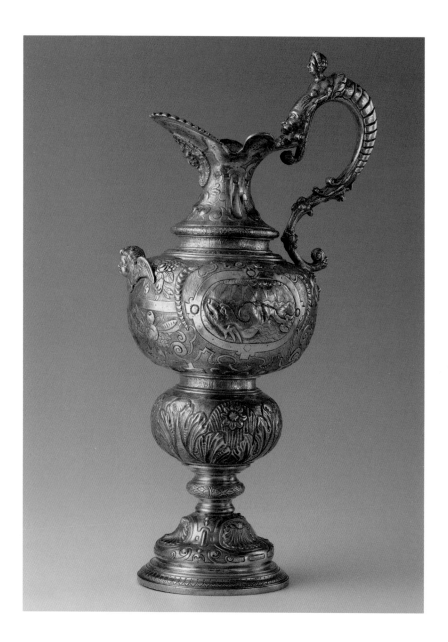

record such flasks, including a series of Bible illustrations by Hans Holbein the Younger. At the end of the sixteenth century globular and oval flasks were produced both in England and in France,[22] and descriptions of flat, oval flasks occur in the inventory of Tudor silver compiled in 1574.[23] English silversmiths also created special miniature flasks to hold aromatic oils and essences.[24]

Six large flasks dating from between 1580 and 1663, measuring 44 to 50 cm high, and densely decorated, are today in the Armoury. With the exception of a Baroque flask of 1663, they form the only known group of plate of the rare conical form with an elongated neck on a high base. They are extremely impressive objects, usually being produced in pairs, which therefore made them perfect diplomatic gifts. They became a favourite commemorative gift over the next hundred years, their popularity continuing up to the nineteenth century.

The decoration of the oldest flask in the collection, dating from 1580–1, includes delicate engraving of birds, military trophies and hanging drapery in the Dutch style, with flowers and sea creatures in rectangles characteristic of work by contemporary English craftsmen (pl.84). A later flask of 1619–20 is adorned with English flat-chased strapwork with clusters of fruit and sea creatures in oval medallions (pl.85) with shells. English decorative art reflected the nation's position as an island kingdom with a powerful navy. English craftsmen made extensive use of water-based motifs: shells, dolphins, sea creatures, mythological Tritons and Hippocamps. All kinds of sea creatures were popular in northern European decorative art during the sixteenth and seventeenth centuries. Sources included a book by the French scholar Ambroise Paré (1510–1590), called *Des monstres et prodiges*, one chapter of which was devoted to sea monsters.[25] All kinds of monsters also featured in the works of the English cleric Edward Topsell: *The Historie of Foure-footed Beastes* (1607) and *The Historie of Serpents* (1608).[26]

Most of the images of sea monsters and fish on English silver were derived from Netherlandish prints: the dolphins on flasks and livery pots were taken from prints by Erasmus Hornick (active 1565–83) or Adriaen Collaert (1560–1618). Frequent use was made of motifs from decorative frames surrounding engraved compositions including marine charts and maps, which were rich in representations of sea fauna: maps issued by Christopher Saxton in 1583, for instance, which feature ships, dolphins, barrel-shaped buoys and monstrous fish splashing in the waves. Dolphins swimming under

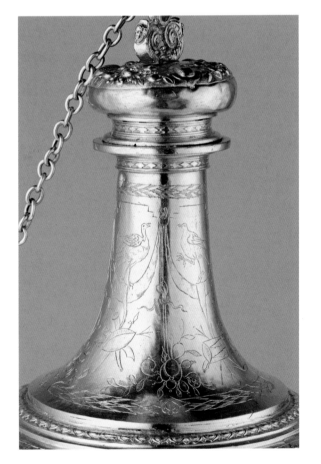

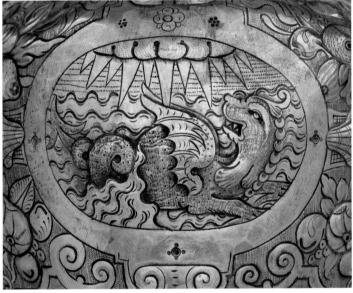

84 (*left*)
Flask (detail showing engraved birds and military trophies), see pl.102)

85 (*above*)
Standing cup (detail showing a sea creature), see pl.115

86
Salt, monogrammed: AS
London, England, 1594–5
The Moscow Kremlin Museums
MZ-651/1-2

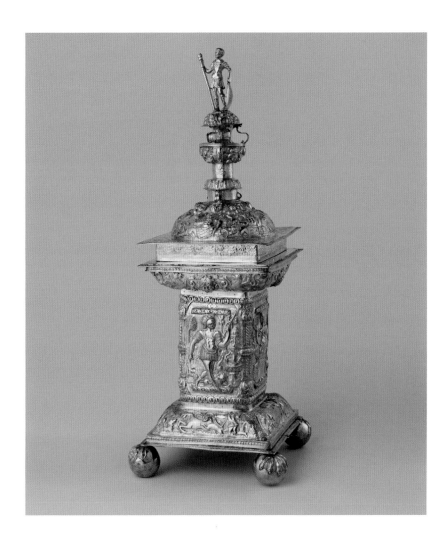

and over sea waves frequently recur in the decoration of English silver of the first half of the seventeenth century, and adorn one of the Armoury flasks in the exhibition (pl.108) and the spectacular basin made for Charles I by Christiaen van Vianen.

In addition to the ovoid and globular (thistle) cups, font-shaped bowls and high-necked flasks, the large standing saltcellar was a characteristically English vessel. English silversmiths produced a range of original salts during the sixteenth and seventeenth centuries: salt itself was rare and expensive and the silver vessels used to hold it were richly prized.[27] There were books on the education of children that carefully set out the rules for using the condiment.[28] The position of the salt in the table setting signified an important place, a particular symbol of the wealth and status of the host, and thus played an important social function. Such salts were perceived as ceremonial pieces, traditionally used in London's livery companies, at the colleges of Oxford and Cambridge, or featuring in lists of royal gifts. By the middle of the sixteenth century two clearly defined kinds of large pillar-like salts were common, one cylindrical, the other having four straight sides. Both are represented in the Armoury's collection of English silver.

The square salt is a symbol of Elizabethan culture (pl.86). It reflects contemporary prints, drawings, woodcarvings and textiles, and even embraces literary and theatrical

themes. Elements of Netherlandish ornament (such as snails on suspended draperies) recur in the engraving; the proportions of the figures are based on models carved in wood; the hunting scenes are similar to those found in contemporary tapestry; depictions of gods recall costumed characters from sixteenth-century pageants. Such rich iconography contributes to the spectacular effect. In contrast, the restrained simplicity of the smooth cylinder form (pl.87) is dominated by its polished metal surface, accentuated by the steeple cover, its profiles and grotesque loops.

The Armoury display of English silver includes different kinds of jug and pot, a considerable number of the 'bellied' type, with the spherical body and S-shaped handle borrowed from German stoneware. Such silver vessels, with their very low base, appeared in England in around 1555. At the start of the seventeenth century the form of these vessels changed, their stems becoming taller and smoother, and their covers more convex; the overall dimensions of the vessel noticeably increased. Decorated ewers illustrate another of the main principles guiding the disposition of ornament in the work of English craftsmen: a symmetrical geometric framework constructed of strapwork and then filled with all kinds of images – dragons, sea creatures, shells, daisies and Tudor roses.

A group of unique items – among them two pairs of large water pots dating from 1604–5 and 1615–16 and a pair of huge leopard ewers of 1600–1 – have come to symbolize the Kremlin Armoury collection (pls 105, 113 and 104). United by their common provenance, each of these outstanding examples of English silver once formed part of the English royal treasury, and is described in the list of plate forming the 'Great Guilt Cubberd of Estate' sold to the royal jeweller John Acton in 1626. The earlier pair of water pots and the leopard ewers are listed with 82 other items, which had a combined weight of 20,011 troy ounces (622.4 kg): 'Two watter-pots gilt, chased in flames, with snake handles, per oz. 732 oz.' and 'Two leopards gilt and enamelled, with chaines, per oz. 1184.'[29] The same water pots are mentioned in an earlier document of 1604–7, a list of plate received by Sir Edward Carey, Master of the Jewel House, from the King's Goldsmith, John Williams, as a replacement for plate presented to the Constable of Castile by James I in 1604. There they are listed as 'Twoo Water pottes of silver guilte chased wth flames of fier and bodies of Roses and thistles, the handles like snakes, the Spoutes like dragons winged, poiz. 733 oz.'[30]

The archive of the Treasury Office for 4 May 1629, records that the pairs of water pots and the leopard ewers were delivered to Russia by Fabian Smith (known in Russian sources as Fabian/Fabin Ulyanov, pl.88), the agent of the Muscovy Company, for Tsar Mikhail Romanov in 1629:

> On that same day by personal decree of the sovereign tsar and grand duke Mikhail Fyodorovich of all Russia taken into the sovereign's treasury to the Treasury Court from the English merchant from Fabian Ul'yanov silver vessels: 2 leopards silver gilded standing on their back legs on their haunches, pressing their tails under themselves, heads screwed on, in their paws fanciful shields, with chains of silver, gold, chain-mail, one weighing one pood 34 pounds 72 *zolotniki* [around 30.6 kg], the other weighing one pood 31 pounds [29 kg], 4 ewers, silver, gilded, forming one with their covers, one weighing 28 pounds 21 *zolotniki* [11.5 kg], the other 27 pounds 72 *zolotniki* [11.36 kg], the third weighing 20 pounds 51 *zolotniki* [8.4 kg], the fourth weighing 20 pounds 24 *zolotniki* [8.30 kg].[31]

The leopard ewers are also listed in the 1635 inventory of the treasury of Mikhail Romanov, while the water pots are included in the Armoury Inventory of 1640.[32]

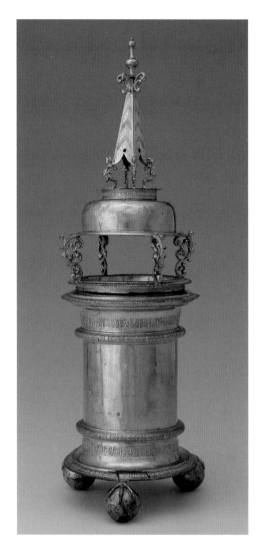

87
Salt
Robert Blackwell
London, England, 1611–12
The Moscow Kremlin Museums
MZ-652

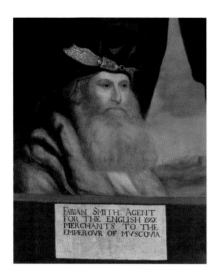

88 (*above*)
Unknown Artist
Fabian Smith
Oil on canvas, after 1637
Guildhall Art Gallery 1725

89 (*right*)
Water pot (detail of embossed decoration),
see pl.113

No other comparable English water pots on this scale are known to survive. The earlier pair (pl.105) measure 64 cm tall, the later pair (pl.113) 62 cm. Both share common features – identical ovoid bowls, almost cylindrical necks, spouts in the form of a dragon's head with wings spread wide, and complex handles in the form of a snake with open jaws curled into a ring. Contrasting decoration distinguishes the two pairs of water pots. That on the earlier (1604–5) pair is typically English, consisting of Tudor roses and thistles, while the base, upper part of the bowl and lid are chased with tongues of flame framed by woven ornament characteristic of late Tudor silver. On the later (1615–16) pair the German ornamental tradition, typified by dramatic tension and pulsating form, is embodied in the sirens with wings spread wide, the wealth of applied detail (featuring lizards and frogs) and the density of decoration (pl.89).

The Baroque period

Among the later English silver in the Armoury is a group made in 1663 in the Baroque style, which include two cups, a flask, a perfuming pot, six '*razsolnik*' bowls, two tankards and a pair of candlesticks, all brought as gifts for Tsar Alexei Mikhailovich from Charles II via the embassy of Charles Howard, 1st Earl of Carlisle (see pl.68), which arrived in Russia in 1664. All of them, with the sole exception of the perfuming pot, are adorned with flowers, a leading trend in mid-seventeenth-century silver decoration.

European silver of the 1650s and 1660s reflected the spread of the Dutch '*Blumenmode*' (fashion for flowers). In England objects were covered with large-scale, naturalistically treated floral ornament, mainly featuring double tulips, poppies and leaves. This dense

decoration, in which contours of different elements flow from one into the other, creates an illusion of movement that is ideally suited to the decoration of English silver. This new approach makes the individual elements seem larger, and emphasizes the dominant feature of Baroque silver: the whole surface is covered with similar patterns that link the different parts, in contrast to the style of decoration found on Renaissance objects, where it is divided into different zones, each with its own specific kind of ornament. A specifically English feature in this trend for flower decoration lay in the inclusion of a variety of animals (pl.90).

Such works are remarkable for their impressive size: the cups are 73 cm tall. Unlike the ovoid cups of the earlier seventeenth century, which have ornamental balusters and loops, the cups of the later Baroque period have cylindrical bowls and smooth or pounced (or punched) baluster stems. A favourite technique was chasing in high relief; the contrast of chased and burnished surfaces creates effects of light and shade that emphasize the silver's sculptural potential. This is seen clearly in a standing cup with a smooth stem and conical cover, where all remaining surfaces are decorated with chasing (pl.111). The same principle is applied to a fruit dish (pl.123). With its round, flat form the fruit dish is comparable to the German and Dutch platters used, during the second half of the seventeenth century, for serving particular delicacies such as oysters, as well as fruit, which were offered with a glass of wine or lemonade. They were placed on tables or passed round to guests; here the specifically English feature is the broad tall stem. In England such dishes were often supplied as stands for matching porringers (a two-handled bowl). These stands were often used to serve fruit, as the Armoury dish evidently was. This example is adorned with animals harmoniously absorbed within the floral ornament, the whole united by a circular progression of animal poses and winding floral stems that are in keeping with the vessel's form.

The English Baroque silver in the Armoury includes one unique piece: the perfuming pot (pl.122), described in the original records as 'curiously enchased and gilt'.[33] It makes magnificent use of *Knorpelwerk* (from the German for 'earlobe') – also known

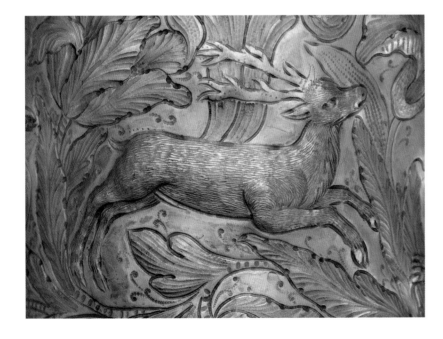

90
Standing cup (detail showing a deer), see pl.126

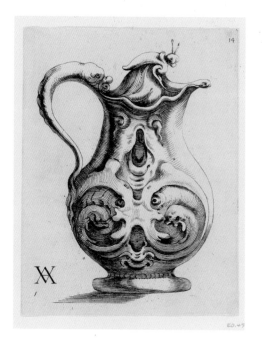

91 (*above left*)
Engraved design by ADAM VAN VIANEN,
*c.*1620. Published in *Modelli artificiosi di
vasi diversi d'argento*, Utrecht, 1646–52
V&A: E.1093–1889

92 (*above right*)
Perfuming pot and stand (detail showing
a grotesque mask), see pl.122

as the auricular style. This type of decoration was established in England by the mid-seventeenth century. It was Dutch master Christiaen van Vianen (1600/5–1667), employed at the court of Charles I, who was responsible for introducing the style in the 1630s. In around 1650 he published *Modelles Artificiels*, an album of engravings based on his own works and those of his father, Adam van Vianen, which illustrated a variety of silver vessels and *Knorpelwerk* decoration, intended as models for others to use (pl.91).[34]

Knorpelwerk is an abstract form of ornament, a striking feature of European Baroque silver, which incorporates smoothly flowing outlines, grotesque masks and animal faces, with curves that resemble the human ear. Extremely sculptural, the style dominates the decoration of the Armoury perfuming pot, with flowing grotesque masks on the sides and cover of the two-handled bowl (pl.92), stylized dolphin feet with smoothly flowing lines, and openwork ornament of stars and circles (pl.122). This latter feature was extremely rare in seventeenth-century English silverwork, being more usually linked with Hispano-Portuguese silver, and coming into its own in England only considerably later, on Rococo silver. The unique and elegant decoration of the perfuming pot reminds us how rare and important is the English silver preserved in the Armoury collection.

The Armoury collection has great historical value as well as huge artistic significance. Its historical value lies in the way it was formed, as English silver was not widely traded in Europe during the period, arriving on the Continent mainly as gifts. The sixteenth century marked the beginning of English diplomatic and trading relations with the Moscow Principality. Many of the pieces shown here arrived in Moscow as diplomatic gifts presented by the first English ambassadors; others were purchased specially by merchants and agents for the tsar's treasury. From the very beginning the collection has been treasured and kept with the utmost care and respect.

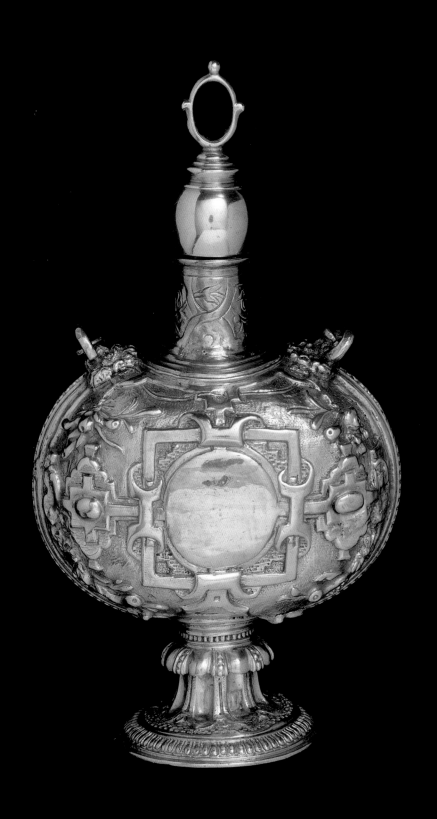

93 (*opposite*)
Casting bottle
England, *c.*1540–50
V&A: 451–1865

94 (*below left*)
Snuffers
England, 1547–53
V&A: M.837–1928

95 (*below right*)
Earthenware pot
England, *c.*1550–60
V&A: M.351–1910

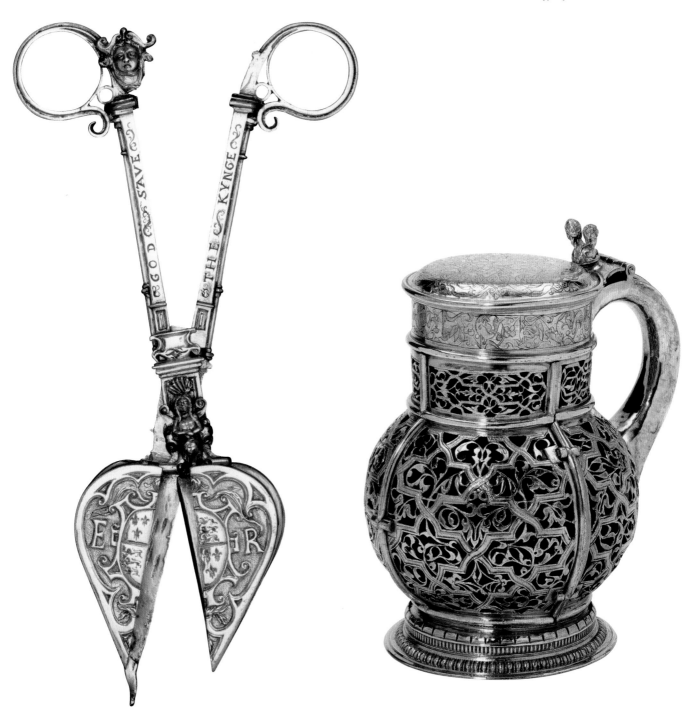

96 (*with view from above*)
Font-shaped cup
London, England, 1557–8
The Moscow Kremlin Museums
MZ-650

97 (*below left*)
The Mostyn salt
London, England, 1563–4
V&A: 147–1886

98 (*below right*)
The Mostyn caster
London, England, 1563–4
V&A: 150–1886

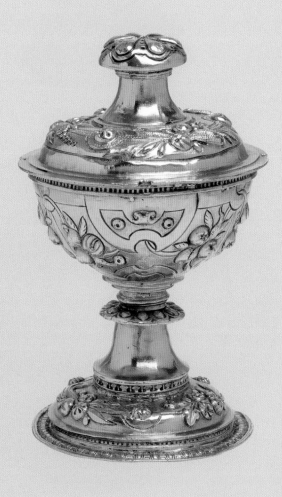

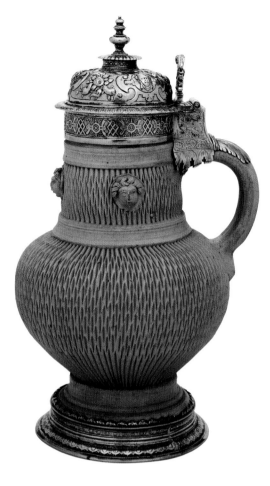

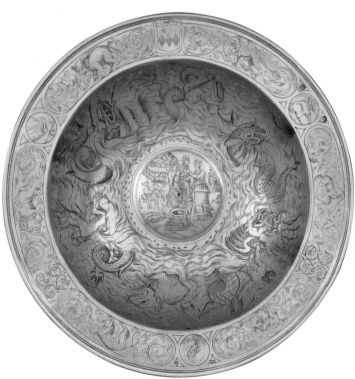

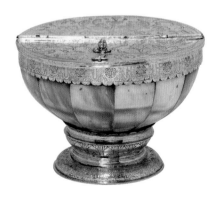

99 (*left*)
Stoneware pot
London, England, *c*.1570
V&A: 130–1908

100 (*below left*)
Spice dish
Roger Flynt
London, England, 1573–4
V&A: M.55c–1946

101 (*below*)
Casket
London, England, *c*.1600
V&A: M.245–1924

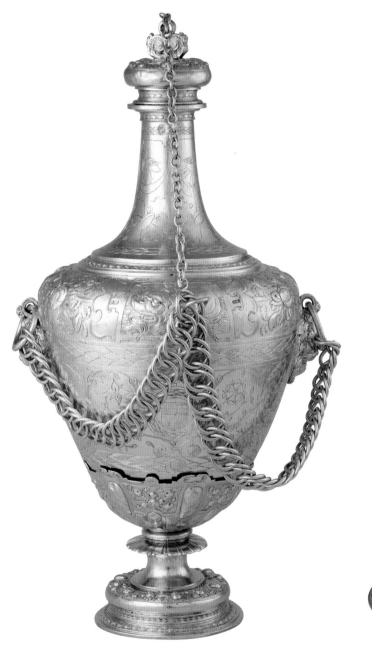

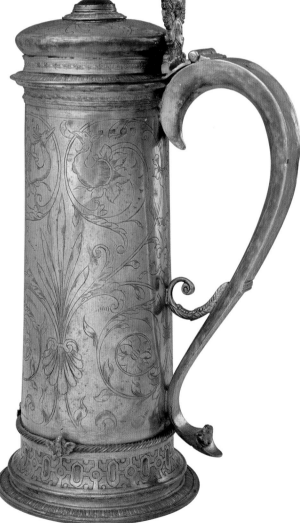

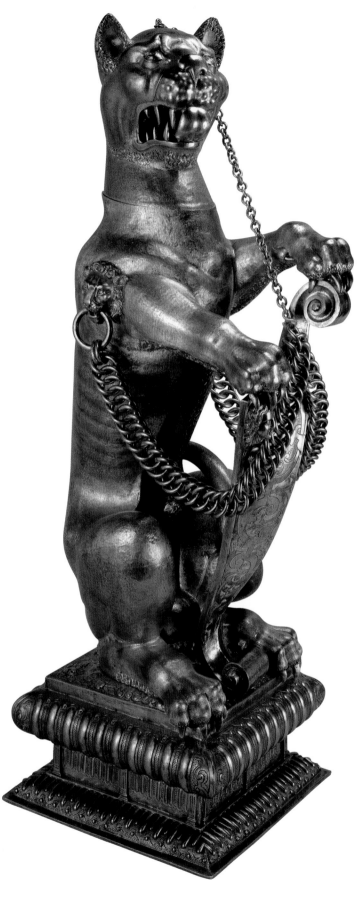

104
Leopard ewer (one of a pair)
London, England, 1600–1
The Moscow Kremlin Museums
MZ-693

105 (*opposite, left*)
Water pot
London, England, 1604–5
The Moscow Kremlin Museums
MZ-642

106 (*opposite, right*)
Livery pot
London, England, 1604–5
The Moscow Kremlin Museums
MZ-645

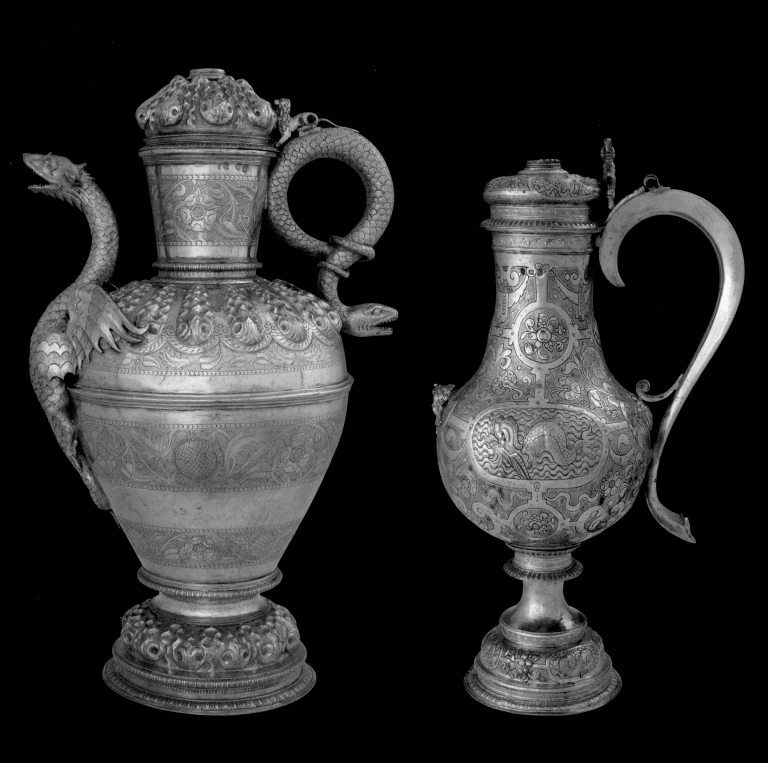

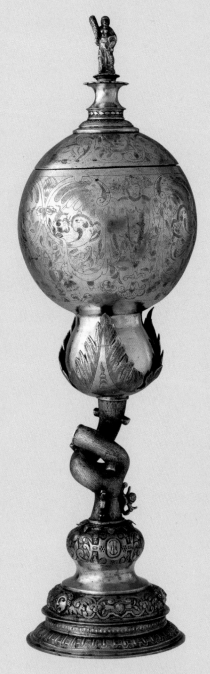

107 (*below left*)
Gourd-shaped cup
London, England, 1604–5
The Moscow Kremlin Museums
MZ-634/1-2

108 (*below right*)
Large flask
London, England, 1606–7
The Moscow Kremlin Museums
MZ-658

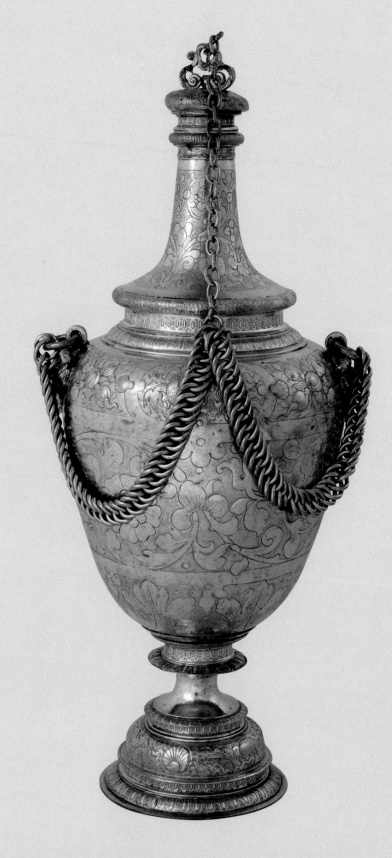

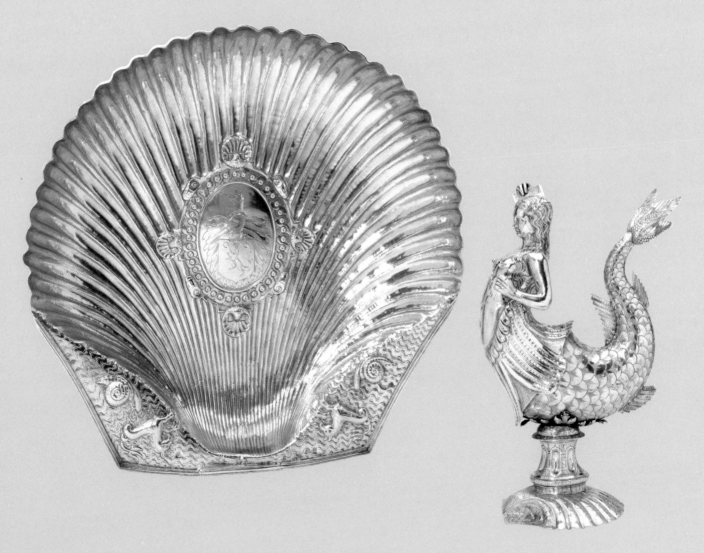

110 (*below left*)
The TvL cup
Possibly Thierry Dierick Luckemans
London, England, 1611–12
V&A: 5964–1859

111 (*below right*)
The Warwick cup
Thomas Francis
London, England, 1617–18
The Moscow Kremlin Museums
MZ-623

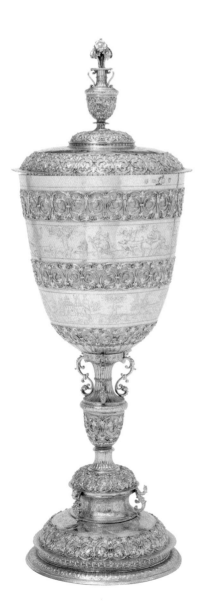

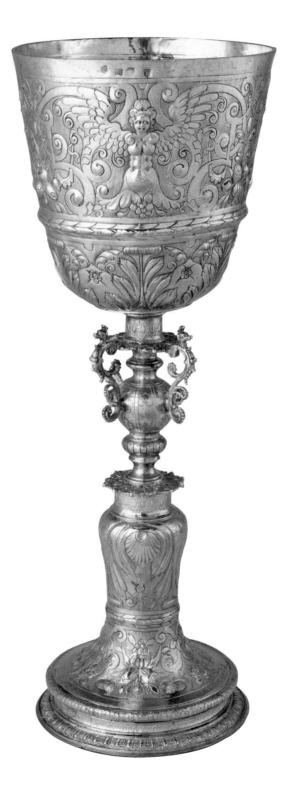

112 (*below left*)
Livery pot
London, England, 1613–14
The Moscow Kremlin Museums
MZ-699

113 (*below right*)
Water pot
Richard Blackwell I
London, England, 1615–16
The Moscow Kremlin Museums
MZ-640

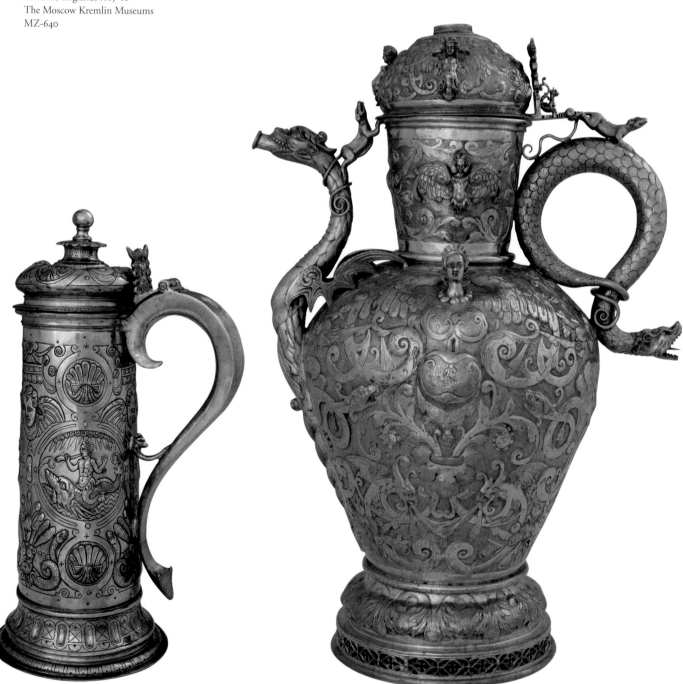

114 (*below left*)
Standing cup
Probably Thomas Cheston
London, England, 1613–14
The Moscow Kremlin Museums
MZ-619

115
Flask (*below right*)
London, England, 1619–20
The Moscow Kremlin Museums
MZ-654

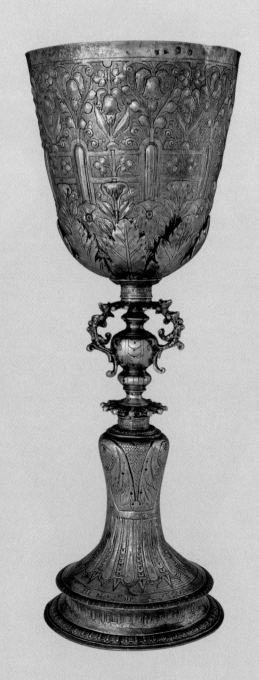

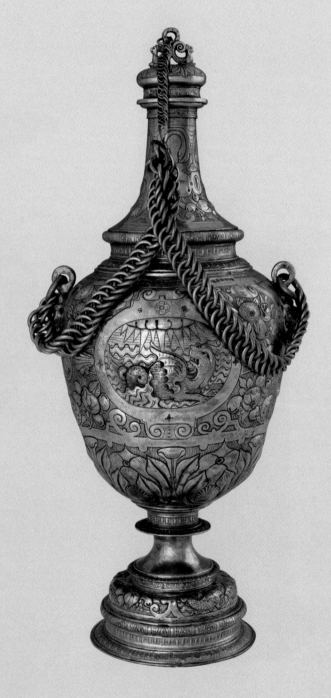

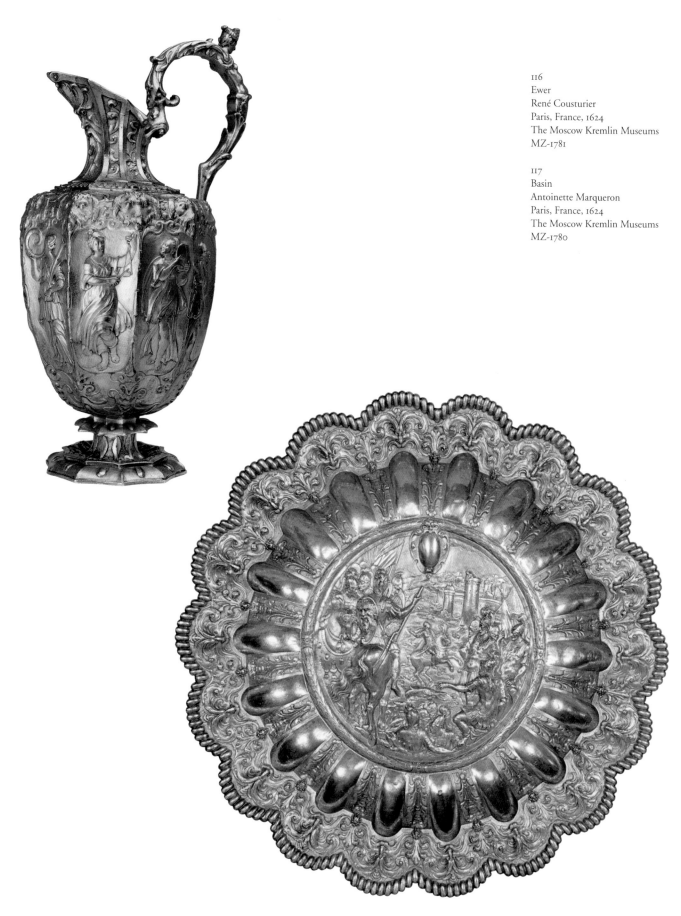

116
Ewer
René Cousturier
Paris, France, 1624
The Moscow Kremlin Museums
MZ-1781

117
Basin
Antoinette Marqueron
Paris, France, 1624
The Moscow Kremlin Museums
MZ-1780

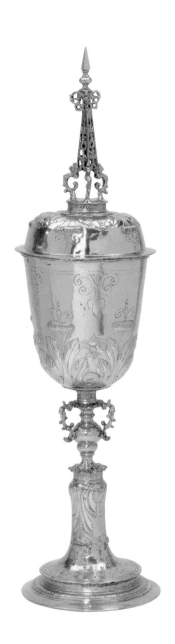

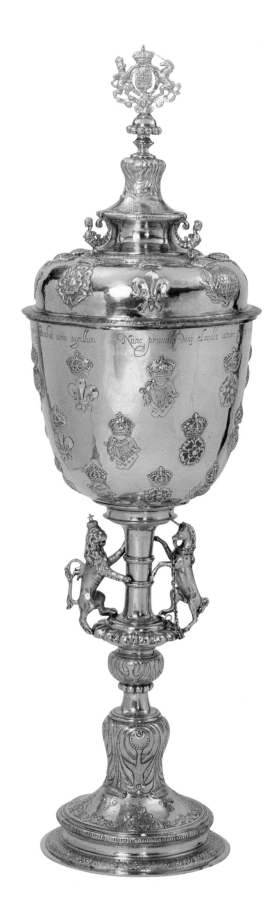

118 (*below*)
The Richard Chester covered cup
Thomas Flynt
London, England, 1625–6
V&A: M.244–1924

119 (*right*)
The Lord Keeper's seal cup
London, England, 1626–7
V&A: M.59–1993

120 (*opposite*)
The Dolphin basin
Christiaen van Vianen
London, England, 1635
V&A: M.1–1918

121 (*opposite, top*)
Lantern clock
David Bouquet
London, England, *c*.1650
(the gong and finial are later restorations)
V&A: M.1139–1926

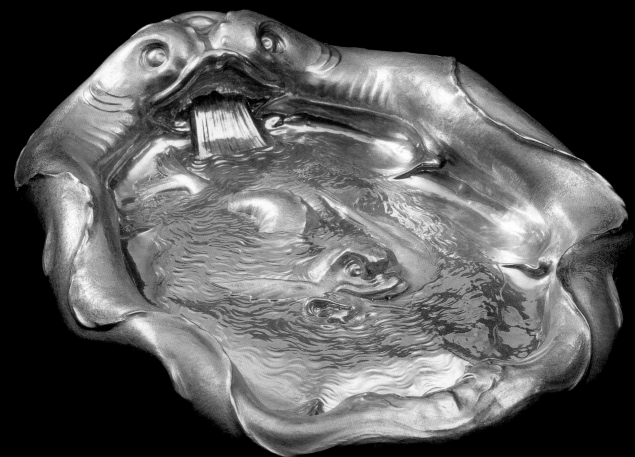

Perfuming pot and stand
Probably John Neave
London, England, *c.*1663
The Moscow Kremlin Museums
MZ-695/1-4

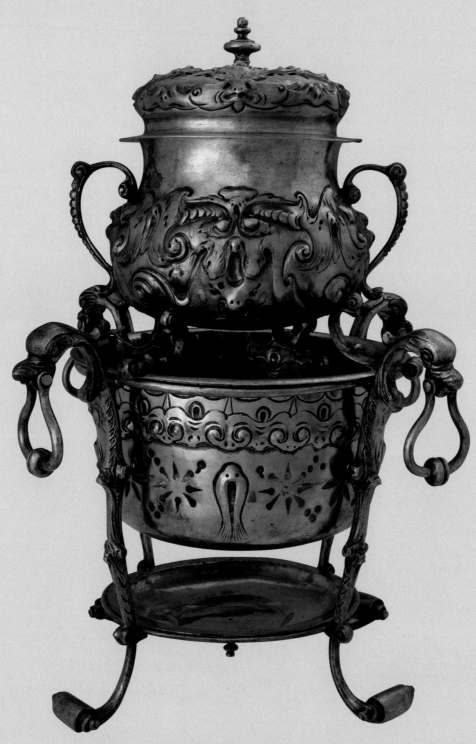

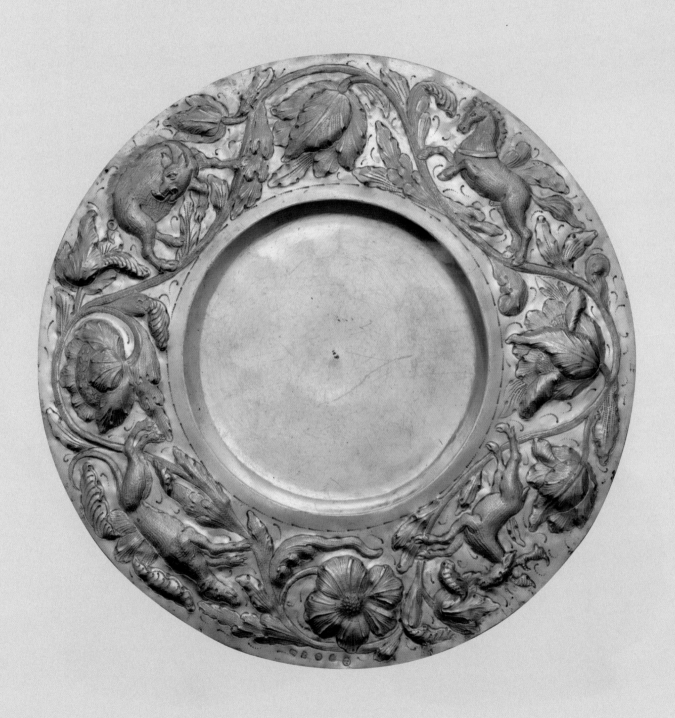

124 (*below left*)
Flask
London, England, *c*.1663
The Moscow Kremlin Museums
MZ-659

125 (*below right*)
Livery pot
Henry Greenway
London, England, 1663
The Moscow Kremlin Museums
MZ-660

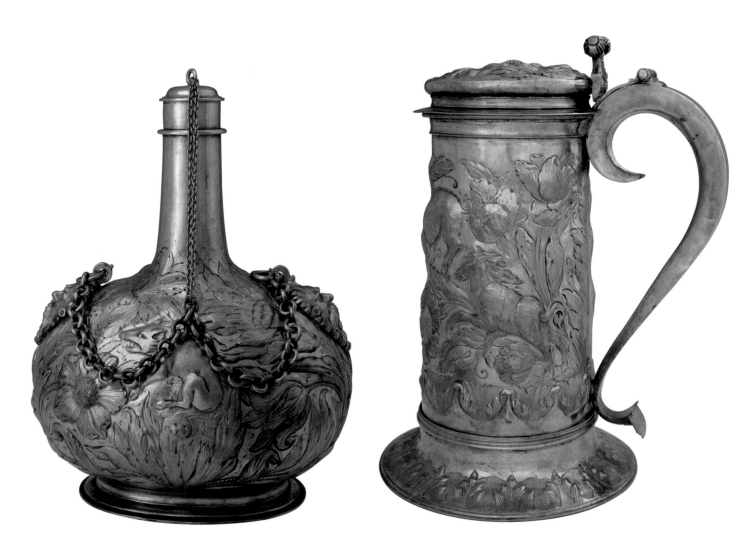

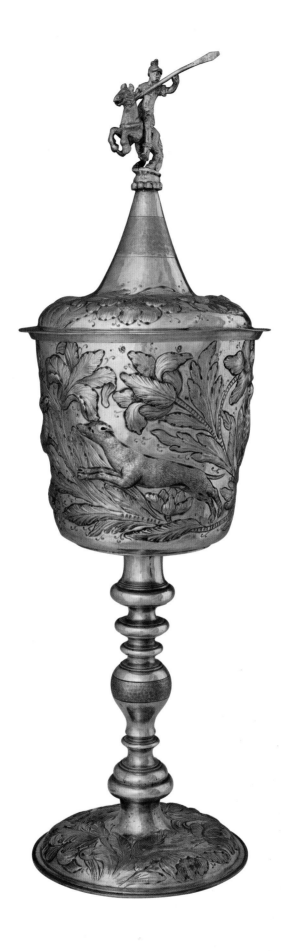

126
Standing cup
Francis Leake
London, England, *c.*1663
The Moscow Kremlin Museums
MZ-621/1-2

Angus Patterson

ARMS AND ARMOUR

In 1514 King Henry VIII received a diplomatic gift from Emperor Maximilian I in the form of a magnificent armour made by Konrad Seusenhofer, Maximilian's court armourer at Innsbruck. All that is left of this armour is the famous 'horned helmet' (pl.127) that has become the emblem of the British Royal Armouries.[1]

This gift had a profound effect on Henry. He understood that martial prowess, both on horseback and on foot, was a key attribute of a Renaissance king, complementing his roles as diplomat, law-maker, patron of the arts, builder, musician and poet. Good armour not only enabled him to develop his skill as a fighter, but also to communicate his grandeur and authority.

In Tudor and Stuart England, representations of great events in paintings, tapestries and sculpture suggest that arms and armour played a key role in both visual and political culture. The English court employed the finest armourers, artists, goldsmiths and engravers to make armour and weapons simultaneously works of art, death, celebration, love, loyalty and triumph. Where the skills were not available locally the court imported them from abroad.

127 (*opposite*)
Field armour of Sir Henry Lee (detail), see pl.139

128
The 'horned helmet', an armet once part of an armour given to Henry VIII by Emperor Maximilian I, made by Konrad Seusenhofer.
Innsbruck, Austria, 1512–14
The Royal Armouries IV.22

The Greenwich Armoury

Maximilian's gift prompted Henry to develop his plans for his own royal armoury to rival the great workshops of Germany and Italy. Initially he had invited armourers from Brussels and Milan to produce armour for his own use and for diplomatic gifts. The first 'Almains', the German armourers that Henry patronized, began work in 1515 in makeshift accommodation in Greenwich.[2]

A site for a purpose-built workshop was chosen close to Greenwich Palace and near the Thames to take advantage of its supply of water. For four years, while the workshop was being built, the armourers hired a mill upriver in Southwark, moving back to permanent buildings in Greenwich in 1520.

The workshop was deliberately situated outside the City of London to reduce tension within the local guild. A company of helmers that had protected the armour trade in London since 1347 became established as the Armourers' Company in 1453. That guild survives today as The Worshipful Company of Armourers and Brasiers. The influx of foreign craftsmen who came to London to work for Henry's court led to riots by native apprentices in 1516 and 1517.[3]

The first master of the Greenwich armoury was Martin van Royne. He led a staff of around 22 that included hammermen who worked the armour into shape, millmen who burnished the metal, locksmiths who assembled and articulated the armour, and labourers, apprentices and administrators. The armoury also employed a mercury gilder, who was paid less than everyone else despite the health hazards of his work. The first generation of armourers came from overseas, but they were gradually joined by English armourers who became 'Almains' by association. They were organized into two main workshops, one devoted exclusively to the King's armour and the other to serve licensed courtiers.[4]

The Greenwich armoury operated for over a century. Two great eras mark its history. For the first 30 years, production focused on making armour for the King and a very few privileged noblemen. This outward-looking period saw Henry establish his reputation as a monarch of international standing. Later in the century, during Elizabeth I's reign, the armouries concentrated on producing some of the most lavishly decorated armour for a circle of courtiers who were vying for the Queen's favour.

Henry's armours

Henry invited scholars, artists, goldsmiths and sculptors to his court, where they created a powerful aesthetic that has become the signature of his reign. Some of the most overbearing expressions of this style are his surviving armours. Although designed for use, their appearance was just as important. At over 6 feet tall, beautifully made and fashionably decorated, they enhanced Henry's physical stature, making it synonymous with his strength and authority as a ruler.

Like the best clothing, good armour was made to measure: Henry VIII was measured in person for his armour and his armourer consulted his tailor.[5] His early armours demonstrate his athletic prowess, supporting the fact that he participated keenly in jousts and foot combat. His famous silvered and engraved armour (Royal Armouries, no. II.5, VI.1-5) was made between 1514 and 1517, although possibly not at Greenwich. The armour is decorated with scenes featuring Saint George and Saint Barbara, and lovers' knots linking the letters 'H' and 'K', standing for Henry and his first wife Katherine of Aragon, whom he married in 1509. This armour and Henry's equally

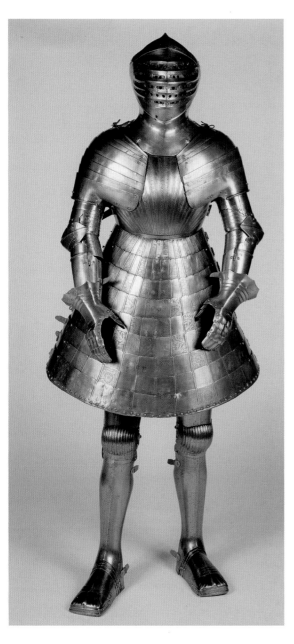

129
Henry VIII's Tonlet armour, made
for his combats at the Field of
Cloth of Gold. Royal Armouries,
Greenwich, England, c.1520
The Royal Armouries II.7

well-known Tonlet Armour (pl.129) – which was designed for fighting at the barriers (combat between two opponents separated by a low fence) and was customized from stock items for wearing at the Field of Cloth of Gold in 1520 – reveal that Henry's waist then measured around 36 inches.[6]

After 1520, Henry's armour, while still battle ready, became more representative than practical. A hint at his expanding girth can be seen in the magnificent 'newe harness all gilte of a strange fashion' which he wore for jousting on Shrove Tuesday in 1527 (Metropolitan Museum of Art, New York, no. 19.131.1,2). This Greenwich armour is etched and gilt with motifs that include the Labours of Hercules, mermaids, merknights, elephants and other animals. Some of the decoration was based on designs by Hans Holbein.[7]

Late in life Henry commissioned two armours that have helped foster his reputation as a magnificent and intimidating king. The great 1540 garniture (Royal Armouries, no. II.8, 6.13) may have been made for the King to wear at a tournament that took place from 1 to 5 May that year and is itemized in a 1547 inventory as 'Complete harness parcell graven and gilte with all manner of peces of advantage for the felde Tilte Turney and fote'.[8] The decoration is in part by Holbein, the etched tritons appearing in a drawing by the artist preserved in his home town of Basel, Switzerland.

The other armour of this period (pl.130) may have been commissioned to celebrate Henry's marriage to Anne of Cleves on 6 January 1540.[9] Both these armours lend solidity to Henry's portly figure, which by this time had a 54-inch waist. Although the armours were designed to work, it is likely that they were made principally for show. They evoke Henry VIII as history remembers him – proud, invincible and threatening.

Greenwich style

Armour style, like clothing style, was international. The armourers in Greenwich followed the prevailing fashions from other parts of Europe, especially southern Germany. While rounded visors and separate waist lames (articulated metal strips) are seen as characteristic of the Greenwich workshop, the distinguishing features of its armour are visible only on the inside. The Almains used leather strapping to secure the articulations of shoulder and leg defences rather than the more common rivets.[10]

Henry VIII's armours express the early sixteenth-century fashion for a burly, overblown armour that proclaims a powerful upper body, an extreme departure from the elongated, sinuous grace of the late fifteenth-century Gothic armours of Maximilian's court. The pinched waistlines, broad hips, square shoulders and straight necklines that characterize the armour reflect the prevailing styles of both men's and women's clothing. This change from a vertical line to a more horizontal line was expressed most vividly in the shoes. The long, pointed 'pikes' and 'poulaines' popular 20 years earlier gave way to an equally impractical square-toed shoe that might be almost as wide as it was long. In England this fashion survived a long time. Under Mary Tudor a sumptuary law to regulate the expense people devoted to their attire stated that 'No man should wear his shoes above 6 inches square at the toe.'[11] Wide shoes were a privilege of the wealthy, and almost all of Henry's surviving armours have sabatons (foot coverings) in this style.

For the first few decades of its operation, the Greenwich armoury imported good-quality medium carbon steel, but the workshop's knowledge about the properties of metal was not sufficiently advanced for it to harden the steel effectively. Between 1544 and 1567, under the mastership of Erasmus Kirkenar, the challenge of hardening steel

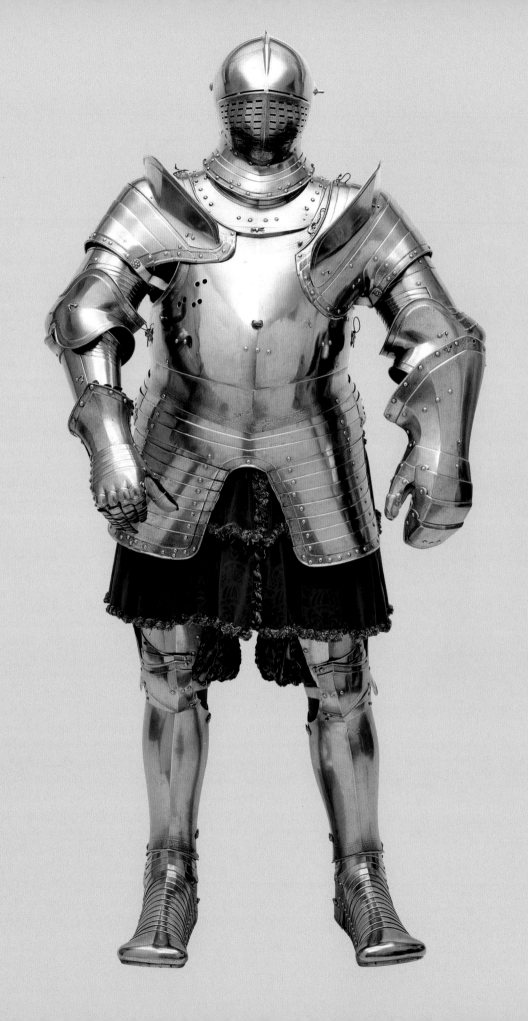

130
Armour of King Henry VIII,
made under the direction
of Erasmus Kirkenar
Royal Armouries, Greenwich,
England, *c.*1539
The Royal Collection
RCIN 72834

without warping was solved by slack quenching (leaving the steel to cool briefly after heating before immersing it in water). Kirkenar's experiments may have encouraged the production of *animes*, the body armour constructed of horizontally articulated plates that is often associated with Greenwich, as the cooling of smaller pieces was easier to control.[12] However, as mid-century portraits of English courtiers show them wearing horizontally banded doublets, *animes* also reflected contemporary fashionable dress.[13]

By the time John Kelte succeeded Kirkenar in 1567 the workshop's technological expertise was comparable to any in Europe. Kelte had started working at Greenwich in 1539 to assist with one of Henry's 1540 armours. His appointment transformed production. As the first English master workman, he was also a freeman of the Armourers' Company. Kelte's influence helped Kirkenar and several other Almain armourers to be sworn into the Company in 1561, 'being well content to be brothers with us'.[14] Thereafter, relations with the Armourers' Company were more cordial.

If the structural quality of Greenwich armour had taken a little time to achieve, its decoration was always of the highest quality. The most common technique was acid etching, usually handed to specialists outside the workshop. It is often referred to in contemporary descriptions as 'graving' but engraved armour is rare. In 1539 Francis Queblaunche, a 'Gilter and Graver of the Kinges Harnes' was paid 30 shillings a month to etch designs by Holbein into Henry's armour.[15]

The etching technique creates a characteristic two-dimensional surface decoration that contrasts with the plainer areas of polished metal. An already formed object is coated with an acid-resistant substance such as wax, into which a pattern is incised, exposing the metal underneath. The metal is then immersed in a solution of hydrochloric or nitric acid and water until its exposed areas have been eaten away. The resist is then removed to reveal the pattern. Gilding or blackening might be added to accentuate the design. The technique creates a shallow relief, making possible a high level of decoration without compromising the structural integrity of the metal. Aesthetically, etching on metal resembles embroidery on clothing.

Under the mastership of Jacob Halder, between 1576 and 1608, a combination of high-quality armour construction and the prevailing fashion for outrageously shaped and coloured clothing brought Greenwich production to its full flowering. Some of the most magnificently forged, etched, gilt and blued armours ever made were produced by the banks of the Thames.

The Jacob Album

Jacob Halder, probably originally from Augsburg or Landshut, was first recorded at the Greenwich workshop in 1558. The importance of his contribution to the history of English armour cannot be overemphasized. He oversaw the workshop at the peak of its creativity and left us a record of production that is the key to understanding the place of armour at the Elizabethan court.

The *Jacob Album* (pls 133, 134 and 135) consists of 29 designs for armour on 56 sheets, dating from around 1557 to 1587. The first two in the series are marked 'MR' for Queen Mary; the rest, produced during Elizabeth's reign, are marked 'ER'. Each design shows a figure in cavalry armour, posed to display as much of the armour as possible, with the sheet opposite showing pieces that can be exchanged in order to convert the armour for lighter cavalry, infantry, tilting or tournament use. The stencilled designs, hand-coloured and annotated by Halder with the name of the person

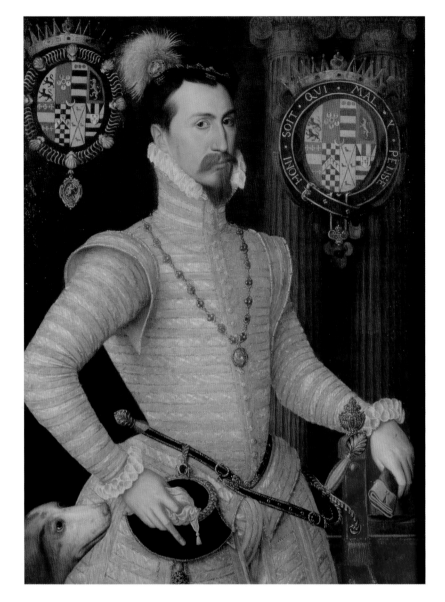

131
Unknown Anglo-
Netherlandish Artist
Robert Dudley, 1st Earl of Leicester
Oil on panel, *c.*1564
Waddesdon Manor,
The Rothschild Collection

who commissioned them, were probably working drawings. Several of the armours produced from the drawings survive, some with minor alterations between design and finished product.

We can tell that the album is incomplete as some of the lost drawings have left imprints on the backs of the sheets. Even so, it reads as a directory of the Elizabethan court. Before the album's rediscovery in the late nineteenth century the provenance of many surviving Greenwich armours was unknown. Robert Dudley, 1st Earl of Leicester, had at least two armours from Greenwich. He was known by his rivals as 'the favourite' for his deep emotional ties with the Queen, and by Elizabeth herself as her 'eyes' (pl.131).[16] His roles as Master of the Horse and member of the Privy Council were typical of the powerful influence exerted by Elizabeth's closest courtiers as both politicians and members of the royal household.

The remains of the tiltyard at Kenilworth
Castle, England, the seat of Robert
Dudley, 1st Earl of Leicester, and the scene
of three weeks of jousting, mock battles,
pageantry and hunting during Elizabeth I's
stay in 1575.

133 (*below left*)
Designs for an armour for Robert Dudley,
Earl of Leicester, from the *Jacob Album*
Greenwich, England, *c*.1565
Watercolour on paper
V&A: D.593&A–1894

134 (*below right*)
Designs for an armour for Sir Christopher
Hatton from the *Jacob Album*
Greenwich, England, *c*.1575
Watercolour on paper
V&A: D.600&A–1894

Dudley's entertainment of the Queen at Kenilworth (pl.132) in 1575 is one of the
most famous episodes of her reign. During her three-week stay Dudley held plays,
mock battles, pageants, firework extravaganzas and hunts, all of which expressed politi-
cal messages that highlighted his importance to her.[17]

Dudley's armours shown in the album do not survive (pl.133). On the other hand,
Sir Christopher Hatton had at least three, possibly four, armours included in the album
(pl.134), elements of which survive from all of them (see pls 142 and 143). He first
came to the Queen's attention for his skilful fighting and dancing during tournaments,
earning the roles of Gentleman Pensioner in 1564 and Captain of the Guard in 1572. He
joined the Privy Council in 1577 and within 10 years was appointed Lord Chancellor.
His rise to power left him in debt by £42,000. His lavish commissions of armour,
etched with lovers' knots that symbolize an almost romantic obsession with the Queen,
are typical of his extravagant spending to impress.[18]

The leading patron of the armoury, whose armour is included in the album
(pl.135), was Sir Henry Lee (1533–1611; pl.138). He, too, used his armour to express his
devotion to the Queen. Three armours in the album are ascribed to Lee, one of which,
Halder notes, was imported from 'beyonde see', but decorated and supplemented at
Greenwich. The other two were made entirely at the Greenwich workshops. One sur-
vives almost intact, commissioned by Lee for fighting against the Spanish Armada (see

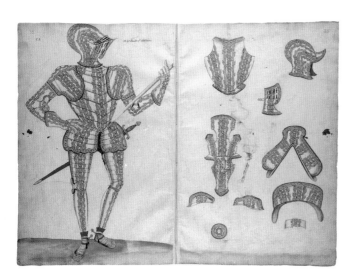

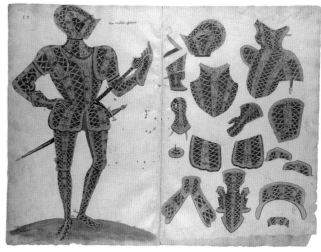

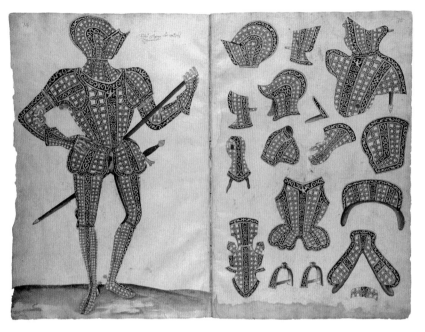

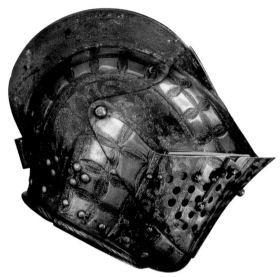

pls 139 and 128). To his frustration, Lee was deployed to guard northern England, away from the action: 'My horses are in one place, my saddelles, furnyture, and armore in an other, and mysellf in the thurde.'[19] Elements of the other one to survive (see pls 136–7), etched and gilded with quatrefoils and strapwork, testify to the magnificence of perhaps the most spectacular design in the album.

Lee held several key appointments in the royal household, including Master of the Royal Armoury between 1578 and 1611. In 1571 he became the Queen's Champion, each year renewing his vow to defend her honour. He established the Accession Day tilts, probably in around 1581, which were costly annual festivals of jousting, poetry, music and feasting, all aimed at glorifying the Queen through performance. Lee is credited with the choreography and scripts for these events. These tournaments, which revived the entertainments staged at Greenwich during the first year of Elizabeth's reign, included the tourney involving Dudley and other knights heading two skirmishing armies. This mock battle was followed by jousting and foot combat, and ended with fireworks and shooting.[20]

These noblemen were the fashion leaders of their day, and their armour was a visible declaration of their role as patrons of the arts and leaders of taste. Elizabeth encouraged competition at court and, as there was no king to upstage, her courtiers could continually attempt to outdo one another. Each might pay up to £500 for a decorated garniture (outfit), for which they required a royal licence.[21]

The *Jacob Album* could not express this extravagance more clearly. The puffed and layered clothing that was fashionable at court is mirrored in the exaggerated forms of the tassets (thigh protectors) and breastplates, and the etching that decorates them. The 1570s was the era of the 'peascod' doublet, which distorted the body with its padded elongated form that protruded over the waistline. The satirist Phillip Stubbes ridiculed the fashion: 'What handsomeness can there be in these doublets which stand on their bellies like, or much bigger than, a man's codpiece … for my part, handsomeness in them I see none and

135 (*above left*)
Designs for an armour for Sir Henry Lee from the *Jacob Album*
Greenwich, England, *c.*1585
Watercolour on paper
V&A: D.604&A–1894

136 (*above*)
Close helmet from an armour of Sir Henry Lee
Greenwich, England, *c.*1585–7
The Royal Armouries IV.43

137 (*below*)
Locking gauntlet from an armour of Sir Henry Lee
Greenwich, England, *c.*1585–7
The Worshipful Company of Armourers and Brasiers

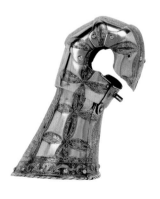

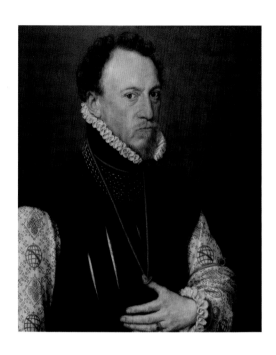

138 (*above right*)
ANTONIS MOR
Portrait of Sir Henry Lee
Oil on panel, 1568
National Portrait Gallery, London
NPG 2095

139 (*right*)
Field armour of Sir Henry Lee
Greenwich, England, 1587–8
The Worshipful Company of
Armourers and Brasiers

140 (*below*)
Falling buffe from a field
armour of Sir Henry Lee
Greenwich, England, 1587–8
The Worshipful Company of
Armourers and Brasiers

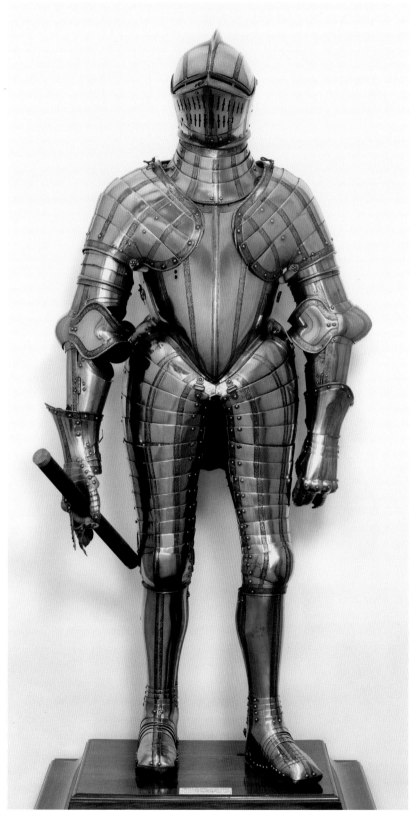

much less profit. And to be plain, I never saw any wear them but I am supposed him to be a man inclined to gourmandice, gluttonie and such like.'[22] Serving no obvious function, the 'peascod' breastplate was the military expression of this fashion.

Had these designs been produced 50 years earlier, they would have looked very different. The best-quality armour was made to measure and deeply dependent on the fashions of the time. The earliest designs in the album show elements of former tastes – broad shoes, thigh-hugging leg defences – but it is the later designs that are the album's glory, produced at exactly the time fashions for Elizabethan men were at their most outrageous. Halder's death in 1608 placed the armoury in the hands of William Pickering, an Englishman with a distinguished career within the Armourers' Company. Some superb armours were produced, notably that for Henry, Prince of Wales, in 1611 (Royal Collection, no. WIND.678),[23] but both demand and output gradually declined. In 1630 a royal commission recommended that the Greenwich workshop should close. In 1642 a London armourer called Edward Ansley was appointed to retrieve the remaining royal armour from Greenwich, and two years later it was taken to the Tower of London, where in the 1660s it was displayed as the 'Line of Kings', which represented the kings of England from William the Conqueror (in a Greenwich armour that was in fact made in around 1590) to Charles II.[24] The present-day Royal Armouries Museum has its roots in this display.

Weapons

It was not only armour that paraded the English courtier's martial credentials. No self-respecting noblemen would be seen at court without the rapier and dagger, considered to be essential fashion accessories. This combination was designed for use away from the battlefield, although its role as working male jewellery evolved from the wearing of military swords. The rapier was a thrusting and slashing weapon with a light, slender blade, while the more robust dagger was used for parrying and thrusting in close. Rapier scabbards were suspended from a sling, while the dagger was generally worn in a sheath on the left hip. As costume jewellery, the decorated sword hilt was at its most extravagant between 1580 and 1620.

Decorated swords were ripe for imitation, and rapiers were subject to sumptuary laws. The length of one's blade was determined by rank; nobody below the level of the son of a baron could, according to an English law of 6 May 1562, 'wear any sword, rapier, or any weapon in their stead passing the length of one yard and half a quarter of blade at the uttermost, neither any dagger above the length of twelve inches in blade'.[25] However, meeting a minimum standard was as important as not exceeding a maximum one. When Arthur Throckmorton went to court in 1583 he complained in his diary about the great expense of improving his wardrobe and having his rapier silvered. He even had to sell land to finance his appearance.[26]

The methods used to wield the sword also changed with fashion. George Silver (c.1560s–1620s), a gentleman who wrote about swordsmanship, complained of men 'sick of a strange ague' who bought these rapiers and adopted new, choreographed fencing styles imported from Italy and France: 'Fencing … in this new-fangled age, is like our fashions, everie daye a change.' Silver was nostalgic for a time when martial training was aimed at preparing men to go to war for good causes, rather than to defend personal honour in civilian life. 'We like degenerate sonnes, have forsaken our forefathers vertues with their weapons.'[27]

While many of the early blades were imported from Toledo (Spain) and Solingen (Germany), during the early seventeenth century the Hounslow sword factory, west of London, made thousands of high-quality blades for gentlemen's swords, particularly hunting hangers. As had been the case with the armourers, many of the initial Hounslow bladesmiths were from Germany.

Firearms too became the badge of the courtier. They were collected for their modernity as technical devices, and for the way they expressed an up-to-date knowledge of military strategy. What made guns popular at the Tudor court was a new efficient firing mechanism. The wheel-lock was a circular, spring-loaded device that was wound with a spanner to high tension. When the trigger was pulled, inside the wheel-lock a clamp holding a small block of iron pyrites against the spinning wheel created sparks that ignited the powder in the pan. They were the first guns to fire mechanically, and removed the need for long and dangerous match-cords that had to be kept dry. They could be carried loaded and ready to fire. Wheel-locks and the development of increasingly powerful gunpowder encouraged the use of smaller guns, including the pistol.

Wheel-lock guns were expensive. Many were as finely chiselled and engraved as works of art. The stocks were often decorated with fine bone and horn inlay, drawing on the skills of furniture makers and engravers. A range of accessories was required to maintain and operate them, including spanners for the mechanism, measured charges, powder flasks and priming flasks. These too were often painstakingly decorated to match the gun.

On the battlefield, gun-toting cavalry were drawn mainly from the aristocracy and superseded knights carrying lances. Squadrons of riders charged in line and discharged their pistols in unison, before wheeling around to be followed by a second line. In civilian life, however, guns were feared. Whereas longer swords were restricted according to the status of the wearer, confining their use only to the most respectable, the law tried to ban the smaller guns. A sword proclaimed its threat from the hip and presented a visible danger whereas a wheel-lock pistol could be hidden, ready to fire from distance and required little skill to be deadly. A law introduced by Elizabeth I in 1579 described pistols as 'in time of peace only meet for thieves, robbers an[d] murderers'.[28] Elizabethan fears were well-founded: six years later, Prince William of Orange was shot dead, the first head of state assassinated using a handgun.[29]

The technical demands made of armourers, swordsmiths and gunsmiths were of the highest order. Specialist craftsmen had to adapt established designs, often published in a plain rectangular format, to fit awkward shapes. A range of components in a variety of materials had to be assembled as a single piece. This single piece then had to perform a complicated technical role and withstand powerful, sometimes explosive, forces. The attention lavished on weapons and armour in Tudor and Stuart England testifies to the centrality of martial prowess in the reputation of the English nobleman.

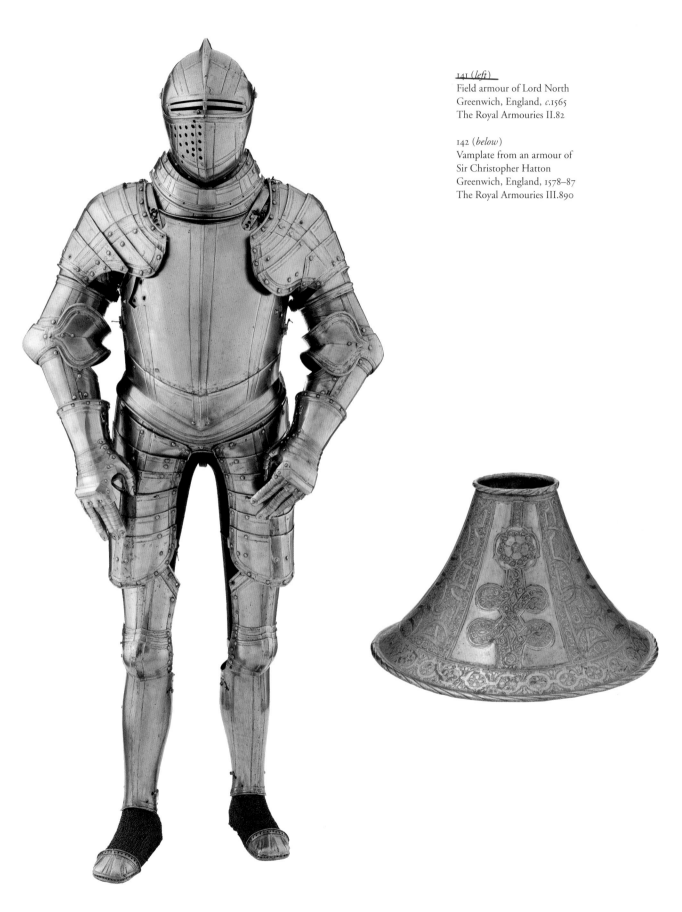

141 (left)
Field armour of Lord North
Greenwich, England, c.1565
The Royal Armouries II.82

142 (below)
Vamplate from an armour of
Sir Christopher Hatton
Greenwich, England, 1578–87
The Royal Armouries III.890

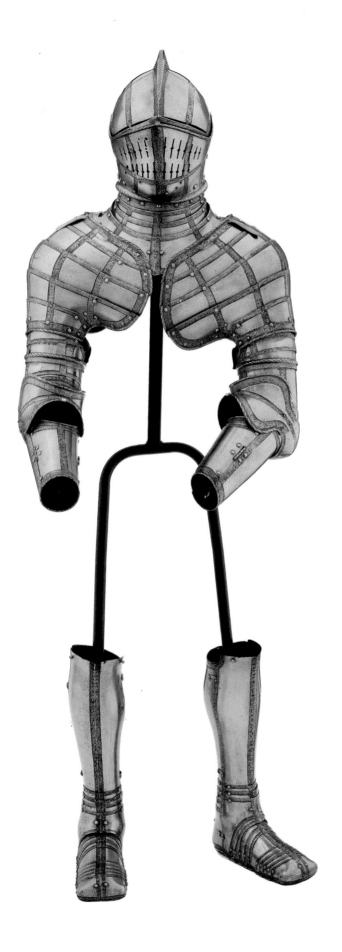

143
Portions from a field armour possibly
belonging to Sir Christopher Hatton
Greenwich, England, c.1587
The Royal Armouries II.77

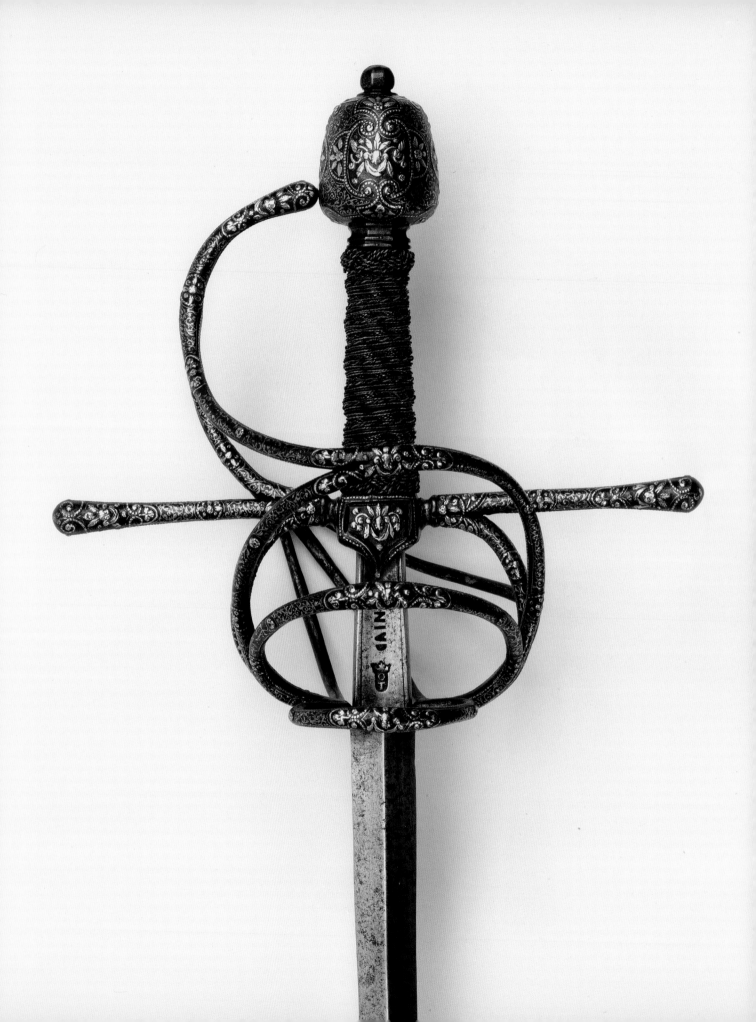

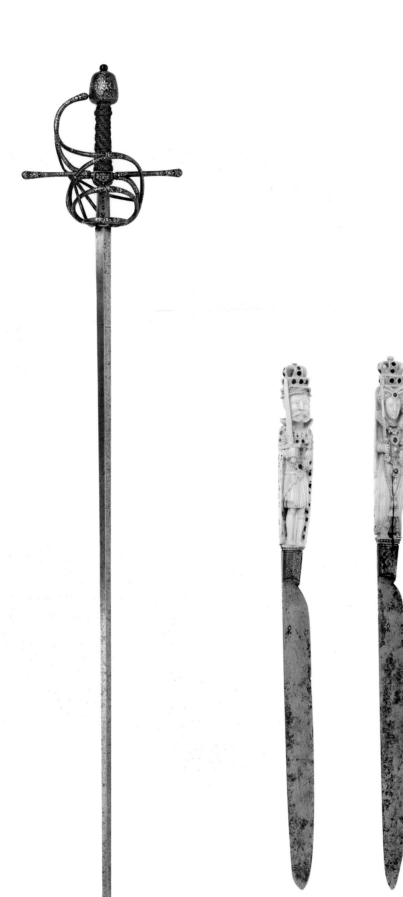

144 (*left with detail opposite*)
Rapier
England, *c.*1600
V&A: M.51–1947

145 (*below left*)
Knife
Arnold Smyth
London, England, 1607
V&A: 463–1869

146 (*below right*)
Knife
Arnold Smyth
London, England, 1607
V&A: 465–1869

Pair of pistols
Pervusha Isaev
Armoury workshops,
Moscow, Russia, 1600–25
The Moscow Kremlin Museums
OR-156 and OR-157

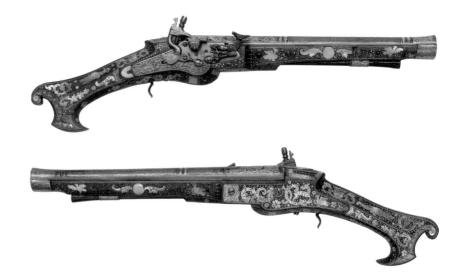

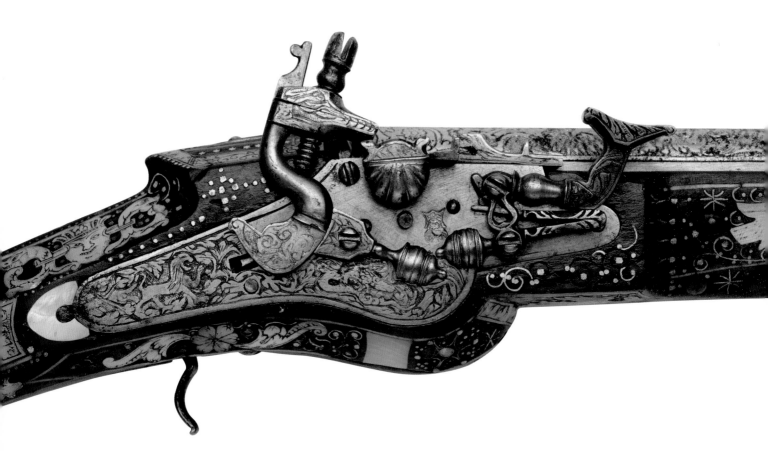

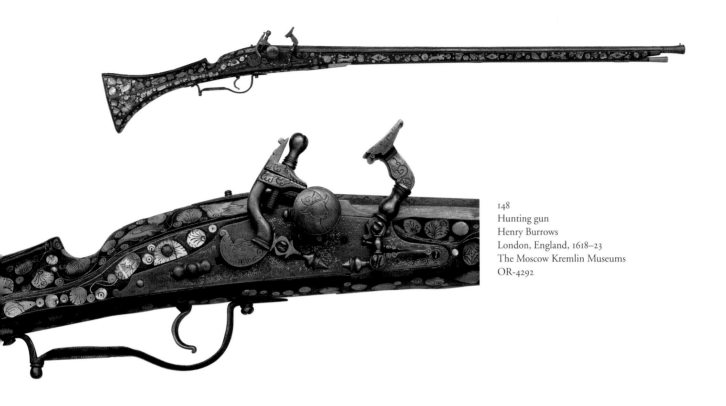

148
Hunting gun
Henry Burrows
London, England, 1618–23
The Moscow Kremlin Museums
OR-4292

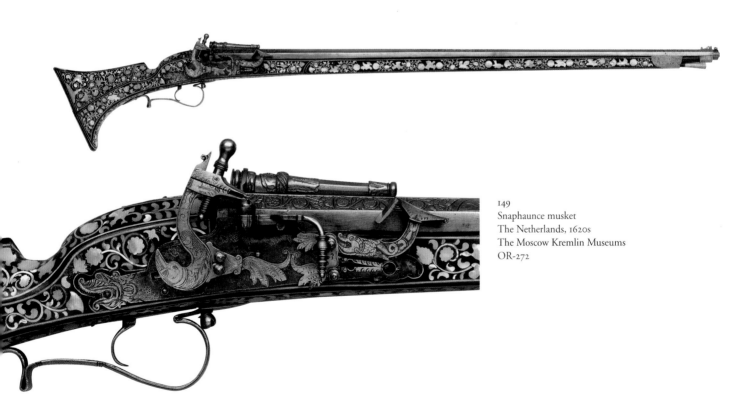

149
Snaphaunce musket
The Netherlands, 1620s
The Moscow Kremlin Museums
OR-272

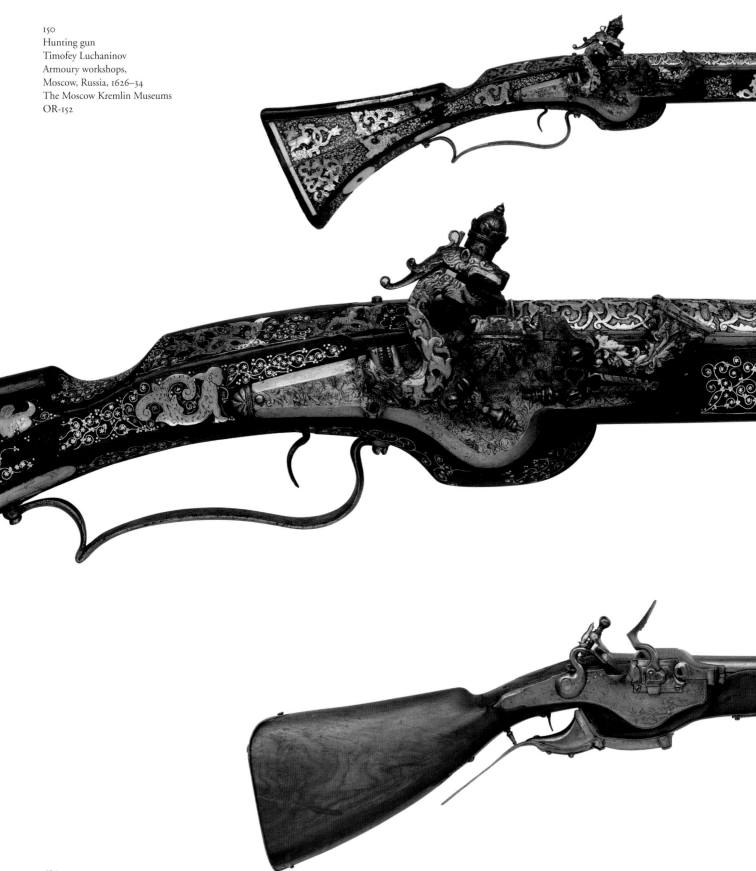

150
Hunting gun
Timofey Luchaninov
Armoury workshops,
Moscow, Russia, 1626–34
The Moscow Kremlin Museums
OR-152

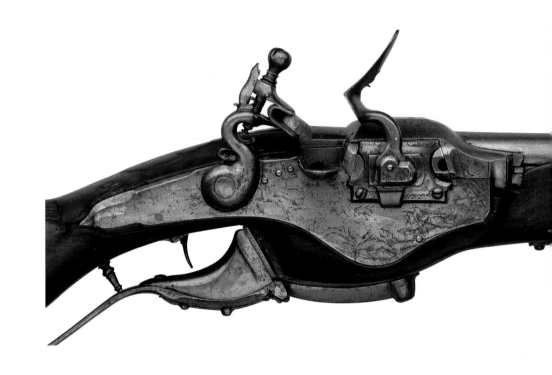

151
Seven-shot magazine hunting gun
Caspar Kalthoff the Elder
and Harman Barne
London, England, 1658
The Moscow Kremlin Museums
OR-104

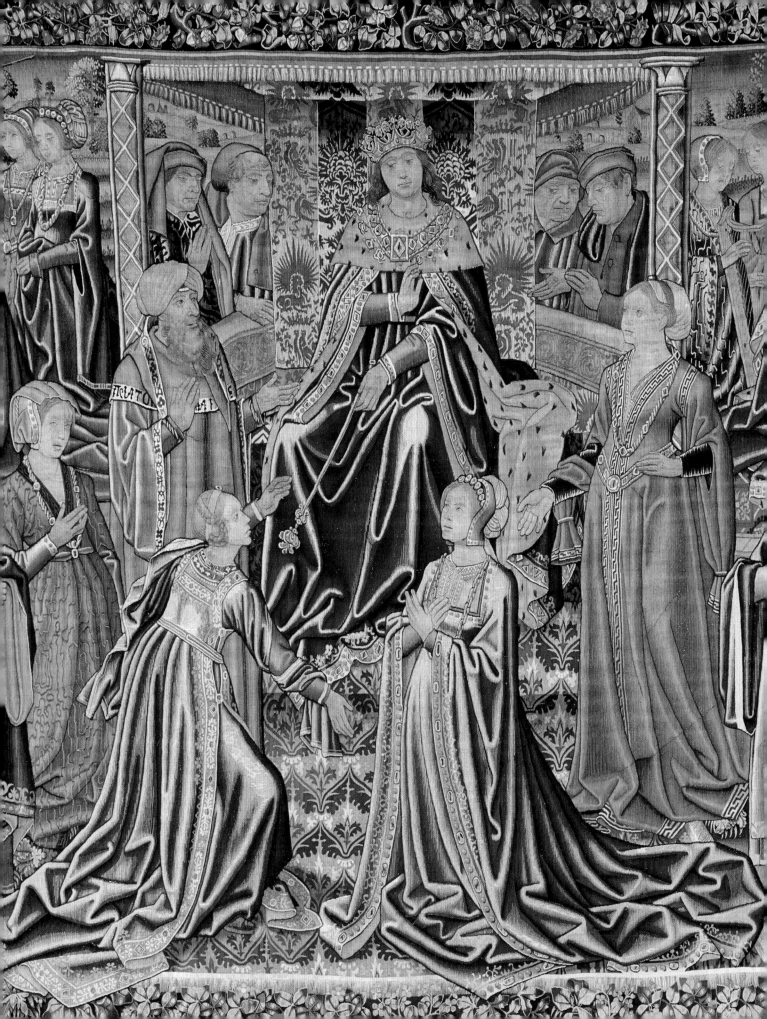

Clare Browne

'SILKS, VELVETS, CLOTHS OF GOLD AND OTHER SUCH PRECIOUS RAIMENTS': CLOTHING AND FURNISHING THE TUDOR AND STUART COURTS

The visual splendour of the Tudor and Stuart courts was deeply dependent on the range, magnificence and sheer quantity of the textiles used for furnishings and fine clothing. It can be difficult now to appreciate how opulent the palace interiors and the courtiers themselves would have appeared, because those few fragmentary garments and fabrics that survive are mostly worn and faded from their original brilliance. Listings in inventories and wardrobe accounts, which were compiled in great detail because of the value of the textiles included, are our best evidence that the extraordinary furnished interiors and fashions portrayed in contemporary paintings and eyewitness descriptions were indeed as extravagant as depicted. In use, their visual effects would have been heightened by the play of light on different textures and colours, in movement through day-lit and candle-lit spaces, and by the juxtaposition of the elaborate and finely detailed clothing of the monarch and courtiers against the contrasting rich furnishings of the royal palaces' rooms.

Henry VIII fully recognized the importance of magnificently furnished settings to the assertion of his majesty. Tapestry hangings in particular served a combination of purposes beyond the simply aesthetic, and in their scale and quantity, and the appreciation paid to them, they became the pre-eminent figurative art form at the Tudor court.[1] The inventory taken after Henry's death listed 2,450 tapestry wall hangings, one of the largest collections ever amassed. This huge number included many tapestries passed down in the royal collection from previous centuries, which were still valued and used, reasserting in the atmosphere of traditional splendour and antiquity that they conveyed, the Tudor monarchy's dynastic inheritance.[2] But Henry also purchased new tapestries, imported mostly from Flanders, spending huge amounts of money. The acceptance by the royal court of this massive expenditure underlines the significance of tapestry as an outstanding medium of both art and propaganda in this period (pl.153).

The King's collection of tapestries was divided between the 'standing' and 'removing' wardrobes (furnishings kept either for use at a single location, or moved between them as required) of the various palaces and lesser royal residences. The Royal Household moved frequently between residences, during Henry's reign an average of 50 times per year, peaking at 81 times in 1541.[3] Tapestry hangings were readily portable, once rolled up for transport, and flexible in their display, and could be freely moved between rooms and buildings for the regular progressions of the Royal Household, or put out for particular feast days and celebrations. As well as on palace walls, they were hung out in the streets of London to mark royal occasions. They also decorated the walls of tents and pavilions during tournaments, manoeuvres and diplomatic missions, including the meeting place

152 (*opposite*)
Tapestry, *Esther and Ahasuerus* (detail),
see pl.154

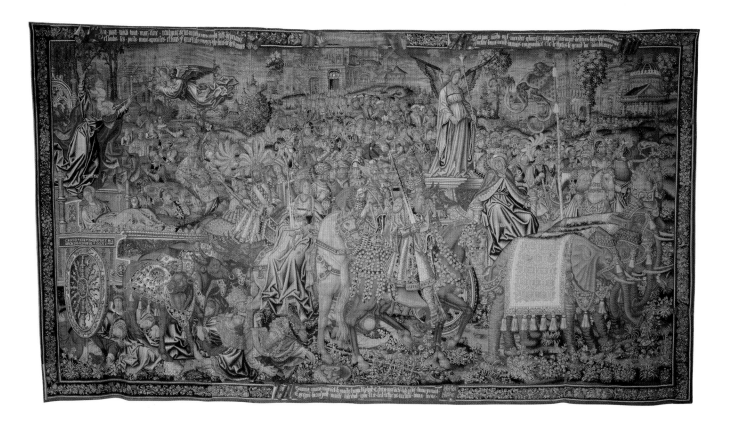

for Henry's encounter with the French King Francis I in 1520, known as the Field of Cloth of Gold. Both Francis and Charles V of Spain were also enthusiastic acquirers of tapestry, and Henry would have been shown or have heard reports of their finest pieces. The spirit of competition between the courts and the monarchs, as well as a knowledge of Papal tapestry commissions in the High Renaissance style, all influenced Henry's increasing expenditure and his own ambitious commissions.

The tapestry hangings in the royal collection were wide-ranging in their figurative subjects and included religious and mythological themes, classical history, allegory, chivalry and heraldry. The depicted tournaments and hunting parties reflected the hedonistic activities that the court pursued, while the allegorical and biblical scenes were their moral exemplars. In the Ten Articles of 1536 issued by Henry and his advisers, produced as a doctrine for the new Church's faith, images were permitted as part of the education of young nobles as 'representatives of virtue and good example', and the tapestries that covered the walls of the royal apartments often had such clear didactic intention (pl.154). The message could also be political: the most important palaces all had substantial sets of tapestries depicting the Old Testament story of the Patriarch David, suggesting how closely this subject was connected in court culture with the Tudor dynasty and Henry's vision of himself as patriarch of his people.[4] Although seen predominantly by the court and courtiers, Henry wanted the messages of his tapestries to communicate to as wide an audience as possible. In 1527 he ordered the Banqueting House at Greenwich, which had been built and furnished for celebrations of the peace treaty with France, to be opened to public exhibition for three days so that 'all honest persons' might admire the tapestry hangings and plate.[5]

153
Tapestry, *The Triumph of Fame over Death*
Brussels, 1507–10
V&A: 439–1883

154 (*below*)
Tapestry, *Esther and Ahasuerus*
Brussels, *c*.1510–25
V&A: 338–1866

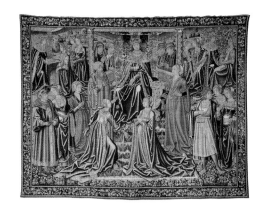

Tapestries chosen for their high quality and allusive subject matter could be deployed to pay tribute to a visiting dignitary, like those temporarily hung to furnish Bridewell Palace for the visit of the French ambassador in 1538. And as liberality was a component of the magnificence expected of a great ruler, a gift of tapestry was perceived as a generous gesture acknowledging rank: Henry included fine sets of tapestries in the dowries of both his sisters when they married foreign kings.[6] In the same way, their confiscation could be especially lucrative: Cardinal Wolsey had his personal collection of more than 600 tapestries, which had huge financial value, appropriated in 1529 when he fell from favour with Henry.

The use of tapestry at the English court reached its peak in Henry's reign. While Edward VI, Mary and Elizabeth continued to make use of the accumulated collection of royal tapestry hangings for furnishing the palaces, and for ceremonial occasions such as coronations, they did not add to it with new commissions as their father had done. But James I did choose to give his patronage to a new English industry, an equivalent to the highly successful French royal tapestry workshops set up in Paris a few years earlier. The manufactory at Mortlake, west of London, was established in 1619 and supported with royal grants, reflecting James's personal interest in the enterprise, and that of his son, Charles Prince of Wales. While its first products were copies of tapestry sets acquired in the previous century by Henry VIII, the purchase in 1623 of Raphael's original designs for the Sistine Chapel's *Acts of the Apostles* enabled a new weaving of that series, plus outstanding new designs were made for Mortlake (pl.155) by the artist Francis Clein (1582–1658). Charles I and his court were able to commission English tapestries as fine as any that could be imported from Europe at that time.

155
Tapestry, *Perseus on Pegasus*
Mortlake, England, 1630–49
V&A: T.228–1989

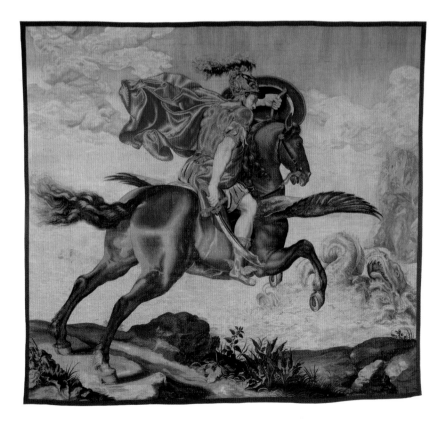

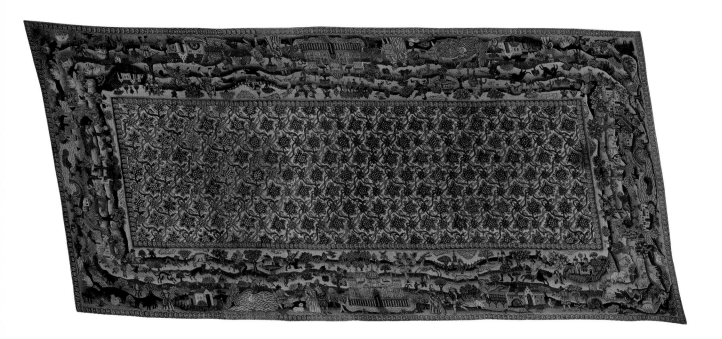

Although for the sheer amount of space they covered, as well as their conspicuous expense, tapestry wall hangings were dominant in the furnished interiors of royal and aristocratic residences, other luxury textiles added to the cumulative effect of colour and texture on display. Almost all were imported, including the silks woven with metal thread known as 'cloth of gold', and the even more precious 'cloth of tissue', incorporating raised loops of gilded metal thread as well as metal thread and wire forming part of the ground weave; this was reserved for royal use. Another prestigious imported textile used at court but whose visual effect – in contrast to the complex, richly woven silks – depended on subtle nuances of light, was fine linen damask, used for the ceremonies associated with dining. The best was woven in Flanders and, as it could be made to commission, sometimes included royal arms and other devices chosen to appeal to the sensibilities of the English court; a napkin dated 1605 alternates the arms of James I and the Order of the Garter with scenes from Edmund Spenser's poems *The Faerie Queene* and *The Shepheardes Calender*.[7]

Since textiles were of such importance to interiors as a major means of providing colour, decoration and comfort, there was inventiveness and enterprise in their creation. Alongside the tapestries and linen damasks imported from Flanders, the velvets, cloth of gold and other silks from Italy, the wool carpets from Turkey and silk carpets from Persia, other textile furnishings were produced in English workshops newly established or revived – particularly for embroidery. The profession of embroidery, which had produced work of exceptional quality in medieval England, had declined in the fifteenth century, but rose to high standards again during the reigns of Henry VII and Henry VIII. The supply of clothing and furnishings for the everyday use of the royal family, as well as the extra needs of tournaments and revels, state visits and other ceremonies, required substantial quantities of embroidered decoration, including throne and bed canopies, wall hangings, horse trappings, livery for servants and heralds' tabards. Alongside this courtly display there was the more domestic need, before the development of fixed upholstery, to bring colour and comfort into rooms with wooden furniture. This was met with the

156
Table carpet, known as the
Bradford Table Carpet
England, 1600–15
Canvaswork
V&A: T.134–1928

157
Detail of panel, embroidered
by Mary Queen of Scots
England, *c*.1570
Canvaswork
V&A: T.33–1955

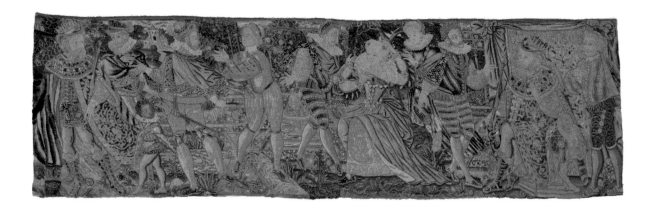

158
Bed valance
England, Scotland or France, 1580–1600
Linen canvas, embroidered with wool
and silk
V&A: T.135–1991

159 (*below left*)
Cushion cover with the Royal Arms
Made by or for Mary Hulton
England, 1603–25
Linen canvas, embroidered with silk,
wool and metal thread
V&A: 816–1893

160 (*below right*)
Cushion cover with floral design
England, *c*.1600
Silk satin, embroidered with silk
and metal thread, edged with gilded
bobbin lace and tassels
V&A: T.21–1923

extensive use of covers and cushions, curtains and valances, decorated with needlework and embroidery. Needlework, in which a canvas ground fabric was covered in stitches creating figurative scenes or decorative patterns, could be worked professionally to produce large-scale pieces such as the Bradford Table Carpet (see pl.156). But the technique was also very suitable for amateur working, learned by girls from elite families as part of their education, and was a pastime with which Mary Queen of Scots occupied herself during captivity in England in the 1560s and 1570s. Typical of the time, Mary drew on published prints and books, including natural history and emblem books, for her designs, adapting and combining motifs from different sources (pl.157). Larger needlework pieces incorporated many of the themes typical of woven tapestry hangings, like scenes from the Bible and classical literature, allegory and tableaux of courtly and rural life (pl.158). Heraldic motifs were also extensively used in needlework, reflecting a pervasive interest in family connection and the desire to put it on show (pl.159).

As well as figurative needlework on canvas, other forms of embroidered decoration and the appliqué of precious fabrics, metal threads and ornaments such as pearls could be used to embellish silk and linen furnishings: for example, the diplomatic gift made by Francis I to Henry VIII in 1532 of a set of bed hangings 'wrought throughout with pearls on crimson velvet'.[8] Many designs were derived from an established repertoire of Renaissance ornament including arabesques and strapwork, but might incorporate details characteristic of English taste, such as meadow flowers (see pl.160).

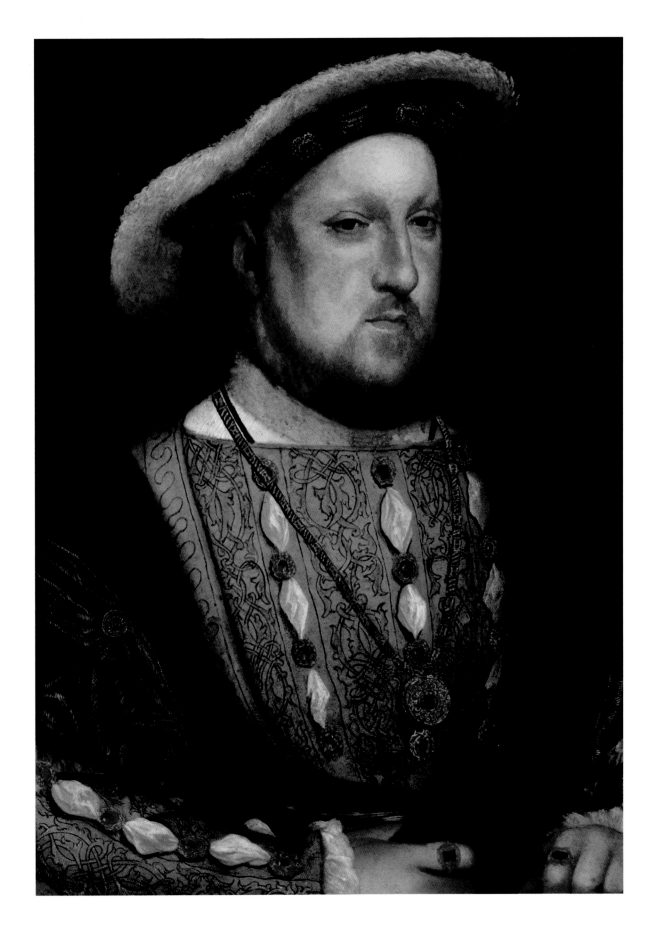

Amid such richly furnished settings the monarch, royal family and courtiers dressed themselves in appropriately luxurious clothing, according to their status and social aspiration. Clothing was central to the expression and perception of identity, and a series of sumptuary laws sought to dictate its use, making explicit the link between rank and dress.[9] In the early sixteenth century Henry VIII, Francis I and Charles V led the fashions of their courts, as described by Bishop John Fisher in his sermon on the Field of Cloth of Gold, 'three great princes of the world … showing their royalty, showing their riches, showing their power, with each of their noblesse appointed and apparelled in rich clothes, in silks, velvets, cloths of gold and other such precious raiments'.[10]

During Henry's reign, the use of sable fur, cloth of tissue or the colour purple was restricted to royalty (pl.161). Beneath these a hierarchy of fabrics, furs and colours was laid down in law, which applied to men only; women were generally expected to reflect the rank of their male family head in their choice of dress. The colour of textiles was an important aspect of the legislation, the higher status of some colours indicative of the higher costs of the dyestuffs, the extra production costs incurred in their dyeing, and their association with expensive imports rather than cheaper, home-produced cloth. While the colour blue, when applied to woollen clothing, was associated with lower classes and servants, its use in silk, and in particular as blue velvet, was very restricted, and used for royal mourning. Scarlet and crimson were the most highly prized shades of red, and legislation made distinction between silks in intense shades achieved with insect-derived dyes and the muted reds of plant-dyed wools. Black, expensive to achieve, was prestigious and of social significance, a key part of royal wardrobes. Attitudes to fur were equally hierarchical, their exclusivity based on their rarity and import from distant places, including Russia and Scandinavia. Dark furs were particularly sought after, either to complement black clothes or contrast with pale ones.[11]

The choice of fashionable dress at court allowed the wearer to embody taste, affluence, allegiance through allegorical symbolism and patriotism by wearing fabrics or styles perceived to be English; or, in the case of ambassadors, to reflect the status of their masters and their esteem for the court they were visiting. Court was the focal point for the introduction of new ideas about clothing styles, and Henry ensured that he had access to the full range of what was available, granting licences to foreign merchants to import textiles on the understanding that the king should have 'first sight and choice of them'.[12] He not only chose for himself, but also made gifts of clothes and textiles to his household and court, and even clothed noble prisoners, his choices intended to convey the extent to which they were at his mercy. The giving away of clothing served the practical purpose of making way for new in the royal wardrobe, but also gave opportunity for the rewarding of service, the exercise of generosity and demonstration of friendship. Gifts of fine clothing to King James V of Scotland and his court even became part of the struggle between Henry and Francis I over who could exert more influence there.[13] And this extravagance added to the huge cost of clothing and textiles for the Great Wardrobe, which consistently overspent its budget, acquiring an average of 1,500 yards (1,372 metres) of silk each year during the 1540s, for Henry's personal use or for his gifts.[14]

Even more than for her father, a preconception has grown of Elizabeth I's extravagant attitude to clothing. In fact, her control over the magnificence of her appearance was highly managed, and one of careful economy governing necessary expense.[15] During the years that matrimonial alliances with European monarchs were being considered for her, it was necessary to project an image combining majesty with regal elegance and

beauty. Later the manipulated illusion of an ageless Queen was sustained to support the continuing stability of her reign. Both required enormous expenditure on rich materials, and highly skilled workmanship to do justice to the making and decoration of her garments. Elizabeth was not exceptional in her spending in this way, but there is no doubt that she had a great personal love of fine clothing, and during her reign gifts to her of clothes and textiles became increasingly and competitively elaborate, in particular at the traditional gift-giving time of the New Year, but also on her progresses around her realm. Textile gifts from all ranks of her court and household included ornamental items of clothing such as petticoats, bodices and ruffs, gloves and slippers, purses and handkerchiefs. Gifts of embroidery, if worked by ladies of the court, might literally embody a labour of love or professed loyalty, such as the red silk skirt embroidered in silver thread by Mary Queen of Scots for Elizabeth in 1574. Mary accompanied it with the message that it was worked out of 'the desire I have to employ myself in anything agreeable to her'; the French ambassador reported that Elizabeth had received it very well and had softened in her attitude towards Mary.[16]

Such gifts could incorporate complex symbolism intended to demonstrate loyalty. In the later part of Elizabeth's reign a fashion developed for emblems to be added to the decoration of garments, sometimes clearly depicted in portraits of her.[17] This fashion is so closely connected with Elizabeth's person that its appearance in portraits of her courtiers may denote items that had been given as presents by her, or were adapted from parts of her own clothing passed on to them (pls 162 and 163). The Queen herself had her own clothing remodelled when necessary, and gifts from her wardrobe were highly regarded perquisites, even to ladies of the highest rank.

Sumptuary legislation continued during Elizabeth's reign, enforced by economic and moral considerations as well as the attempted preservation of distinctions of rank, but was finally abolished by James I in 1604.[18] The attitude prevailed at his court that there should be no constraint on the clothing choices of the elite in society, and James himself set the example of unrestricted expenditure, his annual wardrobe expenses in the first five years of his reign being almost four times that of the last years of Elizabeth's (pl.164).[19] His courtiers were barely constrained from being seen to compete in magnificence with the King. Richard Sackville, 3rd Earl of Dorset, for example, wore clothing so elaborate to the wedding of Princess Elizabeth to the Elector Palatine in 1613 that a witness reported 'he dazzled the eyes of all who saw'.[20] They may be the clothes in which he was depicted in his portrait by William Larkin (pl.165).

In this period the use of lace provides the clearest example of how high status in clothing and accessories worn at court was often closely related to its impracticality. The techniques of lacemaking had developed during the sixteenth century partly out

162
Petticoat panel, silk satin embroidered with silk and metal thread
England, c.1600
V&A: T.138–1981

163
Dress trimming, silk satin embroidered in silk
England, c.1600
V&A: T.378–1976

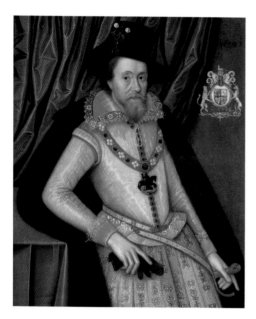

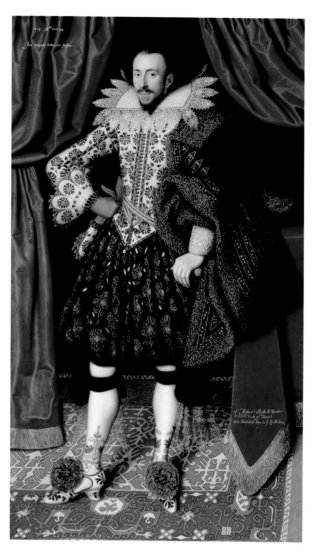

164 (*above*)
JOHN DE CRITZ
James I
Oil on canvas, *c*.1610
National Maritime Museum, London
BHC2796

165 (*right*)
WILLIAM LARKIN
Richard Sackville
Oil on canvas, 1613
Kenwood House
English Heritage

of the desire to ornament the white linen garments worn for comfort and practicality under more elaborate silks. Visible at throat, neck and wrists, lace was a means of drawing attention to, and framing, the face and hands, and as it became more confident and sophisticated in technique was required to be more spectacular in its effects. The ruffs and standing collars worn at the Elizabethan and Jacobean courts reached a peak of fragile splendour: their creation was hugely labour-intensive and their manipulation into temporary starched rigidity was for the fleeting time they could be worn before needing to be re-laundered and re-shaped (see pl.35). Whoever wore a lace ruff or collar would understand how it would be perceived as a marker of his rank, affluence and taste, having to accept the sacrifice to his comfort and all other practical considerations in the wearing of it.

In their prevalence and richness, the textiles used at the Tudor and Stuart courts were much more than a functional backdrop to courtly life. Clothing and furnishings, as gifts or as display, were important statements of power, influence and taste, and of the visual splendour that encapsulated the English monarchy's self-confidence.

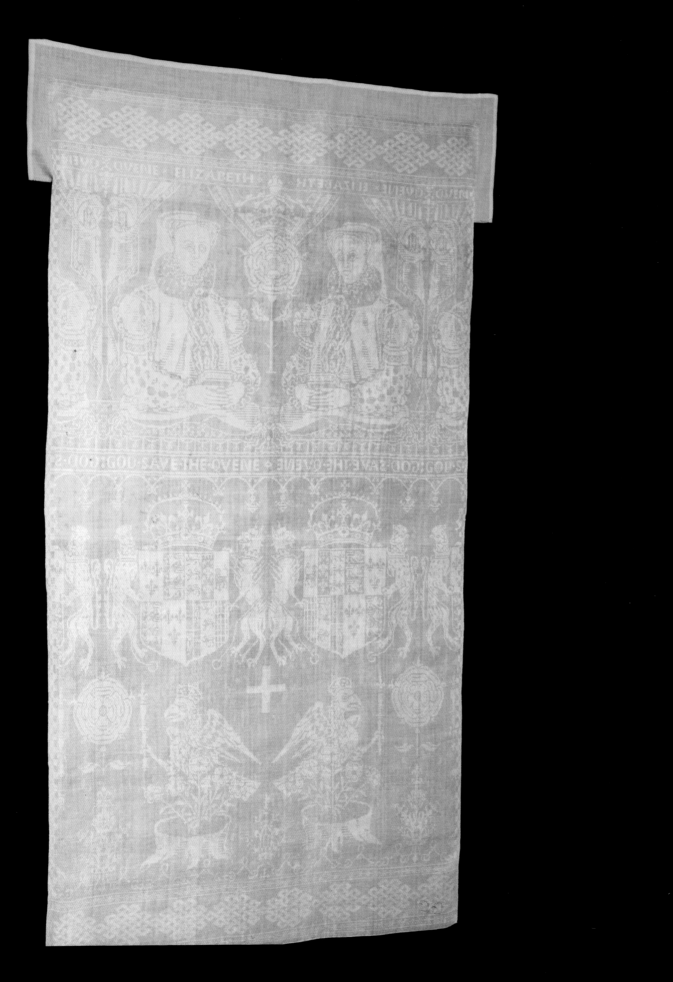

166 (*opposite*)
Napkin
Southern Netherlands, 1558–1600
Linen damask
V&A: T.215–1963

167 (*below*)
Bed valance
England, Scotland or
France, 1580–1600
Linen canvas, embroidered
with wool and silk
V&A: T.136–1991

168 (*below, middle*)
Bed valance, depicting
Venus and Adonis
England, Scotland or
France, 1580–1600
Linen canvas, embroidered
with wool and silk
V&A: 879–1904

169 (*bottom*)
Bed valance,
depicting Myrrah
England, Scotland or
France, 1580–1600
Linen canvas, embroidered
with wool and silk
V&A: 879A–1904

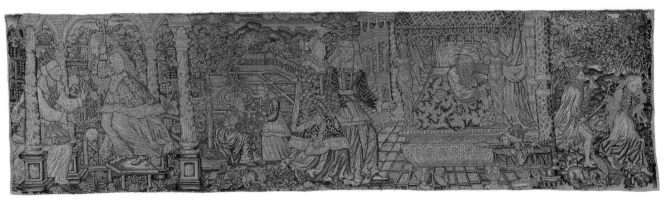

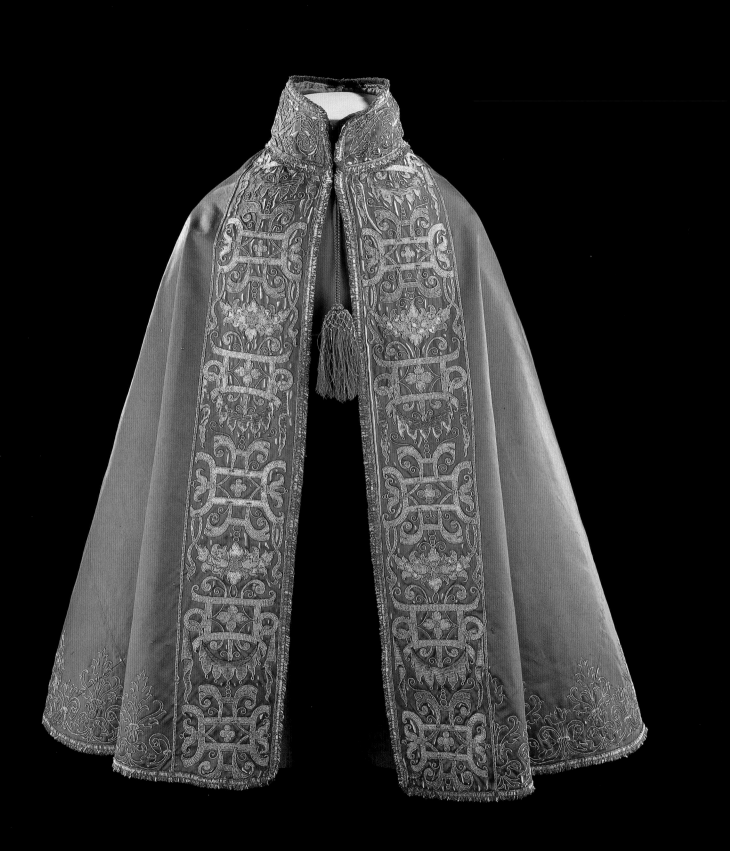

170 (*opposite*)
Man's cloak
France, 1580–1600
Silk satin, embroidered
with metal thread and silk
V&A: 793–1901

171 (*right*)
Woman's coif
England, *c*.1600
Linen, embroidered with silver and
silver gilt thread, spangles and pearls,
with metal bobbin lace
V&A: T.239–1960

172 (*below*)
Man's nightcap
England, *c*.1610
Linen, embroidered in silver and silver
gilt thread, with metal bobbin lace
V&A: T.75–1954

173
Ruff
Italy, 1600–20
Needle lace worked in linen thread
V&A: T.14–1965

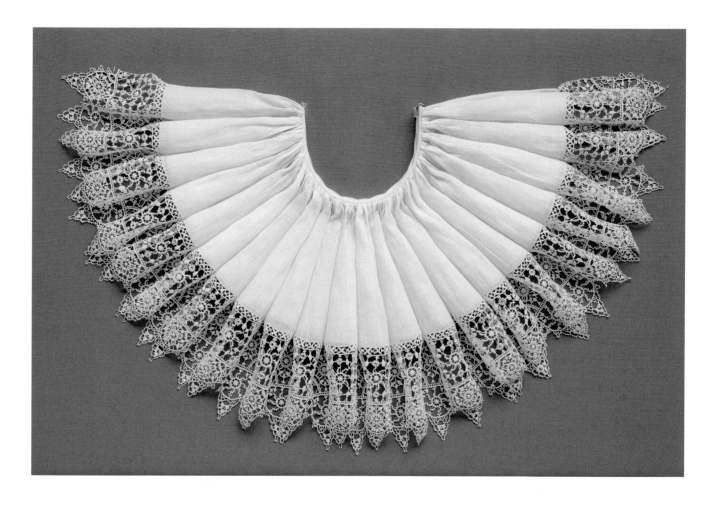

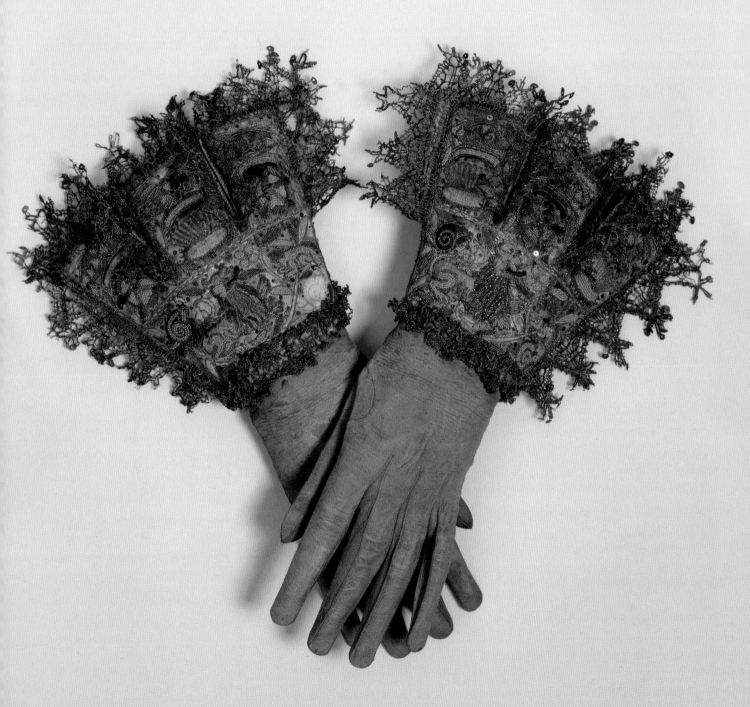

174
Pair of gloves
England, 1603–25
Leather with silk satin gauntlets,
embroidered with silk, metal
thread and seed pearls, trimmed
with metal bobbin lace
V&A: 1506&A–1882

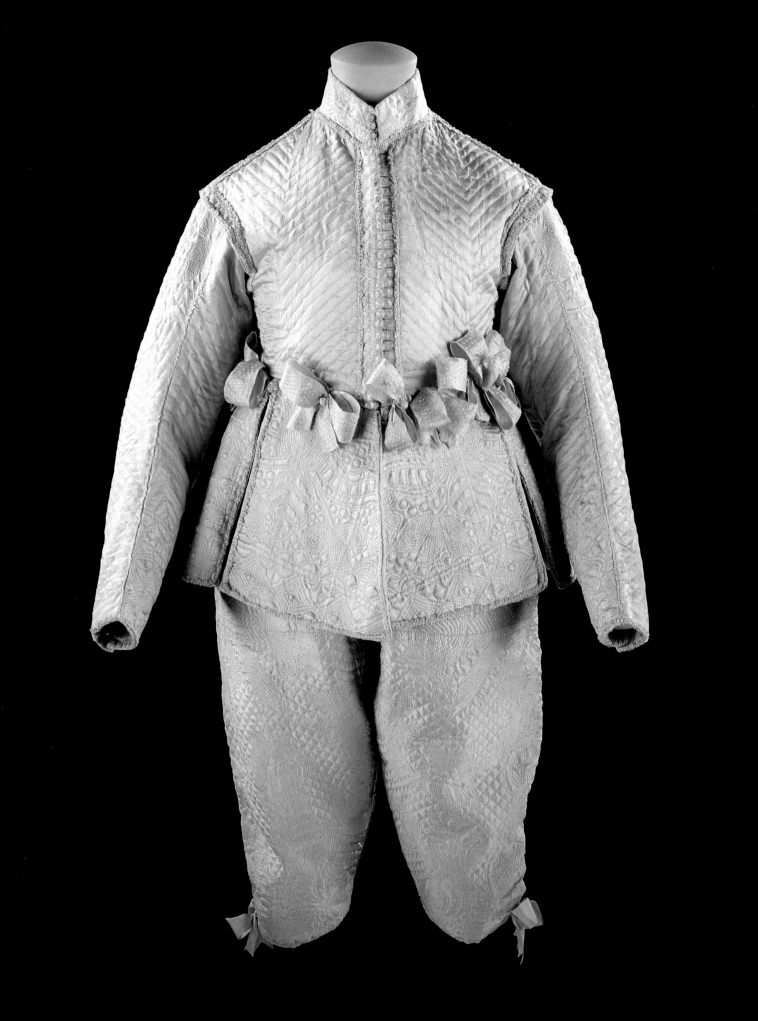

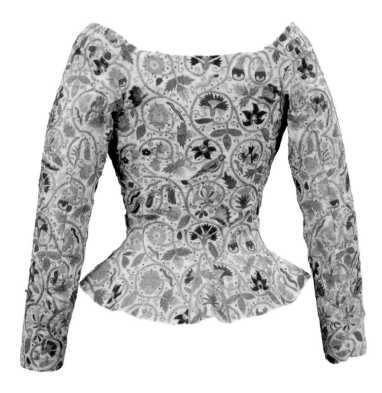

175 (*opposite*)
Doublet and breeches
England, 1630s
Silk satin, quilted, with applied silk band
V&A: 347&A–1905

176 (*left*)
Woman's jacket
England, 1610–20
Linen, embroidered with silk
and metal thread, and spangles
V&A: 1359–1900

177 (*below*)
Embroidered *Eikon Basilike*
England, *c*.1650–60
Silk satin, embroidered with silk,
metal thread and seed pearls
V&A: T.117–1936

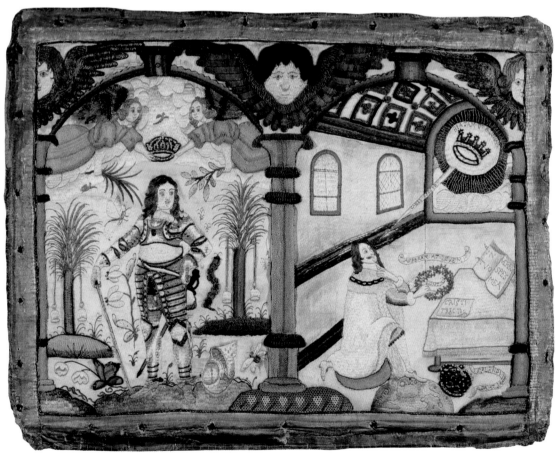

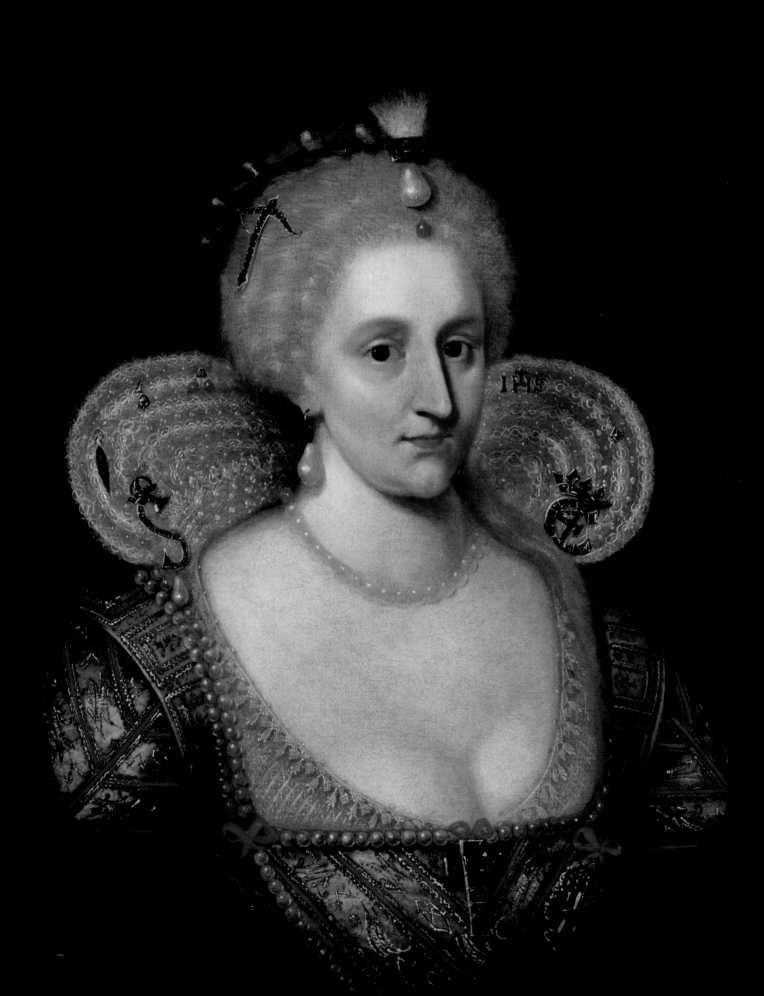

Richard Edgcumbe

'O, THOSE JEWELS! THE PRIDE AND GLORY OF THIS KINGDOM!'

'That infinite wisdom of God, which hath distinguished his angels by degrees, … which hath made differences between beasts and birds … and among stones given the fairest tincture to the ruby and the quickest light to the diamond, hath also ordained kings, dukes or leaders of the people, magistrates, judges, and other degrees among men.'[1] Sir Walter Raleigh, who described himself at his execution in 1618 as a soldier, sea captain and courtier, 'which are all places of Wickedness and Vice', but modestly omitted his accomplishment as historian and poet, expressed the contemporary understanding of creation.[2] Gemstones are part of the divine order that stretches from God to the smallest object. In 1603, for his last New Year's gift to Queen Elizabeth before her death, Raleigh gave her 'one Jewell of golde like a Spade garnished with Sparkes of Diamondes and Rubyes, and a Snake wyndeing rounde about with one dyamonde in the head and a Rubye pendante withoute foyle'.[3]

'Among stones', wrote Henry Peacham in *The Compleat Gentleman* (1622), 'we value above all the diamond', king of its part of creation, just as lions, eagles, whales and Jupiter's oak had primacy in theirs.[4] Prominent on the hat of James I in the portrait by John de Critz (pl.164) are the diamonds and ruby of the 'Mirror of Great Britain' commissioned to celebrate the union of the Crowns (but not the kingdoms) of England and Scotland in the person of James. In the portrait after Paul van Somer of James's consort, Anne of Denmark (pl.179), diamonds are densely set on a cross and a miniature case on her bosom, and on the letters 'S' and 'C' pinned to her ruff, which honour her mother, Queen Sophie, and her brother, King Christian IV of Denmark. A small 'IHS', the sacred name of Jesus, in diamonds is high up on her ruff. A diamond crossbow, which matches one in the inventory of Elizabeth's jewels in 1600, is pinned into her hair, a motif explained in Geffrey Whitney's *A Choice of Emblems* in 1586 as invention surpassing strength.[5] On her head a pearl hangs beneath a large diamond, like the tears from Cordelia's eyes 'as pearls from diamonds dropp'd'.[6]

Yet fashion and monetary value made perilous the survival of any jewel, not least those in royal ownership. Sir John Eliot in the House of Commons in 1626 wished that search could be made 'for the treasures and jewels that were left by that ever-blessed princess of never-dying memory, queen Elizabeth! O, those jewels! the pride and glory of this kingdom! which have made it so far shining above all others!'[7] The charge was unreasonable to the extent that recycling of unfashionable or broken plate and jewels to make new objects was standard practice, but Charles I and his favourite, the Duke of Buckingham, had gone beyond this, as indeed had Elizabeth in 1600, to use the proceeds to fund their policies. Major jewels, including the 'Three Brothers', which Elizabeth

179 (*opposite*)
After PAUL VAN SOMER
Anne of Denmark
Oil on canvas, 17th century
(after a portrait of *c.*1617)
National Portrait Gallery, London
NPG127

had worn and James I had declared inalienable from the Crown, were sent to the
Netherlands in 1625 to be pawned on the orders of Charles I.[8] By 1642, at the outbreak
of civil war, when Queen Henrietta Maria was on the same mission, the Parliamentarian
Bulstrode Whitelocke could write that while Charles was 'furnished with moneys from
the queen upon the pawned jewels', funding for Parliament's army included gifts 'even
by some poor women' of 'their wedding rings and bodkins [hairpins]'.[9]

During the Civil War, the regalia in Westminster Abbey lay within the power of
the Parliamentarians, who controlled London. In 1643, Henry Marten, following a
resolution of Parliament, forced open 'a great Iron Chest' in the Abbey, and declared
that 'there would be no further use of those Toys and Trifles'. Six years later, after the
execution of Charles I, came the order that the appointed trustees of the regalia 'are to
cause the same to be totally broken, and that they melt down the Gold and Silver of
them, and to sell the Jewels for the best Advantage of the Commonwealth'.[10] The revo-
lution of 1649 was less respectful of the regalia than its counterpart in Russia in 1917.

Although rings can be found in considerable numbers, surviving Tudor and early
Stuart jewellery set with substantial gems is rare, even including a number of the larger
jewels in the Cheapside Hoard, which owes its existence to deliberate concealment
during the middle of the seventeenth century.[11] Why did any jewellery survive? The
reverence of a family for its jewels played a crucial role, and our gratitude to the families
who kept their jewels cannot be overstated, but even in such families the presence of
major gemstones put the jewellery in jeopardy.

George Carey (1548–1603), 2nd Baron Hunsdon, son of Queen Elizabeth's first
cousin, made his will with pride in 1599, leaving to his faithful, virtuous and true-loving

wife 'the use and occupation of my greate Aggate [pl.180] wherein is embossed the Portraiture of Perseus and Andromache' as well as his jewel with two 'faire and greate Amatistes orientall' and his jewel 'of the great diamond of the golde Myne or otherwise called a Topas orientall sett about with diamonds'. He directed that they should be for the use of his wife during her lifetime, unless she altered them or alienated them, in which case they should pass to their daughter Elizabeth during her lifetime, and, it would appear, on to his brother to descend with the barons of Hunsdon,

> so long as the conscience of my heires shall have grace and honestie to per-
> forme my will for that I esteeme them righte Jewells and Monuments worthie
> to be kept for their beautie and rarenes and that for money they are not to be
> matched nor the like yett knowne to be founde in this Realme[12]

The jewels were together until at least 1635 when Elizabeth, seemingly with a change of direction, bequeathed the 'three entayled Iewells' to the Berkeley family into which she had married.[13] The great agate, known as the Hunsdon Onyx, and such treasures as the Hunsdon Girdle Prayer Book (pl.181), repository of the last prayer of Edward VI, and the Hunsdon Ship (pl.182), which all lack major gemstones, survive to this day, but not the amethyst or topaz jewels that were entailed.

The Drake Jewel and the Drake Star

In the family of Sir Francis Drake (1540–1596), the Drake Jewel, a fine mounted cameo in an enamelled gold setting set with diamonds and rubies (pls 185 and 186), was the subject of intense concern throughout the seventeenth century. By tradition a present from Elizabeth I, the date at which Drake acquired it is uncertain, but he is wearing it in a portrait dated 1591 (pl.184). Inside, the Drake Jewel contains a portrait of Elizabeth by Nicholas Hilliard and a painting on parchment of a phoenix, one of her favourite devices, a symbol of her uniqueness and her chastity, and an assertion of hereditary kingship.[14] In the will of Drake's brother, Thomas, in 1606, the Drake Jewel was listed as the last of three fair jewels 'called a compass, a starre, and the late Queen's Majesty's picture', which were to remain in his wife's hands 'as long as she shall be unmarryed'.[15]

181 (*right*)
The Hunsdon Girdle Prayer Book
England, *c*.1553–60
Enamelled gold case mounted with a shell cameo, containing a manuscript book
Trustees of the Berkeley Will Trust
V&A: LOAN:MET ANON.2:4–1998

182 (*far right*)
The Hunsdon Ship Pendant
Western Europe, *c*.1580
Wood, gold, enamel, pearls, diamonds
Trustees of the Berkeley Will Trust
V&A: LOAN:MET ANON.2:3–1998

As with the Hunsdon jewels, the early history of the Drake Jewel shows a tension between a desire to allow the widow to continue to enjoy the Jewel and a wish to ensure that it returns to descend with the male line. Thomas Drake's son, Sir Frances Drake, 1st Baronet, made no will before his death in 1637 and his widow drove a hard bargain when she wished to re-marry. In return for a payment of £3,000 to her daughters, she relinquished any claim to a wide range of objects belonging to her late husband, including 'a great tablett or jewell with Queen Elizabeth's picture in it which was lately belonging to Francis Drake, knight, deceased', but she kept for herself 'all jewells, chains of gold, borders, gold rings ... other than the aforesaid great jewell'.[16]

Sir Francis's son, Sir Francis Drake, 2nd Baronet, was born into a circle that took Parliament's side in the developing struggle with the King. He married the daughter of the Parliamentary leader John Pym (1584–1643). Writing his will in April 1661, after Charles II had been restored to the throne, he bequeathed the 'great Jewel that was given with the great gilt covered cupp by Queen Elizabeth to Sir Francis Drake a predecessor' to his nephew and heir, also called Francis Drake.[17]

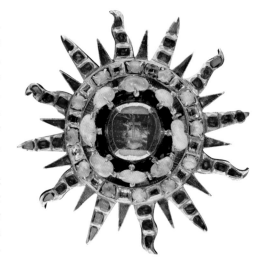

183 (above)
The Drake Star
Probably England, c.1580–90
Gold, enamel, table-cut rubies and diamonds, cabochon opals, on the reverse a miniature under glass
Private collection, normally on long-term loan to the National Maritime Museum, Greenwich

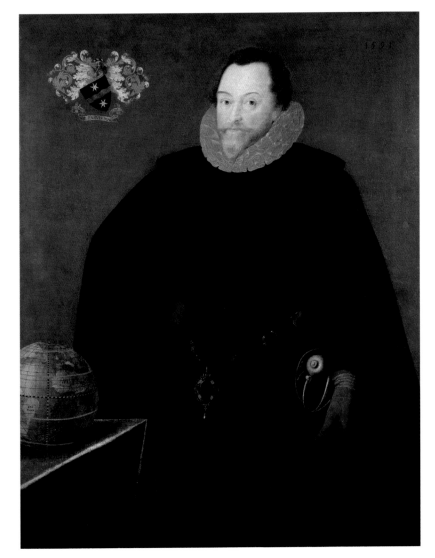

184 (with detail above)
MARCUS GHEERAERTS THE YOUNGER
Sir Francis Drake
Oil on canvas, 1591
National Maritime Museum, Greenwich,
Caird Collection: BHC2662

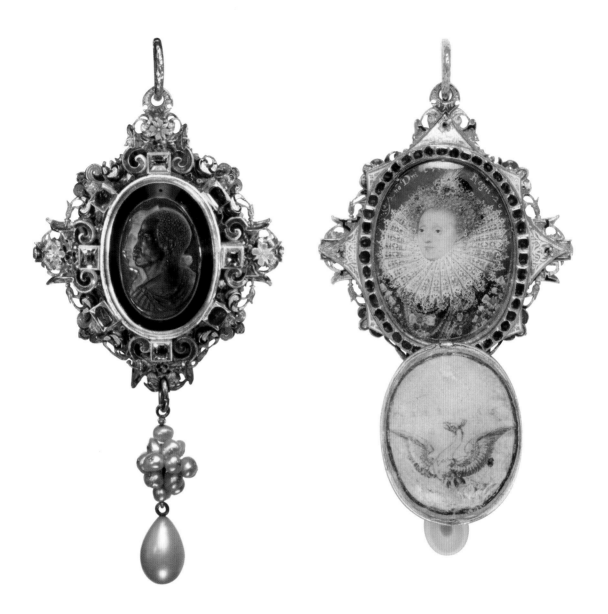

185 (*above left*)
The Drake Jewel
Western Europe, *c.*1580–90
Gold, enamel, rubies, diamonds,
pearls, sardonyx cameo
Private collection, normally on long-term
loan to the Victoria and Albert Museum

186 (*above right*)
The Drake Jewel (interior)
Gold, enamel, rubies, portrait of
Elizabeth I by Nicholas Hilliard
painted in watercolour on vellum, *c.*1586;
a phoenix painted on parchment
Private collection, normally on long-term
loan to the Victoria and Albert Museum

However, he bequeathed to his wife 'my two little jewels, the one being of dymonds, the other of rubies. The Dymond Jewell had a crowne lately on the top of it, a little pendant of dymons on the bottom; and the Rubies a picture on the backside.'[18] The ruby jewel is the Drake Star (pl.183), mentioned in Thomas Drake's will in 1606, but the diamond jewel is no less interesting. Clearly the crown was removed at some point in the struggle during which Charles I lost his, the wearing of the crown emblem being unacceptable for the daughter of Pym. The diamonds would have made the remainder of the jewel vulnerable: it is last heard of about 60 years later.[19]

In actual fact, Sir Francis's wife died in May 1661, shortly before his own death in 1662. The Drake Star re-appears in the possession of his brother, John Drake, when he bequeathed 'my jewel called the Star Jewel' to his son William in 1681, asking also that 12 gold rings of the value of £6 or £7 should be given to the gentlemen who were the bearers at his funeral.[20]

Nevertheless, by 1708 the Drake Star was in the possession of Joseph Drake, brother of Francis Drake, 2nd Baronet, who bequeathed it to his great nephew, Francis

Henry Drake, who succeeded as 4th Baronet in 1718 and received from his father the Drake Jewel.[21] Both Star and Jewel descended in the family and the Drake Jewel, as one of the great Tudor jewels associated with a hero of legendary status in the nineteenth century, was worn by Lady Seaton. In her portrait by Edwin Long, painted in 1884, she stands with the Armada fleets behind her and the Jewel at her neck (pl.187).[22] By this time it had acquired an extra cluster of pearls rather than the single pendant pearl shown in Drake's portrait.

Cameos and intaglios

Cameos, such as that at the centre of the Drake Jewel, stood a better chance of survival than precious stones. Over 50 cameo portraits of Elizabeth have come down to us, more than of any contemporary European monarch.[23] Typically, the profile faces left, and she wears a ruff on her neck and jewellery or insignia on her bodice. This is the image of Elizabeth from the mid-1570s to the end of her reign. Large cameos, of the size of the Sieve Cameo (pl.188), were worn prominently by leading courtiers, at their waists on long chains or ribbons. The cameos proclaim loyalty to the monarch, and the courtiers' proximity to her. They were the epitome of Elizabethan taste, patriotism and the cult of the Queen.

No gift from Elizabeth could be more appropriate. In 1598 a cameo reached Russia among the presents sent by Elizabeth with Francis Cherry: 'a gold stud and with it a stone, and on the stone a carved image of the Queen'. Julia Kagan suggests that this cameo may have served as the model for the carving of a portrait of Tsar Boris Godunov.[24]

In the large cameo (pl.188) Elizabeth holds a sieve in her hand, a symbol found in painted portraits from 1579 onwards. It alludes to the Vestal Virgin Tuccia who, to prove her chastity, was said to have carried water in a sieve, without spilling a drop, from the Tiber to the Temple of Vesta. In the case of Elizabeth the sieve stands for her virginity, perceived as one of the virtues that had made possible 'continuall peace … with sundry miracles, contrary to all hope' during the first 20 years of her reign.[25]

Both the Sieve Cameo, mounted in a thin gold band, and the small cameo (pl.189) lack the richly enamelled and stone-set mounts that would once have held them. The small cameo would probably have been worn in a ring. The fairy Queen Mab in *Romeo and Juliet* was described as 'no bigger than an agate-stone / On the fore-finger of an alderman'.[26] If the Cheapside Hoard, to which the cameo belongs, was the stock of a

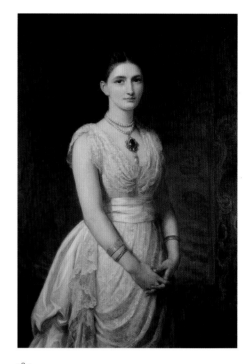

187
EDWIN LONG
Portrait of Lady Seaton
Oil on canvas, 1884
Plymouth City Museum and Art Gallery

188 (*far left*)
Cameo of Elizabeth I with a sieve
Probably London, England, *c.*1579–85
Sardonyx
V&A: 1603–1855

189 (*left*)
Cameo of Elizabeth I
Probably London, England, *c.*1575–1603
Sardonyx
Museum of London
A14063

London jeweller, it may have been he who plundered it for its gold setting within 50 years of its carving.

The third cameo of Elizabeth, the Barbor Jewel (pls 190 and 191), is set with rubies and diamonds, yet it too may have lost an earlier setting, because the delicate enamelled ornament derives its attenuated triangular leaves and dotted trails from the pea-pod style which originated in about 1615 (see, for example, pl.192, a design by Hans Georg Mosbach, published in Paris in 1626).[27] The cameo is said to have been owned by William Barbor (1540–1586), who according to the family story owed his escape from burning as a heretic under Queen Mary to the accession of Queen Elizabeth. His descendants honoured his memory and the cameo of his Queen, but did not hestitate to reset the stone in the latest Continental fashion.

Tudor and early Stuart heraldic seal rings survive in considerable numbers, and are represented here in gold by the Boteler Ring (pl.193), of about 1580, found 'stuck on the tooth of a harrow' on Boteler land in Kent in the last years of the eighteenth century, and a ring with a swivelling bezel engraved with the arms of Throckmorton and Carew (pls 194 and 195).[28] The latter belonged to Sir Nicholas Throckmorton (1562–1643), who changed his name in 1611 to Carew when he inherited the estates of his uncle, Sir Francis Carew of Beddington. His sister married Sir Walter Raleigh, who was confined in the Tower of London and writing his *History of the World* when this ring was probably made.

The earliest seal ring in the exhibition is mounted with an intaglio portrait of the ageing Henry VIII (pl.196), probably carved in the 1540s. It was used to seal a document in 1576 by Dorothy Abington (or Habington) of Hindlip, the second wife of John Habington, cofferer (treasurer of the household below stairs) to Queen Elizabeth.[29] Two

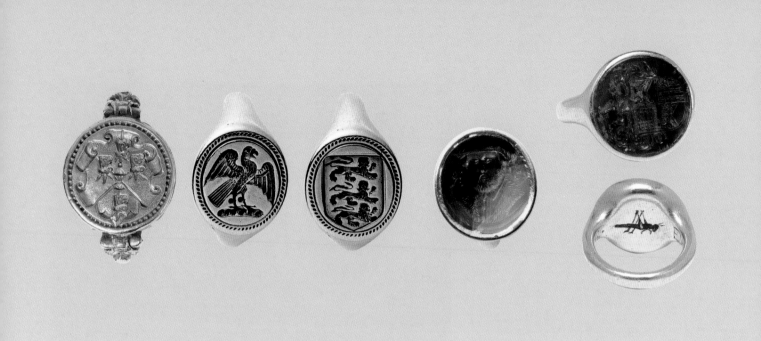

of his sons were in the circle of Anthony Babington whose plot to replace Elizabeth with Mary Queen of Scots was exposed in 1586. Edward, the elder son, was executed, while Thomas, the younger, Elizabeth's godson, was spared. He survived even the aftermath of the Gunpowder Plot in 1605, when Hindlip House was searched and found to contain 11 'secret corners and conveyances' concealing four Jesuit priests and brothers, including the master creator of such spaces, Nicholas Owen.[30]

The Lee Ring (pl.197) bears the arms of the military engineer and architect Sir Richard Lee (1501/2–1575), showing the crest of a flaming sword. He won his knighthood for his part in the assault on Edinburgh in 1544.[31] The ring is one of seven that features on the outside the arms of an individual and on the inside an enamelled green grasshopper (pl.198), the badge of Sir Thomas Gresham, merchant, royal agent, founder of the Royal Exchange, and the presumed donor of all seven rings to a range of associates.[32] As agent, in 1552 he purchased in Antwerp for Edward VI a 'greate table Dyamounte ring sett in fayer worke enameled blacke redd white and blewe' in a case of 'Leather gilte and velvet within'.[33] The investment by Gresham's older brother, John, in Richard Chancellor's expedition to Russia in 1553 and in the Muscovy Company in 1555 was probably passive.[34]

Engraving a stone of the hardness of sapphire was a virtuoso undertaking: the Knyvett Seal (pls 199 and 200), made in around 1580–90, is an ambitious jewel, possibly saved from recutting by the extent and depth of the engraving of the arms. Among the Knyvetts who might have commissioned it was Sir Thomas, later Baron, Knyvett (1545/6–1622). As Keeper of Whitehall Palace, he searched the vaults under the House of Lords on the night of 4 November 1605 and found Guy Fawkes standing guard over 36 barrels of gunpowder concealed by brushwood and ready for detonation the next day during the opening of Parliament.[35]

Following in the tradition of the Renaissance connoisseurs of Continental Europe, James I bought a collection of gems for Henry, Prince of Wales, and George Villiers, Duke of Buckingham (1592–1628), favourite of both James I and Charles I, acquired much of the gem collection of the artist Peter Paul Rubens.[36] The most important collection in England, however, which included a fine Graeco-Roman intaglio sapphire in

193 (*above, far left*)
The Boteler Ring
England, *c.*1580
Gold, engraved and cast
V&A: M.99–1984

194 and 195 (*above, second and third from left*)
Signet ring
Swivelling gold bezel engraved with the
crest of Throckmorton (pl.194)
and the arms of Carew (pl.195)
England, 1611–43
Gold, engraved
V&A: 808–1871

196 (*above, second from right*)
Seal ring with intaglio of Henry VIII
London, England, *c.*1545
Gold, engraved chalcedony intaglio
V&A: M.5–1960
Frank Ward Bequest

197 (*above, far right top*)
The Lee Ring
London, England, 1544–75
Gold with reverse painted, gilded
and silvered chalcedony intaglio, engraved
with the arms of Sir Richard Lee
V&A: M.249–1928

198 (*above, far right bottom*)
The Lee Ring
London, England, 1544–75
Reverse of the gold bezel enamelled with the
grasshopper badge of Sir Thomas Gresham
V&A: M.249–1928

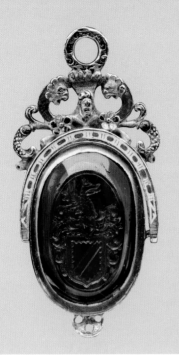

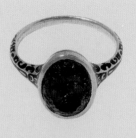

199 (*above left*)
The Knyvett Seal
London, England, *c.*1580–90
Gold, enamel, mounted sapphire intaglio,
engraved with the arms of Knyvett
V&A: M.52–1980

200 (*above centre*)
Case for The Knyvett Seal
London, England, *c.*1580–90
Gold, enamel
V&A: M.52A–1980

201 (*above right*)
Ring with Medusa intaglio
Western Europe, intaglio
100 BC–AD 100, ring *c.*1600
Gold, enamel, sapphire intaglio
V&A: M.553–1910
Salting Bequest

202
HANS VAN GHEMERT, design for
the shoulder and bezel of a ring
Probably Germany, 1585. Blackwork.
V&A: 16969

an enamelled blackwork mount of about 1600 (pls 201 and 202), was acquired by the pre-eminent English collector of antiquities, drawings, pictures and books, Thomas, 14th Earl of Arundel (1585–1646). The collection, which had been offered first to Charles I, was purchased in Italy by Arundel's agent, William Petty, from the dealer Daniel Nys, the probable source being the Gonzaga dukes of Mantua.[37] The collection reached England after a hazardous journey in 1638, only to leave with Arundel when he departed for the Continent in 1642.

The Lulls Album

Apart from surviving jewels, 'the most valuable single source of information' on early seventeenth-century English jewellery is an album associated with Arnold Lulls, a merchant and jeweller born in Antwerp, who was active in London by 1584.[38] In partnership with Sir John Spilman and Sir William Herrick, the royal jewellers, Lulls provided jewels to James I and Queen Anne. Among the records of these transactions is a letter, datable to 1612, pasted into the album, which lists jewels supplied by Herrick and Lulls to James I for £3,039.[39] To Queen Anne, James gave 'a great round perle' (£900), to Prince Henry a chain and a George, the Garter insignia (£800), and to Prince Charles a jewel (£130).

The letter and two of the other sheets pasted into the album include Lulls's name or initials, and the album later belonged to a John Blackwell, probably Lulls's grandson of the same name.[40] All the evidence points to the album as having been in Lulls's ownership, but it has not been established whether he initiated its making or whether his papers were added to an existing album. The album consists mainly of carefully finished record drawings of jewels executed on vellum, the jewels ranging in date from the late 1550s to about 1610, but the drawings made over a much shorter period. Predominantly they show the growing Jacobean taste for non-figurative jewellery in which the art was to maximize the prominence of the gemstones and minimize the visibility of the setting. An aigrette (pl.203) includes six-facet rose-cut diamonds at the top of each spray, V-cut stones set in shields on either side of the sprays, and many table-cut diamonds, of which the largest has a stellar-cut pavilion (facets around the culet at the base of the stone).[41]

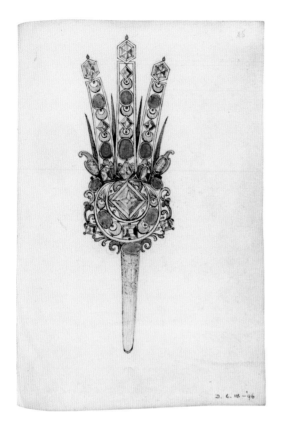

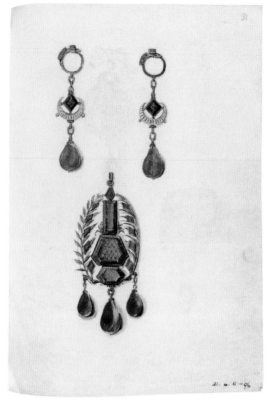

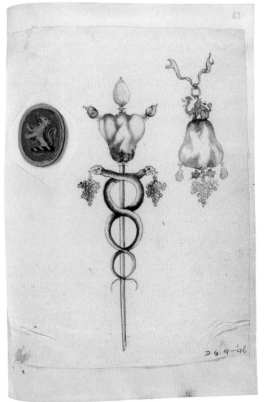

203 (*above left*)
Drawing of an aigrette
England, *c.*1610–20
Pen and ink, and watercolour on vellum
V&A: D.6.18–1896

204 (*above*)
Drawings of earrings and a pendant
England, *c.*1610
Pen and ink, watercolour, body-colour
and gold on vellum
V&A: D.6.11–1896

205 (*left*)
Drawings of a hairpin, pendant
and seal matrix
From the Lulls album, page 47
Possibly made to the direction of
Arnold Lulls, England, *c.*1584–1642
Pen and ink and watercolour on laid
paper (middle and right drawings);
watercolour, bodycolour and gold paint
on laid paper (left drawing)
V&A: D.6.19–1896

206 (*right*)
Grape pendant
London, England, *c.*1600–40
Gold, amethyst
Museum of London
A14186

207 (*far right*)
Grape pendant
London, England, *c.*1600–40
Gold, amethyst
Museum of London
A14187

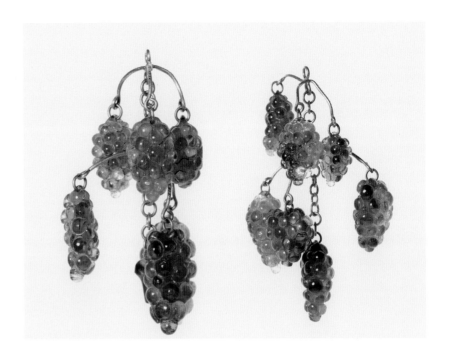

Prominent on three of the added pages are drawings of jewels hung with bunches of purple grapes (for example, pl.205), which provide a parallel to the superb amethyst pendants in the Cheapside Hoard (pls 206 and 207), which has equally enticing green grapes carved from emerald.[42] The pendants are among more than 400 objects found in 1912 in an old wooden casket when the floor of a house in Cheapside, a centre of goldsmithing in London during the early seventeenth century, was being broken up. The hoard was probably concealed in the 1640s during the Civil War.[43]

Amethyst and emerald grape pendants were owned by Lulls's oldest daughter, Susanna Edmonds. In her will, made in 1653, which has been brought to light by Vivienne Larminie, they are listed as 'two Redd Amathist grape pendants hanging att two hands five small Rubies above each hand' and 'my greene Emerald Grape Pendant hanging att a hand and on each side a diamond in the middle of two Leaves'.[44] Susanna's seal with 'a Lyon engraven in a stone', which was 'sett in gold upon a dogge', may explain, and could perhaps be, the seal added on a slip of paper to one of the sheets pasted into the album (pl.205). The seal depicted probably had a transparent intaglio stone of which the reverse had been gilded and painted to provide the colours, as in the Lee Ring, where, however, the colours have largely faded (see pl.198). The pearl pendants hanging from snakes described in Susanna's will find echoes in a number of designs in the album, including the earrings shown in pl.204. Among many jewels, silver vessels and articles of furnishing, she possessed a pair of scissors that had belonged to Queen Elizabeth, some Muscovy money and a topaz watchcase, which recalls a watch set into an emerald in the Cheapside Hoard.[45] The will is a striking example of a woman disposing of her jewellery without constraint. When marrying for the second time in 1646, Susanna had made an agreement with her husband, Simon Edmonds, that she could dispose of a schedule of items as she wished. She relished the task of making her will, listing her jewellery with precision. Larminie notes that not one member of the family of her first husband John Newdigate appeared as a beneficiary. Instead, she left her jewellery to her siblings and their children, who were the descendants of Arnold Lulls, and to her second husband and his relations.

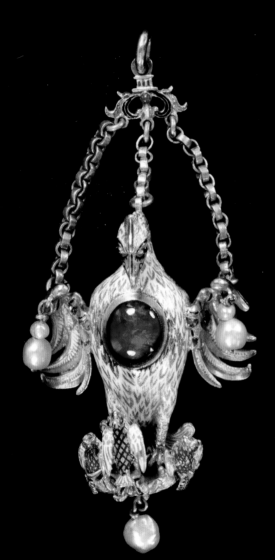

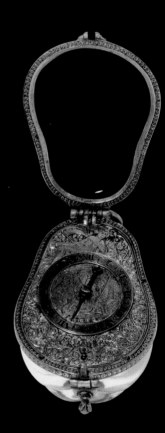

208 (*opposite, top left*)
Serjeant-at-Law's ring
London, England, *c.*1531
Engraved gold
V&A: M.52–1960
Given by Dame Joan Evans

209 (*opposite, bottom left*)
Pendant: The Pelican in her Piety
Probably Spain, *c.*1550–75
Enamelled gold, set with a
foiled ruby simulant (rock
crystal with a red adhesive
layer) and hung with pearls
V&A: 335–1870

210 (*opposite, top right*)
Memento mori ring
England, 1550–1600
Engraved gold and enamel
V&A: 13–1888
Bequeathed by Miss Charlotte
Frances Gerard

211 (*opposite, bottom right*)
Watch
Edward East
London, England, *c.*1635
Rock crystal, gilt-brass,
steel, silver hour ring and
enamelled numerals
V&A: M.360–1927
Given by Miss Eva M. Earle
of Great Yeldham

212 (*right top*)
Ring with cameo of Charles I
England, before 1649; the cameo
attributed to Thomas Rawlins
Gold, carnelian cameo, enamel, rose-
cut diamonds set in silver
Private collection

213 (*right middle*)
Robert Taylor's Grasshopper Ring
London, England, 1575
Engraved gold, with reverse
painted, gilded and silvered crystal
intaglio; back of bezel enamelled
with a grasshopper
Private collection

214 (*right bottom*)
Ring with miniature of Charles I
England, ring, *c.*1780;
miniature, *c.*1649–1700
Gold with a miniature painted
in enamel set under rock crystal
V&A: M.1–1909
Bequeathed by Miss A. Cameron

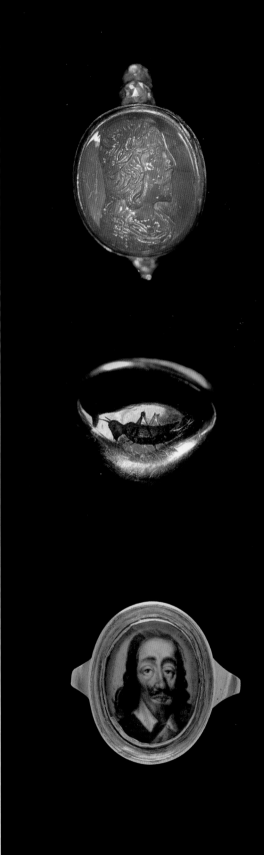

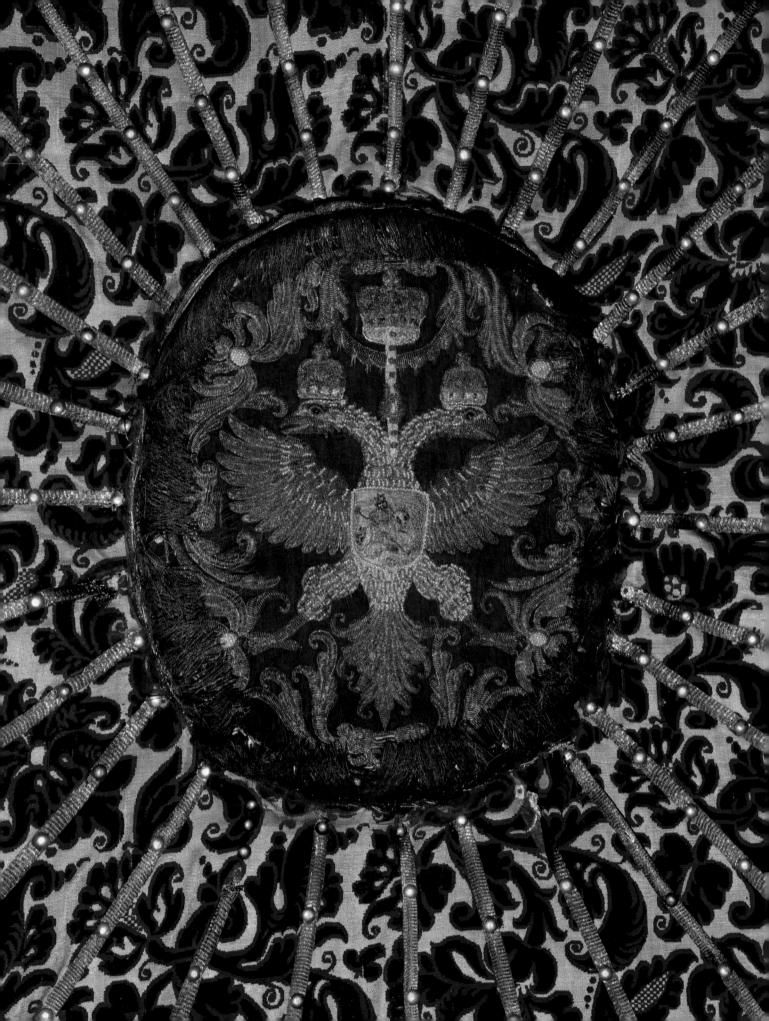

Julian Munby

THE MOSCOW COACH: 'A RICH CHARIOT, ONE PARCELL OF THE GREAT PRESENT'

215 (*opposite*)
Double-headed eagle crest inside the canopy of the Moscow coach, pl.220

216 (*below*)
Preparatory drawing for engraving in Braun and Hogenburg's atlas, *Civitates Orbis Terrarum* showing Queen Elizabeth approaching Nonsuch Palace in a coach, 1568 British Museum, London Acc.1943-10-9-35

Coaches were new to Europe in the mid-sixteenth century. The fashion for riding in horse-drawn carriages may have originated in Hungary in the fifteenth century, and spread to Italy in the early sixteenth century. By the middle of the century we find an almost simultaneous appearance of the 'coach' in European capital cities. Within a short time they were used by royalty and aristocrats, followed by others, contributing, along with the four-wheeled wagon, to a transport revolution that saw traffic jams in cities – and led Stow to remark that 'the world runs on wheels with many, whose parents were glad to go on foot'.[1]

The first coach in England may have been the 1557 gift from the Republic of Venice to Queen Mary (r.1553–58), though tradition gives as the first example the coach owned by the Earl of Rutland and made in 1555, and Queen Elizabeth (r.1558–1603) had the first of her many coaches in 1564.[2] What constituted a 'coach' is rather a mystery; what is certain is that the name did not derive from either the means of suspension of a box on straps (which had emerged much earlier), or the use of springs (which came much later).[3] Whatever the tradition of the Hungarian '*kotchi*', this new concept in travel became associated with narrow square-sided four-poster carriage bodies, such as are depicted in the view of Queen Elizabeth visiting Nonsuch Palace (pl.216), and the earliest examples

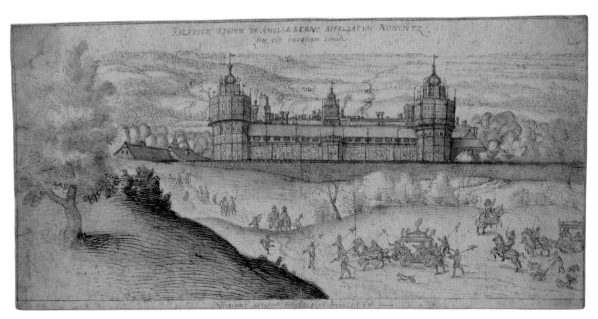

PALATIVM REGIVM IN ANGLIÆ REGNO APPELLATVM NONCIVTZ.

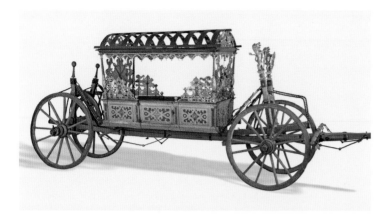

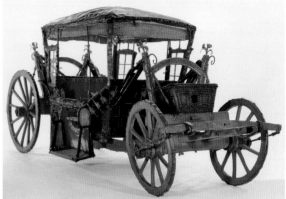

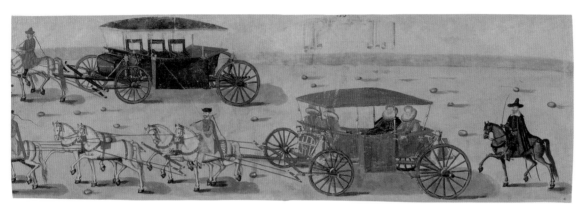

of which survive today at Veste Coburg in Germany (pl.217).[4] Queen Elizabeth spent extravagant amounts during 40 years of building and fitting out her coaches with gold and silver silk and other fabrics (typically, more than £500 worth of fabric on a body costing £200), while her later coaches – and those of James I – were painted and decorated by court painters.[5]

In around 1600 a new type of coach came into use across Europe, as can be seen in many contemporary paintings. Compared with the earlier ones, these are larger, more generously proportioned 'four-posters', like those depicted in the so-called *Stockholm Roll* of the 1605 wedding procession in Krakow of King Sigismund III and Archduchess Constance of Austria (pl.219).[6] These coaches were richly upholstered and hung with curtains, had no fixed windows and were covered with black leather, or painted and decorated. There are only two surviving examples of these new style coaches: the one taken to Moscow by the ambassador Thomas Smith in 1604, and the coach of King Filipe II driven into Lisbon during his triumphal entry of 1619 (pl.218).[7]

These gifts were not entirely unusual. By the early seventeenth century the coach had become a high-status gift accepted as appropriate for royal and imperial exchange and succeeded the fine horses that had so often been presented by rulers to one another. As early as 1599 Elizabeth I sent a 'great and curious present' to 'the Grand Turk', Sultan Mohamed III.[8] The gift included a mechanical organ for the harem at the Topkapı Palace, delivered by its maker, Thomas Dallam, who eventually returned and published an account of his adventures.[9] Travelling with him was the coachman Edward Hale, who delivered the coach. An earlier embassy, in 1593, had led to an exchange of

217 (*above left*)
Wedding carriage of
Dorothea of Denmark, 1561
Art Collection of the Veste Coburg

218 (*above right*)
Coach of Filipe II, 1619
Museu Nacional dos Coches, Lisbon

219 (*above*)
The 'Stockholm Roll' (detail), 1605
Royal Castle Warsaw (ZKW/1528)

presents with the 'Sultana' Safiye (first Lady of the Harem), and later it was suggested that Queen Elizabeth should 'retorne a coache richelye furnished' with her answers to the Sultana's letters.[10] The embassy arrived at Constantinople in August 1599, and the coach 'of six hundred pounds value' was given to the Sultana by the ambassador's secretary, Mr Paul Pindar. The Queen Mother (as she now was) 'did take great liking to Mr Pinder' as well as the coach,[11] rewarded the coachman, and took to riding in her new carriage.[12] In a charming sequel to this event the Sultana asked for a portrait of Elizabeth, and then sent her own presents and a personal letter of thanks, written and sealed in the harem, which still survives today.[13]

Sir Thomas Roe (1581–1644) was sent by James I to India in 1615–16, as ambassador on a mission to the Mogul Jahangir (r. 1605–27) at Ajmer, aimed at establishing an English place in Indian trade. Again the embassy is recorded in contemporary accounts, and gifts included a coach, complete with coachman and musicians.[14] Roe was embarrassed by the coach's faded fabrics and the lack of horses, but the coach was drawn by bullocks and then by hand into the royal court, where it was received successfully, and the Mogul was pulled around in the coach, attired in English fashion, to the accompaniment of music. Later the coach was re-upholstered and given to his Queen Nur Jahan, while further replica coaches were made for the royal court, sumptuously adorned with Indian fabrics, driven by the English coachman (in equally sumptuous Indian livery). The Great Mogul even rode off to war with this curious procession of English coaches.

The 1604 Embassy to Moscow

Sir Thomas Smith (1558?–1625) was sent as a special ambassador to Tsar Boris Godunov, leaving Gravesend on 13 June 1604, and reaching Archangel on 22 July, from where he travelled to Moscow and was escorted into the presence of the Tsar on 11 October 1604.[15] A detailed account of his travels published in 1605 tells the extraordinary story of the 600-mile journey by river from Archangel to Vologda, and the remaining 300 miles over land to Moscow.[16] Smith travelled by coach, until on the final approach he mounted his horse. With trumpets sounding, he was met by a gentleman of the Tsar's stable, given a 'very gorgeously trapped' horse, and proceeded on this mount into Moscow.[17]

Within a few days Smith learned that the Tsar was ready to see him, and that the Emperor's horses would be provided for him to ride, and also 'two gallant white Palfreis to carrie or draw a rich Chariot, one parcell of the great present'.[18] The members of the embassy were brought before the Tsar, kissed his hand and made their speeches. There is no description of the Tsar's reaction to the presents, which included 'a charyott, two great flaggons, a christall cuppe, a bason and ewer, two haunche pottes, one standinge cuppe, one peece of scarlett and fowre peeces of other fine cloathe'.[19] The 'rich chariot' delivered to the Tsar can reasonably be identified as being the highly decorated coach that survives in the Kremlin Armoury Museum. The English party were amazed by the 'great store of massy plate' they were shown, and overwhelmed by the food and drink at the feast. They finally left Moscow in March 1605, having obtained privileges for the Muscovy Company, and began the long return journey. They departed just before the country was gradually plunged into chaos following the death of Boris Godunov in April.[20]

The English coach in the Kremlin

The physical remains of the English missions to Moscow are as remarkable as their history. The English merchants' mansion still survives as The Old English Court in Varvarka

Street in the historic walled centre of Kitai Gorod; it is a rare survival in Moscow of a late medieval house, and enough of a landmark to be shown on early maps of the city.[21] The Kremlin Armoury Museum preserves the finest collection of English sixteenth-century and seventeenth-century silver surviving anywhere,[22] while the magnificent English coach is the oldest of the splendid group of imperial carriages in the Armoury Museum.

The coach, by contrast with the silver, is little known and has been scarcely studied in England. However, the tradition of scholarship associated with the Armoury Museum dates from its foundation in the early nineteenth century, and the opening of its new building in 1852. In studying the coach the early curators were fortunate to have the relevant archives close at hand in the Kremlin and so these – from Alexander Veltman's publication in 1853 to Lyubov Kirillova's carriage catalogue of 2006 – have long been known and studied.[23] The state archives contain much material relating to embassies from Russia's neighbours and trading partners, including lists of ambassadorial gifts, while there are also later records and inventories of the stables department. It is apparent that carriages were a regular and acceptable type of gift. For example, the Polish embassy in 1584 brought a '*kulebka*' and six horses, and in 1590 a 'sledge-coach upholstered in velvet'.[24] The gifts brought by Thomas Smith in 1604 are described in three lists, one of them in English and two in Russian, from which we see that the 'Charyott' was also described as 'a covered sledge (*vozok*) without wheels, bound in red velvet'.[25] The embassy undertaken by the Earl of Carlisle in 1664 again brought a specially prepared carriage, described in the official list of gifts as having 'a large body covered with leather and painted with double-headed eagles in gold'.[26] Records of the Stables Office in the seventeenth century show that carriages were brought from Germany, Austria, Denmark and Holland, either as gifts or by purchase, and that German carriages were especially valued. Coach, and especially sledge making, also became one of the specialist crafts undertaken in the Kremlin for the courts of the Tsar and Patriarch from the sixteenth century onwards.[27]

The English coach appears in the earliest surviving stables inventory of 1706 (based on an earlier list of 1689), and was there ascribed to the year 1625, but this was believed by Veltman to be an error arising from a misreading of Cyrillic numbers and to refer to an earlier date.[28] To add to the confusion there was, in actual fact, a 'coach or charriott of good vallew' being constructed in London in 1624 for presentation to the Tsar, which gave rise to a controversy – resolved by the intervention of the Privy Council – over the quality of silver used for its nails.[29] However, no evidence has been found – that is, in the list of gifts delivered by the ambassador Fabian Smith (Ulyanov) in 1625 – that this carriage was ever taken to Moscow.[30]

The documentation of later changes to the English carriage is also of interest, for accounts survive for the repair of the coach in 1678 in order to receive a Polish embassy. Under the supervision of the court painter Ivan Bezmin, new wheels were provided and the hanging fabrics and a large amount of ironwork were replaced. The upholstered chair (pl.221) was also transferred from another of Tsar Mikhail Romanov's vehicles.[31]

The Moscow coach: a description

The coach has not previously been subject to a full analysis and record, though a magnificent model at a scale of 1:6 was made by the late David Wray in 1974 for the National Museum of Science and Industry, South Kensington, following a study tour to Moscow with the photographer Tom Foxall.[32] It consists of an undercarriage and wheels, with

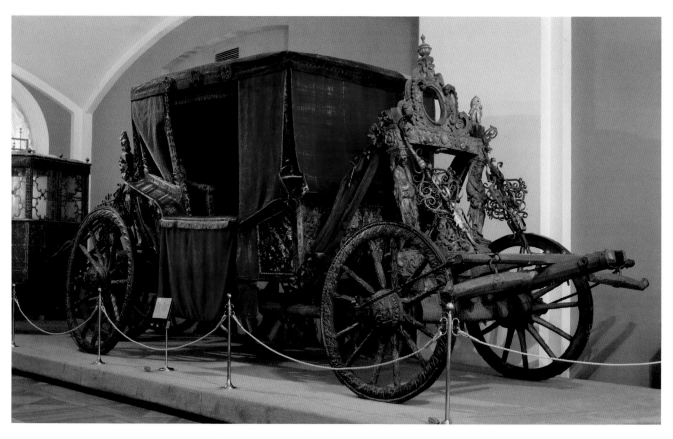

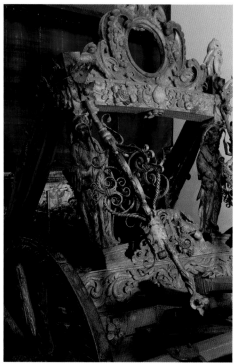

standards, mounted on the fore and rear axles, that carry the carriage body on leather straps. The body is decorated with carving and paintwork, and hung with fabrics (pl.220).

The undercarriage itself is remarkably like that of a farm wagon, and as such of very ancient lineage. It is based on a long, gently curved perch of heavy section joining the fore and rear carriages and braced to the axles. The perch was fixed to the axle at the rear, but at the front is fixed only to the upper axle (bolster) and pinned to the lower axle to allow for turning. The wheels can move at least 40 degrees, meaning that the coach can easily be turned within its own length. Like all timber constructions, it has numerous iron elements that either hold parts together or provide support, especially where – such as the wheels and rotating fore-axle – there is movement between parts (pl.222).

The carriage was designed to be drawn by a team of four or six horses attached to a central pole. The wheels, which are carved and gilded, were replaced in 1678. Early stable accounts in England show that, generally, the replacement of wheels – and even the entire undercarriage – was frequently necessary.

The coach body is hung at each corner by leather straps hanging from the standards (frames of two uprights) and a transom mounted on front and rear axles. The standards are stabilized by strong iron (or steel) rods that secure them to the undercarriage. All the metalwork was painted or gilded, and had stamped decoration or added elaboration with plain and twisted scrolls. As was usual at this period there are no springs, and the leather straps were attached by decorative iron shackles. Perhaps the only potential for movement was in the perch between the axles, which must have been partly able to bend.

The standards are decorated with painted or gilded carving, showing flowing leaf patterns and swags of fruit and leaves. The four posts of the standards are topped by the supporters of the royal arms (lion and unicorn at the rear and, at the front, a griffin but missing the greyhound). At the rear are panels displaying the imperial arms with Saint George and the dragon (whose patronage is shared by Moscow and England). The front panels are cartouches of fruit (the upper one perhaps a later replacement). The four standard posts are treated like columns occupied by full-length figures: a king and a bearded figure with a severed head at the front; and a male warrior holding a club and female warrior with a musket at the back.

The body itself is extremely simple in form, but elaborately decorated. Structurally it consists of a base frame and a plank floor (2.45 × 1.37 m), with four posts on each side supporting a shallow domed roof. The upper part is open while the lower part is panelled, with an opening on each side and a wooden step hung from an iron frame. These were covered with a curtain falling from an upholstered armrest, which is placed across the door to provide support for the hapless servant riding in the 'boot' on either side. The eight canopy posts are covered in velvet and have bases and capitals carved on each side with animals (on the bases) and birds (on the capitals). The two large end panels are carved with battle scenes (pl.223), and the four side panels with hunting scenes. Above the panels is a curved cornice and frieze, with carved fruit and flowers, interspersed with panels painted with hunting and landscape scenes. Overhanging this is a 'mudguard' of red velvet mounted on iron rails supported by gilt iron brackets. The roof canopy is formed of radiating ribs curving down to side frames, covered on the exterior with leather and cut and uncut velvet on a satin ground. The seating within the body consists of an upholstered bench slung on leather straps at the front, and at the rear a throne upholstered in Iranian velvet (a later addition), with a fixed bench between them.

223
Detail of the Moscow coach (pl.220)

224 (*below left*)
Detail of the Moscow coach (pl.220)

225 (*opposite*)
Detail of the Moscow coach (pl.220)

The military subjects on the end panels were perhaps looking forward to prospective Russian involvement against the Turks. The rear panel depicts a vigorous battle, perhaps Ivan the Terrible's victory over the Tatars at Kazan in 1552, or Boris Godunov's defeat of the Crimean Tatars of the Khan Kazy-Giray outside Moscow in 1591.[33] The two armies are readily identifiable, the Tatars bearing the crescent standard and wearing turbans. The front panel shows the Tsar returning in a triumphal procession, seated in a chariot surrounded by jubilant troops. The carving is lively and colourful, and could well derive from prints and engravings of Old Testament battles such as those of the Swiss woodcutter Jost Amman (1539–1591) in the illustrated Bible of around 1565 where Joshua's opponent is similarly turbanned and carries a crescent standard.[34]

The four side panels depict hunting scenes in high and colourful relief with some landscape features such as trees; the two forward panels have hunters in western costume hunting boar and bear (pl.224), while the two rear panels show hunters wearing turbans trailing a lion and leopard (pl.225). The iconographical source for these panels, like so much decorative work of the period, is likely to be an engraving.[35] A close parallel is found in the near-contemporary views of the Medici villas by the Flemish artist Giusto Utens (d.1609), where the hunting of boar and stag occurs in villa landscapes and the hunters display similar dress and posture, suggesting a common source.[36]

Each of the sculpted panels has a painted border, with floral designs on the upright posts and base, two of which have trophies or arms. The top rail has hunting scenes of similar character to the painted frieze above it. The paintings were restored and re-gilded in the 1670s by the Russian artist Ivan Bezmin (d.1696).[37] The scenes of hunting, fishing and fowling are placed within rural landscapes with buildings, ruins and trees, simply but carefully drawn in a rather impressionistic manner. They are clearly of Netherlandish origin.

It is most likely that the coach was made near Smithfield in London as the coach-building trade was first centred in Cow Lane, between Smithfield and Holborn, and only gradually moved westwards later, during the seventeenth century. It was probably constructed by the leading practitioners, although no evidence for its manufacture has been found. Queen Elizabeth I's last coaches, of 1600–3, were built by Walter Ripon or Robert More, with ironwork by Thomas Larkin and decoration by Marcus Gheeraerts the Younger (1561/2–1636) or Leonard Fryer, the Queen's Serjeant Painter (1596–1607). The first coaches built for James I in 1604 were made by John Banks and Robert More, with ironwork by Thomas Larkin, and decorated by Leonard Fryer (followed by his successor as Serjeant Painter, John de Critz the Elder).[38]

The coach provided a highly decorated ambience that moved around with the person of the monarch, providing a richly coloured and textured context for the fine costumes and jewellery of its occupants. In addition, its size and height gave it a presence, and it formed an ideal mobile stage for parading before crowds, presenting its occupants to the people. Even without proper windows it gave some protection from the weather, and was in many ways more practical than riding on horseback. We cannot know how far it travelled, but it was certainly used for ceremonial journeys in Moscow and was very likely used for visits to nearby palaces and monasteries. But for the survival of the Moscow coach we would have no idea of what one of these royal coaches might have looked like, and it is a matter of some wonder that this extraordinary machine has been so little known.

FROM WHITEHALL TO THE KREMLIN: THE DIPLOMACY AND POLITICAL CULTURE OF THE ENGLISH AND RUSSIAN COURTS

1 *Letopis' Dvinskaya [The Dvina Chronicle]* (Moscow 1889), pp.10–13. For the story of early trade and diplomatic relations, see Alexeev 1982, Anderson 1958, Bogushevsky 1878, Dmitrieva 2006, Gamel 1856, Gamel 1865–9, Hamel 1875, Konovalov 1953, Lyubimenko 1933, Martens 1891, Nikashidze 1956, Sokolov 1992, Stuart 1917, Tolstoy 1873, Tolstoy 1875, Vinogradoff 1981, Wretts-Smith 1920, Yakobson 1934–5.

2 'The Charter of the Marchants of Russia, graunted upon the discovery of the saide Countrey, by King Philip and Queene Marie.' – Hakluyt 1598, pp.267–72.

3 'A copie of the first Privileges graunted by the Emperour of Russia to the English Marchants in the yeere 1555.' – Hakluyt 1598, pp.265–7.

4 On the history of trade links and the Muscovy Company, see Arel 1995, Baron 1979, Bushkovitch 1980, Cherkashina 1952, Dyomkin 1994, Gerson 1912, Lyubimenko 1911, Lyubimenko 1912, Lyubimenko 1916, Lyubimenko 1923, Lyubimenko 1933, Page 1912, Willan 1953, Willan 1956.

5 On Jenkinson and his voyages, see Hakluyt 1598, pp.310–14, 324–35, 339–40, 341–52, 402–11; Early Voyages 1886, Huttenbach 1972, Huttenbach 1975, Morton 1962.

6 'The Priviledges graunted by the Emperour of Russia to the English mechants of that company: obtained by the 22 of September, Anno 1567, by M. Anthony Ienkinson.' – Hakluyt 1598, pp.372–4.

7 A brief account of Russia's policy during this period can be found in Lurye 1961, Buganov 1994. For an overview of Anglo-Russian relations at that stage, see Bushkovitch 1994, pp.8–17.

8 The secret task of the ambassadors Fyodor Pisemsky and Neudacha Khovralev in 1582 was to see the Queen's niece Mary Hastings, a potential bride for Ivan the Terrible. – *Ambassadors' Travels 1954*, pp.149–55. It is likely that Shakespeare's famous 'Russian' scene (Act 5, Scene 2) in his *Love's Labour's Lost* (1598) was inspired by the arrival of Pisemsky to London.

9 In a secret letter of 18 May 1570 the Queen stated: 'We enter into a friendly and sisterly league to continue forever with you – great Lord and Emperor – as a mighty prince and our dear brother Emperor Lord and Great Duke of all Russia. Which league we will so observe and keep forever, as to bind ourselves and with our mutual and common forces to withstand and offend all such as shall be common enemies to us both and to defend each of our princely honors the estate of our realms and countries and to help aid and favour each of us the other with mutual helps and aids against our common enemies…' – Tolstoy 1875A, p.91.

10 For the political reasons for this decision, see Bushkovitch 1994, pp.14–15.

11 Bushkovitch 1994, pp.37–47.

12 A report of Mikulin's mission is published in *Ambassadors' Travels 1954*, pp.156–205.

13 The account of this mission was published as a separate edition: Smith 1605. See also Bogatyrov 1995, Arel and Bogatyryov 1997.

14 For an analysis of the international situation during this period, see Jansson and Rogozhin 1994, pp.47–71; Dukes, Herd and Kotilaine 2009, pp.25–53.

15 The National Archive, PRO, State Papers, Foreign, 91/1, fol.228v; Proekt vzyatiya Moscovskogo gosudarstva pod pokrovitel'stvo Anglii, predlozhennyi angliyskim rezidentom Dzhonom Merikom [Plan for taking the Muscovite state under English protection, put forward by the English resident John Merrick]; Chteniya Moscovskogo Obshchestva istorii I drevnostey Rossiyskikh [Readings of the Moscow Society of Russian History and Antiquities] (Moscow 1874), vol.3, pp.76–81; Lyubimenko 1914A; Dunning 1982; Dunning 1989.

16 Cited in Dukes, Herd and Kotilaine 2009, p.28.

17 An account of Zyuzin's journey was published in Jansson and Rogozhin 1994, pp.145–202.

18 Bushkovitch 1994, pp.1–7.

19 On the career of John Merrick, see Phipps 1983.

20 Dukes, Herd and Kotilaine 2009, p.50.

21 Hakluyt 1598, p.249.

22 Hakluyt 1598, pp.249, 250.

23 For more on Russian diplomatic protocol, see Rogozhin 2003, Yuzefovich 1988, Zagorodnaya 2006.

24 'Extracts out of Sir Ierome Horseys Observations in Seventeene yeeres travels and experience in Russia, and other countries adioyning' – Purchas 1626, p.983.

25 Zagorodnaya 2006, p.187.

26 Zagorodnaya 2006, p.190.

27 Cited in Glanville in Dmitrieva and Abramova 2006, p.48.

28 Tolstoy 1875, no.28, p.114.

29 'The Ambassage of the right worshipfull Master Thomas Pandolfe, Esquire, to the Emperour of Russia, in the yeere 1568, briefly written by himselfe' – Hakluyt 1598, pp.376–8; 'A copie of the priviledges granted by the right high and mightie Prince, the Emperour of Russia, &c.' – Hakluyt 1598, pp.379–82.

30 'A briefe discourse of the voyage of Sir Ierome Boyes knight, her Maiesties ambassadour to Ivan Vasilvich, the Emperour of Muscovia, in the yeere 1583' – Hakluyt 1598, pp.458–64.

31 Letters exchanged by Elizabeth I, Lord Burghley and Russian Tsars reflecting Russian displeasure at the behaviour of some British ambassadors – Hakluyt 1598, pp.498–505.

32 *Holinshed's Chronicles*, vol.IV, p.86.

33 *Ambassadors' Travels 1954*.

34 T.E. Hartley (ed.), *Proceedings in the Parliaments of Elizabeth I*, vol.I, 1558–81 (Leicester 1981), p.186.

35 Dukes, Herd and Kotilaine 2009, p.38.

36 *Ambassadors' Travels 1954*, pp.128, 153, 169–70.

37 *Ambassadors' Travels 1954*, pp.119–20, 136–7, 172–3, 175–7, 183, 197–8.

38 *Ambassadors' Travels 1954*, p.177.

39 Cited in Dukes, Herd and Kotilaine 2009, p.37.

40 *Ambassadors' Travels 1954*, pp.177–8.

41 According to Zyuzin's report, 'the conductor, Sir Thomas, the gentlemen, and the merchants, began to drink the cup to their Great Sovereign, King James, sitting at the table, and only removed their hats but did not stand. And the ambassadors, at the King's name, stood to drink the cup to his health and they said … that it is not proper to drink the sovereign's cup sitting. Not only for you, his royal Majesty's born servants, but for us the servants of his Tsar's Majesty, it is not proper to do that, that it does not give honor to your sovereign.' – Alexei Zyuzin's account in Jansson and Rogozhin 1994, p.157.

42 'The King dined in public with the Moscovian ambassador … and during the dinner James toasted twice with very big goblets to the health of the great lord of Moscovy and to the state. On each occasion the ambassador rose from the table and lay prostrate on the floor until his servant notified him that the King was finished drinking … later the King sent the same vessels goblets with the leftover wine, which was not a little, and gave them all away as a present.' – ibid., p.202, note 300.

43 *Ambassadors' Travels 1954*, p.201.

44 The Russians were told by the English officials: 'Our Great Sovereign King James, for the sake of his beloved brother, your Great Sovereign, his Tsar's Majesty, wanting to see his imperial fraternal love and friendship to himself and favoring you, and decorated, gives you an honor that has never been given to the ambassadors of any other states nor any other foreigners. No one besides you has ever been in the King's presence in these rooms.' – Alexei Zyuzin's account in Jansson and Rogozhin 1994, p.176.

45 According to the English officials, 'for other ambassadors this is not done, not only those who come from various states from apart Christian sovereigns but also for Turkish ambassadors this is not done, they that sit on the King's place'. – Alexei Zyuzin's account in Jansson and Rogozhin 1994, p.169.

46 Alexei Zyuzin's account in Jansson and Rogozhin 1994, p.170.

47 'And King James said to the ambassadors that they should put on their hats, and he reminded them about it twice and three times, and by his royal word he insisted strongly on it and bowed slightly that they put on the hats. And King James himself, and his son, Prince Charles, did not put any hats on themselves, and held them themselves and the Queen stood there according to her own Queenly rule and custom.' – Alexei Zyuzin's account in Jansson and Rogozhin 1994, p.174.

48 M. Mauss, *The Gift: Forms and Functions of Exchange in Archaic Societies* (New York 1967); P. Bourdieu, *Outline of a Theory of Practice* (Cambridge 1977); P. Fumerton, *Cultural Aesthetics: Renaissance Literature and the Practice of Social Ornament* (Chicago 1991); N. Zemon Davies, *The Gift in Sixteenth-Century France* (Oxford 2000); Jansson 2005. An extensive bibliography of theoretical works on the subject can be found in Fumerton 1986.

49 Jansson 2005, p.355.

50 Hakluyt 1598, pp.376–8.

51 During her reign Elizabeth sent Russian Tsars more than 60 personal letters, half of those addressed to Ivan IV, the other half to Tsar Fyodor and Boris Godunov. On her correspondence with Russian counterparts, see Evans 1965, Lyubimenko 1914, Tolstoy 1875.

52 Both Pisemsky in 1582 and Mikulin in 1601 presented the Queen with 42 sable skins which seemed to be a standard quantity – *Ambassadors' Travels 1954*, pp.116, 203–4.

53 *Annals of the Bodleian Library, Oxford, A.D. 1598–1867* (London 1867), pp.309–10.

54 Purchas 1626, pp.988–9.

55 Evelyn Diaries, vol.2, pp.177–7.

56 Kirillova in Dmitrieva and Abramova 2006, pp.196–7.

57 Glanville in Dmitrieva and Abramova 2006, p.52.

58 Purchas 1626, pp.988–9.

59 In 1605, when Sir Thomas Smith, ambassador from James I to Tsar Boris Godunov, was leaving Russia after the successful completion of his mission, John Merrick, the agent of the Company, 'presented his Lordship with a fair standing gilt cup and cover, worth thirty pound, likewise his Prestave and Enterpreter very bountifully'. On his part, the ambassador gave the Russian noble assigned to him 'two standing cups with covers'. – Smith 1605, fols G3v, F2r.

60 Gregory Mikulin was given nine items of silverware as a departure gift from the Queen – one large goblet and two smaller ones with lids, two goblets without lids, two flagons, a basin and a ewer. In his turn he presented Sir Edward Hoby, who had been taking care of the Russian ambassador, with an ermine coat lined with lace and decorated with golden buttonholes, as well as a fox-fur hat, bow and arrows. Hoby's servants received sables. – *Ambassadors' Travels 1954*, p.204.

61 Jansson 2005, pp.364–7.

62 In 1622 Prince Charles added 8 pieces of plate to 15 given by James I to the Russian ambassador Isaac Pogojiy. To distinguish the presents, those from the King were marked with red silk ribbons, those from the Prince with white ones. – Nichols 1968, vol.4, p.647.

63 Glanville in Dmitrieva and Abramova 2006, p.52.

64 Roginsky 1959.

65 *Sobranie gosudarstvennykh gramot I dogovorov* [Collection of State Letters and Agreements], part 3, Moscow 1822, pp.162–4.

66 John Evelyn described the audience of the Russian ambassador with Charles II in his Diary: 'Saw the Audience of the Moscovy Ambassador: for his retinue being numerous, all clad in vests of several Colours, & with buskins after the Eastern manner: Their Caps of furr, & Tunicks richly embrodrd with gold and perle, made a glorious shew: the King being sate under the Canopie in the banqueting house, before the Ambassador went in a grave march the Secretary of the Embassy, holding up his Masters letters of Credence in a crimson-taffaty scarfe before his forehead: The Ambassador then delivered it, with a profound reverence to the King, the King to our Secretary of State; it was written in a long and lofty style: Then came in the present borne by 165 of his retinue, consisting of Mantles & other large pieces lined with Sable, Black fox, Ermine, Persian Carpets, the ground cloth of Gold and Velvet, Sea-morce teeth aboundance, Haukes, such as they sayd never came the like; Horses said to be Persian, Bowes and Arrows &c; which borne by so long a traine rendred it very extraordinary: Wind musick playing all the while in the Galleries above: This finish'd & the Ambassador conveyed by Master of Ceremonies to York house, he was treated with a banquet, that cost 200 pounds, as I was assured …' – Evelyn Diaries, 29 December 1662.

67 W. White, *The Rarities of Russia* (London 1662), p.32.

MERCHANT-CLASS PORTRAITURE IN TUDOR LONDON: 'CUSTOMER' SMITH'S COMMISSION, 1579/80

1 Hans Holbein II, for example; see Foister 2004.

2 See Cooper 2001.

3 See Woodall 2007, pp.415–16. Woodall suggests that these may have been the wealthy English traders who had a headquarters in Antwerp and who were led by Sir Thomas Gresham, who himself was painted by Mor.

4 See Hearn 2012, pp.16–25 (forthcoming).

5 London 1995, pp.11–12.

6 Strong 2004; online edn, January 2008.

7 On Gheeraerts, see Hearn 2002.

8 See Van Mander 1994.

9 Van Mander 1994, pp.357–78.

10 Van Mander 1994, p.358.

11 Hearn 2011.

12 Private collection, UK; see London 1995, cats 58–60, pp.108–10 and pp.238–9. The author is grateful to Schulting for many past discussions about Ketel. The portraits were first identified as works by Ketel by Dr Malcolm Rogers.

13 Dietz 2004.

14 Slack 2004. The epitaph in question, inscribed on Judde's funerary monument in St Helen's church, Bishopsgate, London, stated 'TO RVSSIA AND MVSCOVA TO SPAYNE GYNNY WITHOVTE FABLE TRAVELD HE BY LAND AND SEA ...' according to the engraving of it by Stow, after Fisher, published on 1 January 1825 by Robert Wilkinson. The monument still bears this wording today.

15 See photograph in Conway Library, Courtauld Institute, under 'XVIth Century English Sculpture', no.198289.

16 See Jones 1995.

17 See Proceedings of His Majesty's Commissioners on the Public Records of the Kingdom, June 1832–August 1833, ed. C.P. Cooper, 1833, pp.75 and 560; records for this commission show that Ketel was charging £1 for a head portrait.

18 Morgan 2004.

19 Morgan 2004.

20 Engraved by Simon de Passe (1595–1647), published by John Woodall; see Emery Walker negative, box no.181/1, National Portrait Gallery, and Hind 1955, no.51, p.268, reproduced as pl.159c.

ENGLISH LIMNING: THE PORTRAIT MINIATURE IN TUDOR AND EARLY STUART ENGLAND
1 Strong 1984, pp.27–8.
2 Coombs 1998, p.19.
3 Thornton and Cain 1992, p.45; Coombs 1998, p.13.
4 Lloyd and Remington 1996, p.25.
5 Edmond 2004, p.3.
6 Rowan Watson, Western Illuminated Manuscripts: A Catalogue of Works in the National Art Library, 3 vols (London 2011), vol.II, p.779.
7 Strong 1984, p.32; Ekserdjian and De Vere 1996, vol.II, p.865.
8 Coombs 1998, p.24.
9 Strong 1984, p.51; Lois Oliver et al., 'New evidence towards an attribution to Holbein of a drawing in the Victoria and Albert Museum', The Burlington Magazine, CXLVIII (March 2006), pp.168–72.
10 Strong 1984, pp.46–51.
11 Strong 1984, p.47; Strong 1983, cat.30.
12 Auerbach 1954, p.69; see Strong 1984, pp.189–90: 'Appendix: A checklist of miniatures attributed to Lucas Horenbolte'; no.22 (version from Buccleuch Collection) is now National Maritime Museum.
13 Coombs 1998, p.24.
14 Lloyd and Remington 1996, p.12.
15 Ekserdjian and De Vere 1996, vol.II, p.865; Auerbach 1954, pp.103–4.
16 Auerbach 1954, p.75.
17 Strong 1984, p.55; Strong 1983, cat.42.
18 Neale 1960, pp.69–70.
19 Strong 1987, p.128.
20 Strong 1975, pp.16–17.
21 Strong 1975, p.17.
22 Coombs 1998, p.45.
23 Coombs 1998, p.44.
24 Coombs 1998, p.44.
25 Edmond 2004, p.8.
26 Edmond 2004, p.8; Strong 1984, p.74.

27 William Camden, quoted in Edmond 2004, p.9; Coombs 1998, p.34.
28 Edmond 2004, p.9.
29 Strong 1983, cat.171.
30 William Camden, Remaines Concerning Britaine, 1605, p.169 (EEBO: Early English Books Online).
31 Edmond 2004, p.5.
32 Coombs 1998, p.45.
33 Reynolds 1998, cat.5.
34 Coombs 1998, p.34.
35 Edmond 2004, p.5.
36 Neale 1960, p.394; Coombs 1998, p.45; Lloyd and Remington 1996, p.40.
37 Neale 1960, p.220.
38 Edmond 2004, p.6.
39 Thornton and Cain 1992, p.112, n.47
40 Strong 1975, p.17.
41 Strong 1983, see cats 208, 238.
42 Strong 1983, cat.271; Strong 1984, pp.164–6.
43 Lloyd and Remington 1996, p.40.
44 Coombs 2009, p.81.
45 Murdoch 1997, cat.6.
46 Edmond 2004, p.3; Coombs 1998, pp.54–7; Coombs 2009, p.82.
47 Information kindly supplied by Maija Jansson, FRHS, Director Emerita, Yale Center for Parliamentary History, Department of History, Yale University.
48 Lloyd and Remington 1996, p.14.
49 Muller and Murrell 1997, p.130, n.55.
50 Coombs 2009, p.82.
51 Coombs 1998, p.7.

'ARMES AND BESTES': TUDOR AND STUART HERALDRY
We would like to thank Henry Paston-Bedingfeld, Norroy and Ulster King of Arms, and Patric Dickinson, Clarenceux King of Arms, both of the College of Arms, London, and Domenica Blenkinsopp, John Goodall, Bruce Lindsay, James Lomax and Todd Longstaffe-Gowan for their advice.

1 Siddons 2009 includes the best introduction to the subject.
2 London 1978.
3 London 1956 is the best introduction to the subject.
4 Thurley 1993, pp.27–32.
5 Henry VIII 1861–3, III (1), no.750. These beasts were probably of terracotta, as there is evidence for figurative terracottas at the Tudor houses of Suffolk Place in Southwark and Westhorpe Hall in Suffolk; see Morris 2000. At the Greenwich Revels of 1527, the King's beasts that were scattered about the halls of the revel house were of papier mâché; see Anglo 1969, p.217.
6 Marks and Williamson 2003, no.156, pp.292–3; J. Nicolson and R. Burn; The History and Antiquities of the Counties of Westmorland and Cumberland, 2 vols (London 1777), vol.II, p.491.
7 Foster 2011.
8 Thurley 2003.
9 Henderson 2005, pp.76–9.
10 Information kindly provided by Todd Longstaffe-Gowan. Daily Telegraph online at telegraph.co.uk/gardening/6174283/

How-two-Tudor-lion-statues-came-home-to-Hampton-Court-Palace.html (accessed 2 November 2009).
11 Millar 1963, vol.I, cat.43, pp.63–4; vol.II, pl.27.
12 Strong 1979, p.185; Gilbert 1965.
13 London 1956, pp.57–9; Becker, Rochester Bridge: 1387–1856 (London 1930).
14 Howard 1987, pp.37–8, 215; Airs 1995 contains the most extensive discussion of the documentary evidence for Hengrave Hall.
15 Snodin and Styles 2001, p.102
16 Howard and Wilson 2003.
17 Llewellyn 1991; Llewellyn 2000.
18 NADFAS 1993, pp.77–8, provides a useful guide to identifying the changes to the royal coat of arms between 1405 and 1689.
19 Kirillova 2000.
20 Dmitrieva and Abramova 2007.
21 Corbould 1842.

SIXTEENTH-CENTURY AND SEVENTEENTH-CENTURY ENGLISH SILVER IN THE KREMLIN
1 The collection in the Victoria and Albert Museum, London, has 144 pieces dating from the sixteenth and seventeenth centuries (Glanville 1990).
2 Ambassadorial Book 1614–17, fols 57–58v (the information in the Ambassadorial Book has been verified by Irina Zagorodnaya). See also Goldberg 1954, p.446.
3 Ambassadorial Book 1620–1, fols 169r–169v. See also Goldberg 1954, pp.448, 450–1.
4 Goldberg 1954, pp.451–2. The basin from a lavabo set is now in the Trinity Monastery of St Sergius.
5 Ambassadorial Book 1663–4, fols 201v–203v, 283v–286v (the information in the Ambassadorial Book has been verified by Irina Zagorodnaya). See also Goldberg 1954, pp.455–6.
6 Jones 1909, p.XIX.
7 Versions of such cups are published in Penzer 1958.
8 Armoury Inventory 1884–93, part 2, book 2, no.1325.
9 Glanville 1987, p.211; Oman 1978, p.2.
10 Collins 1955, p.43.
11 This ornamental motif, so widespread in English applied arts, featured on weaving, embroidery, wooden carving and all kinds of stucco work. It was an inalienable part of the decoration of English silver, playing a variety of different functions. Tudor roses might be the main organizing element in a ornamental composition or fine bands might be used to accentuate details. They may form a frieze with ova, occupying the place usually given on European silver to egg-and-dart, and thus playing an important role in attributing English metalwork.
12 Strong 1977, pp.47–8, 68–71.
13 With the exception of one, dated 1641 (see Penzer 1960, p.106).
14 A favourite motif in English art as early as the Anglo-Saxon period,

the thistle appears on surviving silver fibulae from the mid to late tenth century, being fashioned with those same diamond facets: see Jackson 1911, figs 83–4. During the later medieval period Gothic furniture was also carved with thistles, usually in the form of circles with a rhomboid pattern framed by leaves: see Dean 1976, pl.1b. Identical treatment of the thistle is seen on two water pots with snake handles in the Armoury (pl.105).
15 Penzer 1959, pp.161–6.
16 An early gold cup with a pyramid steeple on top is mentioned in the inventory of Elizabeth I's plate; it was a gift from Sir Nicholas Bacon in 1573 (see Collins 1955, p.542).
17 Goldberg 1954, ills 14–15, 36, 58–61.
18 On the influence of prints and drawings by Albrecht Dürer on silver, see Markova 1975. English publications of the 1570s (Tusser 1573; Holinshed's Chronicles, 1577) provide evidence that gourds were grown and used in England, among them the bottle gourd.
19 Markova 1975, pl.32.
20 State Hermitage Museum, St Petersburg, inv. nos OG 3311, 329728, 329773.
21 Collins 1955, p.31. One of the basins of this kind is in the Armoury Museum (Siselina in London 1991, pp.138–9, no.93).
22 Davis 1970, pl.18.
23 Collins 1955, nos 687–8. In the author's opinion, flasks of this form were used to carry alcoholic drinks from the cellar into the house.
24 Collins 1955, nos 712–21; Glanville 1987, pl.I.
25 See Les oeuvres d'Ambroise Paré, conseiller et premier chirurgien du roy (Paris 1579); Vingtquatriesme livre traitant des monstres, Des monstres celestes. Opera chirurgica Ambrosii Paraei Galliarum regis primarii, et parisiensis chirurgi (etc.) – Francofurti a. M. Apud Joannem Feyrabend 1594 (Frankfurt 1594).
26 E. Topsell, The Historie of Foure-footed Beastes (London 1607) and The Historie of Serpents (London 1608).
27 Although new forms of salts developed in England were little known outside the country, there is a drawing of a salt 'in the English manner' by the celebrated Hamburg goldsmith Jacob Mores the Elder (1578–c.1609): see Hayward 1976, p.308
28 The Babees Book (c.1475) and The Young Children's Book (c.1500).
29 Cited in Oman 1961, pp.58, 60. Oman suggests that the enamelled decoration was removed before being sent to Russia. The system of measurement here is the troy weight (the standard for precious jewels and metals), not the avoirdupois pounds and ounces system; 1 troy ounce equals 31.1035 grams. The correlation between the weights given by archival records and current weights is frequently inexact.
30 Cited in Oman 1961, p.60.
31 Documents published in Smirnova and Shumilov 1961, pp.224–8. 1 Old

Russian pood equals 16.4 kg; 1 Old R equals 410 g; 1 zolotnik equals 4.3 g.
32 Armoury Inventory 1884–93, part 2, book 3, no.1922.
33 Described in British documents as a 'censer' (cited in Oman 1961, p.58).
34 Christiaen van Vianen, Modelli artificiosi di vasi diversi d'argento (Utrecht c.1650).

ARMS AND ARMOUR
I am grateful to Simon Metcalf, Royal Collection; Commodore Christopher Waite, The Worshipful Company of Armourers and Brasiers; Thom Richardson, Victoria Adams, Alison Watson, Royal Armouries, Leeds; Dr Richard Edgcumbe, Dr Kirstin Kennedy, Mor Thunder, Matthew Storey; Dr Tobias Capwell, Wallace Collection, London; Dr Angela McShane, V&A/Royal College of Art; Amanda Saedler.
1 Richardson 2002, p.8; Rimer, Richardson and Cooper 2009, cat.19, pp.166–7.
2 Rimer, Richardson and Cooper 2009, p.149.
3 Rimer, Richardson and Cooper 2009, p.148.
4 Williams and de Reuck 1995, p.28.
5 Patterson 2009, p.23.
6 Richardson 2002, pp.1, 2–16, 20–2; Rimer, Richardson and Cooper 2009, cat.4, pp.120–7 and cat.21, pp.170–5.
7 Richardson 2002, p.23.
8 Rimer, Richardson and Cooper 2009, p.214, cat.39.
9 Richardson 2002, p.33; Rimer, Richardson and Cooper 2009, p.217.
10 Rimer, Richardson and Cooper 2009, p.152.
11 Patterson 2009, p.35.
12 Williams and de Reuck 1995, p.32.
13 See, for example, the portrait of Robert Dudley (pl.131).
14 Quoted in Williams and de Reuck 1995, p.35; the meeting is described in Glover 2008, p.66 (original source: Guildhall Manuscripts 12079, Freedoms and Apprentices Register 1547–1602, 4 August 1561).
15 Williams and de Reuck 1995, p.31.
16 London 2003, p.68.
17 London 2003, pp.78–9.
18 London 2003, cat.76.
19 A letter by Henry Lee to Francis Walsingham, February 1586/7, quoted in Eaves 1999, p.158.
20 London 2003, pp.75–7.
21 Rimer, Richardson and Cooper 2009, p.153.
22 From Phillip Stubbes, The Anatomie of Abuses (London, 1583, National Art Library, Miscellaneous Tracts temp. Eliz. & Jac. 1, Forster 1857), pp.56–7, quoted in Patterson 2009, pp.45–7.
23 Illustrated in Williams and de Reuck 1995, p.109.
24 Rimer, Richardson and Cooper 2009, pp.153–4.
25 Patterson 2009, p.70.
26 Ashelford 1996, pp.28, 37.
27 From George Silver, Paradozes of Defence (Edward Blount, London, 1599), quoted in Patterson 2009, p.67.
28 'A Proclamation against the common use of Dags, Handguns, Arquebuses, Callibers, and Cotes of Defence Given at our Manor of greenwich,

the 26th day of July in the 21st year of our reign', quoted in Jardine 2005, Appendix 5.

29 See Jardine 2005.

'SILKS, VELVETS, CLOTHS OF GOLD AND OTHER SUCH PRECIOUS RAIMENTS': CLOTHING AND FURNISHING THE TUDOR AND STUART COURTS

1 Campbell 2007. The most authoritative work on the subject.
2 Campbell 2007, p.331.
3 Campbell 2007, p.245.
4 Campbell 2007, p.332.
5 Starkey 1998, p.x.
6 Campbell 2007, p.116.
7 V&A T.18–1951. Napkin, linen damask. Southern Netherlands, 1605.
8 Levey 2007, p.19.
9 Hayward 2009, p.17. Hayward's book examines this subject in exemplary detail.
10 Hayward 2009, p.23.
11 Hayward 2009, p.96 and 101.
12 Hayward 2007, p.33.
13 Hayward 2007, p.19.
14 Hayward 2007, p.119.
15 Arnold 1988, p.1.
16 Swain 1973, p.82.
17 Arnold 1988, p.75.
18 Hayward 2009, p.25.
19 Arnold 1988, p.1.
20 London 1995, p.198.

'O, THOSE JEWELS! THE PRIDE AND GLORY OF THIS KINGDOM!'

1 Walter Raleigh in his Preface to Raleigh 1614, page unnumbered; quoted in Tillyard 1963, p.20. For the fundamental surveys of Tudor and Stuart jewellery, see Somers Cocks 1980 and Scarisbrick 1994 and 1995. I am indebted to Diana Scarisbrick, Hazel Forsyth, Charles Truman, Katie Coombs, Alan Derbyshire, Dinah Winch, Elizabeth Miller, Rowan Watson and Joanna Whalley for generous advice.
2 Nicholls and Williams 2004 (online edn, January 2008).
3 Collins 1955, p.106.
4 Tillyard 1963, pp.42–3.
5 Arnold 1988, pp.72–3; Scarisbrick 1995, p.67.
6 William Shakespeare, *King Lear*, Act IV, Scene 3.
7 Collins 1955, p.3.
8 Ibid., pp.168–70; Strong 1966; for the recycling of Anne's jewels into gifts, see Scarisbrick 1991.
9 Whitelocke 1682 (1853), vol.1, p.178.
10 Ronald Lightbown in Blair 1998, vol.1, pp.344–5. Only the Coronation Spoon, which was sold, but not melted, survived.
11 Wheeler 2003; Forsyth 2003.
12 The National Archives: PRO, PROB 11/102 George Carey, 2nd Baron Hunsdon.
13 The National Archives: PRO, PROB 11/168 'Elizabeth Lady Berkley' (*sic*).
14 Somers Cocks 1980, p.61, no.40; Strong 1987, p.121. The miniature by Nicholas Hilliard has an inscription which now reads 'Ano Dni 1575 Regni 20', but has clearly been repainted. The regnal year

appears under magnification to have been 28, giving a date of 1585–6, but an X-ray by Paul Robbins appears to show that the number may have been painted at an early date as 29 as well as 28. It is impossible to be certain what the third numeral in the year in the inscription originally was. An X-ray suggests that the last numeral of the year may have been 6, rather than 5. 1586 would agree with both the 28th and 29th regnal years, and, taking all the evidence together, is perhaps the most likely reading. This may also be the date of the making of the jewel, but there remains a possibility that the portrait and the phoenix were inserted into a fine existing jewel. For recent interpretations of the cameo, which uses the layers of the sardonyx to depict the profile of a white female head behind a black male bust wearing the *paludamentum* of a Roman general or emperor, see Dalton 2000, pp.178–214; Scarisbrick 2003, p.150; Healy 2011, pp.105–10.
15 Eliott-Drake 1911, vol.1, p.190.
16 Ibid., vol.1, p.259.
17 Ibid., vol.1, p.433.
18 Ibid., vol.1, p.432.
19 Ibid., vol.1, p.435.
20 Ibid., vol.2, p.38.
21 Ibid., vol.2, pp.170, 212.
22 The backdrop was inspired by one of the Elizabethan Armada tapestries made for the House of Lords. Bills 1998, p.144; Farrell 2010, p.419.
23 Kagan 2010, pp.40–55.
24 Kagan 2010, p.41.
25 John Lyly, *Euphues and his England*, 1580, quoted in Strong 1987, p.96.
26 William Shakespeare, *Romeo and Juliet*, Act 1, Scene 4, quoted in Kagan 2010, p.74.
27 Fuhring and Bimbenet-Privat 2002, p.123.
28 Boteler, 'Parishes: Eastry', *The History and Topographical Survey of the County of Kent: Volume 10* (1800), pp.98–121; online at british-history.ac.uk/report.aspx?compid=63616 (accessed 19 October 2011); Shaw 1870, p.66; Throckmorton in Oman 1930, p.86, no.494; Cokayne 1900–9, vol.5, p.26.
29 Somers Cocks 1980, p.52, no.17.
30 Loomie 2004; Hodgetts 2004.
31 Merriman 2004.
32 Hemp 1925; Scarisbrick 1997, pp.57–8.
33 Starkey 1998, p.98.
34 Blanchard 2004 (online edn, January 2008).
35 Nicholls 2004 (online edn, January 2008). Other Knyvetts include Thomas's older brother, Sir Henry Knyvett (1537–98), three of whose daughters married peers, and Sir Thomas Knyvett (*c*.1539–1618), High Sheriff of Norfolk in 1579.
36 Kagan 2010, pp.71–6.
37 Boardman 2009, pp.1–7; p.105, no.181.
38 Hayward 1986, p.228.
39 Larminie 2004 (online edn, 2008); Hayward 1986, p.230.
40 John Blackwell, grandson of Arnold Lulls, is named in the will

of his aunt, Susanna Edmonds (The National Archives: PROB 11/233); Larminie 1995, pp.48–9.
41 For the term 'stellar cut', see Tillander 1995, p.147.
42 Emerald grapes: Museum of London no.A 14112, illustrated Wheeler 1928, pl.VII.
43 Date of concealment proposed by Hazel Forsyth who is masterminding an eagerly awaited exhibition on the Cheapside Hoard to take place in autumn 2013 at the Museum of London.
44 The National Archives: PRO, PROB 11/233 Susanna Edmonds; Larminie 1995, pp.48–9.
45 Forsyth 2003, p.62.

THE MOSCOW COACH: 'A RICH CHARIOT, ONE PARCELL OF THE GREAT PRESENT'

1 J. Munby, 'From Carriage to Coach, What Happened?' in Bork and Kann 2008, vol.6, pp.41–53; this is preparatory to a longer work in preparation: *Medieval Carriages and the Origins of the Coach: The Archaeology of the European Transport Revolution*. The standard account of early coaches in Europe remains Gozzadini 1864.
2 Munby 2003, pp.311–67.
3 Munby, 'From Carriage to Coach' in Bork and Kann 2008, vol.6, pp.45, 53.
4 Illustrated in Munby 2003, pp.312 (Coburg), 313 (Nonsuch). For Coburg, see Gelbhaar 1999.
5 Munby 2003; the stables (Wardrobe) accounts are in the National Archives, PRO Lord Chamberlain (LC) and Audit Office (AO) series.
6 Ostrowski 1999, cat.1, pp.103–5.
7 Bessone 1993.
8 *Calendar of State Papers Domestic 1598–61* (London 1869), p.156 (January 1599).
9 A note of gifts to the Sultan can be found in Jones 1919, p.358; for Dallam, see Mayes 1956, a reference I owe to Tim Tatton-Brown.
10 S.A. Skilliter, 'Three Letters from the Ottoman "Sultana" Safiye to Queen Elizabeth I' in Stern 1965, pp.119–57.
11 Dallam's diary see Bent 1893, p.63 modernized. The front of Pindar's fine house in Bishopsgate is preserved in the Victoria and Albert Museum, London.
12 Henry Lello to Cecil, National Archives, PRO SP 97/4, fol.49, quoted by Skilliter in Stern 1965, p.150.
13 National Archives, PRO SP 102/4, fols 5 and 19, edited by Skilliter in Stern 1965, as documents II and III.
14 Piggott 1992, pp.157–9, quoting Strachan 1989; for the full documentation of the visit, see Foster 1926; for an Indian miniature showing Sir Thomas Roe sitting in the Emperor's court, see Barber 1979, no.58, pl.V (from the British Museum Oriental Department, 1933-6-10-01).
15 Wadmore 1893, pp.82–103 (and 'Pedigree of Smythe of Ostenhanger...' at pp.76–81); also entry in the Oxford Dictionary

of National Biography; his magnificent monument at Sutton-at-Hone in Kent is illustrated in Sotheby's *English Silver Treasures from the Kremlin: A Loan Exhibition* (London 1991), fig.2. For England and Moscow, see Maria Unkovskaya, 'Full of Sound and Fury: The early relations between England and Russia 1553–1700' in Sotheby's *English Silver Treasures from the Kremlin*, ibid., pp.27–34; also her unpublished DPhil thesis 'Anglo-Russian diplomatic relations 1580–1696', Oxford University, 1992; in general, see essays in Shifman and Walton 2001, and Dmitrieva and Abramova 2006.
16 *Sir Thomas Smithes Voiage and Entertainment in Rushia, with the Tragicall Ends of two Emperors and one Empress* (Purchas 1605), from which these quotations were taken, was (incompletely) reproduced in Samuel Purchas's compilation *Purchas His Pilgrimes* (1625), III.iv, pp.747–54, and reprinted by the Hakluyt Society (Extra Series) as *Hakluytus Posthumus or Purchas His Pilgrimes*, XIV (1906), pp.132ff. For the journey, see Parker 1968, p.96, and pp.92–3, 129. A general description can be found in Fletcher 1591, reprinted in Bond 1856.
17 For the diplomatic protocol, see Dmitrieva in this volume, pp.12–35, and Kudriavtseva, 'Ambassadorial Ceremony at the Tsar's Court' in Shifman and Walton 2001, pp.43–61.
18 *Sir Thomas Smithes voiage* (Smith 1625), sign D3; *Purchas His Pilgrimes* (Purchas 1625), III.iv, p.748; Hakluyt Society XIV (1906), pp.135–6.
19 An English list 'in the Record Office at Moscow' quoted in Maskell 1884, pp.1–2; also Oman 1961, p.29 (discussed further below).
20 Crummey 1993, p.218.
21 The building, at 4a Varvarka Street, is now a branch of the Museum of the History of Moscow, having been opened by Queen Elizabeth II in 1994; Johannes Blaeu, *Atlas Major*, vol.II (1662), no.13, 'Aula Anglorum'; reproduced in Sotheby's *English Silver Treasures from the Kremlin: A Loan Exhibition* (London 1991), p.103, no.81.
22 Oman 1961; Goncharenko and Narozhnaya 2000.
23 Veltman 1853; M.M. Denisova, 'Koniushennaia kazna: Paradnoe konskoe ubranstvo XVI–XVII vekov' ['Ceremonial Horse Harness 16th–17th Centuries'], in *Gosudarstvennaia Oruzheinaia Palata Mokovskogo [Kremlia State Armoury Palace of the Moscow Kremlin]* (Moscow 1954), pp.247–304 (and T.G. Goldberg, 'Iz posol'skikh darov XVI–XVII vekov: Angliyskoe serebro' ['Ambassadorial Gifts of the 17th–18th Centuries: English Silver'], ibid., pp.435–506; L.P. Kirillova, *Katalog Sovranya Ekipage XVI-XVIII vekov [Carriages of the XVI-XVII Centuries]* (part of the *Catalogue of the Collection of the State Historical Cultural Museum*

Preserve 'The Moscow Kremlin', Moscow 2006); Kirillova in Dmitrieva and Abramova 2006, pp.196–7; Kirillova 2000, pp.63–78, inv. no.K-36.
24 Kirillova 2000, p.21.
25 Arel and Bogatyryov 1997, pp.439–55 (the source of the English list at p.451 is the Russian State Archive of Ancient Acts, Moscow RGADA fund 35, opis 1, delo 44, fol.1, and is the one quoted by Maskell); see also Kirillova 2000, p.24.
26 Kirillova 2000, p.25.
27 Kirillova 2000, pp.25–7; Kirillova's following chapter (pp.29–39) contains a valuable account of the use of sledges and carriages in Russia.
28 Veltman 1853, pp.138–9; the inventory (RGADA fund 396, opis 2, part 2, delo 1022, fols 395–7) is partly reproduced in Kirillova 2000, p.78.
29 Jones 1944, pp.24–6; quoting W. Prideaux, *Memorials of the Goldsmiths Company*, I, p.137; *Acts of Privy Council of England XXXIX 1623–1625* (London 1933), pp.217, 236; see Glanville in Dmitrieva and Abramova 2006, p.47.
30 As quoted by Goldberg 1954, p.451 (from N. Kologrivov, *Materialy dlya istorii snosheniy Rossii s inostrannymi derzhavami v XVII v. [Material on the History of Russia's relations with Foreign Powers in the Seventeenth Century]* (St Petersburg 1911), p.78, presumably from the 'Book of Receipts and Allocations, 1625' (RGADA fund 396, opis 2, Book 145).
31 Kirillova in Dmitrieva and Abramova 2006, p.197; the source is RGADA fund 396, opis 1, part 2, delo 16433, fol.4 (transcript kindly provided by Olga Melkinova).
32 Wray 1985, pp.79–81 (reprinted from *The Woodworker*, July 1983, pp.417–20). Shealah Wray has kindly allowed me to study David Wray's notes and drawings.
33 Crummey 1993, pp.153–5, 207.
34 J.S. Peters (ed.), *The Illustrated Bartsch*, 20 (Pt 1): *Jost Amman* (Norwalk 1985), p.265, r. 34.
35 Wells-Cole 1997.
36 Mignani 1991, pp.86, 89 ('La Peggio' and 'La Magia').
37 Kirillova in Dmitrieva and Abramova 2006, p.197.
38 Munby 2003, pp.351–3; James I Stable warrant of 18 June 1604, PRO AO 3/1115a (1st book in 1115, unfoliated, around fol.27), and warrant of 14 March 1606, PRO LC9/95, fols 6–29; duplicate account in AO 3/1115c. For the painters see Colvin 1975, p.411; Millar 1963, p.79.

REFERENCES

AIKMAN 1839 – Aikman, James, *An Account of the Eglinton Tournament* (Edinburgh 1839)

AIRS 1995 – Malcolm Airs, *The Tudor and Jacobean Great House: A Building History* (Stroud 1995)

ALEXEEV 1982 – M.P. Alexeev, *Russko-angliyskie literaturnye svyazi (XVIII vek – pervaya polovina XIX veka) [Russo-English Literary connections (XVIII century – first half of the XIX century)]* (Moscow 1982)

Ambassadors' Travels 1954 – Puteshestviya russkikh poslov XVI-XVII vv: Stateynye spiski [The Travels of the Russian Ambassadors, Sixteenth-Seventeenth Centuries: Reports] (Moscow and Leningrad 1954)

ARMOURY INVENTORY 1884–93 – *Opis' Moskovskay Oruzheynay palaty [Inventory of the Moscow Armoury]*, 9 parts, 7 books (Moscow 1884–93)

ANDERSON 1958 – M.S. Anderson, *Britain's Discovery of Russia, 1553–1815* (London 1958)

ANGLO 1969 – Sydney Anglo, *Spectacle, Pageantry and Early Tudor Policy* (Oxford 1969)

AREL 1995 – M.S. Arel, *The Muscovy Company in the First Half of the Seventeenth Century: Trade and Position in the Russian State. A Reassessment*, PhD thesis, Yale University 1995

AREL AND BOGATYRYOV 1997 – M.S. Arel and S.N. Bogatyryov, 'Anglichane v Moskve vremyon Borisa Godunova (po dokumentam posol'stva T. Smita 1606–5 godov)' ['The English in Moscow during the Age of Boris Godunov (From Documents Related to Thomas Smith's Embassy 1604–50)'], *Arkheograficheskiy ezhegodnik za 1997 [Archaeographical Annual for 1997]*, pp.439–55

ARNOLD 1988 – Janet Arnold, *Queen Elizabeth's Wardrobe Unlock'd* (Leeds 1988)

ASHELFORD 1996 – Jane Ashelford, *The Art of Dress: Clothes and Society, 1500–1914* (London 1996)

AUERBACH 1954 – Erna Auerbach, *Tudor Artists* (London 1954)

BARBER 1979 – P. Barber, *Diplomacy, the World of the Honest Spy* (London 1979)

BARON 1979 – S.H. Baron, 'The Muscovy Company, the Muscovite Merchants and the Problem of Reciprocity in Russian Foreign Trade', *Forschungen zur osteuropaishen Geschichte [Studies in East European History]*, 27 (1979), pp.133–55

BARON 1988 – S.H. Baron, 'Thrust and Parry: Anglo-Russian Relations in the Muscovite North', *Oxford Slavonic papers*, 21 (1988), pp.19–40

BENT 1893 – J.D. Bent (ed.), *Early Voyages and Travels in the Levant*, Hakluyt Society, 87 (1893)

BESSONE 1993 – Silvana Bessone, *The National Coach Museum Lisbon* (Lisbon 1993)

BILLS 1998 – Mark Bills, *Edwin Longsden Long RA* (London 1998)

BLAIR 1998 – C. Blair (ed.), *The Crown Jewels*, 2 vols (London 1998)

BLANCHARD 2004 – I. Blanchard, 'Gresham, Sir Thomas (c.1518–1579)', *Oxford Dictionary of National Biography* (Oxford 2004); online at oxforddnb.com/view/article/11505 (accessed 5 November 2011)

BOARDMAN 2009 – John Boardman et al., *The Marlborough Gems* (Oxford 2009)

BOGATYRYOV 1995 – S.N. Bogatyryov, 'Ot Volgi do potoka Amazonki: Zhizn I puteshestvie sera Thomasa Smita' ['From the Volga to the Flowing of the Amazon: The Life and Journey of Sir Thomas Smith'], *Zerkalo istorii [The Mirror of History]*, 2 (1995), pp.52–66

BOGOUSHEVSKY 1878 – N.S. Bogoushevsky, 'The English in Muscovy during the Sixteenth Century', *Transactions of the Royal Historical Society*, 7 (1878), pp.58–129

BOND 1856 – E.H. Bond, *Russia at the Close of the Sixteenth Century*, Hakluyt Society (1856)

BORK AND KANN 2008 – R. Bork and A. Kann (eds), *The Art, Science, and Technology of Medieval Travel*, AVISTA Studies in the History of Medieval Technology, Science, and Art (Aldershot 2008)

BUGANOV 1994 – V.I. Buganov, 'Russia in the System of International Relations from the Second Half of the Sixteenth to the First Half of the Seventeenth Century' in Jansson and Rogozhin 1994, pp.XV–XXVII

BUSHKOVITCH 1980 – P. Bushkovitch, *The Merchants of Moscow 1580–1650* (Cambridge 1980)

BUSHKOVITCH 1994 – P. Bushkovitch, 'Introduction' in Jansson and Rogozhin 1994, pp.1–71

CAMPBELL 2007 – Thomas P. Campbell, *Henry VIII and the Art of Majesty: Tapestries at the Tudor Court* (New Haven 2007)

CHERKASHINA 1952 – N.P. Cherkashina, *Istoriya Moskovskoy torgovoy kompanii v XVI-XVII vv. [The History of the Muscovy Trading Company in the Sixteenth and Seventeenth Centuries]*, MPhil dissertation (Moscow 1952)

COKAYNE 1900–9 – G.E. Cokayne (ed.), *The Complete Baronetage*, 5 vols (Exeter 1900–9)

COLLINS 1955 – A. Jefferies Collins, *Jewels and Plate of Queen Elizabeth I* (London 1955)

COLVIN 1975 – H.M. Colvin et al., *The History of the King's Works III 1485–1660* (London 1975)

COOMBS 1998 – Katherine Coombs, *The Portrait Miniature in England* (London 1998)

COOMBS 2009 – Katherine Coombs, '"A Kind of Gentle Painting": Limning in 16th-Century England', *European Visions: American Voices* (London 2009), pp.77–84; online at britishmuseum.org/research/research_publications/online_research_publications/european_visions.aspx (accessed 16 November 2011)

COOPER 2001 – Tarnya Cooper, *Memento mori portraiture: painting, Protestant culture and the patronage of middle elites in England and Wales*

1540–1630, PhD thesis, University of Sussex, Brighton 2001

CORBOULD 1842 – E.H. Corbould, *The Eglinton Tournament* (1842)

CRUMMEY 1993 – Robert Crummey, *The Formation of Muscovy 1304–1613* (London 1993 edn)

DALTON 2000 – Karen C.C. Dalton, 'Art for the Sake of Dynasty' in *Early Modern Visual Culture: Representation, Race, and Empire in Renaissance England, eds* P. Erickson and C. Hulse (Philadelphia 2000), pp.178–214

DAVIS 1970 – F. Davis, *French Silver, 1450–1825* (London 1970)

DEAN 1976 – M. Dean, *English Antique Furniture, 1450–1850* (London 1976)

DIETZ 1993 – B. Dietz, 'Smythe [Smith], Thomas (1522–1591)', *Oxford Dictionary of National Biography* (Oxford 2004); online at oxforddnb.com/view/article/37985 (accessed 19 October 2011)

DMITRIEVA 2006 – O. Dmitrieva, '"The Golden Chain of Traffic": The First Hundred Years of Anglo-Russian Relations' in Dmitrieva and Abramova, 2006, pp.12–33

DMITRIEVA AND ABRAMOVA 2006 – Olga Dmitrieva and Natalya Abramova, *Britannia and Muscovy: English Silver at the Court of the Tsars* (Yale 2006)

DUKES, HERD AND KOTILAINE 2009 – P. Dukes, G.P. Herd and J. Kotilaine (eds), *Stuarts and Romanovs. The Rise and Fall of a Special Relationship* (Dundee 2009)

DUNNING 1982 – C. Dunning, 'James I, the Russia Company and the Plan to Establish a Protectorate Over North Russia', *Albion*, 21, no.2 (1982), pp.206–26

DUNNING 1989 – C. Dunning, 'A Letter to James I Concerning the English Plan for Military Intervention in Russia', *Slavonic and East European Review*, 67, no.1 (1989), pp.94–108

DYOMKIN 1994 – A.V. Dyomkin, *Zapadnoevropeyskoe kupechestvo v Rossii v XVII v. [The Western European Merchants in Russia in the Seventeenth Century]* (Moscow 1994)

EARLY VOYAGES 1886 – *Early Voyages and Travels to Russia and Persia by Anthony Jenkinson and Other Englishmen, with Some Account of the First Intercourse of the English with Russia and Central Asia by Way of the Caspian Sea*, Hakluyt Society, first series (London 1886)

EAVES 1968 – Ian Eaves, 'The Greenwich Armour and Locking Gauntlet of Sir Henry Lee in the Collection of The Worshipful Company of Armourers and Brasiers', *Journal of the Arms and Armour Society*, vol.XVI, no.3 (September 1998)

EDMOND 2004 – Mary Edmond, 'Hilliard, Nicholas (1547?–1619)', *Oxford Dictionary of National Biography* (Oxford 2004); online at oxforddnb.com/view/article/13320 (accessed 16 November 2011)

EKSERDJIAN AND DE VERE 1996 – D. Ekserdjian and G. du C. De Vere, *Giorgio Vasari: Lives of the Painters,*

Sculptors and Architects, 2 vols (London 1996)

ELIOTT-DRAKE 1911 – Lady Eliott-Drake, *The Family and Heirs of Sir Francis Drake*, 2 vols (London 1911)

EVANS 1965 – N.E. Evans, 'Queen Elizabeth I and Tsar Boris: Five Letters, 1597–1603', *Oxford Slavonic Papers*, 12 (1965), pp.49–68

EVELYN DIARIES – *Diary of John Evelyn*, ed. H.B. Wheatley, 4 vols (London 1906)

FARRELL 2010 – Stephen Farrell, 'The Armada Tapestries in the Old Palace of Westminster', *Parliamentary History*, vol.29, pt.3 (London 2010), pp.416–40

FLETCHER 1591 – G. Fletcher, *Of the Russe Common Wealth* (London 1591)

FOISTER 2004 – Susan Foister, *Holbein and England* (New Haven and London 2004)

FORSYTH 2003 – Hazel Forsyth, *The Cheapside Hoard* (London 2003)

FOSTER 1926 – W. Foster (ed.), *The Embassy of Sir Thomas Roe to India 1615–19* (Oxford 1926)

FOSTER 2011 – Paul Foster in Paul Foster and Rachel Moriarty (ed.), *Chichester – The Palace and its Bishops 1075–2011*, Otter Memorial Paper Number 27, University of Chichester 2011

FUHRING AND BIMBENET-PRIVAT 2002 – P. Fuhring and M. Bimbenet-Privat, 'Le Style "cosses de pois". L'Orfèvrerie et la gravure à Paris sous Louis XIII', *Gazette des Beaux-Arts* (January 2002)

FUMERTON 1986 – P. Fumerton, 'Exchanging Gifts: The Elizabethan Currency of Children and Poetry', *ELH*, 53, no.2 (1986), pp.241–78

GAMEL 1856 – I.K. Gamel, 'Nachalo torgovykh I politicheskikh snosheniy mezhdu Angliey I Rossiey' ['The Commencement of Trading and Political Relations Between England and Russia'], *Zhurnal Ministerstva Narodnogo Prosveshcheniya [Journal of the Ministry of Public Education]*, 2–3 (1856)

GAMEL 1865–9 – I.K. Gamel, *Anglichane v Rossii v XVI i XVII stoletiyakh [The English in Russia in the Sixteenth and Seventeenth Centuries]*, essays I and II (St Petersburg 1865–9)

GELBHAAR 1999 – Axel Gelbhaar, 'Die Kobelwagen, Karossen und Kutschen im Besitz der Kunstammlungen der Veste Coburg', *Achse, Rad und Wagen, Beiträge zur Geschichte der Landfahrzeuge*, no.7 (1999), pp.79–89

GERSON 1912 – A.J. Gerson, 'The Origin and Early History of the Muscovy Company', *Studies in the History of English Commerce in the Tudor Period* (New York 1912)

GILBERT 1965 – C. Gilbert, *A Short Historical Guide to Sheriff Hutton Park* (Leeds 1965)

GLANVILLE 1990 – Philippa Glanville, *Silver in Tudor and Early Stuart England* (London 1990)

GLOVER 2008 – Elizabeth Glover, *Men of Metal: History of the Armourers and Brasiers of the City of London* (London 2008)

GOLDBERG 1954 – T.G. Goldberg, *Iz posol'skikh darov XVI–XVII vekov: Angliyskoe serebro [From ambassadorial gifts of the sixteenth to seventeenth centuries: English silver]*, State Armoury of the Moscow Kremlin (Moscow 1954)

GONCHARENKO AND NAROZHNAYA 2000 – V.S. Goncharenko and V.I. Narozhnaya, *The Armoury, A Guide* (Moscow 2000)

GOZZADINI 1864 – G. Gozzadini, *Dell' Origine e dell'Uso dei Cocchi e di Due Veronesi in particolare* (Bologna 1864)

HAKLUYT 1598 – R. Hakluyt, *The Principal Navigations, Voyages, Traffiques and Discoveries of the English Nation* (London 1589, 2nd edn, London 1598)

HAMEL 1875 – J. Hamel [I.K. Gamel], *Early Voyages to Northern Russia* (London 1875)

HAYWARD 1976 – J.F. Hayward, *Virtuoso Goldsmiths and the Triumph of Mannerism 1540-1620* (London 1976)

HAYWARD 1986 – John Hayward, 'The Arnold Lulls Book of Jewels and the Court Jewellers of Queen Anne of Denmark', *Archaeologia*, vol.108 (1986), pp.227–37

HAYWARD 2007 – Maria Hayward, *Dress at the Court of Henry VIII* (London and New York 2007)

HAYWARD 2009 – Maria Hayward, *Rich Apparel: Clothing and the Law in Henry VIII's England* (London 2009)

HEALY 2011 – Margaret Healy, *Shakespeare, Alchemy and the Creative Imagination* (Cambridge 2011)

HEARN 2002 – Karen Hearn, *Marcus Gheeraerts II: Elizabethan Artist* (London 2002)

HEARN 2011 – Karen Hearn, 'Cornelis Govertszoon Ketel (1548–1616)', *Oxford Dictionary of National Biography* (Oxford 2004); online at oxforddnb.com/view/article/15480 (accessed 19 October 2011)

HEARN 2012 – Karen Hearn, 'Migrant Portrait-Painters in the British Isles in the Sixteenth and Seventeenth Century' in *Migrations: Journeys into British Art*, ed. Lizzie Carey-Thomas, exh. cat., Tate Britain (London 2012)

HEMP 1925 – W.J. Hemp, 'The Goodman and other grasshopper rings', *Antiquaries Journal*, vol.V (1925), pp.403–8

HENDERSON 2005 – Paula Henderson, *The Tudor House and Garden: Architecture and Landscape in the Sixteenth and Early Seventeenth Centuries* (New Haven and London 2005)

HENRY VIII 1861–3 – *Letters and Papers Henry VIII*, catalogued by J.S. Brewer, ed. R.H. Brodie (London 1861–3, 2nd revised edn)

HIND 1955 – Arthur M. Hind, *Engraving in England in the 16th and 17th Centuries* (Cambridge 1955), part II, 'The Reign of James I'

HODGETTS 2004 – Michael Hodgetts, 'Owen, Nicholas (*d.* 1606)', *Oxford Dictionary of National Biography* (Oxford 2004); online at: oxforddnb.com/view/article/21023 (accessed 5 November 2011)

HOLINSHED'S CHRONICLES – *Holinshed's Chronicles of England, Scotland and Ireland*, 6 vols (London 1808)

HOWARD 1987 – Maurice Howard, *The Early Tudor Country House* (London 1987)

HOWARD AND WILSON 2003 – Maurice Howard and Edward Wilson, *The Vyne: A Tudor House Revealed* (London 2003)

HUTTENBACH 1972 – H.R. Huttenbach, 'The Search for and Discovery of New Archival Materials for Ambassador Jenkinson's Mission in 1571–72: Four Letters by Queen Elizabeth to Tsar Ivan IV', *Canadian-American Slavonic Studies*, 6, no.3 (1972), pp.416–25

HUTTENBACH 1975 – H.R. Huttenbach, 'Anthony Jenkinson's 1566 and 1571 Missions to Muscovy Reconstructed from Unpublished Sources', *Canadian-American Slavonic Studies*, 9, no.2 (1975), pp.179–203

JACKSON 1911 – C. Jackson, *An Illustrated History of English Plate, Ecclesiastical and Secular* (London 1911)

JANSSON 2005 – M. Jansson, 'Measured Reciprocity: English Ambassadorial Gift Exchange in the 17th and 18th Centuries', *Journal of the Early Modern History*, 9, nos 3–4 (2005), pp.348–70

JANSSON 2006 – M. Jansson, 'Ambassadorial Gifts' in Dmitrieva and Abramova 2006, pp.198–205

JANSSON AND ROGOZHIN 1994 – M. Jansson and N. Rogozhin (eds), *England and the North: The Russian Embassy of 1613–14*, trans P. Bushkovitch, *American Philosophical Society Memoirs* (Philadelphia 1994)

JARDINE 2005 – Lisa Jardine, *The Awful End of Prince William the Silent, The First Assassination of a Head of State with a Handgun* (London 2005)

JONES 1909 – E.A. Jones, *The Old English Plate of the Emperor of Russia* (London 1909)

JONES 1919 – E. Alfred Jones, 'Old English Plate in Constantinople', *Country Life*, XLV (29 March 1919)

JONES 1944 – E. Alfred Jones, 'An English Coach in the Oruzheinaia Palata, Moscow', *Connoisseur*, 113 (1944), pp.24–6

JONES 1995 – Rica Jones, 'The methods and materials of three Tudor artists' in London 1995, pp.231–9

KAGAN 2010 – Julia Kagan, *Gem Engraving in Britain from Antiquity to the Present* (Oxford 2010)

KIRILLOVA 2000 – Lyubov Kirillova, *The Royal Carriages, Treasures of the Armoury* (Moscow 2000)

KONOVALOV 1950 – S. Konovalov, 'Anglo-Russian Relations, 1617–1618', *Oxford Slavonic Papers*, 1 (1950), pp.64–103

KONOVALOV 1953 – S. Konovalov, 'Anglo-Russian Relations, 1620–1624', *Oxford Slavonic Papers*, 4 (1953), pp.71–131

KONOVALOV 1957 – S. Konovalov, 'Seven Russian Royal Letters, 1613–23', *Oxford Slavonic Papers*, 7 (1957), pp.118–34

KONOVALOV 1958 – S. Konovalov, 'Twenty Russian Royal Letters, 1626–34', *Oxford Slavonic Papers*, 8 (1958), pp.117–56

LARMINIE 1995 – Vivienne Larminie, *Wealth, Kinship and Culture: the Seventeenth-Century Newdigates of Arbury and their World*, Royal Historical Society Studies in History, 72 (1995), pp.57–8

LARMINIE 2004 – Vivienne Larminie, 'Lulls, Arnold (*fl.*1584–1642)', *Oxford Dictionary of National Biography* (Oxford 2004); online at oxforddnb.com/view/article/74580 (accessed 19 October 2011)

LEVEY 2007 – Santina M. Levey, *The Embroideries at Hardwick Hall: A Catalogue* (London 2007)

LLEWELLYN 1991 – Nigel Llewellyn, *The Art of Death: Visual Culture in the English Death Ritual c.1500–c.1800* (London 1991)

LLEWELLYN 2000 – Nigel Llewellyn, *Funeral Monuments in Post-Reformation England* (Cambridge 2000)

LLOYD AND REMINGTON 1996 – Christopher Lloyd and Vanessa Remington, *Masterpieces in Little: Portrait Miniatures from the Collection of Her Majesty Queen Elizabeth II* (London 1996)

LONDON 1956 – H. Stanford London, *Royal Beasts* (The Heraldry Society, Wiltshire 1956)

LONDON 1978 – *British Heraldry from its Origins to c.1800*, exh. cat., British Museum (London 1978)

LONDON 1991 – *English Silver Treasures from the Kremlin: A Loan Exhibition*, exh. cat., Sotheby's (London 1991)

LONDON 1995 – Karen Hearn (ed.), *Dynasties: Painting in Tudor and Jacobean England 1530–1630*, exh. cat., Tate Gallery (London 1995)

LONDON 2003 – Susan Doran (ed.), *Elizabeth: The Exhibition at the National Maritime Museum* (London 2003)

LOOMIE 1987 – A.J. Loomie, *Ceremonies of Charles I: the Notebooks of John Finet 1628–41* (New York 1987)

LOOMIE 2004 – A.J. Loomie, 'Habington, Thomas (1560–1647)', *Oxford Dictionary of National Biography*, Oxford 2004; online at oxforddnb.com/view/article/11832 (accessed 29 October 2011)

LURYE 1961 – Y.S. Lurye, 'Russko-angliyskie otnosheniya i mezhdunarodnaya politika vtoroy poloviny XVI v.' ['Russo-English Relations and International Politics in the Second Half of the Sixteenth Century'] in *Mezhdunzrodniye svyazi Rossii do XVII v.* [*Russia's International Connections Before the Seventeenth Century*] (Moscow 1961), pp.419–43

LYUBIMENKO 1911 – I.I. Lyubimenko, 'Angliyskaya torgovaya kompaniya v Rossii v XVI veke' ['The English Trading Company in Russia in the Sixteenth Century'], *Istoricheskoe obozrenie* [*Historical Review*], 16, books 3–4 (1911)

LYUBIMENKO 1912 – I.I. Lyubimenko, 'Les marchands anglais en Russie au XVIe siecle', *Revue historique*, 109 (1912), pp.1–26

LYUBIMENKO 1912A – I.I. Lyubimenko, *Istoriya torgovykh snosheniy Rossii s Angliey* [*The History of Trading Relations Between Russia and England*] (Yuryev 1912)

LYUBIMENKO 1914 – I.I. Lyubimenko, 'The Correspondence of Queen Elizabeth with Russian Tsars', *American Historical Review*, 19, no.3 (1914), pp.525–42

LYUBIMENKO 1914A – I.I. Lyubimenko, 'A Project for the Acquisition of Russia by James I', *English Historical Review*, 29 (1914), pp.246–56

LYUBIMENKO 1915 – I.I. Lyubimenko, 'Perepiska I diplomaticheskie snosheniya Romanovykh s pervymi Styuartami' ['Correspondence and Diplomatic Relations Between the Romanovs and the First Stuarts'], *Zhurnal Ministerstva Narodnogo Prosveshcheniya* [*Journal of the Ministry of Public Education*] (July 1915), pp.62–7

LYUBIMENKO 1916 – I.I. Lyubimenko, 'Torgovye snosheniya Rossii s Angliey pri pervyh Romanovykh' ['Trading Relations Between Russia and England under the First Romanovs'], *Zhurnal Ministerstva Narodnogo Prosveshcheniya* [*Journal of the Ministry of Public Education*] (November 1916)

LYUBIMENKO 1916A – I.I. Lyubimenko, 'Les relations diplomatiques de l'Angleterre avec la Russie au XVIe siècle', *Revue historique*, 121 (1916), pp.48–82

LYUBIMENKO 1918 – I.I. Lyubimenko, 'The Correspondence of the First Stuarts with the First Romanovs', *Transactions of the Royal Historical Society*, fourth series, 1 (1918), pp.77–91

LYUBIMENKO 1923 – I.I. Lyubimenko, 'Moskovskiy rynok kak arena bor'by Gollandii s Angliei' ['The Moscow Market as an Arena for the Battle between Holland and England'], *Russkoe proshloe* [*Russian Past*], vol.5 (1923)

LYUBIMENKO 1924 – I.I. Lyubimenko, 'The Struggle of the Dutch with the English for the Russian Market in the 17th Century', *Transactions of the Royal Historical Society* (1924), pp.27–51

LYUBIMENKO 1933 – I.I. Lyubimenko, 'Les relations commerciales et politiques de l'Angleterre avec la Russie avant Pierre le Grand', *Bibliothèque de l'École des Hautes Études: Sciences philologiques et historiques*, 261 (1933)

LYUBIMENKO 1933A – I.I. Lyubimenko, 'Torgoviye Snosheniya Rossii s Angliey I Gollandiey s 1553 po 1649 g.' ['Russia's Trading Relations with England and Holland from 1553 to 1649'], *Izvestiya AN SSSR: Otdeleniye obshchestvennykh nauk* [*New of the USSR Academy of Sciences: Department of Social Sciences*], seventh series, 10 (1933), pp.729–54

MARKS AND WILLIAMSON 2003 – R. Marks and P. Williamson (eds), *Gothic: Art for England 1400–1547* (London 2003)

MARKOVA 1975 – G.A. Markova, *Nemetskoe khudozhestvennoe serebro XVI-XVII vv.* [*German Artistic Silver of the Sixteenth to Seventeenth Centuries*] (Moscow, 1975)

MARTENS 1891 – F.F. Martens, 'Rossiya i Angliya v prodolzhenie XVI–XVII vekov' ['Russia and England in the Course of the Sixteenth–Seventeenth Centuries'], *Russkaya mysl* [*Russian Thought*], books 1–2 (Moscow 1891)

MASKELL 1884 – Alfred Maskell, *Russian Art and Art Objects in Russia*, South Kensington Museum Art Handbook (1884)

MAYES 1956 – Stanley Mayes, *An Organ for the Sultan* (London 1956)

MERRIMAN 2004 – M. Merriman, 'Lee, Sir Richard (1501/2–1575)', *Oxford Dictionary of National Biography* (Oxford 2004); online at oxforddnb.com/view/article/16303 (accessed 5 November 2011)

MIGNANI 1991 – D. Mignani, *The Medicean Villas by Giusto Utens* (Florence 1991, etc.)

MILLAR 1963 – Oliver Millar, *The Tudor, Stuart and Early Georgian Pictures in the Collection of Her Majesty the Queen* (London 1963)

MORGAN 2004 – M. Morgan, 'Smythe [Smith], Sir Thomas (*c.*1558–1625)', *Oxford Dictionary of National Biography* (Oxford 2004); online at oxforddnb.com/view/article/25908 (accessed 19 October 2011)

MORRIS 2000 – Richard K. Morris, 'Architectural terracotta decoration in Tudor England' in *Secular Sculpture*, eds Phillip Lindley and Thomas Frangenburg (Stamford 2000)

MORTON 1962 – M.B.G. Morton, *The Jenkinson Story* (Glasgow 1962)

MOSCOW 2003 – *Rossiya–Britanya: K 450-letyu ustonovlenya diplomaticheskikh otnosheny* [*Russia–Britain: to commemorate the 450th anniversary of diplomatic relations*], exh. cat., Moscow Kremlin Museums (Moscow 2003)

MULLER AND MURRELL 1997 – Jeffrey M. Muller and Jim Murrell (eds), *Edward Norgate: Miniatura or the Art of Limning* (New Haven and London 1997)

MUNBY 2003 – J. Munby, 'Queen Elizabeth's Coaches: The Wardrobe on Wheels', *Antiquaries Journal*, LXXXIII (2003), pp.311–67

MURDOCH 1997 – John Murdoch, *Seventeenth-Century English Miniatures in the Collection of the Victoria and Albert Museum* (London 1997)

NADFAS 1993 – The National Association of Decorative and Fine Arts Societies, *Inside Churches: A Guide to Church Furnishings* (London 1993)

NEALE 1960 – J.E. Neale, *Queen Elizabeth I* (Middlesex 1960)

NICHOLS 1968 – J. Nichols, *The Progresses, Processions, and Magnificent Festivities of King James the First, His Royal Consort, Family and Court*, 4 vols (London 1928, repr. New York 1968)

NICHOLLS 2004 – M. Nicholls, 'Knyvett, Thomas, Baron Knyvett (1545/6–1622)', *Oxford Dictionary of National Biography* (Oxford 2004); online at oxforddnb.com/view/article/15800 (accessed 5 November 2011)

NICHOLLS AND WILLIAMS 2004 – M. Nicholls and P. Williams, 'Ralegh, Sir Walter (1554–1618)', *Oxford Dictionary of National Biography* (Oxford 2004); online at oxforddnb.com/view/article/23039 (accessed 29 October 2011)

NIKASHIDZE 1956 – N.T. Nikashidze, *Russko-angliyskie otnosheniya vo vtoroy polovine XVI v. [Russo-English Relations in the Second Half of the Sixteenth Century]* (Tbilisi 1956)

OMAN 1930 – C.C. Oman, *Catalogue of Rings* (London 1930)

OMAN 1961 – C. Oman, *The English Silver in the Kremlin 1557–1663* (London 1961)

OMAN 1978 – C. Oman, 'Niçaise Roussel and the Mostyn Flagons', *Leeds Art Calendar* 83 (1978)

OSTROWSKI 1999 – J.K. Ostrowski et al., *Land of the Winged Horsemen: Art in Poland 1572–1764* (Yale 1999)

PAGE 1912 – W.S. Page, *The Russia Company from 1553 to 1660* (London 1912)

PARIS 2002 – *Un temps d'exubérance: Les arts décoratifs sous Louis XIII et Anne d'Autriche*, exh. cat., Grand Palais (Paris, 2002)

PARKER 1968 – W.H. Parker, *An Historical Geography of Russia* (London 1968)

PATTERSON 2009 – Angus Patterson, *Fashion and Armour in Renaissance Europe: Proud Looks and Brave Attire* (London 2009)

PENZER 1958 – N.M. Penzer, 'Tudor Font-shaped Cups', *Apollo*, February & March 1958, pp.44–9, 82–6

PENZER 1959 – N.M. Penzer, 'The Steeple Cup. Part I', *Apollo* (December 1959), pp.161–6

PENZER 1960 – N.M. Penzer, 'The Steeple Cup, Part II', *Apollo*, April 1960, pp.103–9

PHIPPS 1983 – G.M. Phipps, *Sir John Merrick: English Merchant-Diplomat in Seventeenth-Century Russia* (Newtonville, MA, 1983)

PIGGOTT 1992 – Stuart Piggott, *Wagon, Chariot and Carriage* (London 1992)

PURCHAS 1626 – S. Purchas: his Pilgrimage, or Relations of the World and the Religions Observed in all Ages and places Discovered, from the Creation unto this Present (London 1626)

RALEIGH 1614 – Walter Raleigh, *The History of the World* (London 1614)

REYNOLDS 1998 – Graham Reynolds, *Fitzwilliam Museum Handbooks: British Portrait Miniatures* (Cambridge 1998)

RICHARDSON 2002 – T. Richardson, *The Armour and Arms of Henry VIII* (Leeds 2002)

RIMER, RICHARDSON AND COOPER 2009 – G. Rimer, T. Richardson and J.P.D. Cooper (eds), *Henry VIII Arms and the Man 1509–2009* (Leeds 2009)

ROGINSKY 1959 – Z.I. Roginsky, *Poezdka gontsa Gerasima Semyonovicha Dokhturova v Angliyu v 1645–6 [The Journey of Messenger Gerasim Semyonovich Dokhturov to England in 1645–6]* (Yaroslavl 1959)

ROGOZHIN 2003 – N.M. Rogozhin, *Posol'sky Prikaz kolybel' rossiyskoy diplomatii [The Ambassadorial Office, Cradle of Russian Diplomacy]* (Moscow 2003)

SCARISBRICK 1991 – Diana Scarisbrick, 'Anne of Denmark's Jewellery Inventory', *Archaeologia*, vol.109 (1991), pp.193–238

SCARISBRICK 1994 – Diana Scarisbrick, *Jewellery in Britain 1066–1837* (Norwich 1994)

SCARISBRICK 1995 – Diana Scarisbrick, *Tudor and Jacobean Jewellery* (London 1995)

SCARISBRICK 1997 – Diana Scarisbrick, 'Sir Thomas Gresham and the "Grasshopper" Rings' in *The Royal Exchange*, ed. Ann Saunders, *London Topographical Society*, no.152 (London 1997)

SCARISBRICK 2003 – Diana Scarisbrick, 'The Drake Locket Jewel' in London 2003

SHAW 1870 – W.F. Shaw, *Liber Estriae; or, Memorials of the royal ville and parish of Eastry, in the county of Kent* (London 1870)

SHIFMAN AND WALTON 2001 – B. Shifman and G. Walton, *Gifts to the Tsars 1500–1700: Treasures from the Kremlin* (Indianapolis 2001)

SIDDONS 2009 – M.P. Siddons, *Heraldic Badges in England and Wales*, 3 vols (Woodbridge 2009)

SLACK 2004 – P. Slack, 'Sir Andrew Judde (*c.*1492–1558)', *Oxford Dictionary of National Biography* (Oxford 2004); online at oxforddnb. com/view/article/37622 (accessed 19 October 2011)

SMIRNOVA AND SHUMILOV 1961 – E.I. Smirnova and V.N. Shumilov, 'Kollektsya angliyskogo serebra v Oruzheynoy palate Kremlya' ['The collection of English silver in the Armoury of the Kremlin'], *Voprosy archivovedeniya [Archive matters]*, I (Moscow 1961)

SMITH 1605 – *Sir Thomas Smithes Voiage and Entertainment in Rushia, with the Tragical Ends of two Emperors and one Empress* (London 1605)

SNODIN AND STYLES 2001 – Michael Snodin and John Styles (eds), *Design and the Decorative Arts: Britain 1500–1900* (London 2001)

SOKOLOV 1992 – A. Sokolov, *Navstrechu drug drugu: Rossiya I Angliya v XVI-XVIIi vv. [Meeting Each Other Half Way: Russia and England in the Sixteenth–Eighteenth Centuries]* (Yaroslavl 1992)

SOMERS COCKS 1980 – Anna Somers Cocks (ed.), *Princely Magnificence: Court Jewels of the Renaissance, 1500–1630* (London 1980)

STARKEY 1998 – David Starkey (ed.), *The Inventory of King Henry VIII*, vol.I, The Transcript (London 1998)

STERN 1965 – S.M. Stern, 'Documents from Islamic Chanceries', *Oriental Studies 3* (Oxford 1965), pp.119–57

STRACHAN 1989 – M. Strachan, *Sir Thomas Roe 1581–1644: A Life* (Salisbury 1989)

STRONG 1966 – Roy Strong, 'Three Royal Jewels: the Three Brothers, the Mirror of Great Britain and the Feather', *Burlington Magazine*, vol.108, no.760 (July 1966), pp.350–3

STRONG 1975 – Roy Strong, *[Folio Miniatures] Nicholas Hilliard* (London 1975)

STRONG 1977 – R. Strong, *The Cult of Elizabeth* (London 1977)

STRONG 1979 – Roy Strong, *The Renaissance Garden in England* (London 1979)

STRONG 1983 – Roy Strong, *Artists of the Tudor Court: The Portrait Miniature Rediscovered 1520–1620* (London 1983)

STRONG 1984 – Roy Strong, *The English Renaissance Miniature* (London 1984, revised edn)

STRONG 1987 – Roy Strong, *Gloriana: Portraits of Queen Elizabeth I* (London 1987)

STRONG 2004 – R. Strong, 'Hans Eworth (d.1574)', *Oxford Dictionary of National Bio-graphy* (Oxford 2004); online at oxforddnb.com/view/article/37404 (accessed 19 October 2011)

STUART 1917 – A.F. Stuart, 'Early Russian Embassies to Britain', *Twentieth Century Russia*, 2 (1917), pp.281–7

SWAIN 1973 – Margaret Swain, *The Needlework of Mary Queen of Scots* (New York 1973)

THORNTON AND CAIN 1992 – R.K.R. Thornton and T.G.S. Cain (eds), *Nicholas Hilliard: The Arte of Limning* (Manchester 1992)

THURLEY 1993 – Simon Thurley, *The Royal Palaces of Tudor England: Architecture and Court Life 1460–1547* (New Haven and London 1993)

THURLEY 2003 – Simon Thurley, *Hampton Court: A Social and Architectural History* (New Haven and London 2003)

TILLANDER 1995 – Herbert Tillander, *Diamond Cuts in Historic Jewellery 1381–1910* (London 1995)

TILLYARD 1963 – E.M.W. Tillyard, *The Elizabethan World Picture* (London 1943; Peregrine edn, Harmondsworth 1963)

TOLSTOY 1873 – Y.V. Tolstoy, 'Pervye snosheniya Anglii s Rossiey' ['England's First Relations with Russia'], *Russkiy vestnik [Russian Herald]*, 6 (1873)

TOLSTOY 1875 – Y.V. Tolstoy, 'Angliya I eyo vidy na Rossiyu v XVI veke' ['England and Her Intentions for Russia in the Sixteenth Century'], *Vestnik Evropy [Herald of Europe]*, 12 (1875)

TOLSTOY 1875A – Y.V. Tolstoy, 'Pervye sorok let snosheniy mezhdu Rossiey I Angliey 1553-93: Gramoty' ['The First Forty Years of Relations between Russia and England 1553–93: Letters'], documents collected, transcribed and edited by Y.V. Tolstoy (St Petersburg 1875)

TUSSER 1573 – Thomas Tusser, *Five Hundreth Pointes of Good Husbandrie*, (London 1573)

VAN MANDER 1994 – K. van Mander, *The Lives of the Illustrious Nether-landish and German Paint-ers*, ed. H. Miedema (Doornspijk 1994), vol.1

VELTMAN 1853 – Veltman, *Drevnosti Rosiiskogo Gosudarstva* (Moscow 1853)

VINOGRADOFF 1981 – I. Vinogradoff, 'Russian Missions to London, 1569–1687: Seven Accounts of the Masters of the Ceremonies', *Oxford Slavonic Papers*, new series, 14 (1981), pp.36–72

WADMORE 1893 – J.F. Wadmore, 'Sir Thomas Smythe, Knt. (A.D. 1558–1625)', *Archaeologia Cantiana*, XX (1893), pp.82–103

WELLS-COLE 1997 – Anthony Wells-Cole, *Art and Decoration in Elizabethan and Jacobean England: The Influence of Continental Prints, 1558–1625* (Paul Mellon Centre for Studies in British Art, 1997)

WHEELER 1928 – M. Wheeler, *The Cheapside Hoard of Elizabethan and Jacobean Jewellery*, London Museum Catalogues, no.2 (London 1928)

WHITELOCKE 1682 (1853) – Bulstrode Whitelocke, *Memorials of the English Affairs from the Beginning of the Reign of Charles the First to the Happy Restoration of King Charles the Second*, 4 vols (Oxford 1853)

WILKINSON 2002 – Frederick Wilkinson, *Those Entrusted with Arms: A History of the Police, Post, Customs, and Private Use of Weapons in Britain* (Leeds 2002)

WILLAN 1953 – T.S. Willan, *The Muscovy Merchants of 1555* (Manchester 1953)

WILLAN 1956 – T.S. Willan, *The Early History of the Russia Company 1553–1605* (Manchester 1956)

WILLIAMS AND DE REUCK 1995 – Alan Williams and Anthony de Reuck, *The Royal Armoury at Greenwich 1515–1649: A History of its Technology*, monograph 4 (Leeds 1995)

WOODALL 2007 – Joanna Woodall, *Antonis Mor: Art and Authority* (Zwolle 2007)

WRAY 1985 – David Wray, 'Boris Godunov's Coach', *Carriage Journal*, 23.2 (1985), pp.79–81

WRETTS-SMITH 1920 – M. Wretts-Smith, 'The English in Russia during the Second Half of the Sixteenth Century', *Transactions of the Royal Historical Society*, fourth series 3 (1920), pp.72–102

YAKOBSON 1934–5 – S. Yakobson, 'Early Anglo-Russian Relations, 1553–1613', *Slavonic and East European Review*, 13 (1934–5), pp.597–610

YUZEFOVITCH 1988 – L.A. Yuzefovitch, *Kak yi posol'skikh obychayakh vedyotsya… [As 'tis According to Ambassadorial Custom…]* (Moscow 1988)

ZAGORODNAYA 2006 – I. Zagorodnaya, 'English Diplomats at the Court of the Tsars' in Dmitrieva and Abramova 2006, pp.176–194

THE NATIONAL ARCHIVES, KEW
PRO, PROB 11/102 – George Carey, 2nd Baron Hunsdon
PRO, PROB 11/ 168 – 'Elizabeth Lady Berkley'
PRO, PROB 11/233 – Susanna Edmonds

RUSSIAN STATE ARCHIVE OF ANCIENT ACTS,
Ambassadorial Book 1614–17 – 'Priezd v Rossiyu posla Ivana Merika s pozdravleniyami o vstuplenii na prestol gosudara tsarya Mikhaila Fyodorovicha i s predlozheniem 1) o primirenii rossiyskogo dvora so shvedskim po pros'be o sem shvedskogo korolya. 2) o podtverzhdenii zhalovannoy gramoty angliyskim kuptsam besposhlinno torgovat'. 3) o dozvolenii angliyskim kuptsam s tovarami ezdit' Volgoyu v Indiyu …' [The arrival in Russia of Ambassador John Merrick with congratulations on the Accession of Soverign Tsar Mikhail Fyodorovich to the throne and with the suggestion 1) of the reconciliation of the Russian court with that of Sweden at the request to that effect of the Swedish king. 2) of confirmation of the charter granted to the English merchants to t rade without payment of duties. 3) of permitting English merchants to travel with their goods along the River Volga to India …], Russian State Archive of Ancient Acts, Moscow, fund.35, op.1, part 1, delo 11

Ambassadorial Book 1620–1 – 'Priezd v Rossiyu knyazya Ivana Merika s pozdravleniyami ob uchinyonnom mezhdu Russkim i Pol'skim gosudarstvami peremirii i o vozvrashchenii iz plena patriarkha Filareta, s predlozheniem ob uchinenii soyuza protiv obshchikh nepriyateley i o dozvolenii poprezhnemu angliyskim kuptsam khodit' Volgoy v Persiyu v rassuzhdenii ponesyonnykh imi v torgovle ubytkov. Tut zhe i otpusk ego …' [The Arrival in Russia of Prince [sic] John Merrick with congratulations on the peace concluded between the Russian and Polish states and on the return from captivity of Patriarch Philaret, with the suggestion of conclusion of a peace against common enemies and permitting English merchants as before to travel the River Volga to Persia with regard to the losses they have made in trade. Also his departure …] Russian State Archive of Ancient Acts, Moscow, fund.35, op.1, part 1, delo 7

Ambassadorial Book 1663–4 – 'Priezd v Moskvu angliyskogo velikogo i polnomochnogo posla Charlusa Govorta s synom i s zhenoyu, I s sekretaryom Andreem Morvelem s predlozheniem o podtverzhdenii mezhdu oboimi gosudarsvami druzhby i lyubvi i o dozvolenii besposhlinnoy torgovli …' [The arrival in Moscow of the senior and plenipotentiary ambassador Charles Howard with his son and wife, and with his secretary Andrew Marvell, with the suggestion that the friendship and love between the two states be confirmed, and that duty-free trade be permitted …], Russian State Archive of Ancient Acts, Moscow, fund.35, op.1, delo 11

ARMOUR

Armour of Henry VIII (pl.130)
Royal workshops, Greenwich,
England, under the direction of
Erasmus Kirkenar, c.1539
Steel, with etched borders, 183 × 132 cm
The Royal Collection (RCIN 72834)

Field armour of Lord North (pl.141)
Royal Armouries, Greenwich,
England, c.1565
Steel, 179 × 80 × 40 cm
The Royal Armouries (II.82)

Vamplate from an armour of
Sir Christopher Hatton (pl.142)
Royal Armouries, Greenwich,
England, 1578–87
Steel, with etched and gilt decoration,
height 13.8 cm, back diameter 24.6 cm,
front diameter 72 mm
The Royal Armouries (III.890)

Portions from a field armour
possibly belonging to Sir Christopher
Hatton (pl.143)
Royal Armouries, Greenwich,
England, c.1587
Steel with etched and gilt decoration,
right greave and sabaton 50.5 × 11 × 29 cm,
left greave and sabaton 51 × 11 × 30.5 mm,
upper body as mounted 97 × 61 × 48 cm
(including helmet)
The Royal Armouries (II.77)

Field armour of Sir Henry Lee
(pls 128 and 139)
Royal Armouries, Greenwich,
England, 1587–8
Steel, etched, the etching originally
partly gilded on a black background
possibly with highlights painted in red
and green, 179 × 79 × 49 cm
The Worshipful Company of
Armourers and Brasiers

Falling buffe from a field armour
of Sir Henry Lee (pl.140)
Royal Armouries, Greenwich,
England, 1587–8
Steel, etched, the etching originally
partly gilded on a black background
possibly with highlights painted in red
and green, 31 × 30 × 18 cm
The Worshipful Company of
Armourers and Brasiers

Close helmet from an armour of
Sir Henry Lee (pl.136)
Royal Armouries, Greenwich,
England, 1585–7
Steel, with etched, gilded and blackened
decoration, 27.6 × 19.6 × 34.3 cm
The Royal Armouries (IV.43)

Locking gauntlet from an armour
of Sir Henry Lee (pl.137)
Royal Armouries, Greenwich,
England, c.1585–7
Steel, with etched, gilded and blackened
decoration, length 32 mm, depth at
knuckles 13.3 mm, depth at arm
13.1 mm, width at widest point 13.7 cm
The Worshipful Company of
Armourers and Brasiers

ARMS

Rapier (pl.144)
England, c.1600
Steel, the hilt damascened with gold
and encrusted with chiselled silver,
124.8 × 22.5 × 12.4 cm
V&A: M.51–1947

Pair of pistols (pl.147)
Pervusha Isaev, Armoury workshops
Moscow, Russia, 1600–25
Steel, silver, wood, mother of pearl,
engraved, encrusted, gilded and silver-
gilt, overall length 58 cm, barrel length
35.9 cm, calibre 16 mm
The Moscow Kremlin Museums
(OR-156 and OR-157)

Hunting gun (pl.148)
Henry Burrows
London, England, 1618–23
Steel, wood, mother of pearl, ivory,
engraved, gilded, carved, encrusted,
damascened with gold, overall length
122.6 cm, barrel length 87.7 cm,
calibre 11.5 mm
The Moscow Kremlin Museums
(OR-4292)

Snaphaunce musket (pl.149)
The Netherlands, 1620s
Steel, wood, ivory, mother of pearl,
wrought, engraved, carved, encrusted
and silver-gilt, overall length 161.7 cm,
barrel length 124.4 cm, calibre 19 mm
The Moscow Kremlin Museums
(OR-272)

Hunting gun (pl.150)
Timofey Luchaninov,
Armoury workshops
Moscow, Russia, 1626–34
Steel, wood, silver, mother of pearl,
wrought, engraved, carved, encrusted,
gilded and silver-gilt, overall length
124.8 cm, barrel length 89.6 cm,
calibre 10 mm
The Moscow Kremlin Museums
(OR-152)

Seven-shot magazine hunting gun
(pl.151)
Caspar Kalthoff the Elder
and Harman Barne
London, England, 1658
Steel, copper alloy, wood, engraved,
carved and damascened with gold,
overall length 136.7 cm, barrel length
91.2 cm, calibre 15.5 mm
The Moscow Kremlin Museums
(OR-104)

CUTLERY

Knife (pl.145)
Arnold Smyth
London, England, 1607
Steel blade, etched and damascened
with gold, carved ivory handles set
with semi-precious stones and pastes,
length 29.8 cm
V&A: 463–1869

Knife (pl.146)
Arnold Smyth
London, England, 1607
Steel blade, etched and damascened
with gold, carved ivory handles set
with semi-precious stones and pastes,
length 29.6 cm
V&A: 465–1869

Fork (not illustrated)
Richard Crosse
London, England, 1632–3
Silver, 17.5 × 1.2 × 0.6 cm, 39.7 grams
V&A: M.358–1923

HERALDRY

The Dacre Bull (pl.55)
Cumbria, England, 1507–25,
banner added c.1844
Carved, painted and gilded oak,
with tinned copper banner,
326.3 × 58 × 110.5 cm
V&A: W.6:1 to 5–2000

The Dacre Griffin (pl.52)
Cumbria, England, 1507–25,
banner added c.1844
Carved, painted and gilded oak,
with tinned copper banner,
342 × 57.5 × 107.5 cm
V&A: W.7:1 to 4–2000

The Dacre Ram (pl.53)
Cumbria, England, 1507–25,
banner added c.1844
Carved, painted and gilded oak,
with tinned copper banner,
339 × 63.1 × 114.5 cm
V&A: W.8:1 to 4–2000

The Dacre Dolphin (pl.54)
Cumbria, England, 1507–25,
banner added c.1844
Carved, painted and gilded oak,
with tinned copper banner,
355.8 × 50.3 × 126 cm
V&A: W.9:1 to 5–2000

Pair of heraldic royal beasts,
possibly 'Leopards of England',
known as 'Kyng's Beestes' (pl.56)
England, c.1520–30
Taynton stone, 120 × 43 × 37 cm
Todd Longstaffe-Gowan

The Royal Arms of England and
the motto of the Order of the Garter
(not illustrated)
From Barnham Hall, Suffolk, England,
early 1500s (the crown is modern)
Clear and coloured glass, leaded,
painted with pigments and silver stain,
50.2 × 48.3 cm
V&A: CIRC.747–1920

The Crowned Tudor rose
(not illustrated)
Possibly from Nonsuch Palace,
Surrey, England, c.1537
Clear and coloured glass, leaded,
painted with a brown or black pigment
and silver stain, 62.2 × 29.2 cm
V&A: C.456–1919

The badge of Edward VI as the
Prince of Wales (not illustrated)
From Cowick Priory, Devon,
England, c.1545
Clear glass, leaded, painted in enamel
paint and silver stain, 41.3 × 35.6 cm
V&A: C.453–1919

Charles II's Royal Arms of England
(not illustrated)
Henry Gyles
England, c.1682 (restored by
J. Barnett in 1825)
Enamel and glass, painted and silver
stained, 90.7 × 52.4 × 2.9 cm
V&A: C.88: 1-3–1926

JEWELLERY

Serjeant-at-Law's ring (pl.208)
London, England, c.1531
Engraved gold, depth 9 mm,
diameter 21 mm
V&A: M.52–1960
Given by Dame Joan Evans

Ring with intaglio of Henry VIII
(pl.196)
London, England, c.1545
Gold, engraved chalcedony intaglio,
24 × 19 × 28 mm
V&A: M.5–1960
Frank Ward Bequest

The Hunsdon girdle prayer book (pl.181)
England, c.1553–60
Enamelled gold case mounted with a
shell cameo, containing a manuscript
book including the last prayer of
Edward VI, 64 × 51 × 19 mm
Trustees of the Berkeley Will Trust
V&A: LOAN:MET.ANON 2:4–1998

The Lee Ring (pls 197 and 198)
London, England, 1544–75
Gold with reverse painted, gilded and
silvered chalcedony intaglio engraved
with the arms of Sir Richard Lee; on
the back of the bezel a grasshopper
enamelled in green, the badge of Sir
Thomas Gresham, 26 × 26 × 20 mm
V&A: M.249–1928

Pendant: The Pelican in her Piety
(pl.209)
Probably Spain, c.1550–75
Enamelled gold, set with a foiled
ruby simulant (rock crystal with a red
adhesive layer) and hung with pearls,
96 × 38 × 24 mm
V&A: 335–1870

Robert Taylor's Grasshopper Ring
(pl.213)
London, England, 1575
Gold, with reverse painted, gilded and
silvered crystal intaglio engraved with
the arms of Taylor impaling Stonehouse;
on the back of the bezel a grasshopper
enamelled in green, 24 × 13 mm
Private collection

The Barbor Jewel (pls 190 and 191)
Probably London, England,
cameo c.1575–85, setting c.1615–25
Gold, enamel, set with an onyx cameo,
table-cut rubies and diamonds, and
hung with pearls, 60 × 31 × 10 mm
V&A: 889–1894
Given by Miss M. Blencowe

The Hunsdon Onyx:
Perseus and Andromeda (pl.180)
Western Europe, c.1575–95 ;
the cameo probably Milan
Onyx cameo, probably carved in
Milan, mounted in enamelled gold,
125 × 84 × 10 mm
Trustees of the Berkeley Will Trust
V&A: LOAN:MET.ANON2:5–1998

Cameo of Elizabeth I with a sieve (pl.188)
Probably London, England, c.1579–85
Sardonyx, 55 × 40 mm
V&A: 1603–1855

The Boteler Ring (pl.193)
England, c.1580
Gold engraved with the arms of Boteler,
found at Eastry, Kent, 29 × 19 × 25 mm
V&A: M.99–1984

The Hunsdon Ship Pendant (pl.182)
Western Europe, c.1580
Wood, gold, enamel, pearls,
table-cut diamonds, 72 × 51 × 14 mm
Trustees of the Berkeley Will Trust
V&A LOAN:MET.ANON 2:3–1998

Memento mori ring (pl.210)
England, 1550–1600
Engraved gold and enamel, 24 × 14 × 21 mm
V&A: 13–1888
Bequeathed by Miss Charlotte
Frances Gerard

The Drake Star (pl.183)
Probably England, c.1580–90
Gold, enamel, table-cut rubies and
diamonds, cabochon opals in the form
of a sun-in-splendour; on the reverse
a miniature under glass, probably of
Elizabeth, diameter 50 mm
Private Collection, normally on
long-term loan to the National
Maritime Museum

The Drake Jewel (pls 185 and 186)
The miniature of Elizabeth I by
Nicholas Hilliard, possibly dated 1586
Western Europe, the miniatures painted
in London, c.1580–90
Gold, sardonyx cameo, enamel, table-cut
rubies and diamonds, pearls; miniatures
painted in watercolour on vellum and
on parchment, 125 × 60 × 17 mm
Private Collection, normally on
long-term loan to the Victoria and
Albert Museum
V&A LOAN:MET.ANON.1–1990

The Knyvett Seal and Case
(pls 199 and 200)
England, c.1580–90
Gold, enamel, mounted with a
sapphire intaglio, engraved with the
arms of Knyvett, seal 52 × 25 × 12 mm;
case 46 × 32 × 15 mm
V&A: M.52&A–1980

Ring with Medusa intaglio (pl.201)
Western Europe, intaglio:
100 BC–100 AD, ring c.1600
Gold, enamel, sapphire intaglio,
16 × 24 × 23 mm
V&A: M.553–1910
Salting Bequest

Grape pendant (pl.206)
London, England, c.1600–40
Gold, amethyst, 53 × 30 mm
Museum of London (A14186)

Grape pendant (pl.207)
London, England, c.1600–40
Gold, amethyst, 47 × 24 mm
Museum of London (A14187)

Signet ring (pls 194 and 195)
England, 1611–43
Swivelling gold bezel engraved with
the crest of Throckmorton and arms
of Carew made for Sir Nicholas
Throckmorton who adopted the
name of Carew in 1611
Gold, 27 × 17 × 26 mm
V&A: 808–1871

Watch (pl.211)
Edward East, London, England, c.1635
Rock crystal, gilt-brass, steel, silver
hour ring and enamelled numerals,
57 × 29 × 23 mm
V&A: M.360–1927
Given by Miss Eva M. Earle of
Great Yeldham

Ring with cameo of Charles I (pl.212)
England, before 1649; the cameo
attributed to Thomas Rawlins
Gold, carnelian cameo, enamel,
rose-cut diamonds set in silver
24 × 22 × 14 mm
Private collection

Ring with miniature of Charles I (pl.214)
England, ring: c.1780, miniature:
c.1649–1700
Gold with a miniature painted in enamel
set under rock crystal, 21 × 21 × 19 mm
V&A: M.1–1909
Bequeathed by Miss A. Cameron

MANUSCRIPTS, MAPS AND FOLIOS
Designs for an armour for Robert
Dudley, Earl of Leicester (pl.133)
From the Jacob Album, Greenwich,
England, c.1565
Watercolour on paper, 431 × 291 mm
(D.593–1894); 431 × 289 mm
(D.593A–1894)
V&A: D.593&A–1894

Designs for an armour for
Sir Christopher Hatton (pl.134)
From the Jacob Album,
Greenwich, England, c.1575
Watercolour on paper, 430 × 292 mm
(D.600–1894); 430 × 290 mm
(D.600A–1894)
V&A: D.600&A–1894

Designs for an armour for
Sir Henry Lee (pl.135)
From the Jacob Album,
Greenwich, England, c.1585
Watercolour on paper, 431 × 288 mm
(D.604–1894); 431 × 288 mm
(D.604A–1894) V&A: D.604&A–1894

Manuscript chart of the northern
coast of Russia (not illustrated)
From an atlas compiled by
Lord Burghley, William Borough,
London, 1568
Ink and watercolour on vellum,
1000 × 850 × 30 mm
The British Library
(Maps 9, tab 14 map 107)

Map of Russia, Muscovy and the land
of the Tartars (pl.12)
Abraham Ortelius, after Anthony
Jenkinson
Antwerp, Flanders, 1570
Ink and watercolour on paper,
336 × 660 mm
The British Library (Royal MS
18.D.III, ff.123v–124)

The league between the Muscovites
and the English (not illustrated)
England, 1601
Ink or pencil on paper in bound
manuscript, 226 × 166 × 37 mm (closed)
College of Arms (Vincent 151)

The First Folio (not illustrated)
William Shakespeare, Mr. William
Shakespeares comedies, histories &
tragedies: published according to
the true originall copies, edited by
I. Heminge and H. Condell
London, England, printed by
William Jaggard and Edward Blount,
engraving of William Shakespeare
by Martin Droeshout, 1623
Bound volume, 332 × 230 × 55 mm
National Art Library
V&A: L.1392–1882

Drawings of a hairpin, pendant
and seal matrix (pl.205)
From the Lulls Album, page 47
Possibly made to the direction of
Arnold Lulls, England, c.1584–1642
Pen and ink and watercolour on laid
paper (middle and right drawings);
watercolour, body colour and gold
paint on laid paper (left drawing),
220 × 160 × 21 mm
V&A: D.6.19–1896

MINIATURES
Thomas Seymour, Lord Seymour
of Sudeley (pl.33)
Unknown artist (Holbein school), c.1545
Watercolour on vellum, 58 × 45 × 35 mm
National Maritime Museum
(MNT 0137)

Elizabeth I (pl.35)
Nicholas Hilliard
England, 1585–6
Watercolour on vellum, stuck to
pasteboard; set into a vellum mount
in the 17th century, 44 × 37 mm
(65 × 85 mm including frame)
V&A: P.23–1975

Unknown Youth (pl.36)
Nicholas Hilliard
England, 1590–3
Watercolour on vellum, stuck to
a playing card with a six of hearts,
52 × 42 × 10 mm
V&A: P.3–1974

Unknown Lady (pl.39)
Nicholas Hilliard
England, c.1590
Watercolour on vellum, stuck
to plain card, 51 × 41 × 5 mm
V&A: P.8–1945

Unknown Lady, formerly called Frances
Howard, Countess of Somerset (pl.42)
Isaac Oliver
England, c.1596–1600
Watercolour on vellum, stuck to plain
card, 214 × 200 × 30 mm (including frame)
V&A: P.12–1971

Unknown Woman in a Masque Costume
(pl.44)
Isaac Oliver
England, 1609
Watercolour on vellum,
stuck to plain card, 62 × 51 mm
V&A: P.3–1942

Unknown Man (pl.41)
Isaac Oliver
England, c.1610
Watercolour on vellum, stuck to
a playing card, 43 × 35 × 4 mm
V&A: P.129–1910

James I and the Ark (pl.40)
Nicholas Hilliard
England, c.1610
Locket of enamelled gold, with
miniatures stuck to card,
closed 30 × 19 × 5 mm, open 42 × 19 × 5 mm
V&A: M.92–1975

Anne of Denmark (pl.43)
Isaac Oliver
England, c.1612
Watercolour on vellum, 55 × 43 mm
V&A: FA.689

Charles I as the Prince of Wales (pl.47)
Sir Balthazar Gerbier
England, c.1616
Watercolour on vellum, put down on
a leaf from a table-book, 50 × 39 mm
V&A: P.47–1935
Peter Oliver

Mrs Edward Norgate (born Lanier)
(pl.46)
England, c.1616–17
Watercolour on vellum, put down
on pasteboard, 54 × 43 × 9 mm
V&A: P.71–1935

Unknown man, formerly identified
as Sir Arnold Breams (pl.38)
Follower of Nicholas Hilliard
England, 1617
Watercolour on vellum, 57 × 47 mm
V&A: Evans.2

Elizabeth of Bohemia,
daughter of James I (pl.45)
Peter Oliver
England, c.1623–6
Watercolour on vellum, put down
on pasteboard, 56 × 41 × 7 mm
V&A: Dyce.88

MEDALS
Medal commemorating the marriage of
Henry VII and Elizabeth of York (pl.18)
Prague, late 15th century
Silver gilt, diameter 53 mm
Museum of London (NN18449)

'State of England' medal
commemorating the marriage of Mary
Tudor and Philip II of Spain (pl.19)
Possibly by a Netherlandish
follower of Jacopo da Trezzo
Madrid, Spain or the
Low Countries, 1555 or later
Copper alloy, diameter 65 mm
Museum of London (NN18452)

Games counter depicting the
'Defeat of the Armada' (pl.20)
Possibly Dordrecht, Netherlands, 1588
Copper alloy, diameter 28 mm
Museum of London (NN18457)

Coronation medal of Charles I (pl.21)
Nicholas Briot
London, England, 1626
Silver, diameter 29 mm
Museum of London (A7528)

MISCELLANEOUS
Goblet (not illustrated)
Probably by Jacob Verzelini the Elder
and engraved by Antony de Lysle
Crutched Friars Glasshouse,
London, England, 1550–1600
Clear glass, with trails and diamond-
point engraving, 16.8 × 12.7 cm
V&A: C.226–1983

Seal die of the Muscovy Merchants
Company (not illustrated)
London, 1555
Silver, diameter 51 mm
British Museum (1928.0315.1)

Comb (not illustrated)
Possibly France, late 16th or 17th century
Elephant ivory, carved, pierced and
gilded, 12.5 × 6 × 4 cm
Museum of London (80.271/29)

Shoehorn (not illustrated)
Robert Mindum
Possibly London, England, 1600
Horn (bovine), 28 × 5.8 cm
Museum of London (58.38/5)

Nonsuch chest (not illustrated)
London, England, c.1600
Oak inlaid with various woods and
metal fittings, 59.4 × 122.8 × 58 cm
V&A: 342–1905

Fireback, with 'C R' and The Royal
(Boscobel) Oak (not illustrated)
England, probably Weald,
mid 17th century (after 1651)
Cast iron, 75.5 × 90.2 × 2.7 cm
V&A: 255–1906

Trunk, with monogram of William III
and Mary II on the lid (not illustrated)
England, 1689–1702
Softwood and leather with metal
fittings and studs, 67 × 96.5 × 56.5 cm
V&A: 497–1894

Great White Pelican (Pelecanus
onocrotalus) taxidermy specimen
(not illustrated)
Probably mounted by G. Pickhardt,
c.1880–1900
910 × 490 × 450 cm
Natural History Museum
(NHMUK 1996.41.27)

Model of an English coach
(not illustrated)
David C. Wray
England, 1974–82
Wood, textile, velvet, silk thread,
brass, leather, polychrome paint,
46 × 146 × 38 cm
National Museum of Science
and Industry (1982–806)

PAINTINGS AND DRAWINGS
Nonsuch Palace from the South (pl.15)
Joris Hoefnagel
England, 1568
Black chalk, pen and brown and black
ink, watercolour, heightened with white
and gold, on paper, 216 × 325 mm
Christie's, London

Queen Elizabeth receiving the
Dutch ambassadors (pl.16)
Germany, c.1585?
Gouache on paper, 24.4 × 37.5 cm
Staatliche Museen Kassel
Graphische Sammlung (10430)

A Tsar receiving a delegation in the
Hall of the Palace of Facets (pl.23)
Attributed to Simon Boguszowick
1630s
Oil and tempera on panel, 43.5 × 64 cm
(painting), 53.7 × 75 cm (framed)
Hungarian National Museum, Budapest

Charles II receiving the Spanish
Ambassador, the Prince de Ligne (pl.24)
Attributed to François du Chastel
Painted from direct observation, 1660
Oil on canvas, 134.5 × 160 cm
Prince de Ligne, Château de Beloeil,
Belgium

PORTRAITS
Henry VII (pl.57)
Unknown English artist
England, 16th century
Oil on panel, 49.5 × 59.7 cm
V&A: 572–1882

Henry VIII (pl.161)
After Hans Holbein the Younger
London, England, late 16th or early
17th century (after a portrait of c.1536)
Oil on copper, 27.9 × 20 cm
National Portrait Gallery (NPG 157)

Edward VI (not illustrated)
After William Scrots
England, late 16th or early 17th century
Oil on oak panel, 41.9 × 44 cm (panel)
V&A: 493–1882

Elizabeth I (The Hampden Portrait)
(pl.17)
Attributed to Steven van Herwijk or
otherwise Steven van der Meulen
England, 1563
Oil on canvas, 196 × 140 cm
Private collection

Alice Smith née Judde (pl.26)
Cornelis Ketel
London, England, 1579
Oil on panel, 46.8 × 39 cm
Private collection

Thomas Smith the Younger (pl.27)
Cornelis Ketel
London, England, 1579
Oil on panel, 46.8 × 39 cm
Private collection

Robert Dudley, 1st Earl of Leicester (pl.131)
Unknown Anglo-Netherlandish artist
Probably England, c.1564
Oil on panel, 107 × 80 cm
Waddesdon Manor, The Rothschild
Collection (14.1996)

Sir Jerome Bowes (pl.22)
Unknown English artist
England, c.1583
Oil on canvas, 248.1 × 152 × 9.5 cm
English Heritage, Suffolk Collection
(88019152 (RH 2))

Sir Francis Drake (pl.184)
Marcus Gheeraerts the Younger
England, 1591
Oil on canvas, 119.8 × 91.4 cm
Caird Collection, National Maritime
Museum, Greenwich (BHC2662)

Robert Devereux, 2nd Earl of Essex
(not illustrated)
Marcus Gheeraerts the Younger
England, 1596–1601
Oil on canvas, 119.4 × 94 cm
National Maritime Museum
(BHC2681)

James I (pl.164)
John de Critz
London, England, c.1610
Oil on canvas, 104.2 × 83.8 cm
National Maritime Museum
(BHC2796)

Anne of Denmark (pl.179)
After Paul van Somer
London, England, 17th century
(after a portrait of c.1617)
Oil on canvas, 27.9 × 20 cm
National Portrait Gallery (NPG 127)

Henry Wriothesley, 3rd Earl of
Southampton (not illustrated)
After Daniel Mytens
London, England, c.1618
Oil on canvas, 88.9 × 68.6 cm
National Portrait Gallery (NPG 52)

Charles I (pl.69)
After Anthony Van Dyck
London, England, c.1635–7
Oil on canvas, 123.2 × 99.1 cm
National Portrait Gallery, NPG 2137

Henrietta Maria (pl.70)
After Anthony Van Dyck
London, England, c.1632–5
Oil on canvas, 109.2 × 82.6 cm
National Portrait Gallery (NPG 227)

Charles Howard, 1st Earl of Carlisle (pl.68)
Sir Godfrey Kneller
London, England, 1684 (enlarged
by William Aikman, 1728)
Oil on canvas, 304.8 × 188 cm
Castle Howard, North Yorkshire
(PO 0199)

Tsar Alexei Mikhailovich (pl.25)
Pfandzelt Lucas Conrad
Holland, 1766
Oil on canvas, 43 × 32 cm
The Moscow Kremlin Museums
(ZH-2015/1-2)

Fabian Smith (pl.88)
Unknown artist
London, England, after 1637
Oil on canvas, 76.8 × 63.8 cm
Guildhall Art Gallery (1725)

Prince P.I. Potemkin (pl.14)
After Sir Godfrey Kneller
Russia, probably 18th century
Oil on canvas, 132 × 104.5 cm
The Moscow Kremlin Museums
(ZH-2018/1)

Tsar Mikhail Romanov (pl.1)
Unknown Russian artist
Armoury School, Moscow, c.1675–85
Oil on canvas, 45.5 × 32.8 cm
State Historical Museum, Moscow
GIM 32936/1-3459

SILVER

Casting bottle (pl.93)
England, c.1540–50
Silver, chased, embossed and engraved,
with applied shaped and punched wire,
height 117 mm; weight 95 grams
V&A: 451–1865

Snuffers (pl.94)
England, 1547–53
Silver gilt, cast, length 208 mm;
weight 197 grams
V&A: M.837–1928

Earthenware pot (pl.95)
England, c.1550–60
Earthenware with silver-gilt cage
mounts, 150 × 90 mm
V&A: M.351–1910

Font-shaped cup (pl.96)
London, England, 1557–8
Silver, chased, cast, gilded, engraved,
height 157 mm, diameter 180 mm;
weight 894.7 grams
The Moscow Kremlin Museums
(MZ-650)

The Mostyn salt (pl.97)
London, England, 1563–4
Silver gilt, height 150 mm;
weight 230 grams
V&A: 147–1886

The Mostyn caster (pl.98)
London, England, 1563–4
Silver gilt, embossed and chased,
height 104 mm; weight 174 grams
V&A: 150–1886

Stoneware pot (pl.99)
London, England, c.1570
White Siegburg stoneware with silver
mounts, height 245 mm; 1092 grams
V&A: 130–1908

Spice dish (pl.100)
Roger Flynt
London, England, 1573–4
Silver gilt, 26 × 252 mm; 504 grams
V&A: M.55c–1946

Flask (pls 84 and 102)
London, England, 1580–1
Silver gilt, cast, chased, engraved,
height 440 mm; weight 29725 grams
The Moscow Kremlin Museums
(MZ-657)

Livery pot (pls 72 and 103)
London, England, 1594–5
Silver, glass, chased, cast, engraved,
gilded, height 385 mm;
weight 2967.8 grams
The Moscow Kremlin Museums
(MZ-664)

Casket (pl.101)
London, England, c.1600
Mother of pearl and silver gilt,
height 85 mm; 385 grams
V&A: M.245–1924

Leopard ewer (pl.104)
London, England, 1600–1
Silver gilt, chased, cast, height 940 mm;
weight 29322.7 grams
The Moscow Kremlin Museums
(MZ-693)

Water pot (pls 75, 79 and 105)
London, England, 1604–5
Silver gilt, cast, chased, engraved,
height 640 mm; weight 11476 grams
The Moscow Kremlin Museums
(MZ-642)

Livery pot (pl.106)
London, England, 1604–5
Silver gilt, chased, cast, height 510 mm;
weight 3823.1 grams
The Moscow Kremlin Museums
(MZ-645)

Gourd-shaped cup (pls 82 and 107)
London, England, 1604–5
Silver gilt, cast, chased, engraved,
height 470 mm; weight 1394.1 grams
The Moscow Kremlin Museums
(MZ-634/1-2)

Large flask (pl.108)
London, England, 1606–7
Silver gilt, cast, chased, height 580 mm;
weight 4568.5 grams
The Moscow Kremlin Museums
(MZ-658)

Mermaid ewer and basin (pl.109)
London, England, 1610–11
Silver, ewer 317 × 125 mm;
basin 95 × 455 mm; 1287 grams
V&A: M.10–1974

The TvL Cup (pl.110)
Possibly Thierry Dierick Luckemans
London, England, 1611–12
Silver gilt, cup height 356 mm,
cover height 140 mm; 1585 grams
V&A: 5964–1859

Standing cup (pl.114)
Probably Thomas Cheston
London, England, 1613–14
Silver gilt, cast, chased,
height 510–20 mm; weight 2033.1 grams
The Moscow Kremlin Museums
(MZ-619)

Livery pot (pls 73 and 112)
Probably William Rayne the elder
London, England, 1613–14
Silver gilt, cast, chased, height 410 mm;
weight 2449.2 grams
The Moscow Kremlin Museums
(MZ-699)

Water pot (pls 65, 89 and 113)
Richard Blackwell I
London, England, 1615–16
Silver gilt, cast, chased, height 620 mm;
weight 8283 grams
The Moscow Kremlin Museums
(MZ-640)

The Warwick Cup (pl.111)
Thomas Francis
London, England, 1617–18
Silver gilt, cast, chased, height 478 mm;
weight 1797.8 grams
The Moscow Kremlin Museums
(MZ-623)

Flask (pl.115)
London, England, 1619–20
Silver gilt, cast, chased, height 480 mm;
weight 2908.7 grams
The Moscow Kremlin Museums
(MZ-654)

Ewer (pl.116)
René Cousturier
Paris, France, 1624
Silver gilt, cast, chased, height 450 mm;
weight 4408 grams
The Moscow Kremlin Museums
(MZ-1781)

Basin (pl.117)
Antoinette Marqueron
Paris, France, 1624
Silver gilt, cast, chased, diameter 750 mm;
weight 1156.7 grams
The Moscow Kremlin Museums
(MZ-1780)

The Richard Chester covered cup (pl.118)
Thomas Flynt
London, England, 1625–6
Silver gilt, chased and embossed,
height 450 mm; 729 grams
V&A: M. 244–1924

The Lord Keeper's seal cup (pl.119)
London, England, 1626–7
Silver gilt, chased and embossed,
height 700 mm; 3826.2 grams
V&A: M.59–1993

The Dolphin Basin
Christian van Vianen (pl.120)
London, England, 1635
Silver, 70 × 350 × 485 mm, 1629 grams
V&A: M.1–1918

Lantern clock (pl.121)
David Bouquet
London, England, c.1650 (the gong
and finial are later restorations)
Silver, 201 × 94 × 86 mm
V&A: M.1139–1926

Perfuming pot and stand
(pls 92 and 122)
Probably John Neave
London, England, c.1663
Silver gilt, cast, chased, openwork
carving, height 450 mm;
weight 5774.9 grams
The Moscow Kremlin Museums
(MZ-695/1-4)

Fruit dish (pl.123)
London, England, 1663
Silver gilt, chased, height 85 mm,
diameter 425 mm; weight 1828.5 grams
The Moscow Kremlin Museums
(MZ-648)

Flask (pls 67 and 124)
Robert Smithier
London, England, c.1663
Silver gilt, cast, chased, height 380 mm;
weight 4308.7 grams
The Moscow Kremlin Museums
(MZ-659)

Livery pot (pl.125)
Henry Greenway
London, England, 1663
Silver gilt, cast, chased, height 400 mm;
weight 4835 grams
The Moscow Kremlin Museums
(MZ-660)

Standing cup (pls 90 and 126)
Francis Leake
London, England, c.1663
Silver gilt, cast, chased, height 730 mm;
weight 4073.5 grams
The Moscow Kremlin Museums
(MZ-621/1-2)

Trumpet (*not illustrated*)
Augustine Dudley
London, England, 1666
Copper alloy with silver mounts,
713 × 146 × 94 mm
Museum of London (64.127)

Firedogs, tongs and shovel (pl.226)
John Coquus,
London, England, 1669
Made for Philip Stanhope, 2nd
Earl of Chesterfield for Bretby,
Nottinghamshire

Silver, firedogs with supports
500 × 330 × 425 mm; and 500 × 330 × 400
mm, weight of each 3677.9 grams;
shovel, scoop end 770 × 177 × 35 mm,
tongs 790 × 13 × 45 mm
V&A: LOAN:MET.ANON 1-4–2011

TEXTILES
Napkin (pl.166)
Southern Netherlands, 1558–1600
Linen damask, 113 × 71 cm
V&A: T.215–1963

Bed valance (pl.158)
England, Scotland or France, 1580–1600
Linen canvas, embroidered with wool
and silk, 540 × 1840 mm
V&A: T.135–1991

Bed valance (pl.167)
England, Scotland or France, 1580–1600
Linen canvas, embroidered with wool
and silk, 57.5 × 213 cm
V&A: T.136–1991

Bed valance, depicting Venus and
Adonis (pl.168)
England, Scotland or France, 1580–1600
Linen canvas, embroidered with wool
and silk, 216 × 57.5 cm
V&A: 879–1904

Bed valance, depicting Myrrah (pl.169)
England, Scotland or France, 1580–1600
Linen canvas, embroidered with wool
and silk, 215.9 × 56.5 cm
V&A: 879A–1904

Man's cloak (pl.170)
France, 1580–1600
Silk satin, embroidered with metal
thread and silk, 98.4 × 196.9 × 50 cm
V&A: 793–1901

Woman's coif (pl.171)
England, c.1600
Linen, embroidered with silver and
silver-gilt thread, spangles and pearls,
with metal bobbin lace, 22.2 × 20.5 cm
V&A: T.239–1960

Cushion cover with floral design
(pl.160)
England, c.1600
Silk satin, embroidered with silk
and metal thread, edged with gilded
bobbin lace and tassels, 51.5 × 48.5 cm
V&A: T.21–1923

Ruff (pl.173)
Italy, 1600–1700
Needle lace worked in linen thread,
203 × 11.5 cm
V&A: T.14–1965

Cushion cover with the Royal Arms
(pl.159)
Made by or for Mary Hulton
England, 1603–25
Linen canvas, embroidered with silk,
wool and metal thread, 52 × 98 cm
V&A: 816–1893

Pair of gloves (pl.174)
England, 1603–25
Leather with silk satin gauntlets,
embroidered with silk, metal thread
and seed pearls, trimmed with metal
bobbin lace, each 9 × 41.5 × 26 cm
V&A: 1506&A–1882

Man's nightcap (pl.172)
England, c.1610
Linen, embroidered in silver and silver-
gilt thread, with metal bobbin lace,
height 190 mm
V&A: T.75–1954

Women's jacket (pl.176)
England, 1610–20
Linen, embroidered with silk and
metal thread, and spangles, 68 × 126 cm
V&A: 1359–1900

Doublet and breeches (pl.175)
England, 1630s
Silk satin, quilted, with applied silk
band, doublet length 69 cm;
breeches length 46 cm
V&A: 347&A–1905

Embroidered Eikon Basilike (pl.177)
England, c.1650–60
Silk satin, embroidered with silk, metal
thread and seed pearls, 36.5 × 47.3 cm
V&A: T.117–1936

INDEX OF NAMES

PICTURE CREDITS

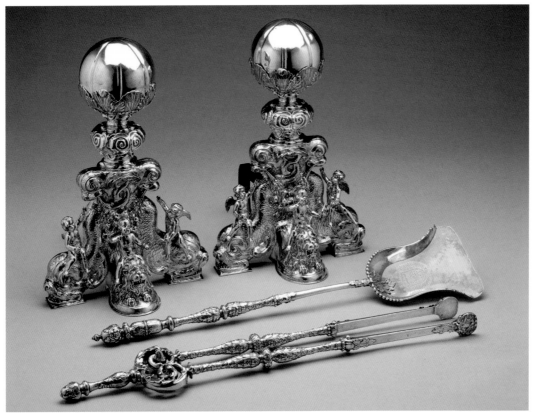

226
Firedogs, tongs and shovel
John Coquus
London, England, 1669
Private collection